HOW TO PHOTOGRAPH
EVERYTHING

POPULAR
PHOTOGRAPHY

HOW TO PHOTOGRAPH
EVERYTHING

SIMPLE TECHNIQUES FOR SHOOTING SPECTACULAR IMAGES

weldon**owen**

CONTENTS

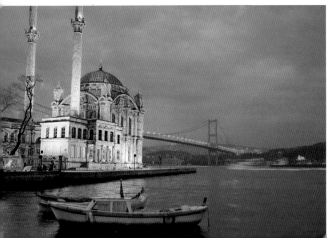
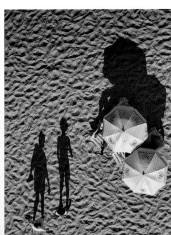

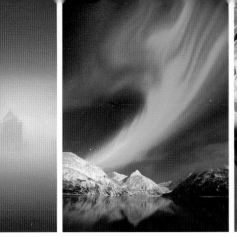

BASICS OF PHOTOGRAPHY

COMPOSITION

WHAT'S THE DIFFERENCE between a quick snapshot and a photo you'd hang on your wall or publish? Composition: the careful arrangement of items in the frame. A successful composition both highlights key visual elements and artfully represents a photographer's view of the world.

FILL YOUR FRAME

A solid rule of thumb for learning to compose dynamic shots is to use every area of your frame—fill it with your subject as well as other elements that add visual balance to your picture. To achieve this tighter view, take a step or two closer to your subject, use a zoom lens, or crop your image later.

But watch out for stray visual elements near the edges, which can get cut off in weird ways—if this happens, crop them out later. And look out for the direction of people, animals, or vehicles moving through the scene: Whether they're facing or heading toward the center of an image or toward the outside of the frame will have a big impact on how static or energetic your image winds up feeling.

An exception to the frame-filling edict is purposely composed negative space (the space around the subject of an image). When used artfully, negative space draws attention to the point of interest.

KNOW THE RULE OF THIRDS

This compositional rule is based on the idea that placing elements in a photograph at certain off-center points adds visual tension and interest. To follow it, first envision your image as if it were a tic-tac-toe board: divided into nine equal parts by two vertical and two horizontal lines. (You can even set your camera to superimpose a grid over your camera's LCD monitor for help framing while you shoot.)

Whether using a superimposed grid or imagining one, frame so that important elements—such as the horizon line or a subject's eyes—land on or near the grid lines and the points where the lines intersect.

LOOK FOR LEADING LINES

As you compose your shot to accentuate the key visual elements, keep in mind that your viewer's eye naturally follows lines, be they straight, curved, zigzag, or spiral. Roads, fences, and linear patterns in the natural landscape can guide the viewer's eye into an image. Strong diagonals will lead the eye straight into the image; a curved shape will prompt a meandering appreciation of elements in the frame.

LAYER PICTORIAL ELEMENTS

Photos translate the three-dimensional world into a two-dimensional image. Unless you're going for an abstract, flattened effect, you'll want to create a sense of the missing dimension—depth—through composition, lighting, and focus.

In environmental shots, whether indoors or out, draw the eye deep into the frame by including picture

LEFT Repetition and symmetry create a strong leading line, bringing the viewer's eye deep into the image.

elements in the foreground, middle ground, and background. Reinforce this depth with your lighting; include a full range of light and dark in the picture.

For portraits and other photos that keep attention on a particular subject, limit your visual elements and choose an unobtrusive background. To separate your subject from the background further, light it more brightly or limit depth of field so that the background goes soft or even blurs out.

FIND PATTERNS AND SYMMETRY

Another way to make a subject stand out from a background is to look for repeating patterns and shapes and symmetrical forms. These make great photo subjects themselves, bordering on abstraction, and are quite pleasing to the eye. But you can also use them to set off contrasting subjects in the foreground, adding depth to your photo without distracting from its focus.

TAKE A POINT OF VIEW

Photographing from a standing position will provide a view that appears normal, and sometimes that's just what you want. But consider other vantage points as well. Shooting from an even slightly higher angle makes your subject seem smaller and possibly more vulnerable or poignant, depending on what it is. The opposite can also be true: Shooting from ground level can make even a small, unobtrusive subject seem large and imposing. When you're shooting, move around and see how your changing perspective alters your relation to what's shown in the frame.

CHANGE ORIENTATION AND SHAPE

One of the easiest things you can do to vary your photos is to pivot your camera to shoot vertically. This orientation is traditional for portraits, but try it with landscapes, pets, sports, and anything else.

Also consider the shape of your frame. All digital cameras have rectangular imaging sensors, but their aspect ratios (the proportion of width to height) differ by brand and model. Full-frame cameras have sensors the same size as a traditional 35mm frame

of film, with a 3:2 aspect ratio. Others are smaller but with similar proportions, and some have Four Thirds sensors, with a 4:3 ratio. Some cameras let you change the aspect ratio, but it's best to capture the biggest image you can, then crop the image yourself if you want to.

And crop you should. Depending on the image you want, you may choose to retain the original framing, trim a little off the edges, make your image perfectly square, or slice it into a long panorama.

STUDY THE GOLDEN RULE

Often called the divine ratio or Fibonacci's ratio, this mathematical principle has long been used in art and architecture and can boost the compositional strength of your images. Essentially, a composition follows the golden rule if, when its longer part is divided by the shorter part, it is equal to the whole length divided by the longer part. This ratio of longer and shorter components repeats within the image, spiraling into the frame. Like the rule of thirds, it divides your scene into a grid of nine sections, but the middle row is slightly compressed, creating a ratio of 1:1.618. Also like the rule of thirds, most digital cameras have a setting that allows you to overlay a grid onto your LCD screen while composing so you can align your elements appropriately.

FIND UNEXPECTED FRAMES

When setting up your shot, look for elements in a scene that, when positioned around the edge of the composition, will help isolate your subject and establish it as the central element. In particular, shooting a scene with an arch above it, or through a window or other opening, will bring the viewer's eye in toward the main element.

SEEK OUT ODD NUMBERS

The human eye is drawn to uneven numbers of elements, as an even number of elements often create a gap in their arrangement that we see as an unsightly blank space in an image. Look for groupings of three and five instead.

RIGHT A daring perspective gets initial attention, while strong diagonal lines and detail throughout the image draw the eye in farther.

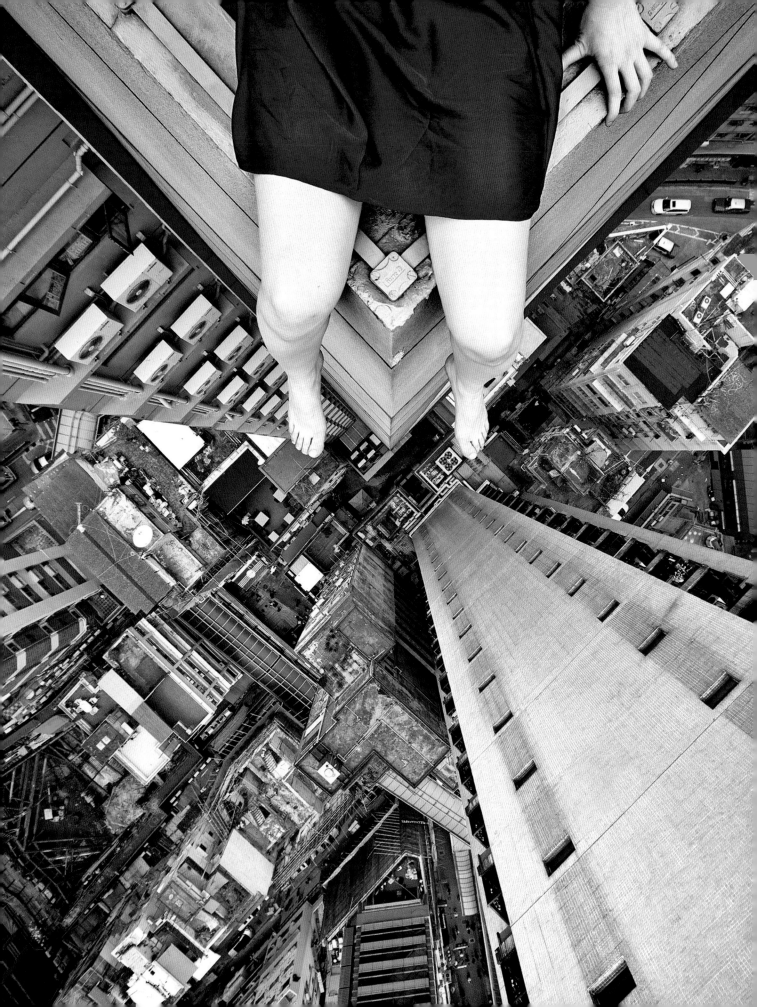

COLOR & TONALITY

DIGITAL PHOTOGRAPHY gives you the freedom to make choices—and compare results—both during and after a shoot. One of the most dramatic elements you can control is color: our visual perception of different types of light. Here are some ways to control color in your images.

COMMUNICATE WITH COLOR

There's a saying in photography: "If you can't make it good, make it big—and if you can't make it big, make it red." Tongue in cheek, sure, but it points to a truth: Color matters. From energetic red to calming blue, each color carries its own visual connotations and emotional impact. Also consider tone (the degree of darkness or lightness of a color). Then you can choose to shoot colors that speak to you, and adjust their subtlety or boldness to further suit your vision.

Your digital camera offers tons of choices for capturing color. You can set saturation levels (which affect the intensity of colors) and even mimic types of film and film processing, such as black-and-white or sepia. These settings can be fun to play with.

However, at *Popular Photography,* we prefer to use neutral settings and shooting modes that capture and store images as RAW files (the digital photo format that contains all of the image and color data from your camera's sensor). This prevents your camera from compressing or processing images as you shoot, which would cause you to lose some image data. Using neutral settings when shooting JPEGs will give you the most control over color in your final images, and you can alter or tweak color with software later to get precisely the color values you want.

USE WHITE BALANCE

Even when it looks white, all light has color. Early and late in the day, sunlight shines reddish gold, while at midday it can look blue. Different types of artificial lights have color, too: Tungsten light bulbs cast a yellow tint, while fluorescents tend toward green. Our brains adjust to differences in color temperature so well that we barely notice them and can easily tell when something's white, even if it's given a bluish or yellowish tint by certain types of light. Your camera needs help with this, though, which is the role of its white balance setting. This adjusts colors for each shot to render them as closely as possible to the colors you see with your eyes. Use auto white balance to have your camera adjust it automatically, or set it yourself through the menu on your LCD or a dedicated button on the camera. It's safe to rely on auto white balance often, as your camera usually gets it right. But if you set it yourself, you'll have an array of settings to choose from, including some variation of daylight, shade, overcast, tungsten, fluorescent, and flash. Each adjusts an image to balance color for the type of light it's named for. For example, the tungsten setting cools colors to adjust for the warm light of tungsten bulbs, adding blue to an image. You can also adjust white balance manually, which is useful in mixed lighting.

TOP FROM LEFT TO RIGHT These three images, all shot in artificial light with the same color temperature as daylight, show the effects of various color temperature settings provided by most digital cameras. At top left, the tungsten setting casts a blue light tinge, while at bottom left the shade setting gives the image a yellow overcast. The daylight setting above at right creates a crisp, white look. **BOTTOM RIGHT** An example of cohesive image created by using a limited palette.

You can use these white balance settings not just to neutralize the color of light, but to creatively alter or enhance it: On a sunny day, for example, you might use the shade setting (which warms colors to compensate for the blue light of open shade) to boost the yellow in an image even further. You can also apply these settings to RAW files later with software.

KNOW COLOR THEORY

Besides the in-camera functions that allow you to explore the technical side of color, there's much to be said for understanding a bit about color's power in picking a subject and composing your photograph. Images that largely feature colors near each other on the color wheel (called analogous colors) often are harmonious, pulled-together studies in line and texture, while images that contain high-contrast complementary colors (which are immediately opposite each other on the color wheel) tend to have a dramatic energy.

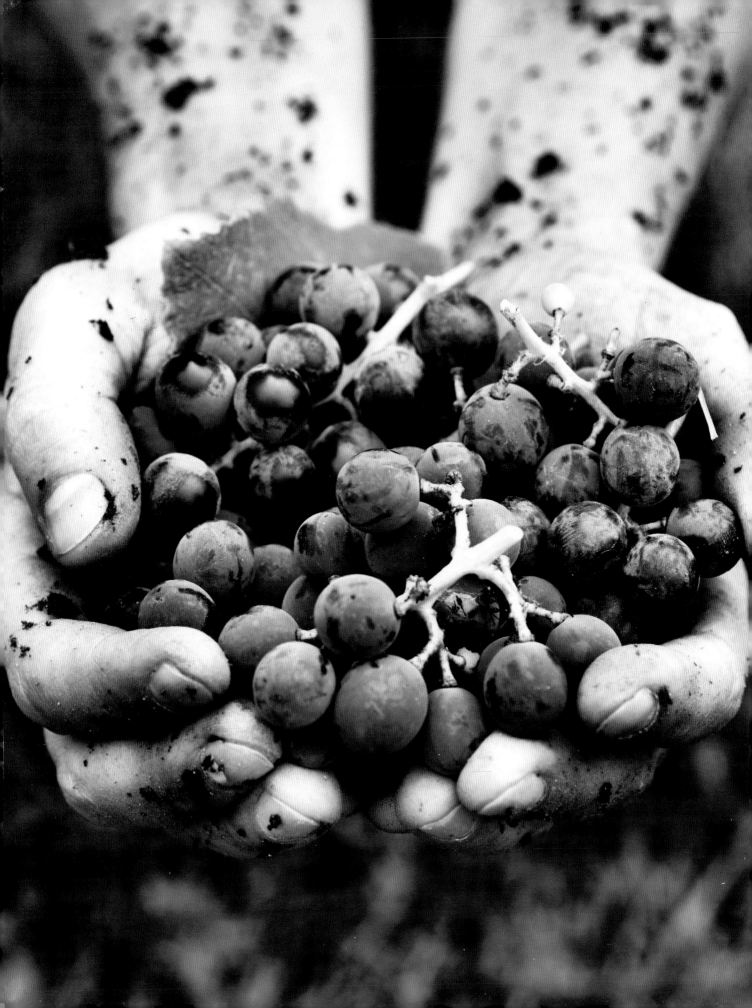

EXPOSURE

GETTING PHOTOGRAPHS that reveal a subject with the right level of detail, sharpness, and amount of contrast depends in part on exposure (how quickly and for how long each image is inscribed on the camera's sensor), which is controlled by three factors: aperture size, shutter speed, and ISO.

UNDERSTAND LIGHT LEVELS

A camera is essentially just a box with a hole on one side and a light-sensitive medium (either film or digital sensor) on the other. Taking a picture lets light through the hole to leave an image on the recording medium. Capture too much light, and the image will be overexposed: Washed out, with details disappearing in highlights. With too little light, the image is underexposed: Details disappear into darkness. The correct exposure—determined by the size of the hole, the length of time it's open, and the sensitivity of the sensor—will give you the optimum balance of highlights, midtones, and shadows, with plenty of detail all the way through.

When you shoot in automatic mode, the camera balances the relationship between the hole's size (aperture), the time it's open (shutter speed), and sensor sensitivity (ISO) all on its own. But you can also use modes (such as aperture-priority and shutter-priority) that let you set any one of those three factors manually and allow the camera to adjust the other two accordingly. You can also control all three at once (when working in fully manual mode) or use exposure compensation, which allows you to make incremental adjustments after you've set your exposure.

Image underexposed by two stops. Image overexposed by two stops.

MEASURE YOUR LIGHT

In order to determine the right settings for a good exposure, your camera (or you, with a handheld light meter) will have to measure the light in the scene. A DSLR or ILC gives you choices when it comes to measuring the light. You can opt for spot metering (to expose a small area properly in mixed lighting or backlighting), center-weighted metering (great for evenly illuminated scenes), and evaluative metering (best for scenes with a wide range of tones). Which to use depends on the scene and your preferences.

For the best exposure in most situations, use evaluative metering and adjust exposure manually

as needed. To see the results of your camera's light-meter reading, refer to its histogram (a graph of the range of tones in an image that you can set your camera to display in its LCD). If the graph shows peaks on the right side (which represents highlights), your image may be overexposed. If it peaks on the left side (which represents shadow), it may be underexposed. An even distribution with a peak in the middle often indicates a proper exposure.

SET THE APERTURE

The hole that lets light into the camera is actually governed by the lens—the lens's diaphragm expands and contracts to let in more or less light, and the size of the opening is referred to as its aperture. Aperture is measured in f-stops. The higher the number, the smaller the opening: f/2 is a big aperture, f/22 a small one. Besides controlling the amount of light that enters, the aperture also affects depth of field, or how deep a plane of the scene appears in focus—in short, how much of a scene is rendered distinctly and clearly without blurring or fuzziness. A smaller aperture yields very deep focus; a larger one captures an image with a shallow area of focus.

At the smallest aperture of any lens, the image tends to go a little soft, so if maximum sharpness is important to you, shoot at intermediate apertures, at least one or two f-stops below the highest number.

An environmental portrait exposed with a small aperture of f/18. This aperture crisply renders both the figure in the foreground and the detail in the background, which contributes to the viewer's understanding of the subject.

Large aperture of f/2 Medium aperture of f/8 Small aperture of f/22

A larger aperture of f/2 keeps the focus on the subject, making the background blurry.

The smallest aperture of f/22 keeps each plane of an image in perfect focus.

An extremely large aperture of f/1.4 places only one part of the image in perfect focus, blurring out the rest of the scene.

CHOOSE A SHUTTER SPEED

The shutter opens and closes to control how long light reaches the sensor for each exposure. In bright sun, it will only need to open for a tiny fraction of a second for enough light to stream in—probably somewhere between 1/60 to 1/1000 sec, depending on the aperture and ISO. In dim light, you'll need to use a much slower speed, perhaps measured in full seconds, to allow enough light to enter the lens. Slow shutter speeds may blur a moving subject, however, since the sensor records what happens while the shutter is open. To keep a moving subject from blurring, you'll have to use a shutter speed short enough that the camera doesn't record motion. And at these slower speeds, even your own motion may create blur by jostling the camera. Use a tripod or the image stabilization system in your camera or lens to prevent or reduce this.

USE THE RIGHT ISO

The sensitivity of your camera's sensor is determined by the ISO setting. Most digital cameras go from ISO 100 past ISO 6400. The brighter the light in your scene, the lower the ISO needed. As the light dims, you have to shoot at ever-higher ISOs to get a good exposure, especially when you're handholding the camera.

The problem with high ISOs is digital noise, which shows up in shadow areas as discolored dots and uneven rough graininess. Smaller sensors and higher megapixel counts also create more noise. To combat it, keep ISO down to 400 or lower and adjust aperture and shutter speed accordingly, or use noise reduction in image-processing, although this reduces resolution.

IMPROVE EXPOSURE

Nailing exposure may not seem easy at first. To troubleshoot exposure issues, set your camera to capture RAW files rather than JPEGs, and tweak your image with software. Another option is to try your camera's autobracketing setting, which takes a fast burst of images at different exposures. You can choose the exposure you like best.

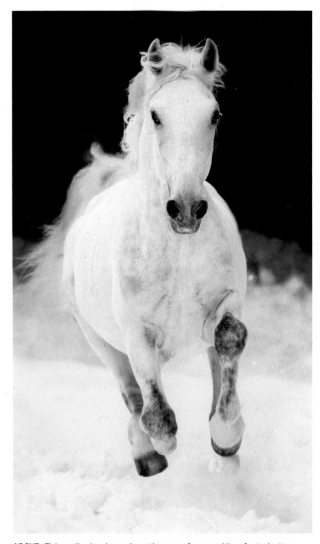

ABOVE This galloping horse's action was frozen with a fast shutter speed (1/1000 sec). **RIGHT** To smooth action into an evocative blur, this river was photographed with the slow shutter speed (1/4 sec) with the camera on a tripod.

Then there's high-dynamic-range (HDR) imaging, which merges multiple images—made by processing a single RAW image at various settings or by shooting a bracket—into a single image. This combination gives a larger range of tones, from highlights to shadows, than is possible with a single exposure. Many cameras have a setting that lets you create HDR images as you shoot. Done subtly, HDR makes a scene with difficult lighting look natural; with a heavy hand, it can create vibrant, glowing scenes.

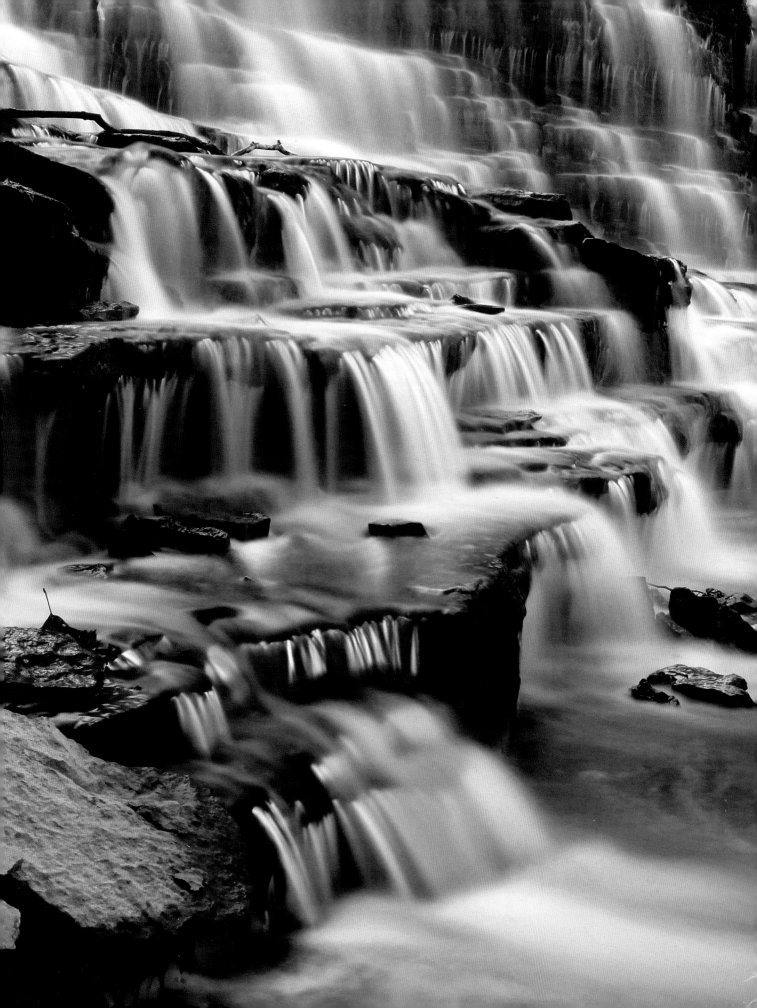

LENSES

||

IT'S ALL IN THE LENS: how close or far away the subject in an image appears to be, how much of a scene is in focus, and how wide an angle of view an image shows. Without interchangeable lenses or at the very least a zoom with a large range, you would have very limited control over the look of your photographs.

||

COMPREHEND FOCAL LENGTH

To put it as simply as possible, a lens concentrates light and directs it toward the sensor in your camera. But the distance a lens requires between itself and the film or sensor in order to capture the subject in focus varies; this distance is called focal length. Lenses with short focal lengths take in a very wide angle of view, while those with long focal lengths have a narrow view.

The focal length at which you shoot makes a big difference in how your images look. For instance, a lens with a very long focal length (a telephoto lens) not only seems to bring distant subjects closer, magnifying them in the frame, but also appears to compress space so that the distance between picture elements seems smaller. And magnifying a subject greatly (which can also be done by moving closer, as with a macro lens) reduces an image's depth of field significantly.

What defines a "normal" focal length? A natural-looking perspective from a not-too-close, not-too-far distance. Usually, a natural perspective can be accomplished by shooting with a lens that's a little longer than the diagonal measurement of the camera's image sensor. So with a full-frame DSLR (its

sensor usually measures 24 by 36 mm), a 50mm lens produces a normal perspective. However, different cameras have different sizes of image sensors, which means that they capture different amounts of a scene. So matching up your sensor size with the right lens for the look you want can pose something of a challenge.

MATCH A LENS WITH YOUR SENSOR SIZE

Consider your sensor size before choosing a lens. A tiny sensor will take in only a small amount of a scene, while a bigger sensor will take in a much larger area of a scene. So in order for a camera with a small sensor and a camera with a large sensor to take photographs capturing an equal amount of a scene, a camera with a smaller sensor would need a lens with a shorter focal length (and its wide angle of view) to compensate. A camera with a bigger sensor would need a lens with a longer focal length.

This means that the same lens may have a different effective focal length depending on the sensor size of the camera to which it is attached. This is something to think about when you're shopping for lenses for your DSLR or ILC. The camera body might contain a full-frame sensor, an APS-C-sized sensor (slightly smaller than full-frame), or a Four Thirds sensor

(slightly smaller than that). ILCs may contain a much smaller sensor. In buying a lens, not choose one that is optimized for your sensor size and equipped with the correct mount for your camera.

UNDERSTAND LENS SPEED

Besides focal length, lenses are defined by their maximum aperture size: the widest you can make the hole that lets light in. Lenses with large maximum apertures, f/2.8 and below, are called "fast"—probably because they allow you to shoot at faster shutter speeds by letting in a lot of light quickly. Not only do fast lenses allow you to shoot in lower light, but also their large apertures let you limit a photo's depth of field more effectively.

Many zoom lenses, especially those sold in kits with DSLRs, have maximum apertures that cover a range. A typical kit lens covers 18–55mm with a designation of f/3.5–5.6. This range tells you that the maximum aperture of the lens is f/3.5 at its widest focal length and f/5.6 at its longest—meaning its maximum aperture size changes depending on how close or far its zoom is adjusted.

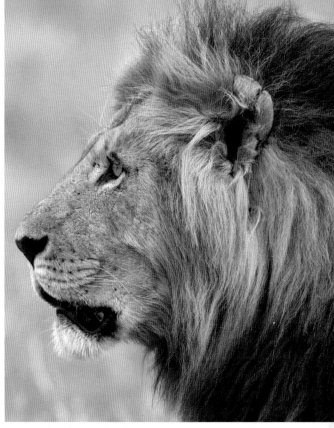
Long telephoto lenses allow for a detailed close-up of a subject that the photographer might not otherwise want to get too close to.

A portrait taken with a 24mm lenses distorts the perspective and includes more background.

A photograph shot with a 50mm lens gives a normal perspective, like the eye sees.

LIGHTING

PHOTOGRAPHY IS ALL ABOUT LIGHT—focused by your lens, it inscribes the image on your camera's sensor. Be it natural sunlight or artificial illumination, the light you choose quite literally shapes and defines your subject and creates your photographs.

TELL HARD LIGHT FROM SOFT LIGHT

First, it's important to understand the qualities of different kinds of light and how they affect a subject in a photograph. Whether the light is natural, such as sunlight, or artificial, such as that from a flash, it comes in essentially two forms: hard and soft. Light appears hard when it is focused in a narrow beam or when the light source is far from the subject. Hard light delivers sharp shadows and high contrast and (when it comes from the side) emphasizes texture.

Soft light is produced by putting a subject very close to a light source or using a very broad light source. It reduces shadows and contrast and suppresses texture. The broader the light source and the closer it is to your subject, the softer the light. Softness increases when light is diffused (scattered and spread out), whether by cloud cover or by translucent fabric. And bouncing light off a large, white matte surface diffuses and softens the beam, too.

USE NATURAL LIGHT

"Keep the sun at your back" is a photographic adage. There are times when that's good advice, but your photos are often better off when sun is coming from the side. Sidelighting sharpens the lines on an image, deepening them and adding character.

Even when you're shooting in sunlight, you can still alter the quality of light in your images. For softer shadows, shoot portraits and nature scenes when the sky is overcast, or position a diffusion panel between the sun and your subject. To reduce contrast, use a reflector to bounce light into shadowed areas in more direct light.

DON'T FEAR THE FLASH

The built-in flash on your camera, if it has one, makes a good starting point for taking control of your lighting. Next, add an accessory flash. You can place it in your camera's hot shoe (the groove on top of your camera that lets it sync) or fire it off the camera, using either a sync cord or a remote trigger. A flash unit with a tilting or swiveling head will give you more control over the direction of the light.

Try flash during the day, even in sun, to tone down harsh shadows by adding what's called fill light. You'll find a fill-flash mode in your camera's settings; to reduce its intensity, use flash exposure compensation.

As much as possible, avoid using direct flash in low light: It will either overwhelm your subject or create severe shadows. You can diffuse the light by buying modifiers specifically built for flash or with do-it-yourself tricks such as rubber-banding white paper

over the flash head. Better yet, soften the light by bouncing it off white walls or ceilings for a more natural look. Practice is key, so spend time getting to know your camera and flash settings so you can reduce or increase the light according to your picture's needs.

DECIDE BETWEEN CONTINUOUS LIGHTS AND STROBE

Whether you're considering portable accessory flashes, as discussed above, or larger studio lights, you have to make the basic choice between flash (strobe) and continuous lights (also called hot lights, although the category also includes cool-burning LEDs and fluorescent bulbs).

Continuous lights stay on the whole time you're shooting, rather than flashing with the shutter. This lets you see their effects on how your subject looks so you can tweak the light carefully; it is the only option for video. But if your subject is in motion and you want to freeze it, you'll need a strobe to add enough light for a fast shutter speed. With a tightly controlled, static subject, either type will work.

A reflector bounces natural light onto a subject.

Natural, soft light lends a warm feeling to the photograph.

Direct, undiffused flash creates a bright, hard light with sharp shadows.

SOFTWARE

CLICKING YOUR SHUTTER BUTTON captures an image, but you may still have a few steps ahead to create a finished photo that you can share online and in print. Software can help you perfect your favorite shots or improve the ones that didn't come out quite right.

PLAY AROUND IN THE DIGITAL DARKROOM

If you take a lot of photographs, you'll have plenty of snapshots that you don't want to labor over—and the more you get right when you take a picture, the less work you'll have to do later. But you may decide to use image-editing software to make adjustments to your keepers—such as your favorite photo projects and photos of big events that you'll want to enjoy for years. Of course, editing software is also handy when your pictures have potential for improvement.

START WITH RAW INGREDIENTS

You'll gain much better control over your finished images by setting your camera to capture RAW files, which contain the full array of data gathered by the camera's sensor rather than doing any in-camera processing. This does leave a bit more work for after shooting, but since RAW files have so much more flexibility, you may find that the adjustments you make in your RAW conversion software are all you need to get your picture to look the way you want it to. And if you want to do further retouching, conversion is a necessary first step to opening your file in an image-editing program.

After you're finished converting and editing, you can save your file as any file type.

If you don't want to bother with RAW, use the highest possible quality setting for JPEG capture. These files are also editable. For extensive editing of a JPEG file, it's best to save it as a file type that can be saved with lossless compression (such as a TIFF—a file type supported by more sophisticated editing programs).

EXPERIMENT WITH SOFTWARE

As you grow as a photographer, you'll probably want to do increasingly sophisticated editing with your image-editing software to get ideal finished images. This post-shooting editing is called post-processing (or post for short), and you'll probably need to upgrade to better software than the program that came bundled with your computer.

Besides the stand-alone image-editing programs, you can find a number of excellent plug-in programs designed for specific tasks, such as working in black-and-white, correcting lens distortion, and making high-dynamic-range (HDR) images.

Here, in rough order of how frequently you're likely to use them (and their level of complexity), are some types of editing and alteration you can do to your pictures with software. You'll also find tips on employing these tools to downsize images for

The photo at left shows a low-contrast image—its bright and dark tones are closer together in range than are the tones in the high-contrast image at right.

photo-sharing sites, adjust color, combine multiple photographs into a single amazing image, and more.

RAW CONVERSION

If you shoot in RAW mode, processing your images by converting them into an editable file is always your first step. You'll find the necessary software on a disc that comes with your camera, though if you want a range of capabilities, you can buy RAW converters from independent software vendors. Either way, your RAW converter will let you make all kinds of adjustments, including white balance, noise reduction, and (to some extent) exposure values. It may let you make some of the fixes you'd otherwise do in an image editor, and with most programs you'll be able to apply your settings to a whole batch of images at once, instead of dealing with each image individually.

Another benefit: Any settings you apply in conversion affect only the images you create in that session. Like a film negative, your original RAW file remains untouched, so you can keep it on file and process it again using other settings.

SHARPENING

Most digital images benefit from a touch of sharpening. It won't make up for bad focus or too little resolution for the image size you want, but it will help define lines and edges. Don't over-sharpen—this can cause visual noise and other distractions in the photo to become more distinct.

IMAGE SIZE

DSLRs produce large image files. That's a good thing, but it makes it hard to email your pictures straight from the camera. Rather than using JPEG compression to make your picture files small enough to email or upload quickly, preserve your image quality by creating a dimensionally smaller copy. You need a resolution of only 72 pixels per inch for the typical computer screen, but at least 240 (preferably 300) for printing. Don't forget to change your document size or your pixel dimensions when you shrink your file. Rename your new image file with the word small or email so you can see at a glance which version it is.

CROPPING

The frame you capture may not be the optimum version of the scene in terms of composition, aspect ratio (the proportion of the frame), or even orientation (horizontal, vertical, or square). To get the best picture, use the crop tool, found in most image editors, to change the size and/or shape of your frame. Note that when you crop, you'll lose resolution, so if you make extreme crops, you'll limit the size at which you can print your finished photo.

CONTRAST

The range and distribution of tones between the darkest and brightest point makes a tremendous difference in a photo. A lot of contrast can give it graphic boldness, especially in black-and-white, but if sloppily applied, it can also wipe out details in the highlights and shadows. Very low contrast can give your photo a moody or old-fashioned feel, but it can also make it simply seem flat and dull. Adjusting the contrast to achieve the effect you want is one of the basic editing skills you need to master.

COLOR

The pixels (light-gathering cells) on a digital sensor gather light in three channels: red, green, and blue. Their opposites—cyan, magenta, and yellow, respectively—combine to make up the visible color spectrum in an image. Software lets you adjust each of these channels separately to get rid of unwanted color casts, add warmth, or deepen tones. You can also adjust overall color saturation, but use a light touch: There's a fine line between vivid and garish.

BLACK-AND-WHITE

The best way to make a monochrome image is to use software to transform a color original, rather than setting your camera to shoot in black-and-white. Allowing your camera to capture an image's full color data means you have more control over the end results because you'll have as much information as possible to work with. Most image-editing programs have simple, automated black-and-white conversion, but you'll be able to finesse the results using more-specialized programs. And monochrome doesn't have to mean gray—with some programs, you can imitate a cyanotype, sepia-tone, or split-tone photo, too.

EXPOSURE AND HDR

You can brighten or darken an image—either overall or in specific areas—in editing. While this won't fix mistakes in your exposure, it may help you recover detail that your sensor recorded but that isn't evident in your unedited picture. To create an image that displays a wider range of tones, try HDR imaging, in which you combine several versions of the same picture taken at different exposures. (Some cameras will do this for you, but you'll have better control of the results if you do it yourself.) More sophisticated image editors have HDR built in, but specialized, stand-alone software is often necessary.

RETOUCHING

Using precision tools in software, you can do everything from get rid of imperfections left in your images by dust on your lens to perform the equivalent of plastic surgery on your models. How far you want to go depends on your taste, your skill, and how you plan to use your photo. As your skills increase—and with the right software—you can fix lens distortion, create the illusion of shallow depth of field, remove unwanted elements from the frame, and make other changes.

COMPOSITING

Besides HDR, you can combine images for all kinds of reasons. To make a panorama, for instance, you'd shoot an overlapping sequence of images that together take in a much wider or taller view than you could fit in a single frame, then stitch all of them into a single picture. (Again, some cameras will do this for you, saving time but not necessarily yielding precisely the photo you want.) You can also combine pieces of images shot separately to invent an entirely new picture. However, creating an image that goes beyond a simple cut-and-paste collage to become a convincing approximation of reality takes a whole lot of skill and plenty of practice.

RIGHT A simple yet surprising composite makes viewers look twice.

PHOTOGRAPHY SUBJECTS

FIREWORKS

WHETHER IT'S A NATIONAL HOLIDAY or a small-town celebration, fireworks shows draw huge crowds who "ooh" and "aah" with each burst of light. Capturing these dazzling displays on camera can be challenging, but with a little extra effort, you'll come home exhilarated from the evening's events, and packing a memory card full of spectacular images.

GETTING STARTED

Fireworks shows are often few and far between, so even if you've shot them before, it's wise to brush up on the basics before heading out to the next pyrotechnics display. Being prepared with the right gear is critical, of course. DSLRs and mirrorless cameras with an interchangeable lens (ILCs) work best, since they offer the kind of exposure control that keeps you on top of conditions that change from one shot to the next. It's even possible to grab good shots with a compact camera equipped with a special fireworks mode that holds the shutter open long enough to capture those magical bursts of light.

Location has a big impact, so scout for a good spot early in the evening or even the day before. Shooting near water adds reflection that will double the dazzle. Keep in mind that you want to be far enough away that the fireworks pop in front of you—rather than directly above you—and try to stay upwind, so smoke doesn't affect the clarity of your images. Fireworks tend to be unpredictable, making it tough to set up a perfect composition. So keep shooting and experiment with camera settings to stack the odds in favor of nabbing some star-spangled shots.

TECH TIPS

EXPOSURE Good starting points for DSLRs and mirrorless ILCs are ISO 100 or 200 and an aperture of f/11 or f/16. Choose bulb mode and hold the shutter open with a cable or remote release for 2 to 5 seconds (shorter during the grand finale to avoid overexposure).

FOCUS Turn off autofocus and manually set it to infinity. Alternatively, focus on a structure that's on the same plane as the fireworks. With the aperture set to f/11 or f/16, you'll have good depth of field.

WHITE BALANCE Daylight white balance generally works well for most fireworks. If you're including buildings in the background, adjust your white balance to the structures' light, shoot in RAW, and fix things in post-processing, if need be.

NOISE Turn off noise-reduction settings that eat up precious seconds so you don't miss the next burst.

FLASH If your camera has a built-in flash, turn it off.

SHOOTING MODE Some compact and DSLR cameras have a fireworks mode; it might be worth giving it a try.

WHAT TO SHOOT

Vary your images to make them as interesting as the show up above. Include a silhouette of some sky gazers in the bottom third of the frame, as shown at right, or zoom to a wider angle and include the surrounding architecture to give a sense of the overall environment. Try out different focal lengths and shoot some salvos vertically, an angle that's most effective for capturing single bursts. Stick with a horizontal orientation for multiple bursts, particularly the dazzling grand finale.

The finale is also the best time to try a long exposure that fills your frame with overlapping fireballs. Focus and set exposure manually, and use a tripod to keep things steady. Set the shutter to bulb mode and hold a black card in front of the lens. Open up the shutter and, when a rocket bursts, remove the card so it is no longer in front of the lens for a few seconds. When that firework starts to fizzle, cover the lens with the card while keeping your shutter open. Pull the card away again when the next rocket goes off. Repeat several times, for a total exposure time of about 15–20 sec, to paint the finale in all its extended glory.

PREVIOUS PAGE The secret to shooting fireworks, says John Cornicello, is a low ISO and a steady camera. "A lot of people think, 'Oh, it is dark out. I need a high ISO or a wide aperture, or a short shutter speed,'" John says. "In reality, while the sky is dark, the fireworks are very bright." Bright and close in sequence, these fireworks were captured with an ISO of 100 and a small aperture (f/14). Experiment with shutter speeds from 1–5 sec to control the trails from the firework blasts.

GEAR UP

Lens The ideal lens is a wide-to-telephoto zoom lens, such as an 18–200mm, which allows you to adjust the focal length for a range of shots. Unless you're using a full-frame camera, keep your camera's crop factor in mind (multiply the focal length by the crop factor to get the 35mm-equivalent).

Small Flashlight Tuck a small flashlight into your camera bag so you can see the settings on your camera in the dark.

Tripod Stabilize your camera with a tripod. If you must handhold it, brace it against your body, breathe in, exhale, then press the shutter button.

Media Cards Bring plenty of gigabytes, especially if you're shooting in RAW or RAW + JPEG.

Radio-Remote Trigger Even if the camera is mounted on a tripod, pressing the shutter button can cause some shake. So pick up a remote trigger for your camera or use a smartphone app to remotely operate the shutter.

Software Whether you use a standard image-editing program or RAW processing software, you might find it helpful to darken the sky to a rich, deep black (Levels or Curves mode works well). You can also apply noise reduction using a stand-alone noise-reduction program or RAW processing software, and combine individual bursts into a composite with layer mode. Since many fireworks situations are mixed lighting, you can also tweak white balance in RAW conversion or an image editor for a more pleasing—if not wholly accurate—color balance.

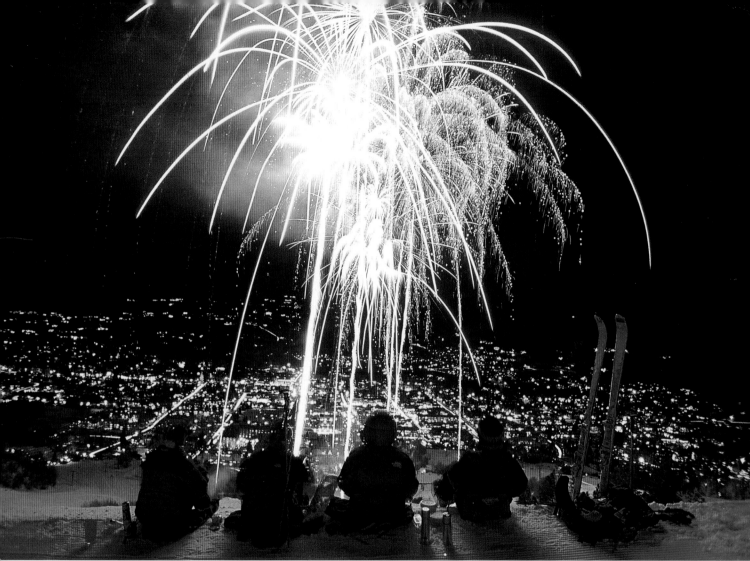

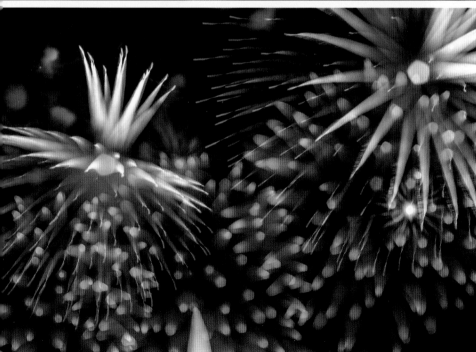

ABOVE Don't forget the human element to fireworks shows. The revelers awash in red light in this image by Michael Brands, for example, provide scale and a sense of devil-may-care closeness to the action.

LEFT Here, David Johnson rendered the fireworks bursts as defocused blurs radiating out from a center point. As each burst flew outward, he evenly rotated the focusing ring until the image was sharp, transforming the fireworks from solid-looking petal-like shapes to pinpoints of light. To recreate this image, start with your exposure out of focus.

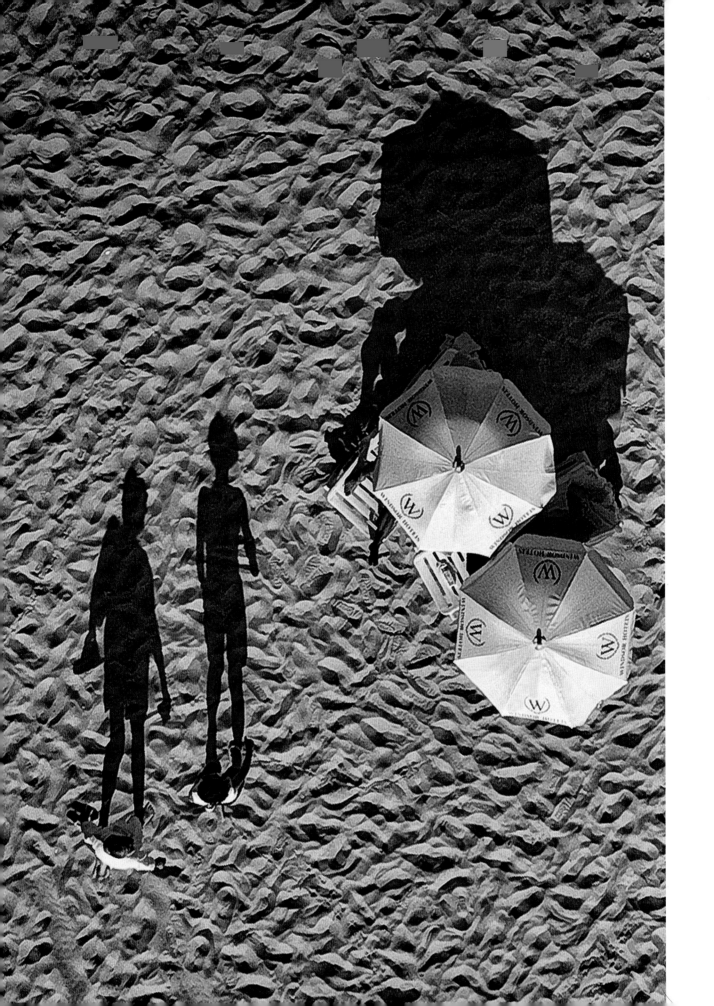

AERIAL

IN 1858, a brilliant French oddball who called himself Nadar went up in a balloon to shoot Paris from the air. Since those early days of photography, images taken from a high vantage point—whether from a mountain, tower, airplane, or drone—arrest us with vistas we can't see ordinarily. Here are some ideas for taking your photography to lofty new heights.

GETTING STARTED

The most common opportunity for aerial photography these days is an airplane journey. For good images, book a window seat that's not obstructed by the wings. For serious aerial shooting, hiring a pilot of a small fixed-wing aircraft is an alternative, albeit an expensive one. A pilot for hire must have a commercial license, and you'll want a craft with an openable window or clamshell for unobstructed photography. If you really want to go high-tech, hire or buy a drone. But please make sure you know what you're doing before sending your unmanned craft off on photographic missions.

You don't need an aircraft to capture the world from on high. Shoot from structures or landforms, keeping in mind that the more vertical the angle, the more arresting the view. Carefully extending a camera an arm's (or a monopod's) length from a vantage point like a skyscraper window can also produce wonderfully weird alterations of perspective. Or focus on an interior: Suspending a camera (preferably fitted with a very wide-angle lens) from the ceiling creates neat new ways of transforming ordinary spaces through dramatic perspective.

TECH TIPS

FOCUS If you're shooting through a plane window, surface imperfections will likely interfere with autofocus, so switch to manual focus. If you have a clear shot through an opening in the window of a small aircraft, you can use autofocus, although it may be faster and more reliable simply to set manual focus to infinity.

EXPOSURE Vibration can cause blurred images, even during a smooth flight. A shutter speed at least as fast as 1/500 or 1/1000 sec is good insurance against blur. If your camera or lenses offer image stabilization, use it to counteract the vibration. Use shutter-priority autoexposure to speed up operations. Since changes in camera orientation will include more or less of the sky, be ready to adjust through exposure compensation.

DEPTH OF FIELD This is a nonissue here, so use the widest possible aperture to capture expansive vistas.

SHOOTING MODE Since time is of the essence when you're winging through the air (or if you're shooting from a roof and the world is moving fast below you), set your camera to continuous (burst) mode for as many captures as possible.

WHAT TO SHOOT

Almost anything viewed from heights looks different—even disorienting. A high perspective can reveal hidden shape and structure—or transform a scene into something resembling an abstract canvas. Some of the most striking images are of dramatic natural landscapes and water formations, such as the twists and turns of a river. Cultivated fields, beaches (filled with bathers, or not), and villages and cities all lend themselves to aerial studies.

Consider light as well. Sweeping views of urban landscapes during the blue hour when the sun sets and city lights come on can be magical. (Don't be afraid to turn up the ISO to maintain sufficiently fast shutter speeds.) Hard-angled sidelight can add a surreal kick to images shot from a high vantage point, as in the beach scene on page 36.

If you're in a plane, bear in mind that takeoff and landing are the best times to capture land features in your photos. Hold the camera lens close to, but not touching, the window, to minimize the camera's reflection. (Or try using the window itself as a frame, as in the opening image on pages 34–35.) Keep the camera to your eye and get ready for when the plane banks, when you'll get the most dynamic images.

PAGES 34–35 If you're lucky enough to snag a great vantage point on an airplane (as Kenneth Mitchell did), here are a few great tips: Switch to manual focus, making sure not to focus on the window itself, and shoot early in the flight to avoid condensation on the window.

PAGE 36 Chico Lima shot this beachscape from the ground using a camera-equipped Hexacopter (a radio-controlled multirotor with a gimbal for the camera and stabilizing gyroscopes), which gave him a view of what the camera "saw" from the sky.

GEAR UP

Action Camera A standard DSLR can be used when shooting on the wing or when attached to aerial devices, but these go-anywhere, attach-to-anything cameras are light and small enough to be rigged to a kite or weather balloon. Some action cams have apps that let you view images and operate the shutter remotely.

Lenses A decent 24–70mm zoom and 70–200mm zoom (in full-frame format) will do fine.

Rubber Lenshood This inexpensive shock absorber for the front of your lens will soften hard impacts with airplane windows. Try to keep the hood close to, but not against, the window to avoid transmitting vibration. Experiment to ensure that your hood does not cause darkening of the image corners—vignetting—at wide focal lengths.

Filters Atmospheric haze can show up both as blurriness and an unwanted shift to blue (due to ultraviolet radiation). Counteract that with an ultraviolet (UV) or a skylight (1A) filter. A polarizing filter also helps cut down haze, but if you're shooting through a window, you can get color banding in the image.

Monopod One of these with a long extension will get your camera up in the air for over-the-crowd shots, or out laterally from a structure for a downward view. Attach the camera firmly to the monopod—and make sure you don't drop the rig!

Camera Strap If you're shooting from an aircraft through an open window or door, the last thing you want to do is drop the camera. At the very least, secure the camera to yourself with a strong neckstrap. Even better, use a harness that adds chest or shoulder straps.

Drone A camera attached to a drone can yield spectacular images, but use discretion before taking what might become a literal plunge. Mid-level multi-rotor models are popular for rigging with cameras like the action camera, but flying them is an acquired skill. Accidents are frequent, ranging from the hilarious to the terribly serious. And there is no doubt that the regulation of drones at federal and local levels will also be increasing.

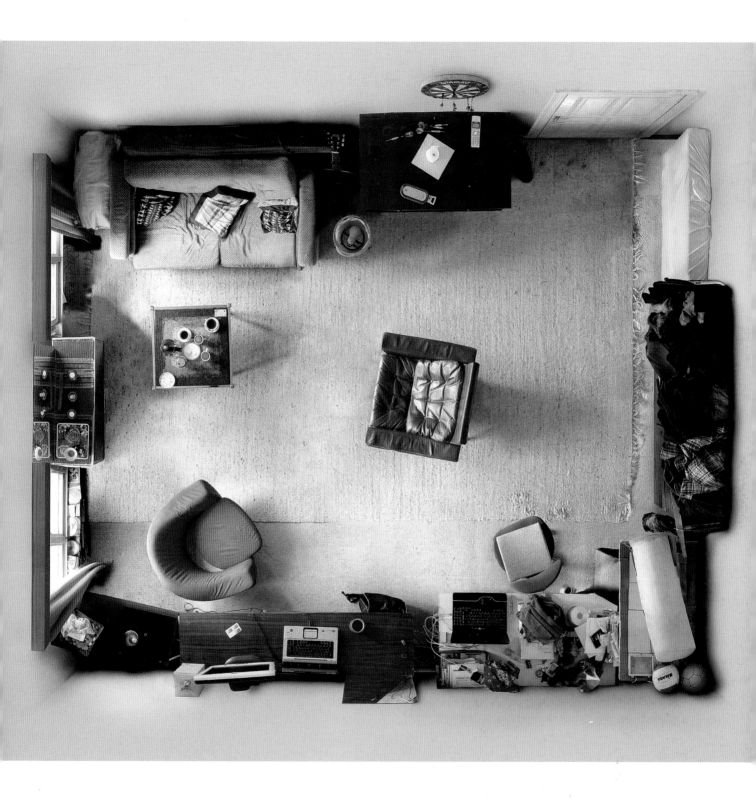

ABOVE Menno Aden wanted to answer the question "Who lives here?" by focusing on the room itself. Standing on a chair with a boom arm for added reach, he shot 150 "fillet-slices" of the space, then stitched them together in software.

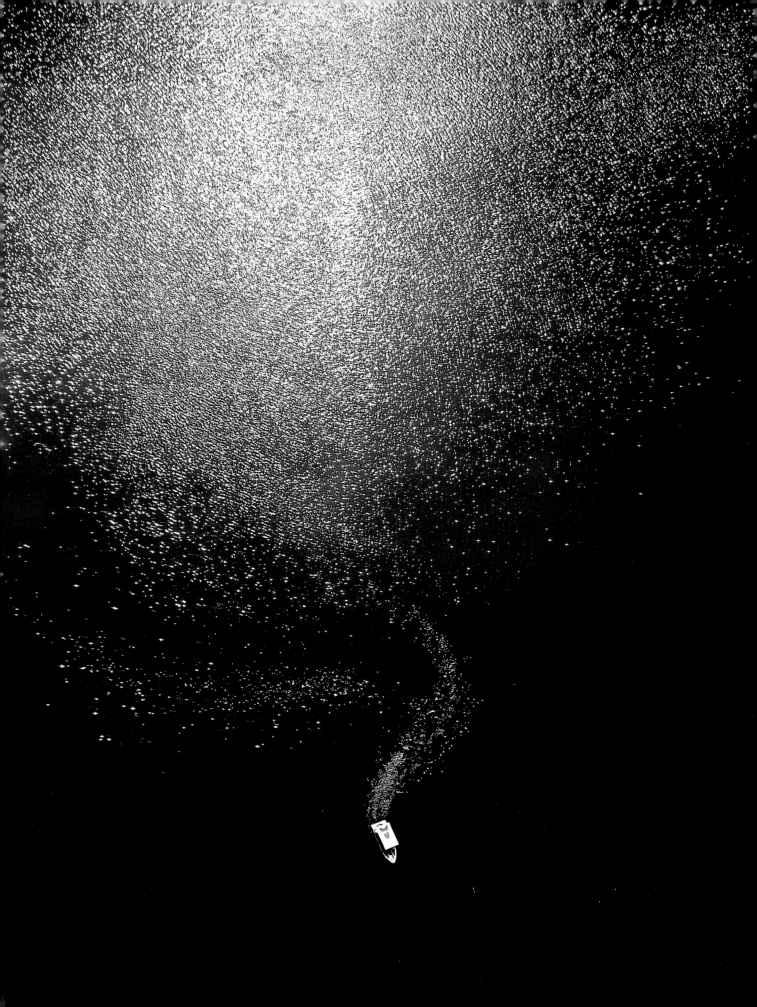

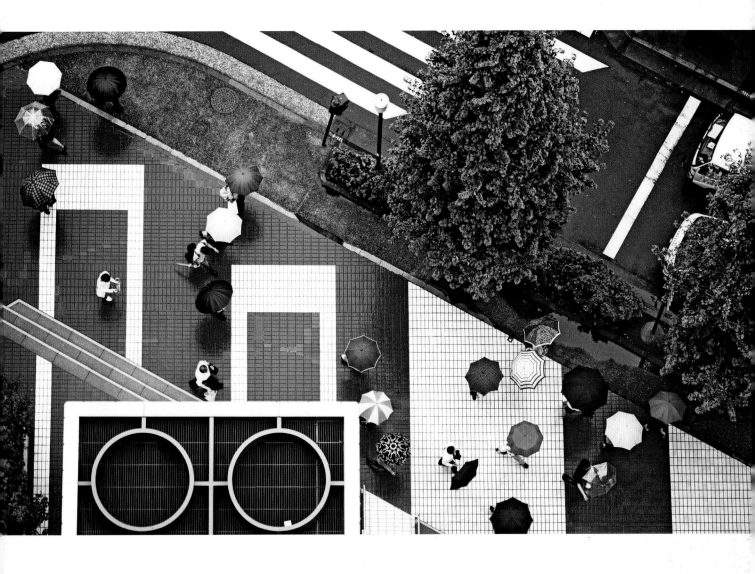

OPPOSITE Looking down from a radio tower in Tianjin, China, Kalee Vidanapathirana shot this photo of a boat cruising along, leaving a sunlit trail of ripples in its wake. He shot with an 18–55mm kit lens at 55mm focal length.

ABOVE Having found his way up a skyscraper, Navid Baraty shot this rainy intersection in Tokyo by extending his arm over the edge of the building, camera in hand, capturing—albeit blindly—the street's striking combination of parallel lines, strong diagonals, and recurring circles.

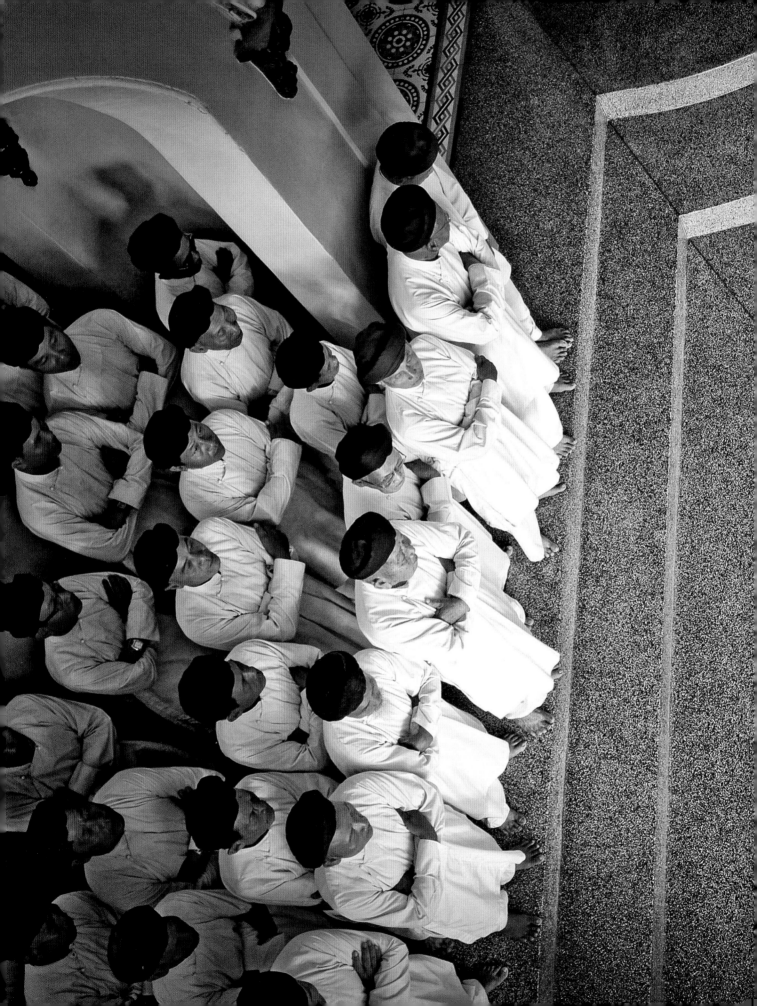

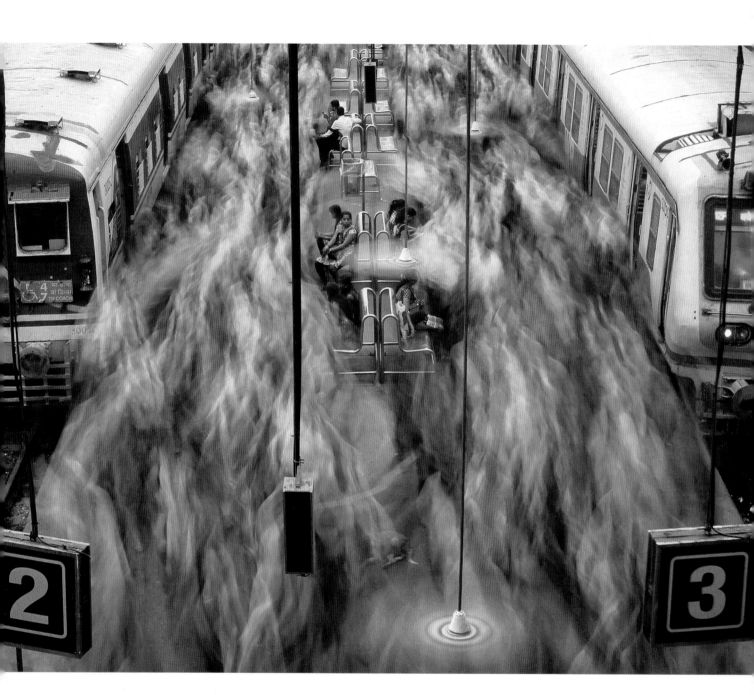

TRAVEL

USING YOUR CAMERA as you explore other countries—or counties—lets you document adventures, hold on to memories, and share your travels with armchair voyagers. Aim for shots that open windows into the vibrant natural world, probe the alleys of distant cities, and capture glimpses of how life is really lived in the places you visit.

GETTING STARTED

Like a good trip, good travel photography begins before you leave home. Learning about the history, culture, and current events of your destination will enable you to capture more meaningful images. If you're interested in particular vistas or terrain—say, jungle ruins or towering desert dunes—old-school resources like postcards or new ones like Google Earth will help you pinpoint the best places to shoot. Guidebooks and apps will help you find your way, but don't spend your trip staring at your smartphone. When you immerse yourself in what's going on around you, you're more likely to capture original images that reflect your particular experience.

Find out about the laws and etiquette concerning photography at your destination. And if you're bringing more gear than a typical tourist would, you may need to look into getting a work visa and an ATA Carnet (like a passport for your equipment).

As you pack your photo bag, keep in mind that you'll want to stay light on your feet. And consider how you'll keep your gear secure. You don't want a thief to carry off expensive items and irreplaceable images.

TECH TIPS

DEPTH OF FIELD Use an aperture of f/8 or higher for greater depth of field. That keeps more of the image in focus, and helps you capture the context around your subjects. It can also give you leeway to shoot discreetly by holding your camera down low and using the depth-of-field scale on your lens to determine the distance you need to be from your subject for sharp focus.

METADATA Make sure that the date and time are set on your camera, especially when you change locations. Some cameras let you set time-zone changes manually, either on the fly or in advance of a trip. If your camera has a GPS, you can use it to tag image files with the locations where they were taken. You can also use a smartphone geotagging app that allows you to import location metadata into your image files later.

SHOOTING MODE Try a panorama mode to create both horizontal and vertical panoramas. But since the goal of travel photography is to capture the places and people you see as you experience them, you'll probably want to stay away from too many heavy-handed special-effects modes.

WHAT TO SHOOT

Whether you're after nature and wildlife shots or documentary-style images of people's lives, the ultimate goal of travel photography is the same: learning something new and capturing it with your camera. The starting point is looking at your subject, be it a moose or a shop clerk with fresh eyes.

The drama that arises from action or composition is always good, but look beyond the superficially striking. For instance, capture details of texture and colors, not just wide-angle shots of monuments and landscapes. Document the idea of traveling itself, shooting train stations, airports, and rickshaw stands. Take candids instead of posed shots—but make sure you approach those you're photographing with respect and honesty.

Travel brings freedom, but since creativity often flourishes when working within constraints, give yourself an assignment or two to accomplish on your trip. It's easy to get lost in the world of visual novelty and end up with a bunch of pretty but unconnected pictures, but that won't happen if you're on a mission to document Greek doorways or Shinto shrines.

PAGES 42–43 Sivan Askayo likes to shoot from many points of view: "You'll be surprised at what you discover," she says. Here, she wanted to photograph the graphic floor pattern, but once she saw the scene from above, she liked how the monks' formation echoed the tile grid.

PAGE 44 Vivek Prakash set a long exposure in order to capture this colorful blur of voyagers, perfectly expressing rush hour in Mumbai, India.

OPPOSITE Helen Cathcart likes to travel light—just a camera body and two lenses. It frees her up to chase down subjects, like this cotton-candy vendor. She shot this photo at an aperture of f/1.2 and at the lowest ISO possible of 100, since it was so bright.

GEAR UP

Travel Tripod A flexible tripod is a good travel option. Otherwise, look for the lightest, most compact tripod that can support your camera and heaviest lens. Compact tripods can collapse as short as 15 inches (38 cm).

Rain Gear Don't let rain keep you holed up in the hotel, hostel, or lodge. Bring along one of those rain ponchos that fold up into a small net bag. For your camera, bring a simple bag-type rainsleeve that you can put over your rig in seconds.

Rechargeable Batteries Bring extra batteries. For travel abroad, you may need a plug adapter or voltage converter for your battery charger.

Storage Device Whether it's additional media cards, a laptop, or a hard drive, something that stores backup copies of your image files will bring peace of mind. Carry it separately from your original image files.

Camera Strap While it's not advisable always to have your camera around your neck when touring unfamiliar locales, a sturdy strap will make your photographic forays more comfortable.

Camera Bag Find a high-quality bag that meets international airline carry-on requirements, is comfortable to carry for long periods, and protects all of your gear well. To discourage theft, look for a discreet one that doesn't scream "camera inside!"

Cleaning Kit A blower brush, microfiber cloth, and small bottle of lens-cleaning fluid will keep your gear in shooting condition on the road.

Gaffer's Tape A small roll of this classic adhesive will help you patch up any minor damage until you can get a repair.

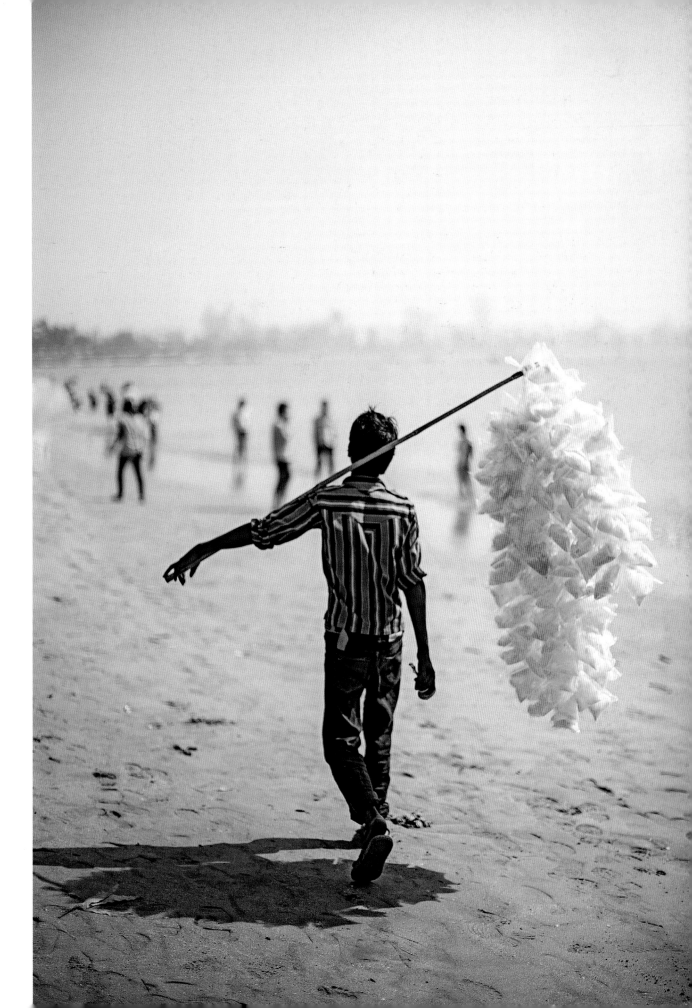

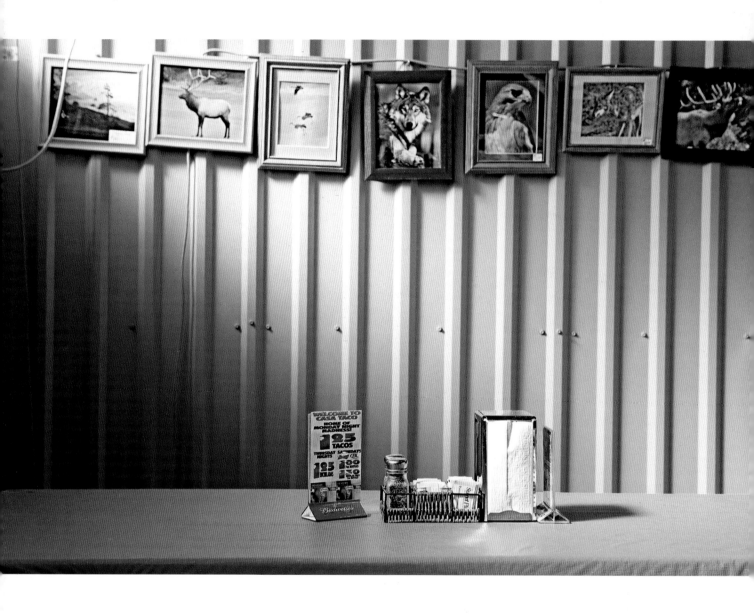

ABOVE The voyage is just as photo-worthy as the destination. Here, Lincoln Barbour's shot of a mom-and-pop taco shop in the Northwest shows the charm of transitory living. Soft but directional sidelighting through a high window bathes the no-fuss table in wan, warm light, while the cheap array of wildlife shots lend plenty of local character.

OPPOSITE TOP Agnieszka Rayss attended this midnight party marking the summer solstice in Iceland's Blue Lagoon. Carefully handholding her camera in the misty spa, she shot these wary waitresses, blending the blue color of the drinks with the landscape.

OPPOSITE BOTTOM Sivan Askayo's ongoing study of laundry set out to dry (called Intimacy Under the Wires) spans cultures and continents. Here, the anonymously displayed clothing in Naples, Italy, provides a glimpse of private life hung out for the public to see. The colors, patterns, and zigzagging lines create a dynamic composition.

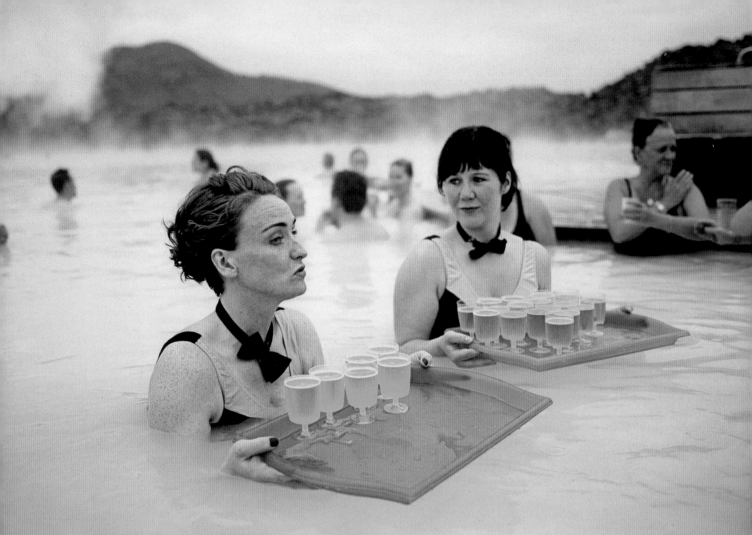

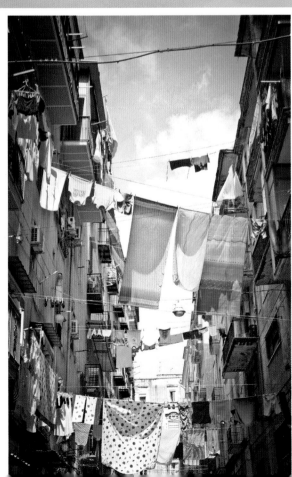

ABOVE The bold bouquets and sweet delights on display in Kenneth Ginn's image of a Florentine confectionery give viewers a sense of place—of the food and flora that it's known for—while a shadowed side street draws the eye diagonally into the frame and makes the image lively.

OPPOSITE When shooting abroad in a location you don't know very well, consider a fixer: a local who can help you navigate, book accommodations, act as a translator, and perhaps even appear in your images—as does Amachee, the Mongolian guide in Brian Pineda's photograph here.

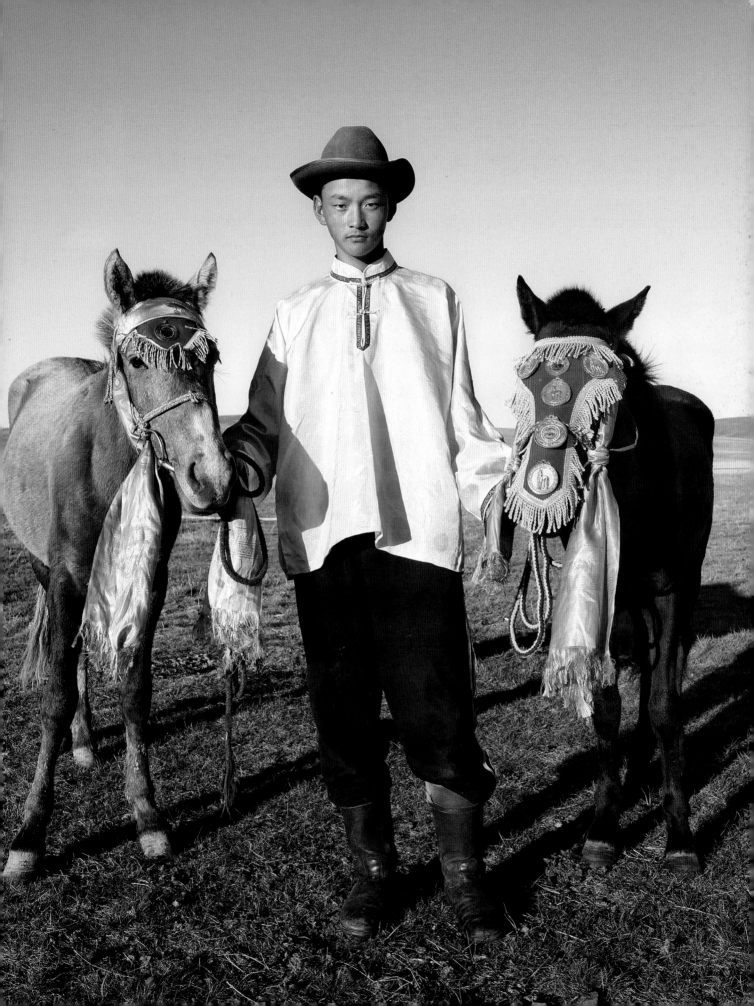

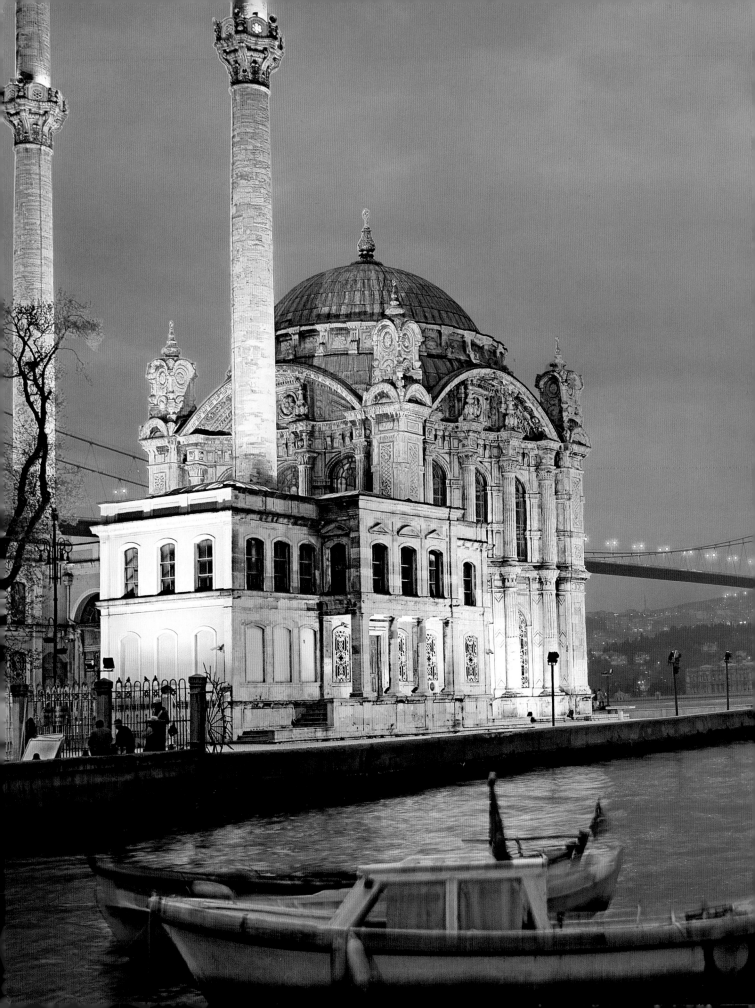

LEFT A special time to document a foreign destination is the blue hour: the half hour at twilight and dawn when the sun is below the horizon, but there's still light in the sky. Setting up his tripod on the banks of the Bosphorus during this time, Frank Heuer played the mosque's golden light off of the chilly tones in the sky, choosing a 1/8-sec shutter speed to faithfully reproduce the bobbing fishing boats in the foreground and the speedier freight ship in the distance.

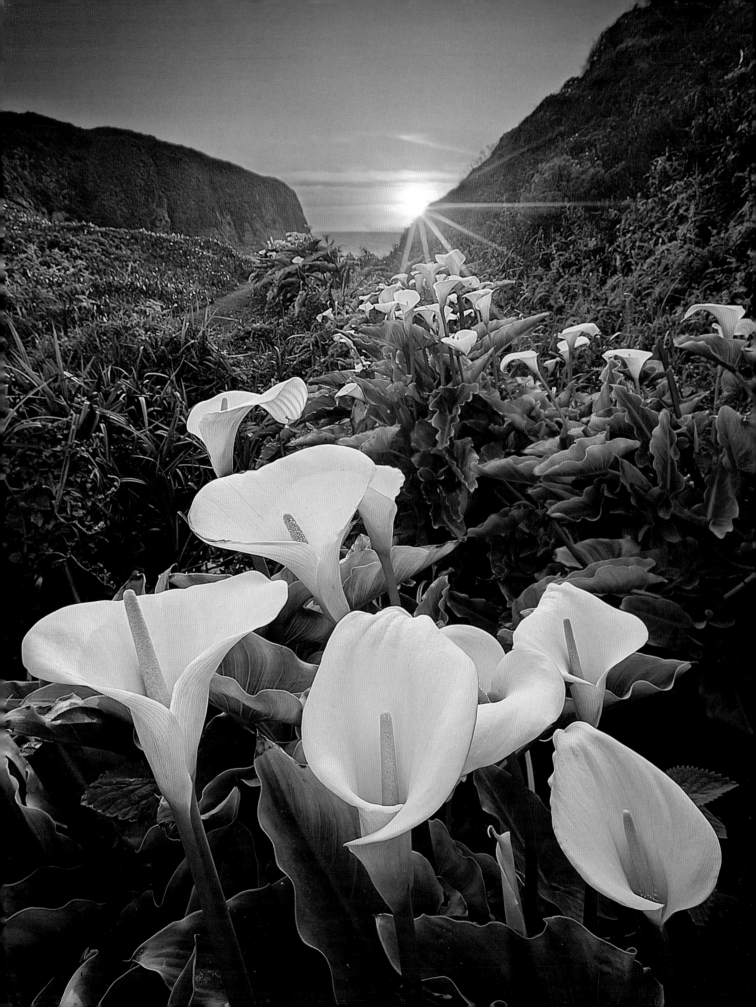

SUNSETS

THERE IS NO GETTING AROUND IT: Photographers the world over are total suckers for sunsets. And why not? They regularly provide some of the most beautiful light shows in nature, almost everywhere. Plus, they are relatively easy to capture with basic gear. The tricky part is getting images that express your personal take on this universal subject, so get creative and get clicking.

GETTING STARTED

A magnificent but fleeting event happens outside your window every day—and with a little prep, you can turn tomorrow's sunset into permanent art. A DSLR or ILC with a wide-to-short telephoto zoom (or a kit zoom) is all the gear you need. Any west-facing area could work as a canvas for a sunset, so take your pick. Water—ocean, river, or lake—provides the classic complement by reflecting the sky's colors. Think about landforms and structures as well, either to complete the composition of a water-focused sunset, or as a main element in a land-focused scene, such as rays slanting through trees on a hilltop.

Before you head out, check the weather forecast. Clear skies work well, but clouds, which catch and scatter the setting sun's rays, can heighten the drama. Check the time of sunset, too: You'll have a small window of opportunity (perhaps a half hour from when the sky begins to color to the time the sun sets), so familiarize yourself with needed camera settings in advance and get to your site early. As you chronicle the day's end, remember it isn't just about color. Watch for a bird on the wing, a strolling beachcomber, or a silhouetted sailboat entering the frame.

TECH TIPS

FOCUS Start out with center-spot autofocus and center-weighted metering setting and switch to spot metering if needed. If there's sufficient contrast, autofocus works best in single-shot autofocus mode.

METERING Remember a sunset's light level changes quickly—you may want to shoot somewhat underexposed. Manual exposure settings via spot meter may be best. Pick an area of the sky that's close to a midtone and meter for that, or spot meter an area that's fairly close to the setting sun. For faster metering, use the autoexposure lock button with the spot meter: Aim the spot at your desired tone and press the button to lock it in. Shoot in RAW mode so that you can dig out more highlight or shadow detail later on in post-processing.

WHITE BALANCE Beware automatic white balance! Even "smart" auto white balance settings may make color dull, so set white balance for the hues you like best. The camera's daylight white balance preset will stress warm reds and yellows and the cloudy preset even more so, while tungsten will push a bluish cast.

WHAT TO SHOOT

When you're shooting a sunset, the literal star of the show is a given. Think of elements in the foreground as the supporting cast. They need to be good in their own right, of course, but above all, they're there to showcase the star. Look for rocks jutting out of the water; rolling fields; or silhouetted buildings, be they skyscrapers or beaten-up shacks.

As always, it's not just what you shoot, it's how you shoot. If you're photographing over a body of water, try slowing the shutter down so the water blurs. For a big, frame-filling sun, use a lens in the 400-to-500mm range. But bear in mind that at that magnification, the sun moves amazingly fast.

For a really different take on sunset, turn around. The sun's dipping rays make for extraordinary lighting in the direction opposite the one that most photographers aim their cameras in. For instance, in the aptly named Sunset District of San Francisco, the light of the sun setting over the Pacific casts a warm glow over the many-colored houses east of the ocean.

Or think subversion. While the ironclad rule is to keep the horizon line two-thirds of the way up or down the frame, try a mid frame rendition, or something even more radical, like shooting with the lit-up horizon at the bottom of the frame.

PAGE 55 For a dramatic starburst like the one in Chris Axe's image of sunset over Cloud Creek, use a starburst accessory filter or shoot at your smallest aperture with a coated lens so you skip the flare.

OPPOSITE A giraffe takes pause under the setting sun in Etosha National Park, Namibia. Ian Plant used a 1.4x teleconverter on a 500mm lens to capture this creature in near silhouette and the blazing sun above him.

GEAR UP

Lenses The most common lens in anyone's lens kit today (a wide-to-short tele) is nearly perfect for sunset shots. Lenses in the very wide range—16mm for full-frame, 10–12mm for APS-C-sensor cameras—can make for a breathtaking perspective in wide-open spaces at sunset. Lenses in the 400mm-to-600mm range will get you closer for an intensely dramatic take on a sunset. Just know that with lenses of these magnifications, you can see the sun move as you view through the camera—you may have mere seconds to get the shot.

Filters The foreground of sunset shots can be significantly darker than the sky exposure; in many instances, this isn't a big issue, as a silhouetted foreground often works well in the composition. But if you want to maintain good detail in the lower part of the frame, a split neutral-density filter can come to the rescue. Position the filter so that the darker portion is over the sky, allowing the darker foreground to maintain some shadow detail. You can also try a reverse neutral-density filter, which has a dark band at the center designed to subdue a bright sun setting on the horizon.

Flash If you're including people in the shot and want them to appear as more than a silhouette, light them right. Use an accessory flash unit dedicated to your camera to balance flash exposure with the sunset. Keep the DSLR in manual exposure for the ambient light of sunset, and set the flash unit on TTL auto for –1 EV or a little less for a natural rendition of a subject in the foreground. For a flashy portrait, keep the sunset exposure low and dial up the flash exposure to 0.0 EV or even a little higher, up to +0.3 EV.

Tripod Sunset can be quite dark, and a tripod lets you not only steady the camera for longer exposures, but also set up a composition and tweak adjustments without worrying about holding the camera steady. Going to be near or in water? Look for sand- and water-resistant tripod legs.

Compass While you're exploring sites during daytime, check to see where the sun will set in the west. Many smartphones have built-in compass apps—not to mention GPS.

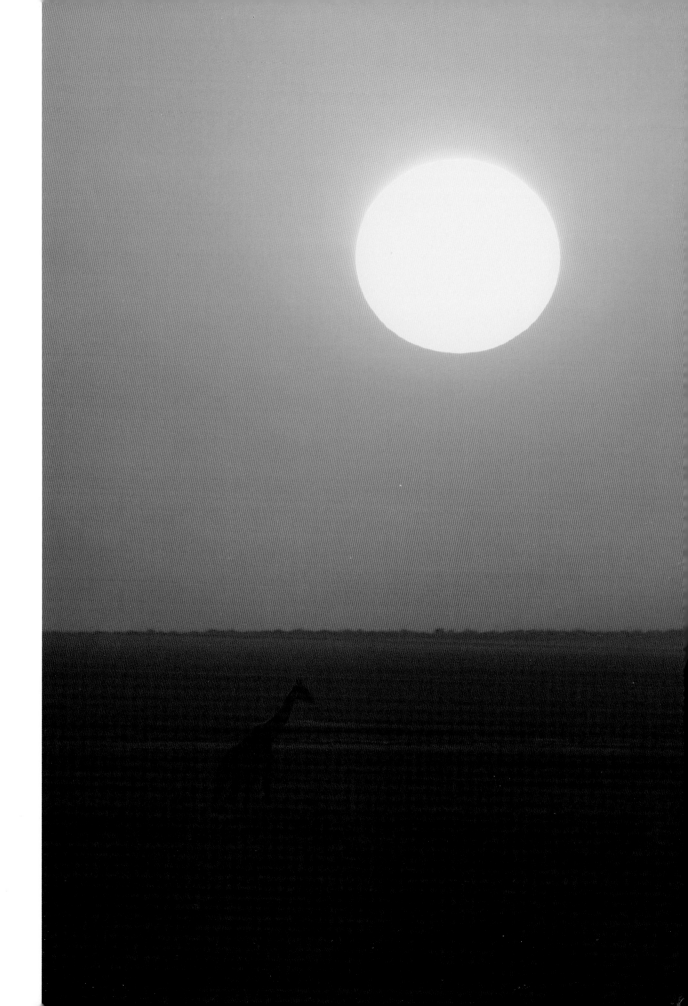

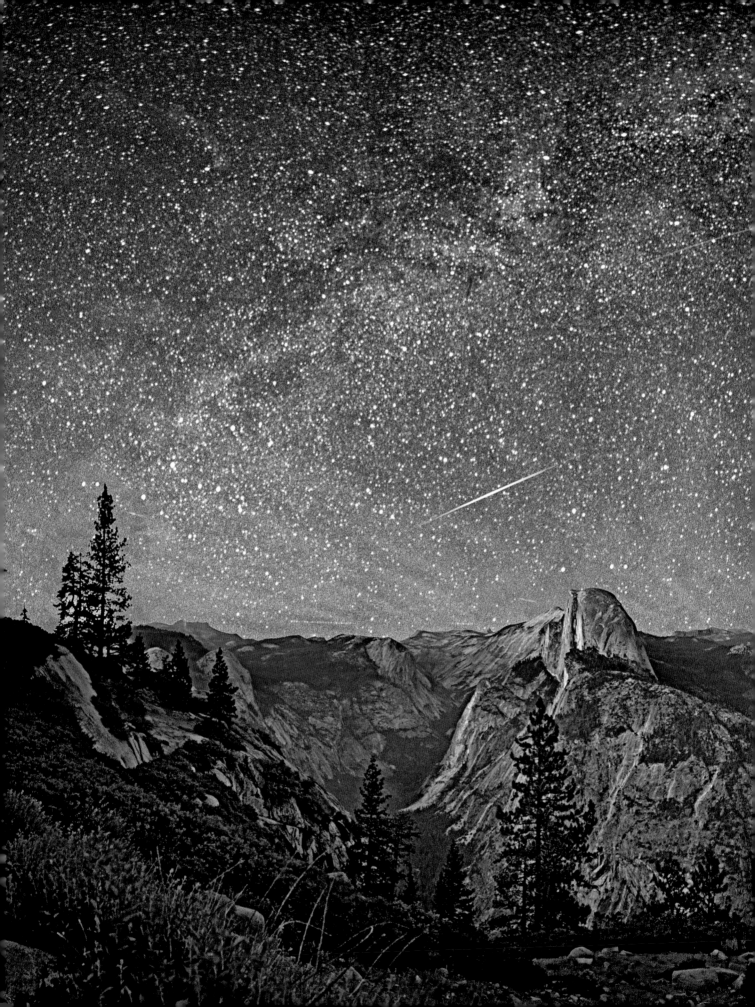

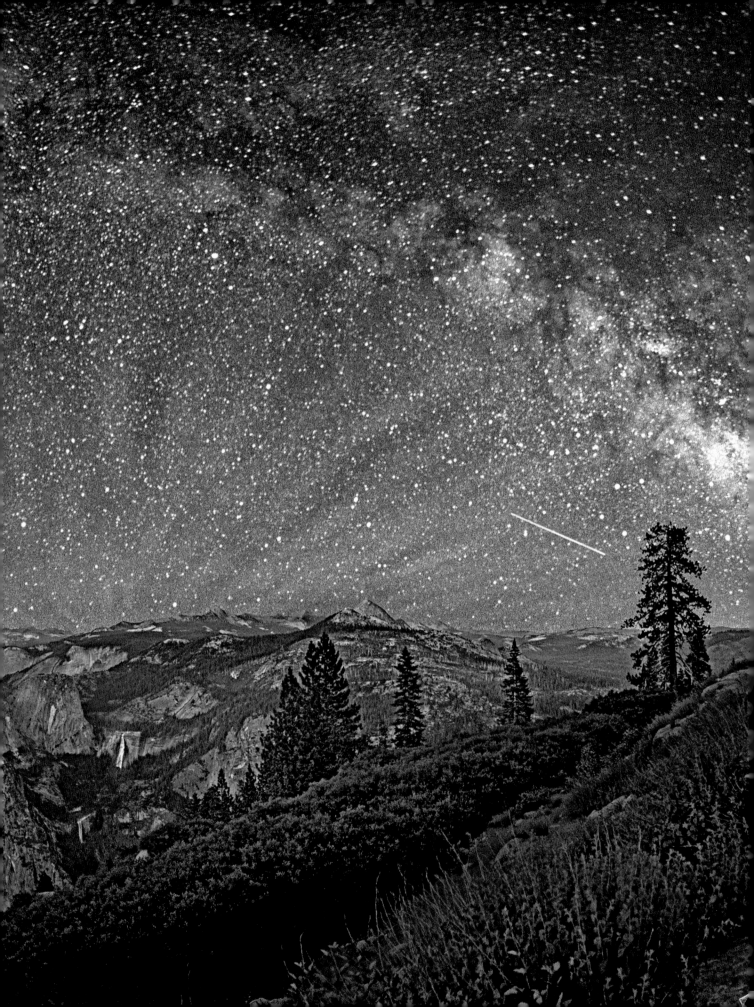

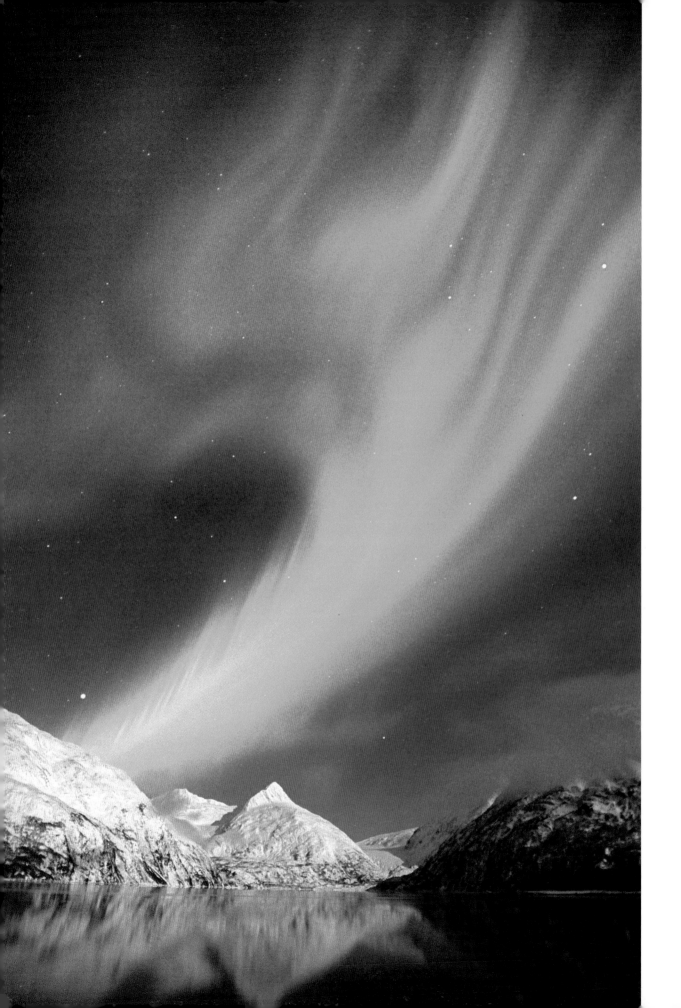

NIGHT SKY

|||

FOR ANCIENT CULTURES and today's stargazers alike, the shimmering night sky has always been a source of mystery and beauty. Space exploration has only increased our sense of wonder when contemplating the moon, stars, and rarer phenomena like comets, inspiring photographers to venture outdoors on clear nights to capture images of the stunning landscapes overhead.

|||

GETTING STARTED

Timing is everything when photographing the night sky. While some celestial events are predictably cyclical (such as the full moon), meteor showers and the aurora borealis are more capricious. Luckily, astronomy websites, magazines, and tracking apps are valuable resources for planning your photographic adventure with vital information on dates, times, and locations from which the phenomena will be visible. Keep in mind that stars seem brightest with the moon is in its crescent phase or low in the sky.

Once you decide on your shoot's location and timing, follow the weather closely. Overcast skies will foil the possibility of capturing celestial magic, but windy weather can wreak havoc, too, blurring trees or bushes you might want to include in the foreground.

Selecting a remote site away from cities and traffic is vital for minimizing stray light during long exposures. Scout shooting positions beforehand, if possible, and on the day of the event, arrive before dusk to set up gear and manually lock in focus before it gets dark. Remote locations come with risks, so prepare for the perils of the terrain and bring a friend along for safety.

TECH TIPS

EXPOSURE Manually set the exposure and use bulb mode for exposures longer than 30 sec. To capture star trails, the shutter may need to be open for hours, depending on the desired effect. A general rule of thumb is to use the fastest (widest) aperture and lowest ISO possible. However, apertures of f/5.6–11 help minimize ambient light, so adjust settings according to each situation. To avoid star trails and other celestial shifts that arise from the Earth's rotation, either use a motorized tracker or divide 600 by the lens's 35mm-equivalent focal length to calculate the maximum exposure time before star trails appear.

WHITE BALANCE Start with auto or use a custom setting. Shooting in RAW lets you change this later.

FOCUS Manual focus is a must. Start with the lens set to infinity and take some test shots to find the perfect focus (use live view and display zoom in when focusing). Then tape the focus and zoom rings in place.

POWER After you've set focus, turn off live view and disable automatic preview to keep batteries from draining during long exposures.

WHAT TO SHOOT

The sky's the limit. The moon's reliable, and fascinating phases make it an ideal subject—whether it's full and dramatic against a dark sky or a slim crescent glimmering in the twilight. In terms of lighting, the best time to photograph the moon is 10 to 20 minutes before sunrise or after sunset.

Or maybe you want to shoot for the stars. If you have the stamina and patience for long exposures, you can capture star trails, the ballet of circular streaks that results from the Earth's rotation. Experiment with including objects like an old barn or a rock formation in the foreground, or capturing multiple images at short intervals and stacking them in post-processing.

Photographing constellations and celestial phenomena such as the aurora borealis without star trails is more challenging. Shorter exposures and higher ISOs can eliminate motion. If you're after longer exposures, a motorized tracking mount is needed to sync the camera with the Earth's rotation. Deep-sky astrophotography is the most difficult of all, since you'll need a telescope in lieu of a long lens to capture distant, dim nebula and galaxies.

PAGES 58-59 Matt Walker made this Milky Way image from a total of ten shots. He took five 30-sec photos of the stars at 10 p.m. at ISO 2500, then five more at 5 a.m. at ISO 100, and stitched them into a panorama.

PAGE 60 To shoot the aurora borealis at its best (as in this shot over Portage Lake, Alaska), plan to be in the Arctic Circle during peak time in the 11-year sunspot cycle. A rule of thumb is to position yourself with light sources to the south, and to bring extra batteries as the cold will drain them quickly.

OPPOSITE To minimize star trails, Willie Huang used a quick shutter and a lens with a wide aperture. He also chose a moonless night to keep the stars crisp in the sky.

GEAR UP

Compact Camera While a DSLR with bulb mode is ideal for astrophotography, if you have a telescope, you can even use a compact camera to photograph the sky via afocal coupling. Essentially, you set up the camera to shoot through the telescope's eyepiece.

Lenses Fast lenses at either extreme—wide or telephoto—work best for astrophotography.

Wide-angle prime or zoom lenses are ideal for capturing the entire night sky, including a terrestrial foreground. Telephoto lenses are best for homing in on specific celestial bodies. Use a tele-extender if needed. For deep sky shooting or extreme close-ups, investigate using a telescope as a lens for your DSLR.

Tripod A sturdy tripod is a necessity. Be sure it's stable for long exposures; use sandbags to prevent tipping if necessary.

Radio-Remote Trigger Operate the shutter with a remote or cable release to prevent camera shake. Be sure that your camera is compatible with your trigger and that the shutter can be set for long periods of time or locked open.

Rechargeable Batteries The shutter will need to stay open for hours, so be sure not to run out of power on site.

Motorized Tracking Mount The combination of a fixed camera position, the Earth's rotation, and an exposure of 30 sec or longer will streak stars across the image. A motorized tracking mount automatically shifts the camera in small increments to counteract the movement of the Earth so the stars remain sharply focused during a long exposure.

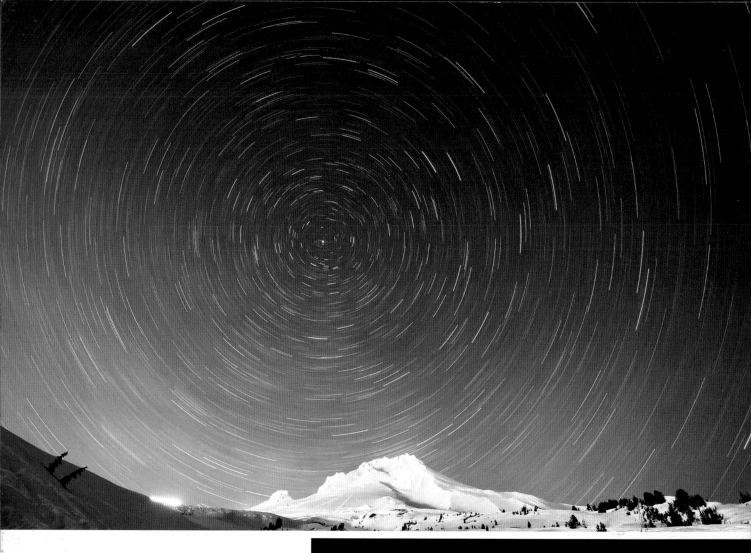

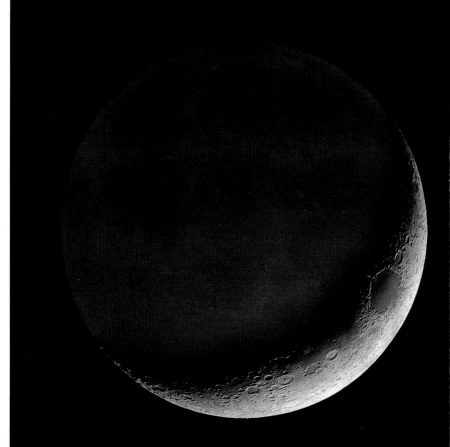

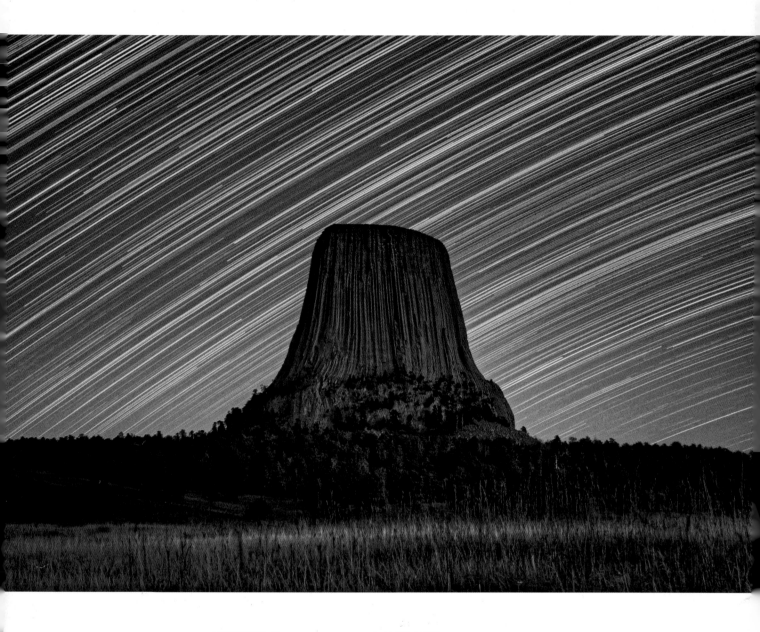

OPPOSITE TOP The north star is always over Mount Hood from Darren White's location here. He used a f/6.3 f-stop to help keep the frosty image sharp. Shooting in cool temperatures helps keep the noise down on long exposures.

OPPOSITE BOTTOM Mark Kilner was after earthshine—the subtle glow caused by sunlight reflecting off the Earth's surface onto shadowed parts of a partial moon. This shot required stacking separate exposures, since exposures best suited for the bright part of the moon don't work for earthshine.

ABOVE After considering the sunset, moonrise, and direction of light from passing cars, Eric Schafer set up his camera on the side of the road, programmed his intervalometer to start taking images, and then took a long nap in his truck! He took 93 shots at a total exposure time of more than six hours, then assembled them in software.

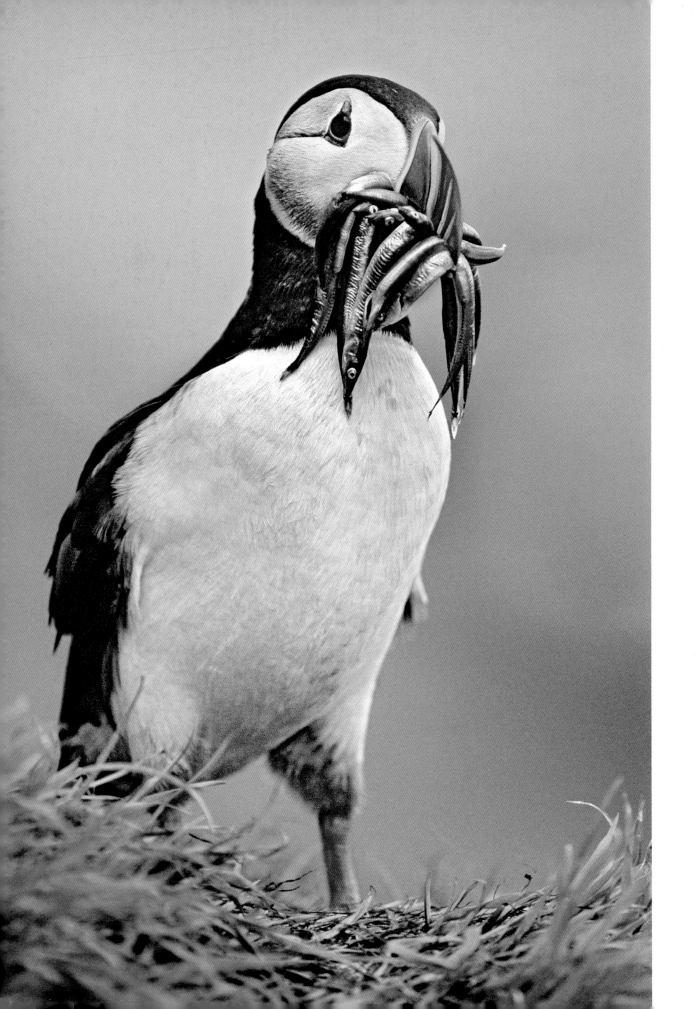

BIRDS

AUTOFOCUS, AUTOEXPOSURE, digital capture—modern technology has revolutionized the imaging of one of the most compelling yet challenging photographic subjects: birds. In today's golden age of avian photography, adept photographers can capture shots of birds on the wing that were never possible before. You can join their ranks with some forethought and practice.

GETTING STARTED

To do justice to our fine, feathered friends, you need a long, fast lens—that's not negotiable. You also need a DSLR with quick and accurate autofocus. But don't sweat it: Those core requirements are probably covered if your camera is fairly new. Crop-sensor models give you a bonus boost in effective focal length, and current DSLRs have great autofocusing, even at lower price points.

The instinct of virtually all bird species is to flee at the approach of mammals, including the two-footed, camera-toting variety. So you'll need to develop a tracker's skills of patience and stealth. Don camouflage to literally blend in with the scenery, and travel light—but don't leave your tripod behind. Holding a camera and big lens can be tiring over time.

To educate yourself on the habits and haunts of the creatures you're hoping to capture on film or in pixels, check out the resources available from groups like the National Audubon Society, British Trust for Ornithology, American Birding Association, and Cornell Lab of Ornithology. For intel on local species, look no further than a nearby birding group.

TECH TIPS

EXPOSURE It's the opposite of what you might expect: For relatively static subjects, autoexposure works just fine. But for birds on the wing, nature pros advise going manual, since the background can change dramatically in a fraction of second, seriously throwing off autoexposure.

METERING Measure the overall light with an incident light meter, or you can use your camera's light meter and a gray card.

FOCUS Autofocusing is the rule. Bird movement is quick and herky-jerky, making manual focusing an exercise in frustration. For birds in flight, use continuous autofocusing and set a multipoint autofocus group based on where you think—or hope—the bird is most likely to enter the frame.

SHOOTING MODE Widely recommended for the best preservation of detail in images, RAW may actually work against you if you're using a fast burst for a flying bird, since it may slow down the frame rate and limit the number of frames you can capture. If so, switch to JPEG-only capture.

WHAT TO SHOOT

Essentially, avian photography boils down to the old-time shooter's refrain: Watch the birdie. That observation can take place in exotic locales or your front lawn. Pros and serious amateurs visit national parks and bird refuges, or follow the migrations of certain species across continents. Bear in mind that many species don't migrate, but "winter over." And remember, cold and snowy conditions can provide dramatic visuals: Think of a red cardinal enlivening a monochrome winterscape.

If you want to shoot in your own backyard, do put up a bird feeder—but don't focus your camera on the feeder. As any avid backyard birder could tell you, wary birds spend time assessing the scene from shrubs or trees across from a feeder, so that's where you should focus and frame. If there's clutter in the background of your subject's preferred perch, try obscuring it with a clump of tree branches or a plain, subtle backdrop.

As for you, hiding in a camo-colored blind is just one way to take surreptitious bird shots. You can also use a remote trigger or Wi-Fi-enabled camera that's operated remotely by your smartphone. Either way, set your camera up on a tripod, adjust the focus and exposure, and trip the shutter when a photogenic bird alights in your viewfinder.

PAGE 66 Frans Lanting made this humorous portrait of a hungry puffin at Vestmannaeyjar in Iceland. To make the brightly colored bird pop even more, he decided to blur the background. A low f/stop (at around 5.6) decreased the depth of field and gently softened the grassy knoll behind the subject.

GEAR UP

Crop-Sensor DSLR Many wildlife pros who ordinarily shoot with full-frame cameras also pack a crop-sensor camera to provide extra magnification for subjects like birds. An APS-C-sensor camera typically produces magnification of 1.5x, which means that a 300mm lens will have the angle of view of a 450mm lens on full frame. A micro Four Thirds camera gives you a 2x magnification factor—a 200mm lens will have the full-frame equivalent of 400mm.

Lenses Since slow lenses mean slow autofocus, long high-speed prime telephoto (f/2.8) lenses are the gold standard for bird photography, not just for reach but also for brightness.

Teleconverter Serious bird photographers almost always pack at least a 1.4x teleconverter matched to their prime lenses. Be aware that you lose a stop of light with a 1.4x converter, and two stops with a 2x converter.

Extension Tube Fast prime and telezoom lenses often don't focus closely enough for small birds at short distances, so you may want at least a 25mm extension tube.

Gimbal Tripod Head Much of bird photography is hurry up and wait. A gimbal head allows you to keep a camera and lens steady at a balance point from which you can quickly track a bird that flies into view.

Binoculars Handy for spotting subjects from afar, but avoid magnifications above 8x, since hand shake will be a problem unless you invest in a pair that has image stabilization.

Camouflage Even a shiny tripod leg can spook a nervous bird. So besides camouflage for yourself, consider special camo cladding for tripods, lenses, and camera bodies. Be sure that your camo matches the environment in which you will be shooting: for instance, green for the woods, tan for a desert.

Portable Blind A number of companies make portable blinds—essentially, small camouflaged tents with a hole for your lens.

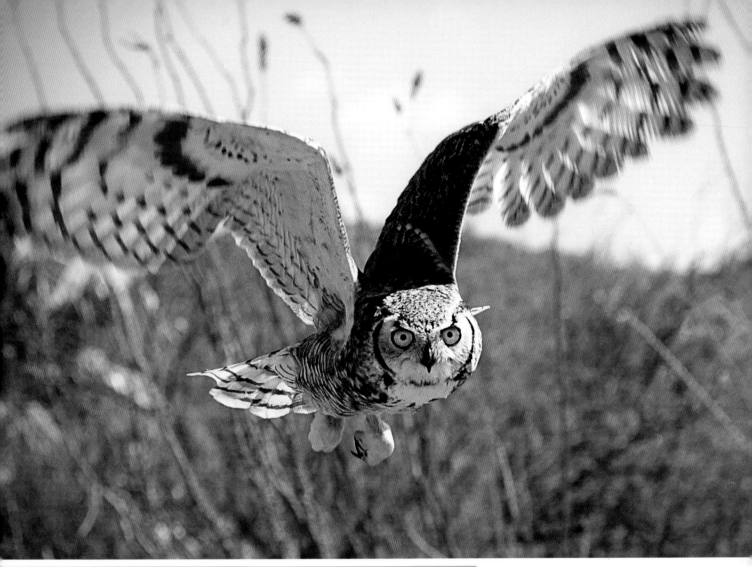

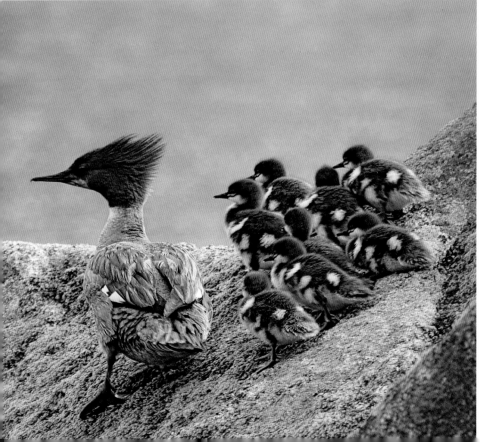

ABOVE Some birds of prey fly close to the ground when looking for a snack. And if you're lucky, one may wing right into your frame. Here, Tony Martin used a relatively fast exposure time (1/1000 sec) to get a sharp picture of a curious owl before it took off.

LEFT Keep your eye out for feathered families—especially when their individual color schemes work together to create a pleasing overall pattern, as in this flock of mergansers, shot by Kathleen Wilkie from the seat of her car in Maine.

ANIMALS

IF YOU'RE INTRIGUED by our animal relatives, use your camera to capture images of their beauty—or fierceness—and perhaps their life-and-death struggles in the wild. You probably have most or all of the gear you need to get started in that pursuit, which can provide a rich education about both photography and your subjects from the animal kingdom.

GETTING STARTED

Experienced wildlife shooters agree on a first principle that applies whether you're shooting at the zoo or on an African safari: Do your homework beforehand. For starters, thoroughly research the behaviors and life cycles of the animals you want to photograph. Determine the best times of year—and day—to capture various species at their dramatic best, whether you're out to capture a wildebeest migration or a bat sleeping upside down in a cave.

You also need to research your venue. For zoos, check the policies on photography, especially tripods. Avoid crowded times, particularly on days designated for school visits. Consult the website for feeding times, new or special exhibits, and layout. For state and national parks, check vehicle access, seasonal limitations, and rules on shooting. National parks, for example, may require you to keep a minimum distance from animals.

Indeed, always be aware of the potential hazards of photographing wild animals—and be mindful of the threat you may pose, particularly to mothers and their young. Caution protects them and you alike.

TECH TIPS

FOCUS For moving subjects, use continuous autofocus, and for very fast movement, set the drive mode to burst. Use an autofocus pattern appropriate for the kind of shooting you'll be doing; generally, a group of central autofocus points works well. For portraits, focus on the eyes and watch for (or set up) lights that will put a nice catchlight in the animal's eyes. When shooting at zoos, you can render bars or fences near-invisible by getting as close as possible to the obstructions, using a long focal length, and the widest aperture (lowest f-number) possible, and manually focusing on the animal.

EXPOSURE Use autoexposure for static subjects. In aperture-priority auto, you can set an aperture that works well with your composition, then adjust ISO until the shutter speed is high enough to ensure sharp shots. Use exposure compensation to adjust for light- or dark-colored animals, or scenes such as snowy landscapes. With rapidly moving subjects, manual exposure is better. Animals may move from light to dark backgrounds, which will throw off autoexposure. Be prepared to adjust settings as the scene shifts.

WHAT TO SHOOT

It's best to start local and small. Frequent forays in nearby parks or wilderness areas will give you more time to hone your wildlife skills than an occasional trip to a faraway locale. And as the badger photograph that opens this chapter proves, images of small critters can be just as compelling as shots of big game. An additional advantage is that those animals may be more habituated to having people around, so they'll allow closer approach without displaying defensive behavior like disappearing into their den.

Sometimes you'll want to capture the whole scene by depicting an animal in its environment, but you can also create arresting images that read like abstract art by zooming in on signature details, such as a zebra's stripes or a flamingo's legs. To do that, pick a body part, find a cool angle, and frame the shot tightly.

An excellent skill for wildlife shooting is one you can hone by tracking other moving subjects, like runners and cars. Set your camera to burst and continuous autofocus, slow the shutter speed down, and pan as smoothly as possible during one long exposure.

PAGES 70–71 Taken in Germany's misty, murky Black Forest during fall, Klaus Echle preserved the moody scenery while using a fill flash to illuminate his scurrying subject. He works mostly in the early morning, when many species are most active.

PAGE 72 Sometimes fascinating wildlife is only as far as the nearest zoo, as is the case with Patrick, a camera-loving gorilla at the Dallas Zoo, who struck many expressive poses in his enclosure for Lisa Pessin for over an hour.

OPPOSITE Photographing predators is dangerous. "You need a lens long enough to let you capture shots without getting eaten in the process," says Adam Liddy, who spotted this gray wolf staring back at him at the end of a four-hour hike in the snow.

GEAR UP

Lenses The go-to optic for photographing creatures at long distances in the wild is the long prime telephoto lens. Pro wildlife shooters routinely pack 500mm or 600mm teles in their kits. For the typical amateur, that's overkill in both expense and bulk. A long fast zoom (70–200mm f/2.8) is an excellent option for framing flexibility, while a wide to slightly long zoom will be invaluable for scenes of animals in their surroundings. An APS-C-only lens with a zoom range such as 18-300mm may be a viable alternative for those with crop-sensor cameras—but these lenses are dimmer.

Teleconverter A less-expensive and lighter-weight option to superlong teles, a 1.4x teleconverter will transform your 300mm lens into a 420mm lens; a 2x converter will give you 600mm. Teleconverters reduce the light transmission of a lens by the same factor: your f/4 lens slows to f/5.6 with a 1.4x converter; with a 2x converter, to f/8. Use the "matched" converter made by the manufacturer of your lens.

Flash A pop of fill flash from an accessory unit can preserve detail. Set the flash to an auto setting of –1 EV or lower for a natural rendition.

Monopod At the very least, bring this to support your rig. Handholding a big zoom or tele can be fatiguing—and an invitation to stress injury.

Tripod with Ballhead The pan-tilt head (a.k.a. three-way head) common on many tripods may prove exasperating when you're trying to follow moving wildlife. A ballhead, which can be loosened and tightened in all dimensions with the turn of a single knob, is a better option.

Gimbal Head With a gimbal head, you can let go of the camera and lens with all friction knobs loosened—and the camera will stay put.

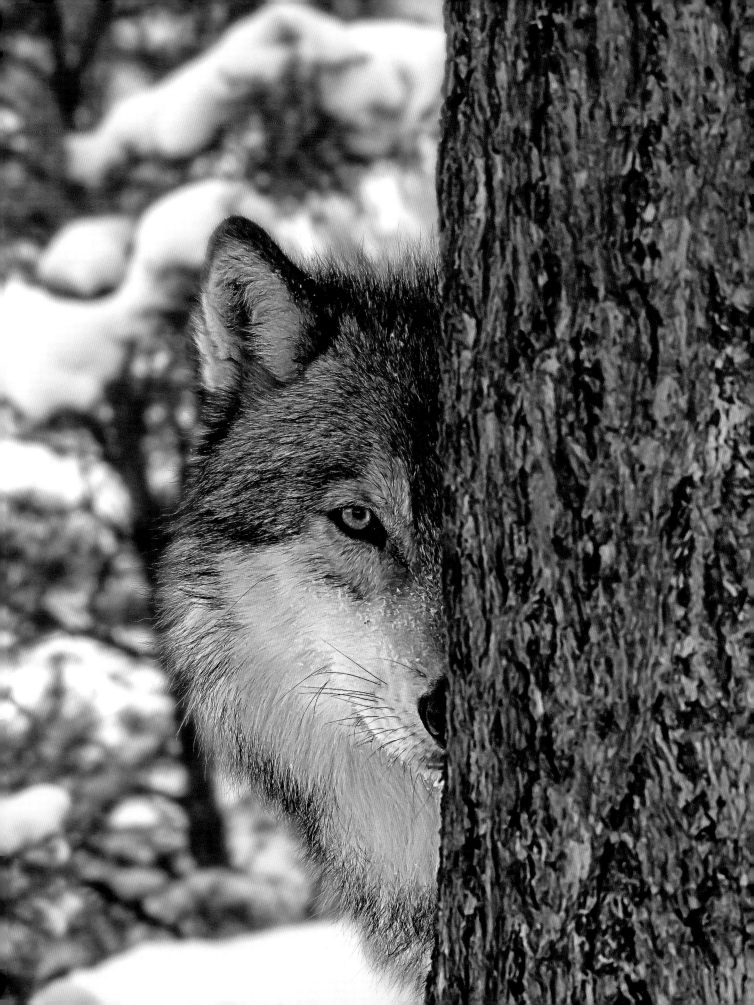

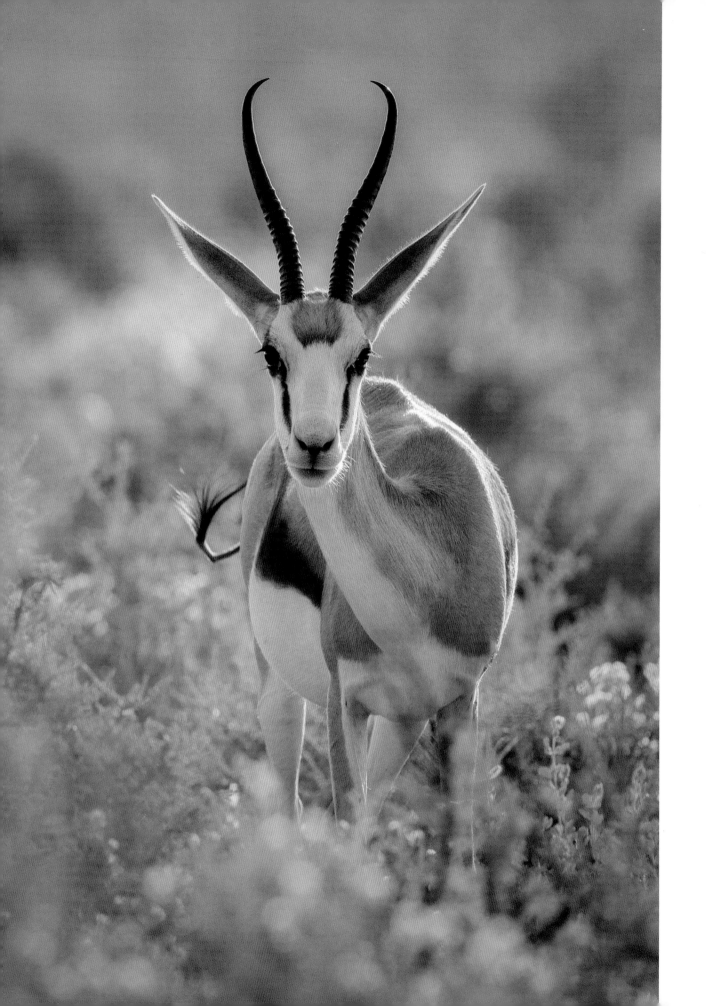

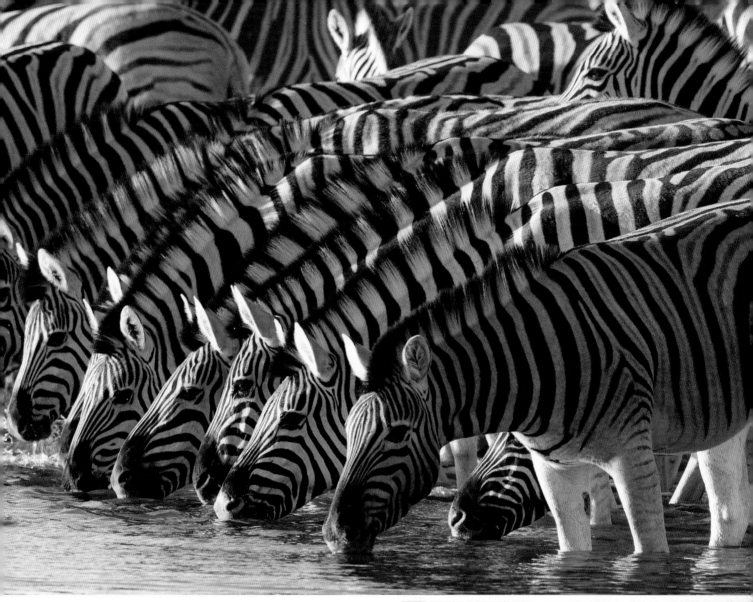

ABOVE One of the biggest savannah conservation areas in Africa, Etosha National Park is abundant in wildlife and photo opportunities. Richard Bernabe caught these thirsty zebras late in the day, composing to play on the repeating motifs in their configuration and coats. He stood in a walled "rest camp" inside the park, from which he set up his camera with a 500mm lens and 1.4x teleconverter.

OPPOSITE Using a 500mm lens with a teleconverter, Richard Bernabe was able to get up close to this springbok gazelle—a gentle grazer that's easily spooked. Gentle whistles and noises may help you briefly attract the gaze of your subject, but don't be surprised if you only get one shot before it flees.

RIGHT After visiting the Everglades over the course of six months, Robert Sullivan found that this American alligator let him get quite close—close enough that he was able to position his camera on the edge of a nearby dock for a startling, water-bird's eye view of the gator's chompers.

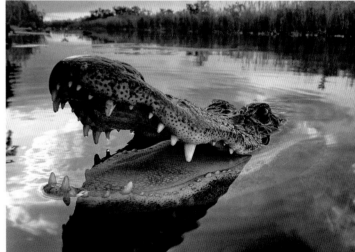

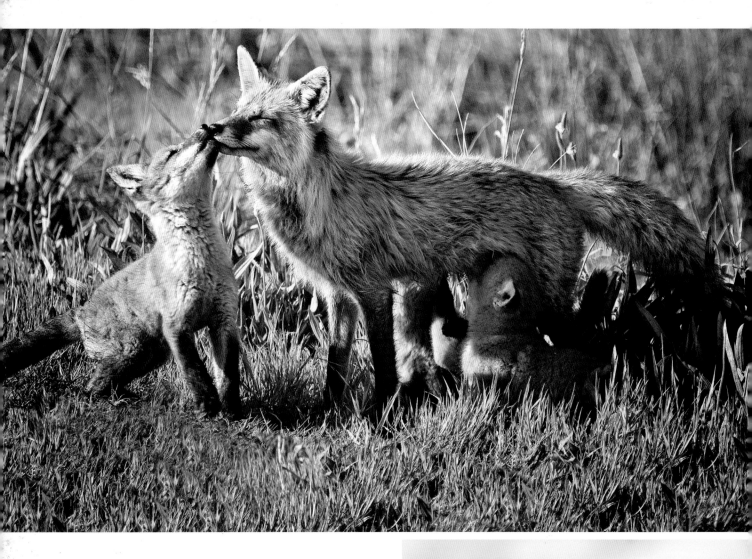

ABOVE Ron Lutz attributes this tender image of a red fox family to luck: "It's not something you can carefully plan," he says. "It's something you hope for." He spotted the foxes in a field nursing and frolicking in early morning light. A massive, camouflaged super telephoto zoom helped him home in and document the action.

RIGHT Shahul Hameed photographed this reptile using a 60mm macro lens. A narrow depth of field blurred the background, emphasizing the lizard's finely detailed scales. It helps to hold the camera at the critter's eye level so viewers can more easily connect with your cold-blooded subjects.

OPPOSITE Walking through Shenandoah National Park, Virginia, Ian Plant caught a hidden gem: a fawn resting underneath woodland ferns right off the trail. He shot with a 105mm lens, taken at 1/60 sec at f/8 and ISO 1600.

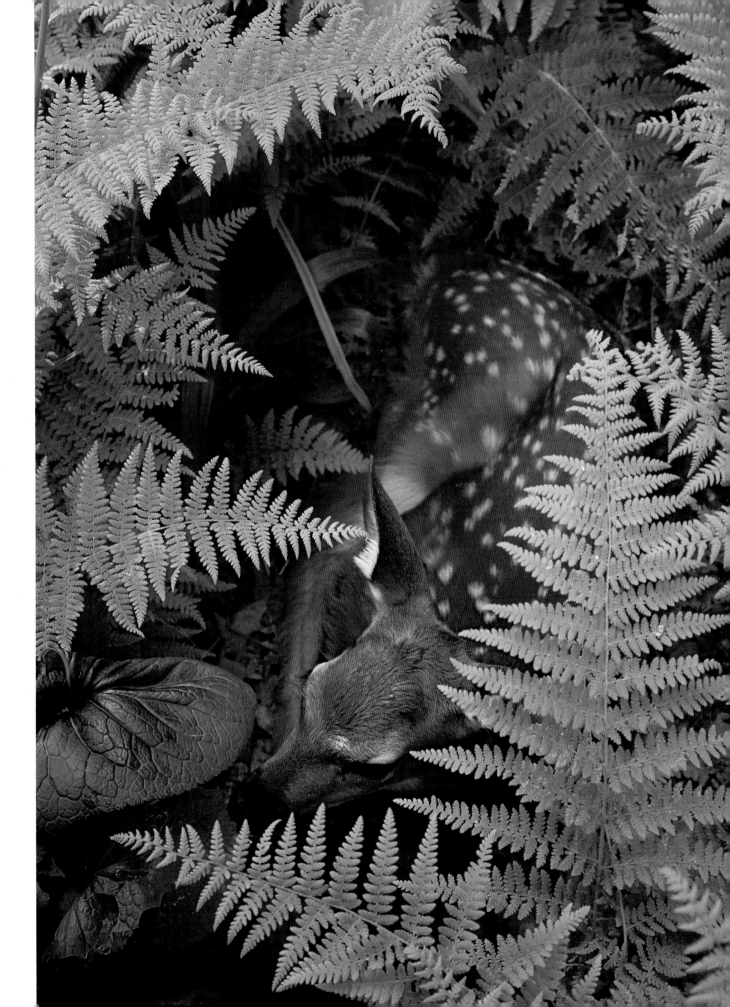

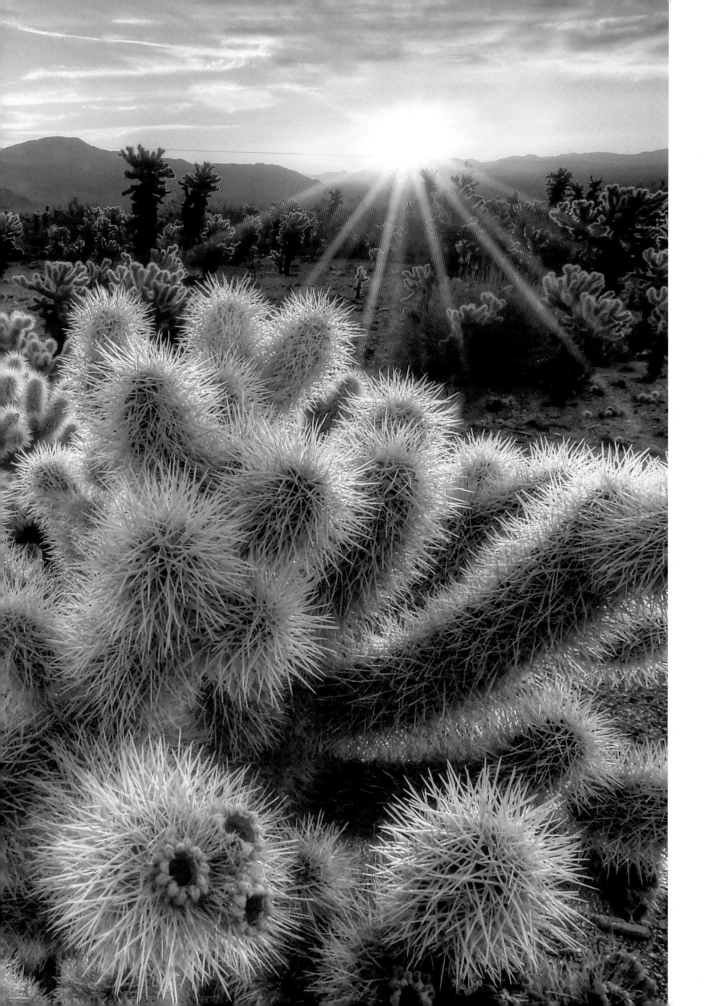

LANDSCAPE

|||

FROM SNOW-COVERED MOUNTAIN PEAKS to wind-sculpted sand dunes, our world is filled with visually arresting landscapes. To turn them into powerful images, combine nature's majesty with your own personal vision of a place by getting creative with vantage points, camera gear, and perhaps some post-processing.

|||

GETTING STARTED

Gorgeous—and photogenic—scenery takes many forms, including towering forests, rolling farmland, dense jungles, and steep gorges. Once you decide where you want to shoot, your next choice is when. Local sites are most convenient and offer the flexibility of returning multiple times to experiment at different times of day—and maybe even different seasons. Landscape shooting during a trip involves less flexibility, but offers unusual and sometimes even once-in-a-lifetime opportunities. Research locations and figure out when and where the best lighting will occur. Keep in mind, though, that popular sites like Yosemite National Park or Alpine ski slopes may be crowded with tourists and other photographers.

Consider exploring landscape-enhancing options, such as novelty lenses (for example, tilt/shift, fisheye, or a selective-focus LensBaby), an infrared-modified camera, and post-processing special effects (such as black-and-white conversion, panoramas, or HDR). You don't have to rely on special effects, however: Think of a story you want to tell or how a place makes you feel, then immortalize your personal experience of a landscape that speaks to you.

TECH TIPS

EXPOSURE Aperture-priority or manual-exposure modes provide the most control over depth of field. Stop down the aperture to f/11, f/16, or f/22 to achieve the best front-to-back focus. For shallower depth of field and a softer look, open up the aperture to around f/2.8. Go with slow shutter speeds of 2 sec or more to capture the movement of blowing leaves, flowing water, or heat waves rising off desert sand.

FOCUS When possible, focus manually to ensure a sharp image. Use live view and any available focus-assist aids, such as zooming in to the scene on the LCD. Use depth of field preview, if available.

WHITE BALANCE As the sunlight changes, your white balance will probably change as well. Depending on the camera, automatic white balance may work during your shoot, but you'll get optimal results if you set a custom white balance as the light alters. That's especially critical when photographing snow or ice scenes, which can easily throw off automatic white balance. To be safe, shoot in RAW or RAW + JPEG so you can make any necessary tweaks in post-processing.

WHAT TO SHOOT

Whether you're up a mountain or on the coast, there are a number of universal considerations in photographing landscapes. For starters, the quality of the light can make or break a portrait of a place. The magical golden and blue hours surrounding sunrise and sunset are excellent times to shoot. Shadows add depth and dimension, so consider including them in your composition. Or try photographing at midday for bold effects—for example, shoot in bright sunlight to grab some lens flare. Dramatic cloud formations enhance landscapes and are often more interesting than a solid blue sky.

Foreground elements, colors, and lines—together or individually—help draw the viewer's eye into the scene. This is especially crucial when photographing wide open spaces such as deserts or plains. As you consider the composition of your landscape, bear in mind the golden rule of thirds, including the visual trick of having an eye-anchoring element, like a rock outcropping or a farmhouse, a third of the way up from the top or bottom of your frame and a third of the way in from one side. Or break expectations by shooting a horizontal scene vertically.

PAGES 80-81 Marco Crupi's image of autumnal trees and their reflection at sunset almost didn't happen: "I was driving to a location when I spotted this gorgeous scene out of the corner of my eye. I made a U-turn as soon as I could," he says.

PAGE 82 Cliff LaPlant cropped his landscape-oriented photograph to make it a portrait, bringing the viewer close to the foreground cactus as the rising sun set its needles aglow.

OPPOSITE Jared Ropelato shot this Oregon canyon with a 70–200mm telephoto and a 95mm focal length to make the space feel even tighter. In post-processing, he emphasized the contrast between the overcast sky and the lush greenery.

||

GEAR UP

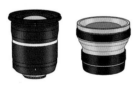

Lenses Wide-angles lenses are the typical choice for landscape photography. One reason is that they provide better depth of field, which is especially important when including foreground elements. Look for focal lengths from about 10 to 28mm. If you'd like to go for an unusual look, consider a fisheye lens or a telephoto of at least 85mm, which will compress the scene.

Filters A split neutral-density filter helps balance the often extreme exposure difference between the land and sky to create an even exposure and increased dynamic range. Polarizing filters provide more saturated colors and richer blue skies; they also cut glare and reflections from water and other surfaces. If you're at a high altitude, a UV filter reduces the atmospheric haze that sometimes interferes with getting a clean, crisp shot.

Tripod A steady camera is critical, especially during low-light times like sunrise and sunset. Although expensive, a carbon-fiber tripod is a lighter alternative that's easier to carry when hiking.

Level A leveling base or spirit level that attaches to your camera's hotshoe ensures level horizon—especially important when shooting panoramas.

Sun-Tracking Smartphone App Plan your shoot with assistance from a sun-tracking app to determine sunrise and sunset times, as well as the angle of the sun and how it affects the location.

Software You'll need software to stitch together panoramas, convert images to black-and-white, or process digital infrared images. Look for an image-editing program with access to color channels. HDR images can often be processed in image-editing software or special HDR plug-ins and applications.

||

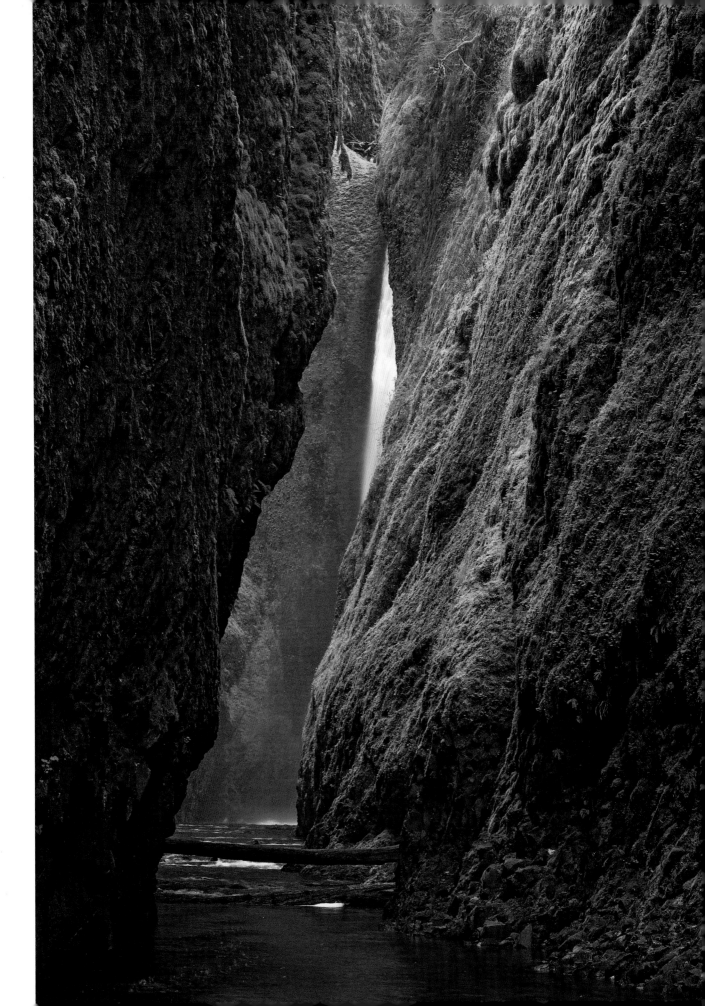

OPPOSITE Adjusting to windy conditions, Paul Marcellini was able to freeze the leaves of this lone mangrove with combined exposures of 1/8 and 1/30 sec at f/13, and ISO 400.

ABOVE Richard Bernabe traveled to this iceberg by boat, then photographed it with a fast shutter speed to minimize vibrations from the engine, and a wide angle to encompass its massive, icy exterior—with a bird for scale. Note that cold temperatures rapidly drain batteries, so come with backup, and let your lens acclimate to the cold temperature before use.

OPPOSITE Getting close to the foreground flowers with a wide-angle lens allowed Ian Plant to emphasize the bright blooms and create depth in this photograph of Mount Saint Helens. The soft pinks and blues in the morning sky provided a fitting complement to the red and purple spring blossoms, too.

ABOVE Black-and-white conversion gives Kah-Wai Lin's photograph of the dunes in California's Death Valley National Park a near abstract aesthetic. He recommends shooting right before sunset—the low-angle light creates stark shadows in the dunes—and getting away from crowds to minimize footprints in the sand.

ABOVE Producing miniature-scale models from big things, like the Slovenian Alps shown above, is what tilt-shift photography—also called "miniature faking"—is all about. By tilting this specialty lens in the direction opposite the one that would produce depth of field, you limit sharp focus to the narrow pivot point of the plane of focus, while the rest of the image blurs. This image doubles the delight with a panorama. To try your own hand at a 360-degree vision, shoot in panorama mode and stitch the resulting images together in software later.

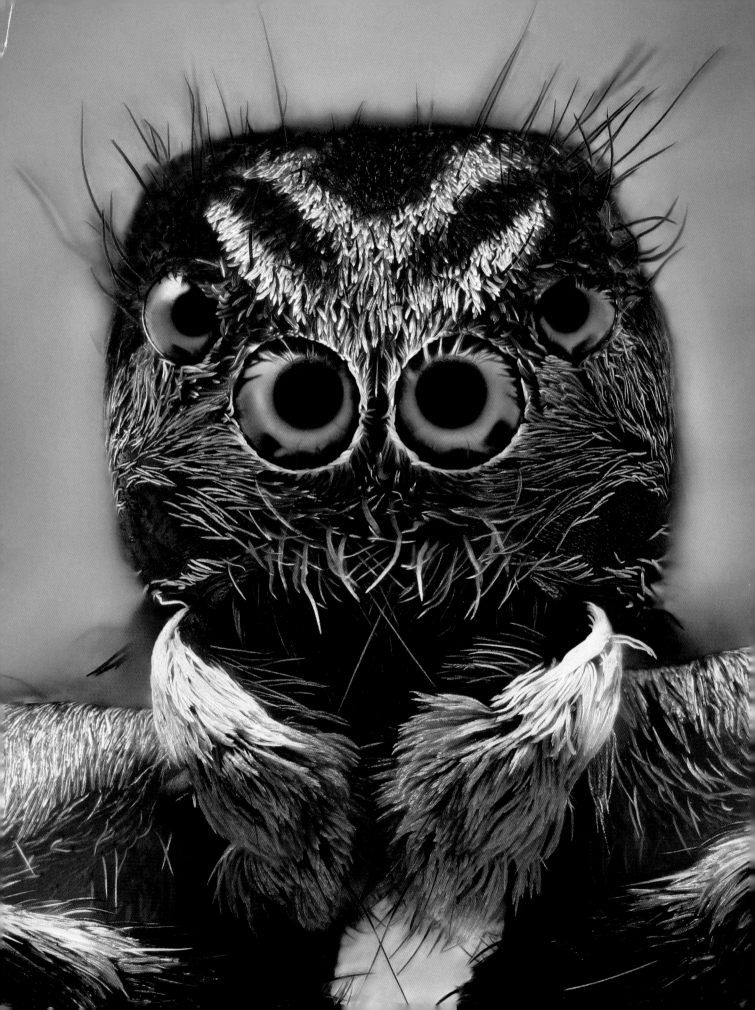

INSECTS

THEY ARE THE ALIEN BEINGS that live among us. Strangely beautiful or frighteningly grotesque, insects—and their arthropod cousins, spiders and centipedes—fascinate homo sapiens, particularly the subspecies known as photographer. Small wonder, because their outlandish features and tiny size make bugs intriguing and challenging subjects.

GETTING STARTED

You can get into many areas of photography with a decent camera and a standard lens, but insect photography requires a bit more. Much of its impact comes from seeing a very small creature very big, which means you'll need a macro lens or another optical accessory capable of extreme closeups.

If you're not already an early riser, start being one. In the cool of early morning, many insects and arthropods are sluggish to the point of near inertia, making them easier to catch with your camera. There are other advantages as well: Dew adds a jewel-like glitter to bugs, as well as to their webs and plant perches. And although they're adept at blending into their surroundings in midday's flat light, the steep-angled rays of early day make bugs stand out from their surroundings.

As with all photography of wild things, knowledge of the behavior of your pictorial prey is power, so bone up on the habitats and behaviors of various bugs. Some insects (such as ladybugs) are nearly oblivious to photographers; others (such as butterflies) will flit away in a heartbeat.

TECH TIPS

EXPOSURE For the most part, you will be shooting through macro lenses or other accessories that use extra extension from the focal plane—which means that there will be considerable dimming of the image. So rely on your camera's through-the-lens meter, not an external one. You will need small apertures (f/16 to f/32) for adequate depth of field in close focusing; set the f-stop you need and shoot in aperture-priority auto.

FOCUS A delicate business with tiny subjects. Manual is your best bet, and, if your camera has magnification aid for focusing (on the LCD or through an electronic viewfinder), use it. If you intend to stack images in post-processing, you may want to set a low-speed burst rate and fire as you adjust the focusing from near to far.

FLASH For extreme closeups, your camera's flash will be useless—it will fire over, not at, the creature. But for subjects at longer focusing distances—for example, a butterfly at arm's length photographed through a telephoto lens—the built-in flash can provide great fill light. Set it to -1 stop output or less for a subtle effect, or to full power to really pop your subject.

WHAT TO SHOOT

Head out to your backyard or a nearby patch of woods with your eyes peeled and your camera at the ready. Bugs and spiders are everywhere, but you may not notice many at first, as they blend into the scenery. (Finding a praying mantis in a rose bush requires real concentration!) Once you've sighted your quarry, get creative. Go for a head-on, alien-esque portrait, like the one on page 92. Or try environmental shots that emphasize a bug's behavior, be it sipping nectar from a bright blossom or skimming along a pond's surface.

The extreme limitation of depth of field that comes with high magnification can work in your favor, since it throws cluttered backgrounds out of focus to create a pleasing blur—as in the two photos at right. If possible, position yourself so that the background is a contrasting color (say, a blue butterfly on a red barn).

And you don't need to limit yourself to natural backgrounds. Use a simple field setup (Google some nifty tips from the U.K. conservation group Meet Your Neighbours) so you can shoot insects against a white studio-style background. This kind of setup is well worth your while if you want to showcase a creepy-crawly in a "glamour" portrait.

PAGE 92 A shallow depth of field keeps the attention on this dark and hypnotic spider, helping him pop off the blurred background.

OPPOSITE TOP Longer macro lenses can help you zoom in on more skittish subjects, such as butterflies. Your best opportunity for photographing these shy critters is during their annual migrations, when the volume of possible subjects increases.

OPPOSITE BOTTOM Mehmet Karaca used a 60mm macro lens to sneak into the tiny, highly camouflaged world of stick bugs. A shutter speed of 1/250 sec froze the creature midstep.

GEAR UP

Lenses A true macro lens allows subject magnifications up to 1:1, or "life size"—that is, the subject is the same size as in life on the sensor or film frame. (Think of an image of a 1-by-1½-inch (2.5-by-3.8-cm) postage stamp filling a 35mm frame corner to corner.) Bug photography complicates things further. The 50mm focal length, the most popular in macro primes, requires you to be 2 inches (5 cm) away from your subject for 1:1. Try that with a skittish butterfly. Longer macro lenses, such as 100mm or 180mm macro, give your more

working distance. The downside of the longer macros is that they are proportionally more expensive, too.

Extension Tubes These provide relatively inexpensive extra magnification with any lens; when used with a macro lens, you can get magnifications greater than life size. Many tube sets can support both autoexposure and autofocus.

Focusing Rail At high magnifications, focusing with the lens' focusing ring becomes nearly impossible. It is more effective to move the entire lens

back and forth, and a focusing rail allows you to make smooth, fine adjustments.

Bellows Extension tubes on steroids, bellows allow for much greater extension and still higher magnifications.

Beanbag Simple, cheap, effective camera support. It's far easier to use than a tripod when you're on your belly.

Macro Flash Some units attach to the front of your lens, allowing for balanced illumination of small subjects.

Software A recent revolution, focus stacking—the combination of multiple images taken at different focus points—has made photography of insects and other small beings and things incredibly more impactful. Recent versions of Adobe Photoshop allow image stacking; serious bug shooters like dedicated stacking apps.

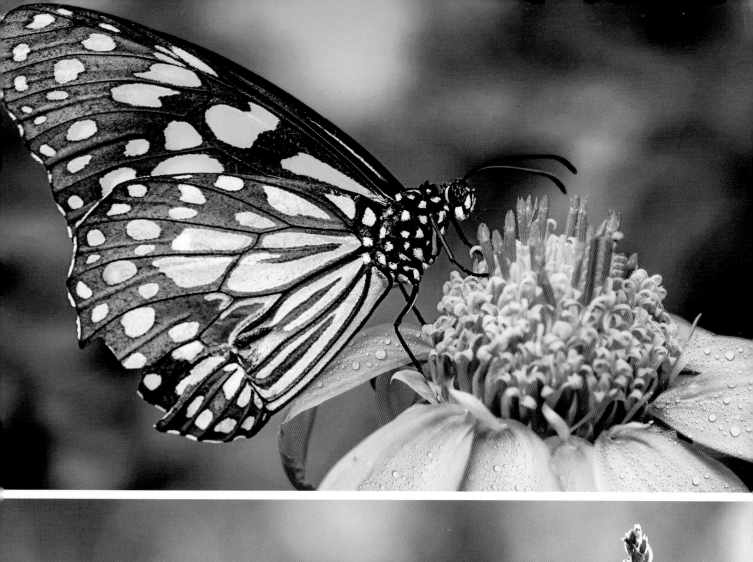
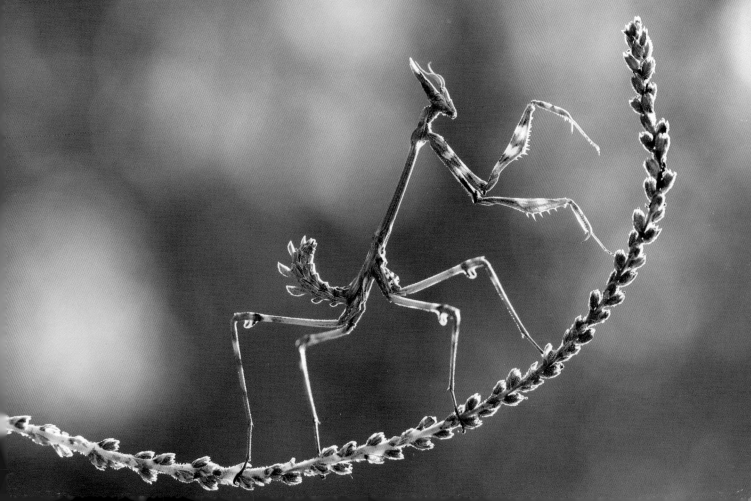

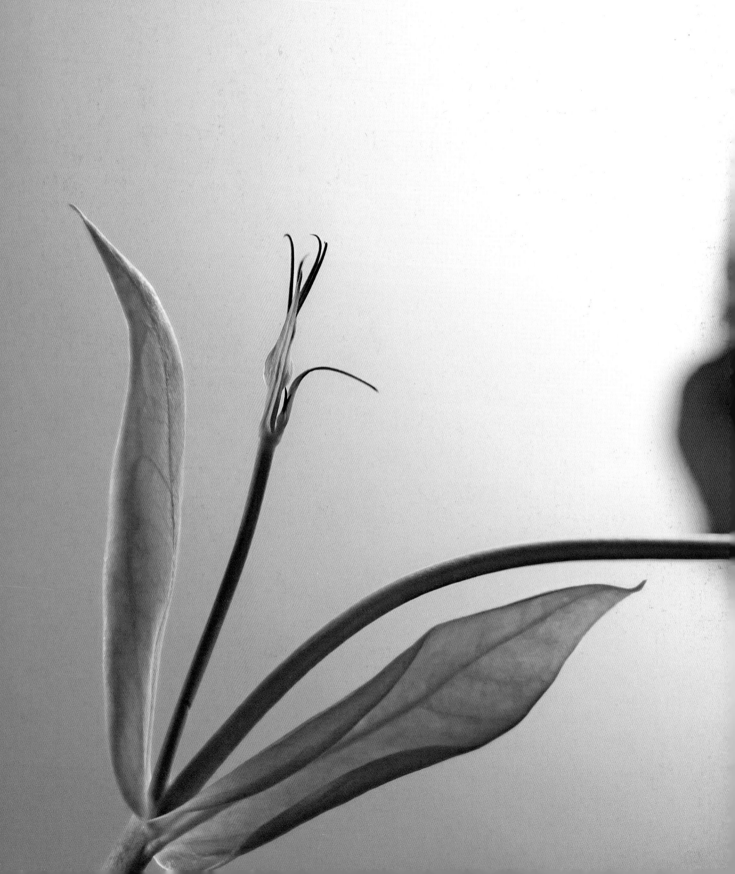

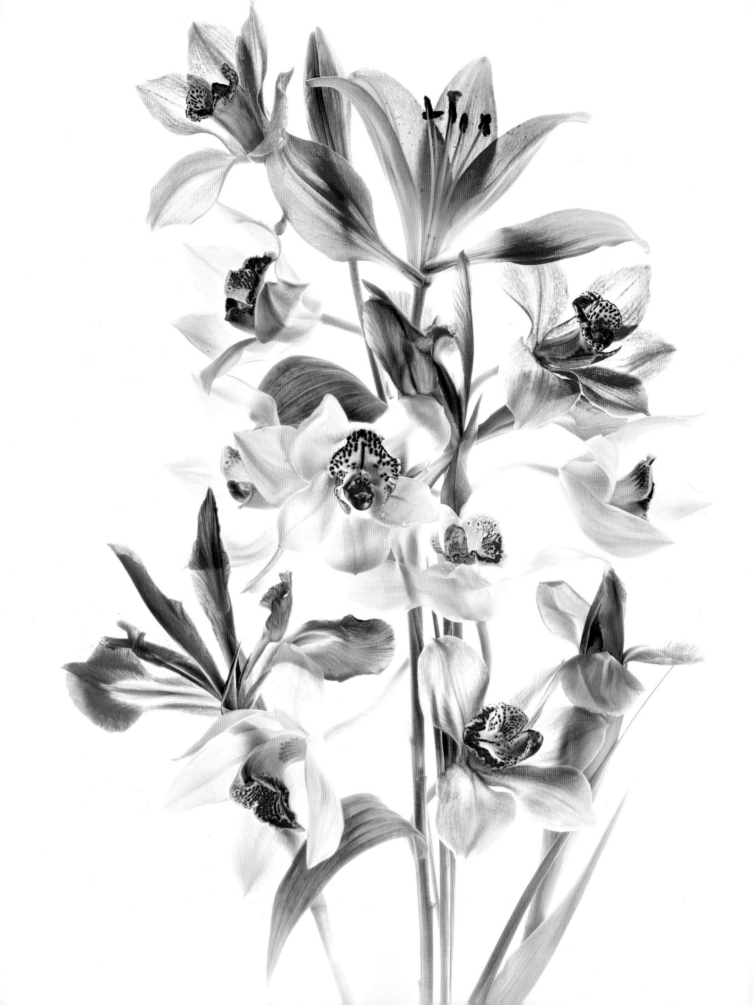

FLORALS

||

IT'S HARDLY SURPRISING that flowers are one of the most popular photography subjects—gorgeous single blooms, artful arrangements, and broad landscapes of wildflowers present a lovely array of visual possibilities. But given the millions of flower images out there, how do you make yours stand out? Fill the frame with flowers' graceful forms, varied textures, and vivid colors.

||

GETTING STARTED

Flowers may be seasonal, but opportunities to photograph them flourish year-round. In colder climates, backyards and outdoor public gardens enter hibernation during the winter, but enclosed gardens, florists, and even neighborhood supermarkets are excellent sources for year-round floral models. Of course, your options really bloom with warmer temperatures. Check online to research the peak times for wildflowers, tulips, and cherry blossoms. Pay a visit to flower farms and festivals or just step outside into your own yard.

While investigating public gardens for potential shoots, check their photography rules. Tripods are often prohibited, as is selling your images. Despite potential restrictions, formal gardens offer a wealth of flowers you may not find elsewhere.

Given flowers' often short lifespan, particularly with cut flora, plan ahead. Outdoors, time picture-taking according to the availability and direction of natural light—keep an eye on the weather, too. Shafts of sunlight can light up details, although flowers' hues often shine brightest in overcast conditions.

TECH TIPS

FOCUS Focus is always a critical component in floral photography, particularly when you're shooting macro. Manually focus the lens, using the camera's focus-assist options, such as live view and focus peaking (the latter highlights the areas that are in focus so you can double-check for accuracy).

DEPTH OF FIELD Once you've carefully selected your focus point, adjust the aperture to control depth of field. A shallow one (a small aperture around f/2.8) blurs the background while keeping part of the flower in focus. A broad depth of field is best used when filling the frame to keep as much of the flower in focus as possible. Experiment with depth of field until you reach the balance that fits best with your aesthetics.

WHITE BALANCE A frame-filling shot of cherry blossoms, or a sweeping panorama of a field of single-color wildflowers, can wreak havoc on your camera's automatic white balance—even the smartest DSLRs and ILCs will try to compensate for that overall color cast. Switch to a manual white-balance preset for the lighting conditions, whether sunny, overcast, or cloudy.

WHAT TO SHOOT

Yes, there's power in the petal, but be sure to give non-bloomers like ferns and mushrooms their due. Bear in mind that nature not only creates beautiful flowers and plants, but enhances them by attracting bees, ladybugs, butterflies, and other photogenic bugs. With skill—and a little luck—you can shoot them within a flower's petals for a striking environmental portrait. Dew or residual raindrops are another way of adding visual richness. (Lacking nature's cooperation, you can add drops with a spray bottle.)

A macro shot is an obvious choice when photographing flora, since it captures fine, often-overlooked details. One option is to move in close to eliminate the background, filling the entire frame with the flower or a part of its structure, such as the center of a sunflower or a lily's stamen. Extreme closeups can transform an image from a realistic representation to an intriguing abstract of hues, shapes, and textures. At the other extreme, a wide-angle shot of rows or a field full of flowers can also be an arresting study in pattern and color.

PAGES 96–97 Norman Press shot this unique rear view of a flower in a studio, where strong backlighting aimed through a light tent created a translucent effect. Meanwhile, an extremely shallow depth of field and a macro lens kept the focus on the stem and leaves behind the bloom.

PAGE 98 To create this luminous, minimalist floral image, Harold Davis artfully arranged blooms on a lightbox, then bracketed several high-key HDR exposures and stacked them in software.

OPPOSITE In this shot of flowers during snowfall, Magda Wasiczek used a fast macro lens at near maximum aperture for shallow depth of field, blurring the noisy background and giving blustery contrast to the simple poppies.

GEAR UP

Compact Camera While a DSLR is ideal because of its interchangeable lenses (even more so if it has a tiltable LCD screen), compact cameras, whether point-and-shoot or advanced, have macro—and sometimes super macro—features that allow extremely closeup images.

Lenses Macro lenses come in a variety of focal lengths.

A longer focal length, such as a 100mm macro lens, provides a greater lens-to-subject distance, allowing you to shoot from farther away—which is key when you don't want to scare off any insects that might be enjoying the flower's pollen. Meanwhile, wide-angle zooms or primes are best for photographing larger fields of flowers. These lenses provide not only a broader angle of view but also better front-to-back sharpness.

Light Tent Soften illumination by placing a small light tent with an opening for the camera over the flower. Or place a diffuser (a sheer piece of white fabric will do) between the light source and the subject.

Reflector or White Card You can use one to bounce the light—particularly when using flash—to prevent hard, direct light and help eliminate shadows.

Focusing Rail When using a macro lens, it can be difficult to focus due to the extreme magnification. A focusing rail lets you move the camera forward and back to get the sharpest image possible.

Tripods When shooting macro, any small movement is exaggerated, so a tripod is necessary. Some tripods have a reversible center column to position the camera over the flower without bending. A tripod macro arm accessory provides even more flexibility when angling the camera.

Clamps No law says that you can't artfully reposition a blossom in the field for a better background or to prevent motion blur (unless you're in a botanical garden), so bring something to gently anchor the flower.

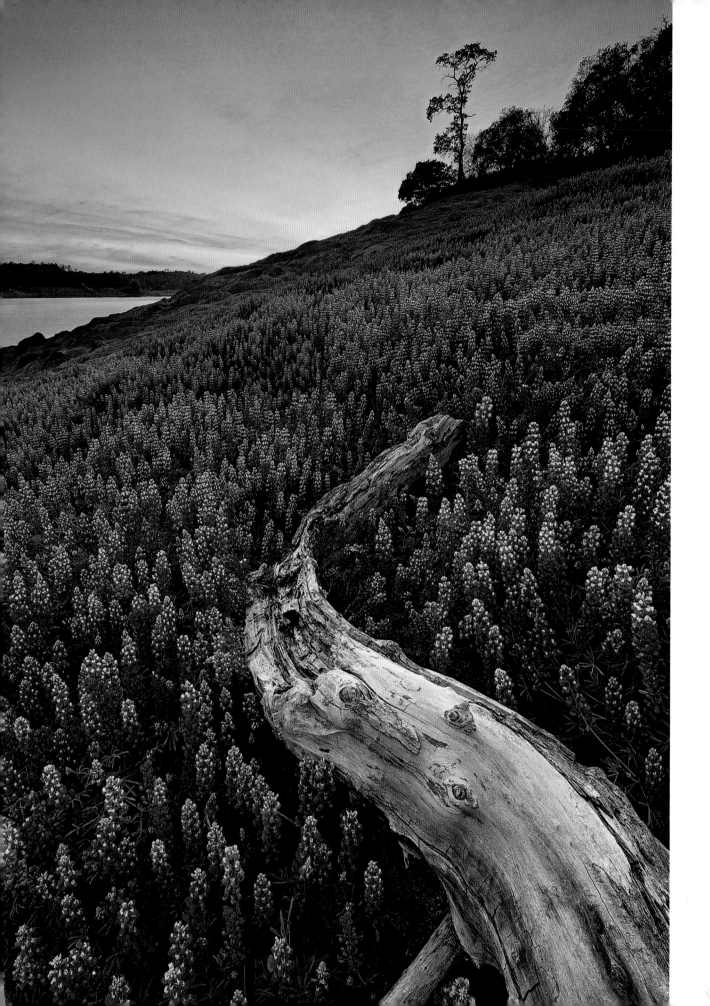

OPPOSITE Once every five or ten years, hundreds of lupine flowers bloom at once on the shores of California's Folsom Lake. Willie Huang was there to capture a recent flowering, using a high ISO and wide aperture to minimize the appearance of flower movement during sunset. He also stacked several shots in image-editing software to ensure sharpness throughout the image from front to back.

LEFT A macro lens lets you isolate a part from the whole, creating a nearly abstract image that makes viewers question what they see. Here, Florian Andronache focused on the stamens of an orange lily.

ABOVE Shon Baldini was headed out to a shoot at the beach when he spotted a crop of pansies growing by his porch and snapped a few test shots. "I started seeing colors, patterns, and possibilities everywhere," he says. "However, a bit of a breeze was making it difficult to get a sharp macro shot." He placed a large golf umbrella over the flowers to protect them from the wind, aiming the flash into the umbrella to turn it into a large soft box.

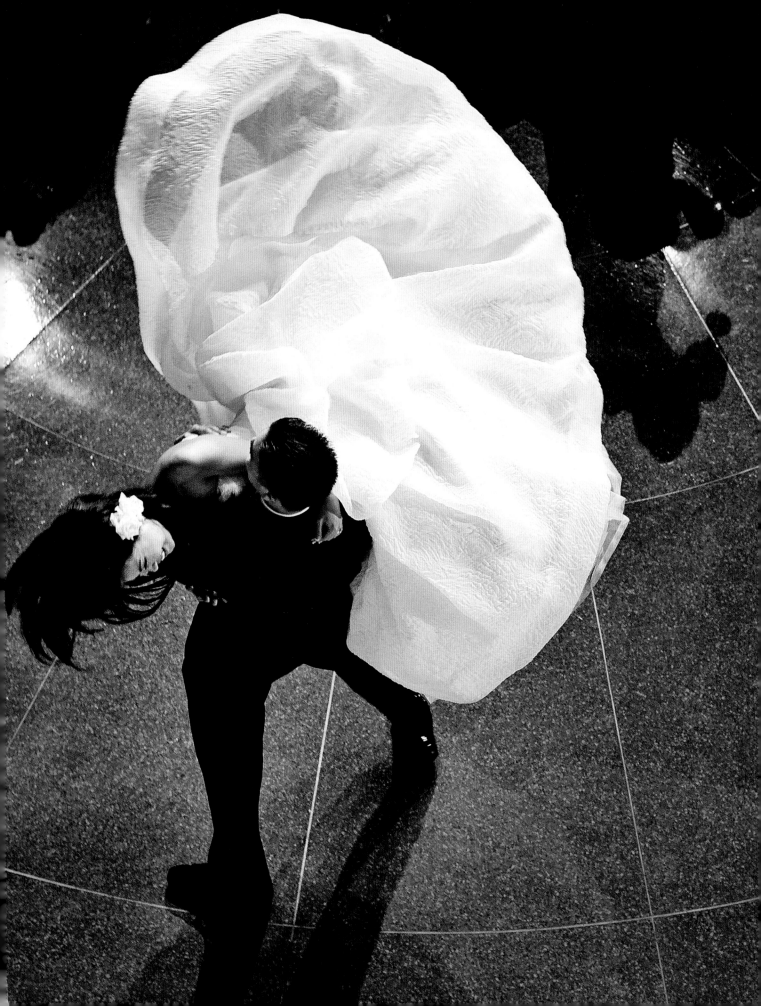

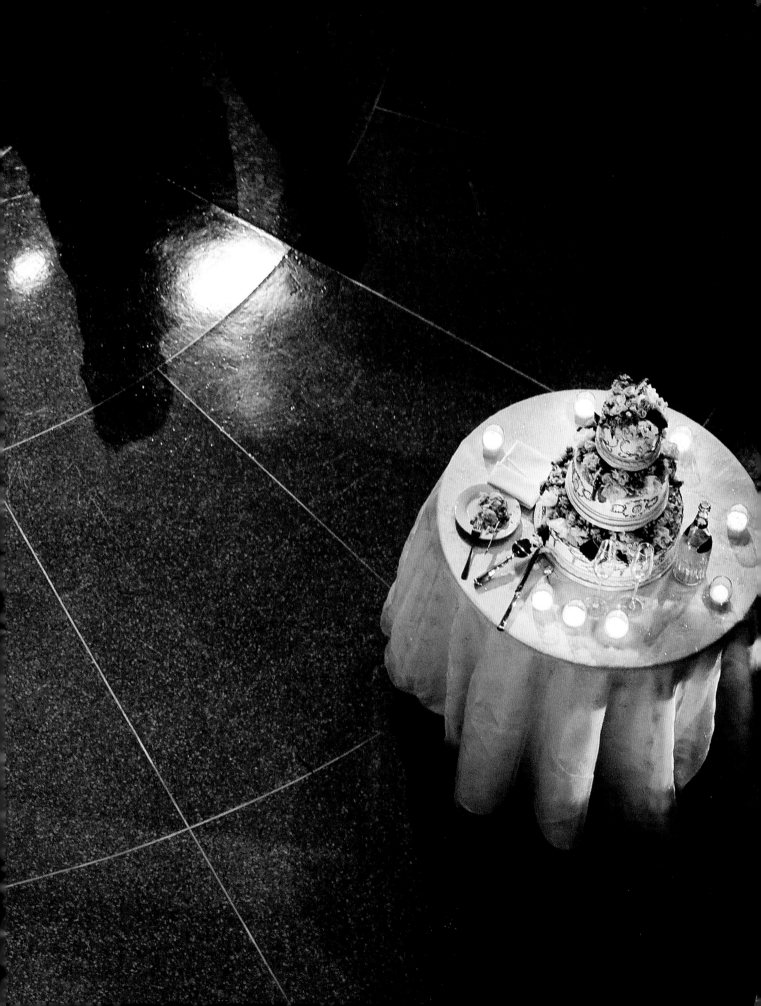

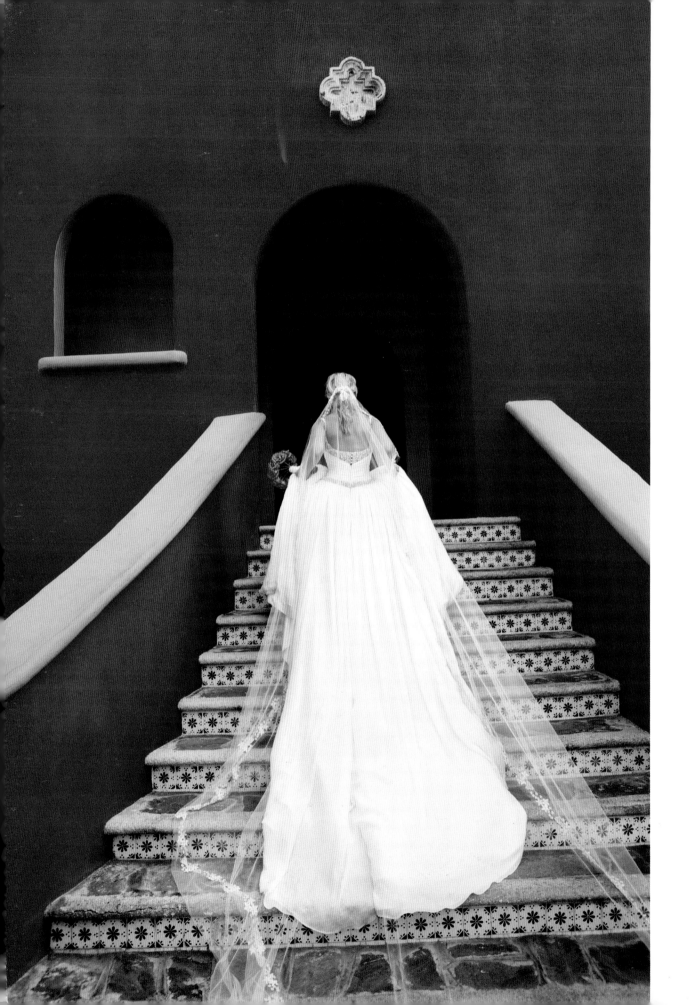

WEDDINGS

LIKE FINDING THE RIGHT PERSON to spend your life with, wedding photography can be a challenge. It requires the skills of a portraitist, a photojournalist, and a still life artist—along with an amiable, unflappable outlook. There are no second takes, so the stakes are high. But the rewards are also great, as your images will be treasured for generations to come.

GETTING STARTED

Timing is everything when it comes to weddings, so setting a realistic shooting plan for the big day makes all the difference. Ask for a detailed schedule of all events and go over the couple's wish list of moments that they'd like captured (as well as possible timeline problems), then create a shot list for guest portraits. It helps if a designated attendee can identify people for portraits during the wedding, too—make sure to allow ample time to wrangle all the relevant relatives.

Scout the venue in advance for nice portraiture sites and interesting shot concepts; you'll figure out which gear to bring and learn if you've budgeted enough time to get between places during the day. If you'll be shooting in a house of worship, ask if there are gear restrictions or where you can stand.

Most important, spend time getting to know the couple and making them comfortable with you. An engagement session can help you learn what's distinct about their story: a shared passion, their quirky sense of humor, or just the way they look at each other. These are the details that make their love unique—and that will make your photos unique, too.

TECH TIPS

METERING Underexposing white wedding dresses is a perennial problem. To capture the details of the dress without turning it gray, you can spot-meter it and then bump your exposure up a stop or two. The exact increment will depend on your camera and the scene. Check the image histogram and decrease your exposure slightly if it shows a slope that's very high on the right. If you have a handheld meter, you can use it in incident mode to quickly get an accurate reading. Save RAW files to give yourself a little leeway with exposure too.

FOCUS A single-point autofocus mode works well for portraits, detail shots, and photographs of people taking vows and giving toasts, but for processions and dancing, a tracking (a.k.a. "continuous" or "servo") autofocus mode may work better. Practice on another active subject before the wedding. Face-tracking autofocus can be useful, but avoid it in situations where your subjects may turn their faces to the side and get dropped. While wide apertures will aid your autofocus and give your shots a beautiful shallow depth of field, don't forget to stop down to at least f/8 for group shots to keep everyone in focus.

WHAT TO SHOOT

Whether you were hired, volunteered, or got roped into the role of wedding photographer, it's your job to capture once-in-a-lifetime moments as they fly by. No pressure. Actually, lots of pressure, so consider teaming up with someone who can cover wide angles when you're on closeups, photograph the groom getting ready when you're with the bride, or go for cocktail-hour candids while you're shooting portraits.

For most weddings, you'll document the preparations, ceremony, and reception, staying late to shoot all of the toasting, flower-tossing, and tipsy dancing. Non-Western weddings can involve additional ceremonies, so ask the bride and groom to clue you in if you're shooting a tradition you don't know very well.

Your focus, of course, will be on the couple tying the knot, but make sure to get everyone on their portrait list, to photograph the venue, and to take detail shots of the food and decorations, including the cake before it's cut. You should also get shots of the wedding dress, shoes, rings, and other wardrobe items before the ceremony—these choices say a lot about the couple's personalities and the spirit of the event.

PAGES 104–105 David Getzschman composed this bird's-eye view of the dance floor, including the untouched wedding cake as a clue that this was a first dance, then waited for the groom to give the bride a celebratory spin.

PAGE 106 Many wedding photos tend toward the pastel, but Dina Douglass looks for bold colors and graphic, polished forms that please contemporary couples.

Her advice? Make sure you also capture what's important to the family. "Crucial details can happen in the blink of an eye and if you miss that, in the parents' view, you will have ruined the entire wedding," she says.

ABOVE Don't forget to linger on the pre-ceremony rituals. Here, Sean Flanigan froze a quiet and introspective moment as the bride gazed into a hand mirror and adjusted her homemade veil.

ABOVE This tabletop view of the groom's accessories tells a clever, masculine story. Hilary Cam used live view to manually focus and check the placement of the objects against a grid, and a tripod so he could rearrange elements while keeping the camera locked.

RIGHT For this fun dressing-room shot, Todd Laffler climbed a lightweight stepladder and bounced his on-camera flash off the ceiling onto the bride.

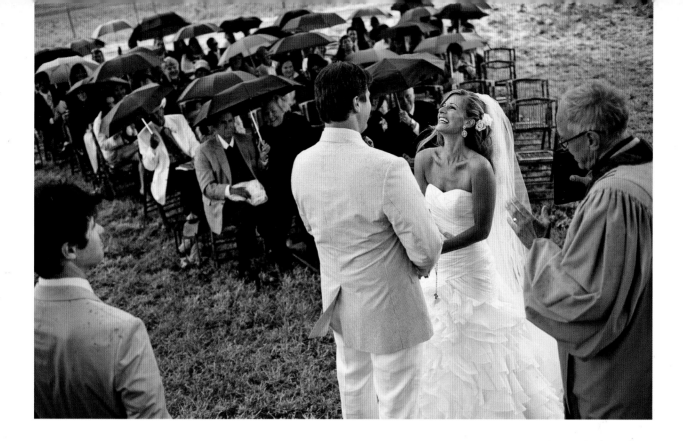

GEAR UP

Lenses A telephoto zoom lets you take tight shots of people from the back of the room. Make sure yours has a good range of focal lengths for portraits—about 85mm to 150mm—and a wide maximum aperture for shallow depth of field.

Accessory Flash Use small flash units to add a little fill in bright outdoor light, bounce light off the wall in the reception hall, and freeze action on the dance floor. Make sure you have the necessary stands or clamps.

Reflectors Have an assistant hold a reflector to bounce a little fill into sunlit portraits or bounce flash in spaces where there's no available wall.

Rechargeable Batteries Err on the side of bringing too many batteries, and don't forget your charger. Also consider using a battery grip with your camera or a battery pack for your flash unit for extra juice.

Wedding Photography App Mobile apps will help you manage client information and keep schedules, contacts, shot lists, and other useful data at your fingertips during the event.

ABOVE When rain was forecast for this outdoor wedding, the wedding planner embraced the challenge and bought colorful umbrellas. David Getzschman then balanced on the railing of the footbridge behind the altar to get this elevated vantage point, capturing a true moment of sunshine in the bride's expression.

OPPOSITE The napkin patterns, the flowers on the table, the hand-painted place cards—these details captured by Delbarr Moradi make a wedding personal, and in this case, creative and fun.

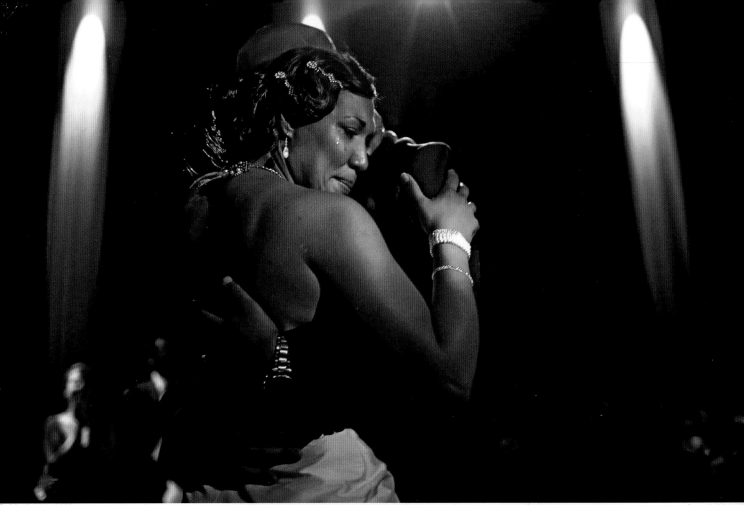

ABOVE Given the intimacy of the moment, Tyler Wirken thought using off-camera flash would be too harsh. Instead he motioned for his assistant to stand just off to the right with the video light.

RIGHT Kitty Clark Fritz shot this behind-the-scenes photo from inside the newlyweds' limo, using a relatively high shutter speed (1/500 sec) to account for the engine's vibration.

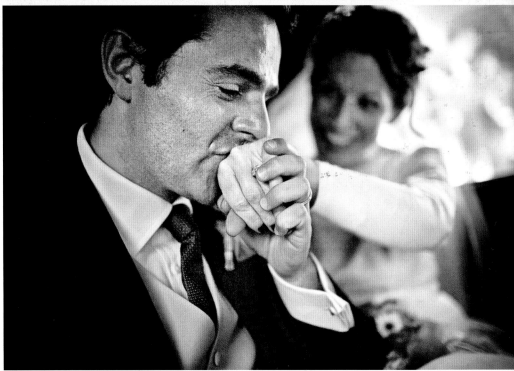

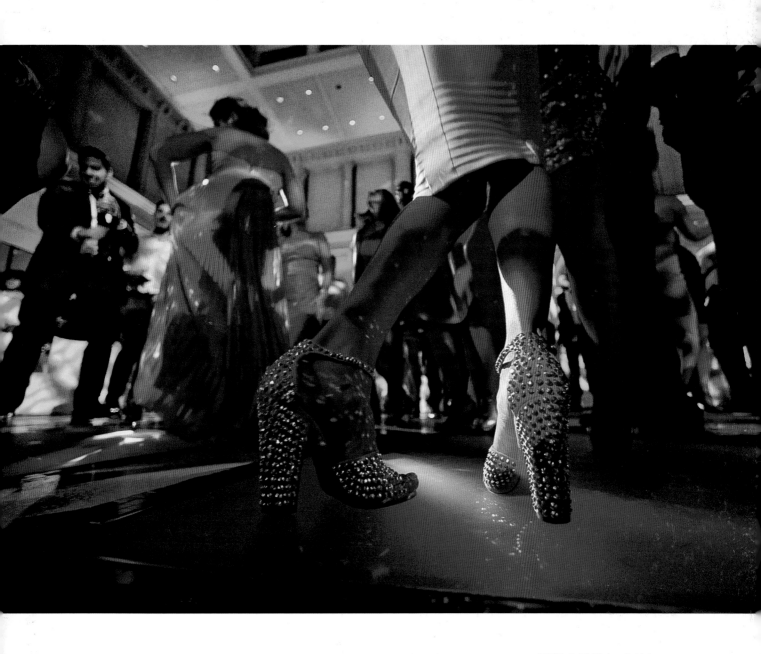

ABOVE To highlight a bride's bedazzled shoes without sacrificing any of the dance floor festivities going on around her, Ron Antonelli got in low and close with a 14mm lens. He also forwent the flash, relying instead on the room's ambient light and color.

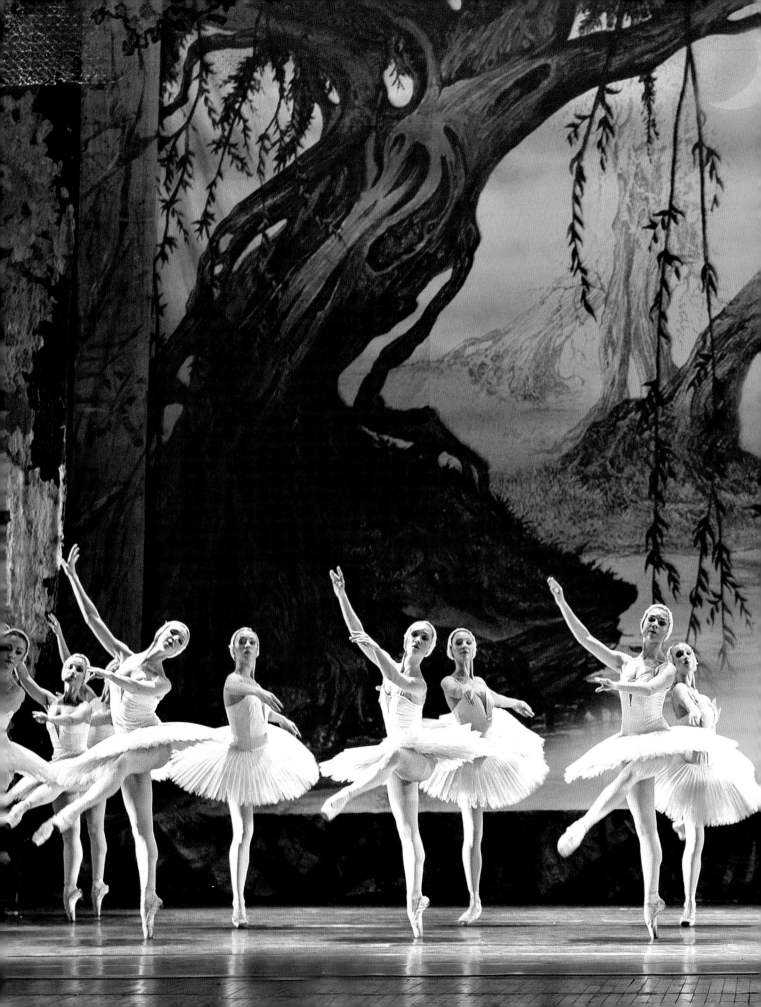

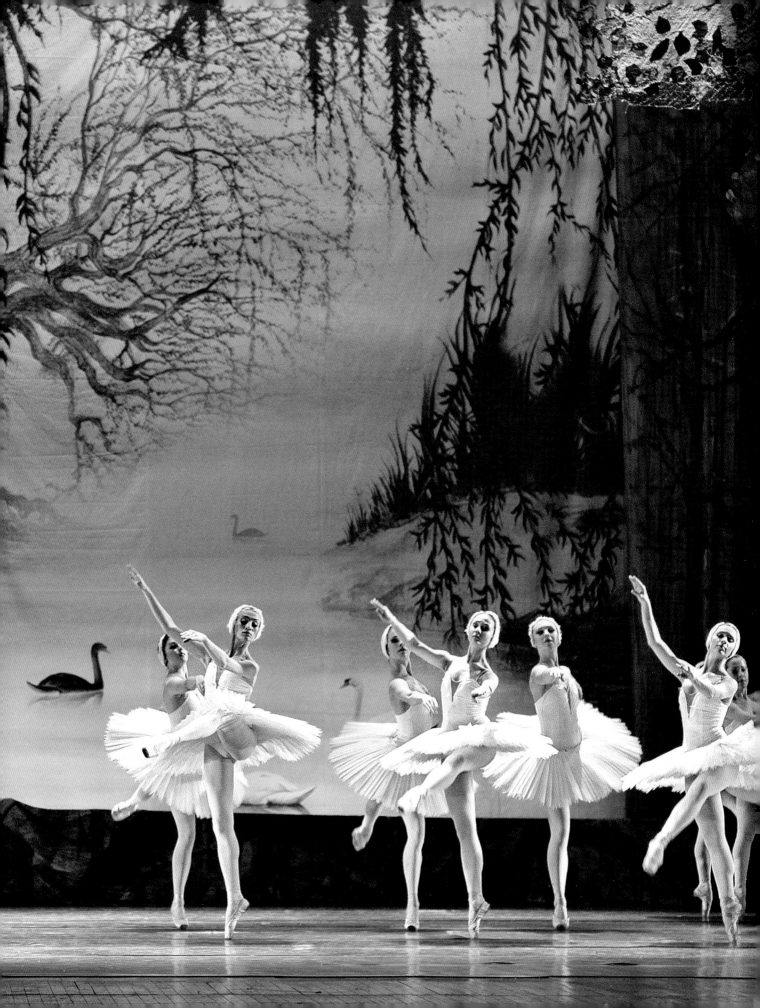

DANCERS

THERE ARE MANY MANIFESTATIONS of the art of dance, from a fledgling ballerina's first *en pointe* to a hip-hopper's body pop. That's what makes dance so mesmerizing to watch—and photograph. Here are some ideas on capturing beautiful bodies in motion, whether they're waltzing across a ballroom or gyrating on a stage.

GETTING STARTED

Unless you already have contacts, finding dancers to fulfill your vision is the logical first step. Local companies and studios are good sources, especially if you share your photos as a thank-you. It's also courteous to let the dancers warm up before shooting and periodically ask if they want a rest. They may make it look easy, but dancing is hard work.

Before you shoot, consider your preferred genre and the conditions you'll be shooting in. The split-second timing needed to freeze a jazz dancer's high kick might require a complex lighting setup, but a DSLR and available light may be all you need to create an affecting portrait of a corps member at the barre.

Photographing performances (even children's recitals) often requires permission. With pros, you're more likely to gain access to dress rehearsals and you may be restricted to certain areas. When you have the option, position yourself in a seat midway between the stage and the rear of the theater. Familiarize yourself with the choreography and light-marking beforehand, so you and your camera are ready for lifts, leaps, and other moments of high drama.

TECH TIPS

EXPOSURE For in-studio shots, set the shutter speed to expose the background's ambient light. Keep the setting no faster than its flash sync speed, usually 1/200 sec or less. When using high-speed strobes, set the flash duration and aperture to expose the subject and use a light meter to determine the flash exposure. If shooting a performance, push the ISO to achieve a minimum of 1/250 sec or faster and a minimum aperture of f/4. Use exposure compensation to adjust for light changes.

LIGHTING When you're in a studio, use a flash to freeze the dancer in motion, setting it to fire at a minimum of 1/1000 sec or faster, depending on the speed and force of the dancer's movement. At a performance, kill that flash—the only stars people should see are the ones on the stage, not those caused by your gear.

WHITE BALANCE When shooting a dance performance, it's safest to shoot in RAW or RAW + JPEG. Use auto white balance unless you know that the lighting will not change.

WHAT TO SHOOT

Dance photography is all about capturing movement—and just as there are all kinds of movement, there are innumerable ways to immortalize it. You might opt to freeze an awe-inspiring leap with a short flash, or blur it into a slow-motion dream by holding the shutter open. A shot of a dancer suspended in midair is best achieved in a studio setting with experienced dancers and high-speed strobes. At the other end of the spectrum, continuous lighting and a long exposure—1/30 sec or slower—produces a gently smeared abstraction of a dancer in flight.

Combining long exposure with strobe lighting creates altogether different interpretations of movement. Experiment with the effects you can achieve with stroboscopic shots, as well as second-curtain sync. Another interesting way to capture motion is to simply pop a flash manually when the dancer hits the peak position in the middle of a long exposure. Try integrating props or lightweight fabrics into the shoot, or have the dancer or an assistant toss flour, colored powder, glitter—or even water—to add a dynamic layer to the image.

PAGES 114–115 Sitting in the first few rows during a dress rehearsal, the photographer set her camera to a high ISO (1600–3200) and used a wide lens to encapsulate the entire stage. A zoom lens is also helpful, as you won't necessarily be able to sit in the front row during a show.

PAGE 116 Setting up his studio with a black backdrop, a continuous HMI light, a single strobe, and beauty fans to make fabric float, Brian Kulhmann created the effect of floating underwater with dancers. He shot at exposures of 1/15 sec at f/8, and ISO 100.

GEAR UP

Lenses Ideal focal length depends on the size of the studio, camera-to-subject distance, and the height and width of the backdrop. An 85–105mm prime lens should work in a studio to frame the dancer without including the edges of the backdrop. A telephoto lens is crucial for when you're shooting recitals from the back of an auditorium.

Speedlights These come in handy for stroboscopic and dragging the shutter (second-curtain sync), as well as some slower stop-action shots.

High-Speed Power Pack For studio shots, high-end power packs are necessary for fast recycling during fast-moving action. These are very expensive, so consider renting a power pack and compatible heads. The flash heads should be capable of minimum flash durations of 1/1000 sec (preferably faster). A wireless triggering system is needed to sync the strobes with your camera.

Light Modifiers If you're working with studio lights, you have the luxury of using soft boxes, grids, and other modifiers to play with your lighting.

Tripod or Monopod A support like a tripod is optional for some shoots, but a must if you need to pre-focus.

Radio-Remote Trigger or Cable Release Trigger Cable releases and other remotes are helpful for action shots, since they allow you to track dancers' movements unrestricted by the viewfinder.

Hand-Held Light Meter Some high-end system light meters feature narrow-angle spotmeters that read via built-in optical viewfinders. These will allow you to meter specific areas of a stage set or other scene, and set the exposure manually on your tripod-mounted camera, without having to bother aiming the camera for a meter reading, then repositioning it for the right composition.

LEFT Christian Witkin shot this troupe of ballerinas in a studio, which allowed him to give dancers direction, get up close to the action, and use natural light.

ABOVE As part of his ongoing project Dancers Among Us, Jordan Matter captures dancers in complex poses in everyday contexts. For him, it is "a way to express the feeling of being fully alive in the moment, unself-conscious, and present."

STILL LIFE

THE ART OF STILL LIFE has come a long way since the days of the Old Masters, when artists faithfully reproduced lavish displays of fruits and flowers with oil paints. While there's nothing wrong with mimicking the lighting and styling of centuries-old paintings, you might want to leverage the power of the camera—and the pixel—to create your own interpretation of this classic art form.

GETTING STARTED

Still lifes boil down to three things: the objects you choose to photograph, the way you arrange them, and how you light them. As demonstrated by the Old Masters (and the new ones who took the images here), artful composition and lighting can transform everyday objects into subjects of mystery and beauty.

The imagery in still lifes can be a representation of the artist's vision or mood, or just a visually appealing composition without any deeper meaning. Whichever you're going for, the process begins by gathering the objects you want to include in the image. Next, aesthetic and practical considerations will dictate the location for your shoot. The corner of an antique desk may be the perfect background for your shot, or you may want to set up a mini studio by placing an empty table against a solid-colored wall or plain backdrop.

If you want to photograph the scene with natural light the way the Old Masters did, shoot near a window or even on the sill. Or take the shoot outdoors. Indoors or out, directional artificial light will enhance your photos, since highlights and shadows are critical components of a striking still life.

TECH TIPS

EXPOSURE Keep the ISO as low as possible to avoid image noise. Shoot in aperture-priority mode at around f/8 or higher for broad depth of field, even if it means you have to shoot at 1/20 sec (use a tripod and a radio-remote trigger, a cable-release trigger, or your camera's self-timer).

FOCUSING Manual focusing all the way is the rule—you want to control the precise focusing point in a still life. A general principle to go by is to focus one-third of the way into the scene to get the maximum depth-of-field at any aperture. Use the depth-of-field preview of your DSLR or ILC to make sure everything you want in focus is in fact in focus—the live view feature makes this easier. Keep in mind that everything doesn't have to be within the depth of field—many beautiful still lifes fall off into soft focus.

WHITE BALANCE Color accuracy isn't everything in a still life. Depending on your subject, consider using a white-balance setting that pushes the color cast a little warmer (for that basket of fruit) or a little cooler (for that assortment of machine parts).

WHAT TO SHOOT

Small objects with interesting shapes, colors, and textures are ideal for a still life. For a nostalgic feel, select vintage pieces, especially ones that tell a personal story: say, a pair of your great-grandmother's opera-length gloves coupled with her pearl necklace dangling from an antique jewelry box. Another way to evoke days gone by (and add texture to the image) is to photograph your tableau through a transparent piece of fabric.

For a more modern, sleek look, select one or two items with strong, graphic lines. A monochromatic backdrop and surface paired with dramatic lighting focus the viewer's attention on the main subject. Keep the arrangement very simple, and limit the number of colors to emphasize the object's form. For instance, you might shoot a beautiful piece of fruit set on a windowsill as a sheer curtain gracefully arches in the summer breeze (which you can create with a fan). At the other end of the spectrum, if you have a collection of small items—maybe embroidery scissors, coins, or buttons—arrange them geometrically for an interesting and unusual still life.

PAGES 120–121 On an overcast day, Amy Weiss composed pears and a bottle on a windowsill, then hung a sheet of transparent plastic and sprayed water over it to fake a misty window.

PAGE 122 Still lifes often present a hyper-realistic view, but they can be whimsical, too. Laura

Today used binder clips to secure a book's spine into a trunk shape, then creased and paper-clipped the pages into branches.

OPPOSITE Alice Gao's curated tablescape has a sophisticated muted palette with a single bright pop of color, warmed up by natural light from a side window.

GEAR UP

Lenses Macro lenses, particularly 10mm or 60mm, are ideal for most still-life scenes. An 85mm or 105mm prime lens allows you to fill the frame with your subject. No worries if you don't have primes; a midrange zoom lens with close-focusing capabilities will also work well. Avoid wide-angle lenses, since they may cause distortion.

Backdrops A still life background can be as simple as an existing wall or a paper or cloth backdrop mounted on a stand. Or tape a large piece of paper or fabric to the wall.

Accessory Flash Don't use your camera's built-in flash. Instead, use off-camera flashes, either handheld away from the camera or on a light stand.

Continuous Lights or Strobes For ultimate lighting control, use studio-style continuous lights or strobes. An inexpensive one-light setup provides more than enough power for a small scene.

Black Foam Core To block direct light, mount black foam core on a small stand, or make your own mini V-flat.

Reflector Regardless of the type of light you're using, chances are you'll want to redirect it to enhance your photograph. To fill in shadows, use a reflector (a piece of thick white paper or foam will do).

Other Lighting Sources Natural light enhanced with light modifiers is the least expensive and often the most beautiful illumination for still life. Nevertheless, artificial lighting doesn't have to be expensive—household lamps, lit candles, and even a flashlight for light painting, are all viable sources of light.

Softbox For a flattering diffuse glow, use a softbox, diffuser, scrim, or grid. On a budget? Use a sheer piece of white fabric.

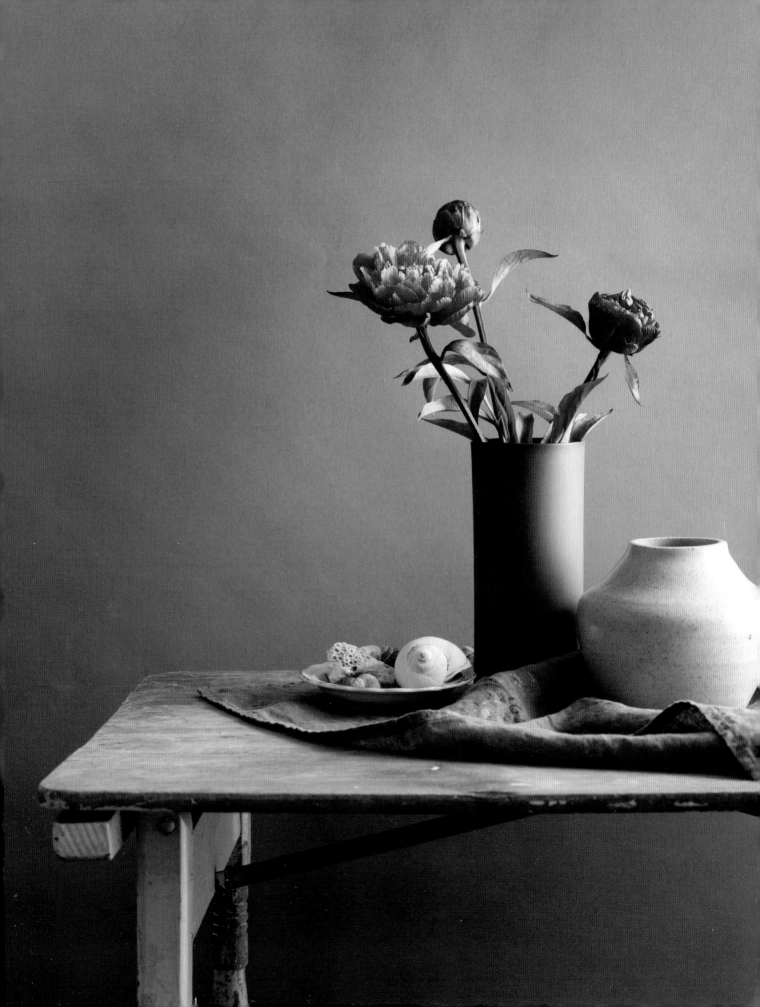

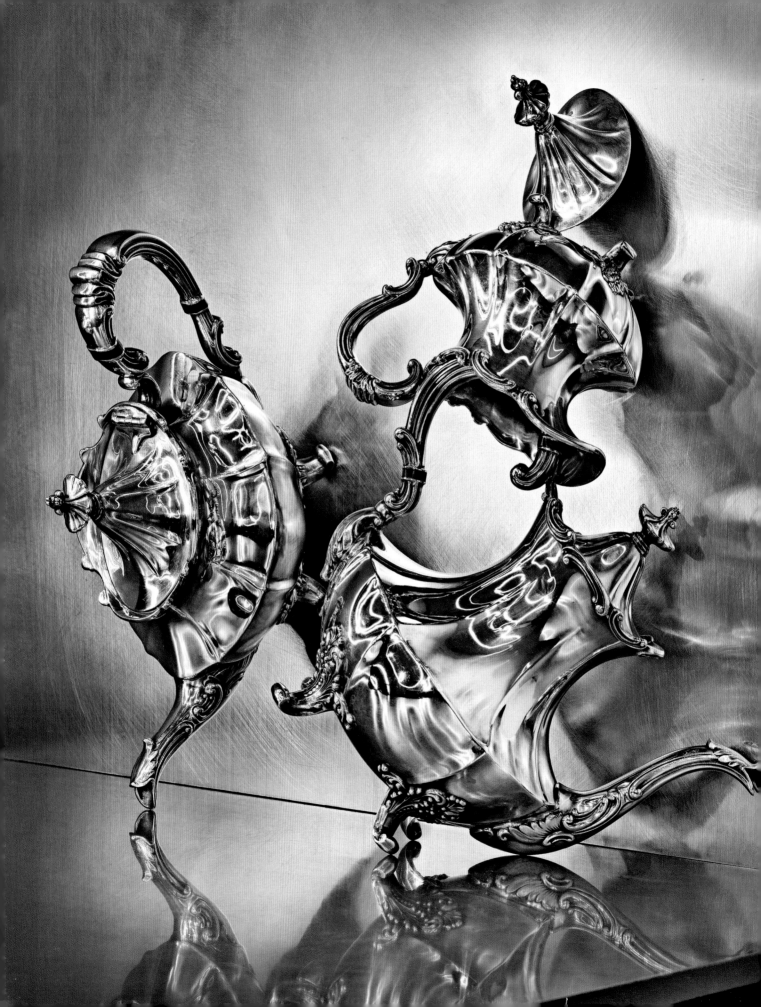

OPPOSITE Sue Tallon aimed to create something nonsensical with interesting surface qualities and spectacular reflections. To draw out white light from the shiny surface of the tea set, she moved an 18-inch (45.75-cm) fluorescent tube around in a dark room with the shutter open. The "wand" allowed her to paint light onto the metal tea pots.

ABOVE Vladamir Shipulin took this shot in the early evening, with only a little natural light from sunset illuminating the bookshelf. He opened up his aperture and bumped the ISO up to 1600 to counteract the darkness. To highlight the fish in the jar, he "painted" light on it with a compact flashlight.

FOOD

COLORFUL VEGETABLES, delicately textured herbs, luscious desserts, and artfully plated main courses whet the appetite . . . and engage the eye. You can stage your own mouth-watering photo shoot—be it a closeup of raw ingredients or a panorama of a full smorgasbord—with a little planning and attention paid to timing.

GETTING STARTED

To find inspiration, look through cookbooks and magazines, paying attention to lighting and the angles from which the images were shot. Whether you're documenting a family recipe or adding some photogenic fruit to your portfolio, consider the elements of the image you're after, and gather the needed props, like cutlery, dishes, and a tablecloth. White plates and a subtle tablecloth usually work well as understated backdrops for tasty subjects.

Food quickly loses its visual appeal when it's sitting out, so stage the table ahead of the shoot. Set up your props, lighting, and camera (including focus, exposure, and other settings), using substitute dishes or drawings as stand-ins for the food. When you get the real thing out, work quickly to capture food's scrumptious good looks—especially if family and friends are waiting to eat your models.

While shooting at home lets you control conditions, striking images can also be captured at restaurants. To avoid disturbing other diners, stick with your smartphone or compact camera, limit the number of shots, and turn off the flash.

TECH TIPS

FOCUS Manually focus the lens to direct the eye of the viewer, emphasizing color and texture. Think carefully about depth of field to create a sharp focal point with a transition to a soft background. If you want more overall focus than even a small aperture like f/22 will deliver, try focus stacking. Take several shots with different focal points and blend them in post-processing.

HIGH-DYNAMIC RANGE (HDR) High-contrast dishes, such as chocolate cake with vanilla ice cream, quickly lose shadow and highlight detail. Bracket several shots at different exposures and combine them in image-editing software to enhance tones and texture.

LIGHTING One of the best sources of lighting for food photography is the simplest—window light. Position your dish near a window that casts indirect daylight. If the window casts direct sunlight, place a scrim over the window—or even just draw a white curtain over it.

WHITE BALANCE There's no use shooting something delicious if the color in the final image makes the dish look unappetizing. Use manual or custom white balance settings in order to render the food's color faithfully.

WHAT TO SHOOT

Basic, uncooked ingredients that remain in their original state over time are a good starting point. You can take your time, exploring different lighting and angles when you're photographing an egg in its shell, raw fruits and vegetables, and other stable foodstuffs. Herbs and spices, whole and ground, are good subjects as well.

If you're after cooked quarry, you've got some options. A single, beautifully plated dish (be sure to wipe any excess sauce from the edges of the plate) is elegant in its simplicity, while a multicourse presentation laid out on a table can capture the spirit of a celebration.

Perspective is always important in photography, especially when you're shooting food. Try using a ladder to shoot down on a setting, then mix it up by shooting at table height. When you're ready for more challenging shots, enlist an assistant or at least your camera's self-timer. Sauce or other viscous liquid pouring onto a steaming main dish—especially when the liquid is backlit—can make for a mouth-watering image. Similarly, the drips from a melting ice cream cone can add a sense of movement and fun.

PAGES 128–129 Alex Farnum's overhead shot keeps the focus on the food, but the guests fringing the table and the strong diagonal line of the arms passing a bowl demonstrate that food photography can be about coming together to share a meal, too.

PAGE 130 Parsee fish can't always carry the show. Helen Cathcart turned to styling to create a more appealing shot, opting for a plate and tablecloth of similar pattern and palette. To keep the food in focus but the background soft, she shot with an aperture of f/1.8.

OPPOSITE To give a decadent dessert center stage (as in Annabelle Breakey's image here), try using quiet, monochromatic props and backdrops.

GEAR UP

Compact Cameras & Smartphones DSLRs and mirrorless interchangeable lenses are preferable because of their manual exposure and focus controls, but point-and-shoot cameras and smartphones are also fine for photographing your dinner at restaurants.

Lenses Prime macro lenses, such as a fast 100mm or 50mm macro, are ideal for food photography. A 100mm lens lets you maintain more camera-to-subject distance and is useful when shooting overhead from a ladder. Fast lenses, with apertures of f/2.8 or wider, allow more depth-of-field and shutter-speed flexibility.

Softboxes or Umbrellas Whether you use an off-camera flash or studio lighting (continuous or strobe), be prepared to diffuse the light with modifiers such as softboxes or an umbrella.

Reflectors Reflectors and scrims come in handy for directing and managing both natural and artificial light.

Tripod Although you may shoot some images handheld, you'll need a tripod for slower shutter speeds and bracketing, if you choose to do focus stacking or HDR. Be sure the tripod extends high enough for overhead shots, particularly when shooting from a ladder.

Blower Brush Fine brushes and straws let you gently reposition small ingredients on set.

Miscellaneous Gear You'll need a ladder or step stool for overhead shots. Keep a clean piece of cloth handy to wipe up excess sauces or spills.

Flashlight App If you need more light when shooting your meal at a restaurant, ask your dining companion to use the flashlight app on a smartphone.

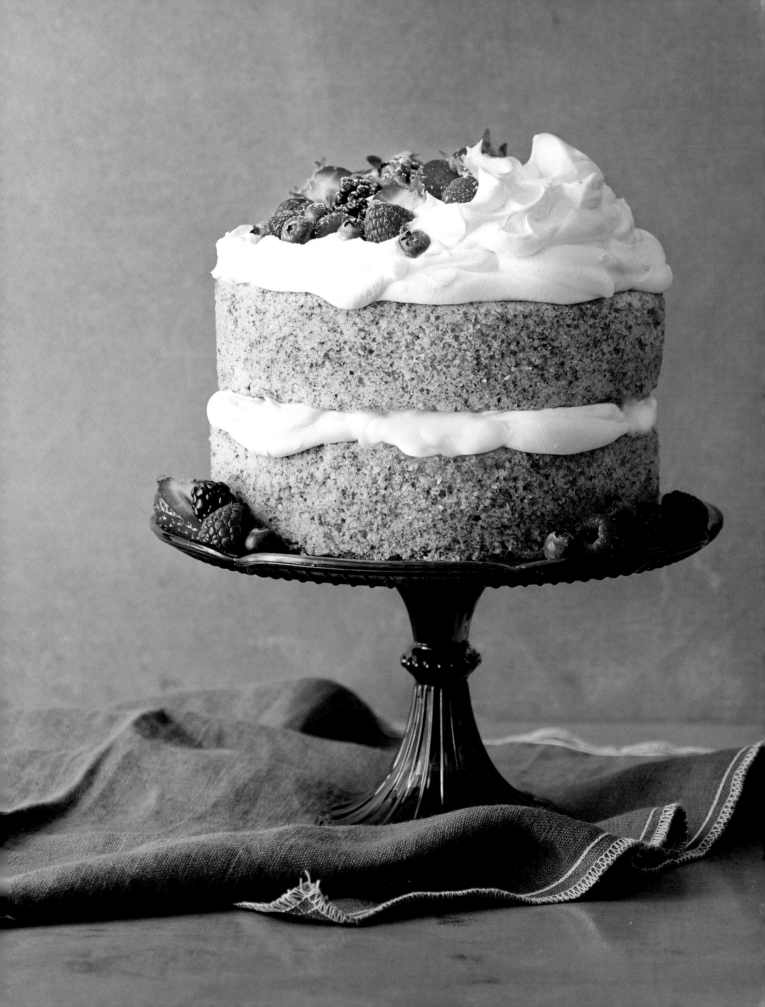

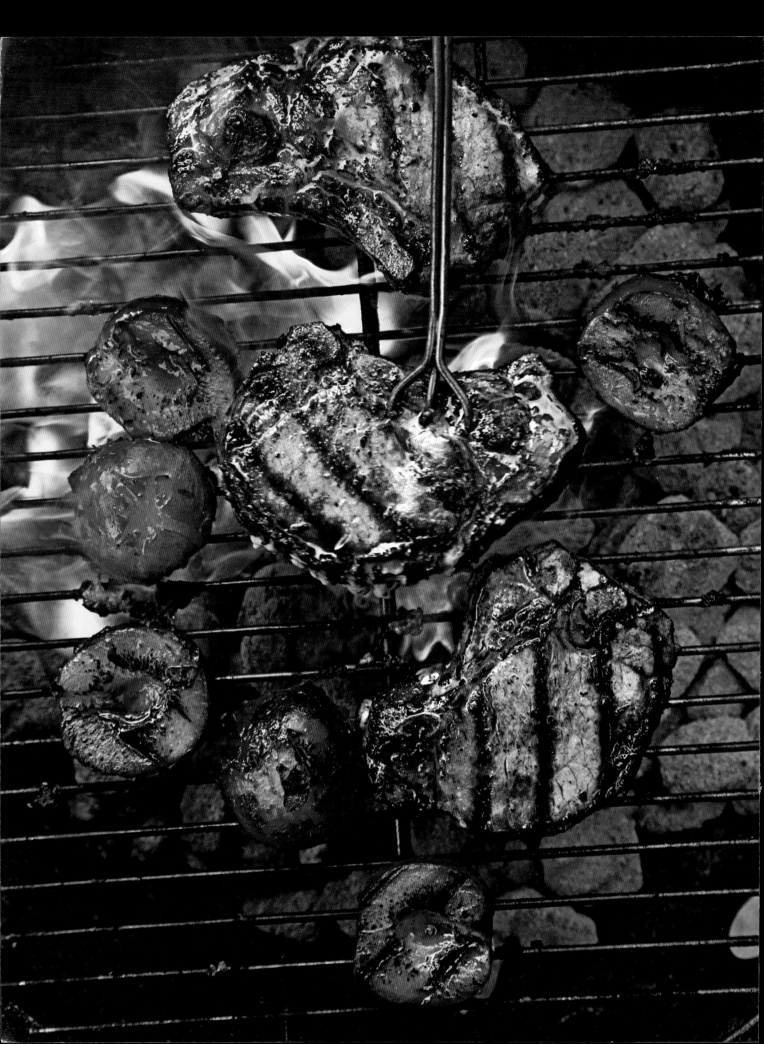

ABOVE Eric Wolfinger's arrangement of raw salad ingredients—complete with soil from the garden—tells a story about where food comes from. He backlit the delicate array to amplify its colors and used a short depth of field to highlight detail in the foreground blossoms and leaves.

LEFT Food often looks its finest when it's fresh—especially when being drizzled with dressing, as in Eric Wolfinger's shot here. He used natural sidelighting from a door to create a zen-like feel, and pushed the vignetting with software for a moodier look.

OPPOSITE Try shooting a cook in the act for a dynamic, process-oriented look at food, as in this grilling shot by Ray Kachatorian.

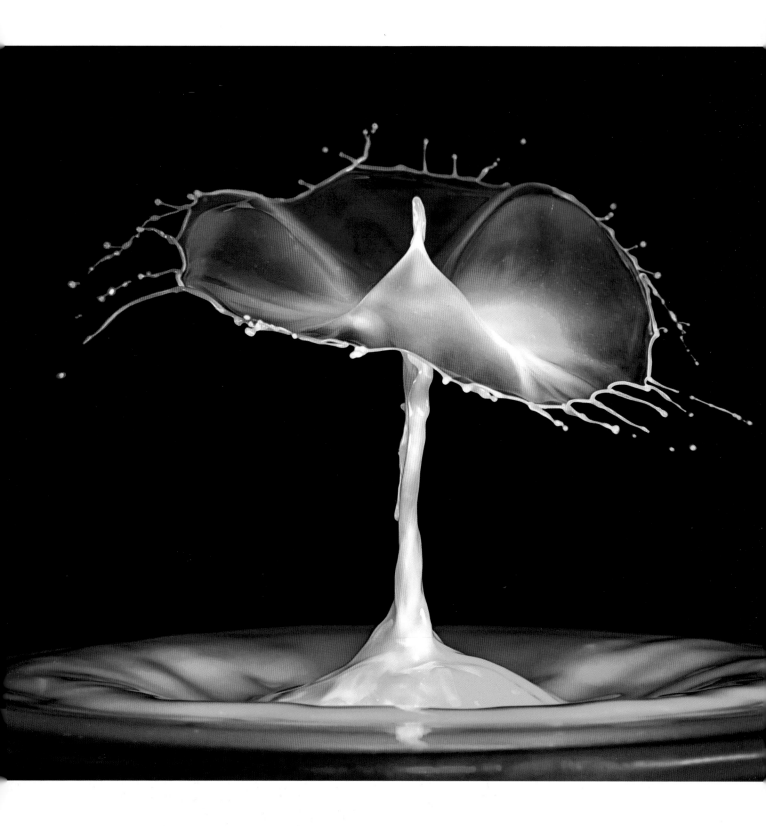

HIGH-SPEED SPLASHES

SPILLS AND DRIPS caught in midair, surging waves, and crowns of droplets—the movement of liquids is often too fast for us to really see. But high-speed photography allows us to freeze the fascinating shapes and trajectories of fluids in action. While it requires lots of setup, high-speed photography is easier than it looks—especially if you're armed with patience and a few tricks.

GETTING STARTED

Gear intensive and messy, working with liquids requires good planning. Whether it's a pour, a splash, or frozen-in-air droplets you're after, gather up the needed tools and find a space—perhaps in your kitchen or garage—where stray spills won't cause harm and can be wiped up easily. Cover surfaces with plastic trash bags and protect flashguns and other gear with plastic wrap. Easy access to a sink is helpful, as is the ability to darken the room.

Depending on the space, you may need to set up a platform that's slightly larger than the container you're using. Leave enough space to position one or two flashguns to the sides of the container. If spills and splashes are an issue, the backdrop should be waterproof; otherwise, a large sheet of paper, a cloth, or even a wall will work.

Viscous liquids tend to form the most interesting shapes. Experiment with milk, cream, or paint; or try mixing water with glycerin, guar, or xanthan gum. For standout drops or splashes, put a few drops of food coloring into the mixture, and consider using colored acetate gels to add more hues.

TECH TIPS

EXPOSURE Water's movement can be unpredictable, so splash and high-speed droplet photography require broad depth-of-field with aperture settings somewhere between f/8 and f/16. ISO should be set at the camera's lowest setting to avoid image noise. Since the flash freezes the water in flight, shutter speed should be set on bulb or below the camera's sync speed.

FOCUS Disable autofocus and focus manually using a stand-in object to estimate the focal point. For consistency, mark the point from which you're dripping the water. Run a string unobtrusively over the container or dangle a pen or other object from a lightstand. You can also create your own valve drip and hang it over the container's edge.

FLASH Stick with off-camera flash. In order to achieve the flash duration necessary (faster than 1/16,000 sec) to freeze liquid in motion, set the flash output power to 1/32. Increase the flash duration if you'd like your images to feature motion blur.

WHAT TO SHOOT

Photographing a stream of liquid as it's poured into a glass is a simple first splash exercise. Use a heavier glass, or anchor a stemmed wine glass to a surface. Tilting the glass on an angled board adds an off-kilter perspective and helps create a wave as the liquid rises up the side of the glass and is poured out. Position a flash (or two) to bounce off a white background to illuminate the liquid and, with a bottle or spouted container in one hand and a remote that supports your camera's burst mode in the other, snap away as the liquid flows into the glass.

You can also try filling a fish tank with water and photographing the splash as you drop objects (like the orange slice you see here) into the container. Sidelighting with two flashguns and a black backdrop will help eliminate pesky reflections.

When it comes to freezing droplets in midair, there are two basic options. The first captures a single drop as it hits and bounces off a liquid-filled tray. A more complex approach is the drop-on-drop or drip collision method, where a second drop strikes the pillar created by the first drop. A commercial drip valve or timer system that controls the drips and triggers the flash via infrared beam is recommended for the latter method, since it's difficult even if you pride yourself on quick reflexes.

PAGE 136 Markus Reugels masterminded this collision, in which one drop splays into a disk shape upon striking a pillar created by another drop. Reugels created the striking colors by mounting red and blue gels over three superfast (1/25,000 sec) snooted shoe-mount flashes, all operated via wireless remote. A 1:1 macro lens helped Reugels home in on the splash.

GEAR UP

Radio-Remote or Cable-Release Trigger High-speed droplet photography takes multitasking to a whole new level. You'll need remote or wireless triggers to activate the flash and the shutter. Handheld remotes should be capable of working with your camera's burst mode (some remotes trigger only a single shot even when the camera is set to continuous shooting). Some triggers, like those designed specifically for water-drop photography, use infrared beams to control the flash and also have a drip valve for perfectly timed drop release.

Macro Lens If you want to fill most of the frame with splashing water droplets, a macro lens is recommended. Keep in mind that a longer macro lens, such as 100mm, keeps your gear farther away from errant splashes. Macro capabilities are less critical when shooting poured liquids, which may require a slightly wider angle of view.

Accessory Flash A minimum of a single off-camera flash is required, although two or three flashguns are ideal—each of which must be compatible with your triggers. The ability to manually dial down the power output to at least 1/32 power is imperative. A footed stand can hold the flashgun upright.

Backdrop Keep the emphasis on your splashy subject with a black or neutral background.

Tripod Splash photos require such thorough setup that handholding the camera is virtually impossible. For closer shots, you may also want to consider a boom arm.

Remote Flash Control When shooting with a strobe, use a remote trigger to fire the flash.

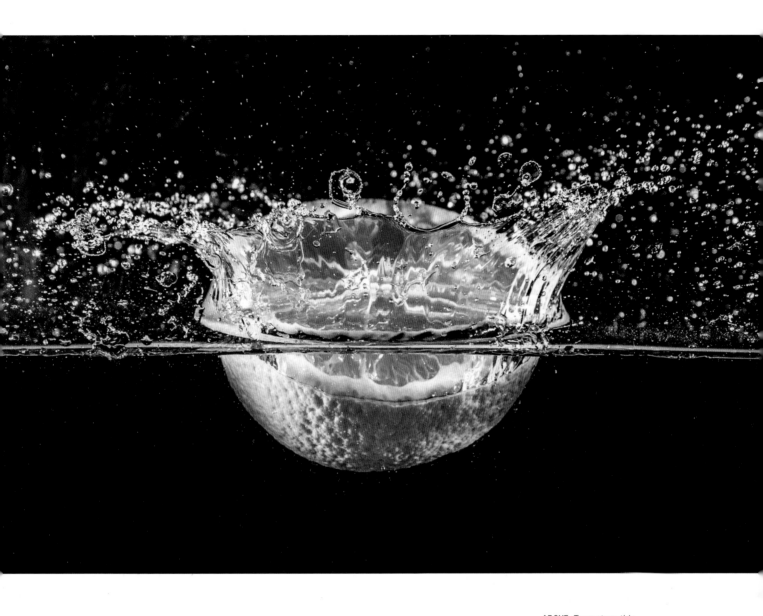

ABOVE To capture this supersharp splash of an orange hitting water's surface, fifteen-year-old Tom Smith set up two off-camera, radio-triggered flashes, one at the front and one at the back of a fish tank. When trying a similar idea, use your flashes in manual mode, at the lowest power for the shortest flash duration—usually 1/32 or 1/64 power. Dial in a midrange aperture (such as f/11) and the lowest ISO possible.

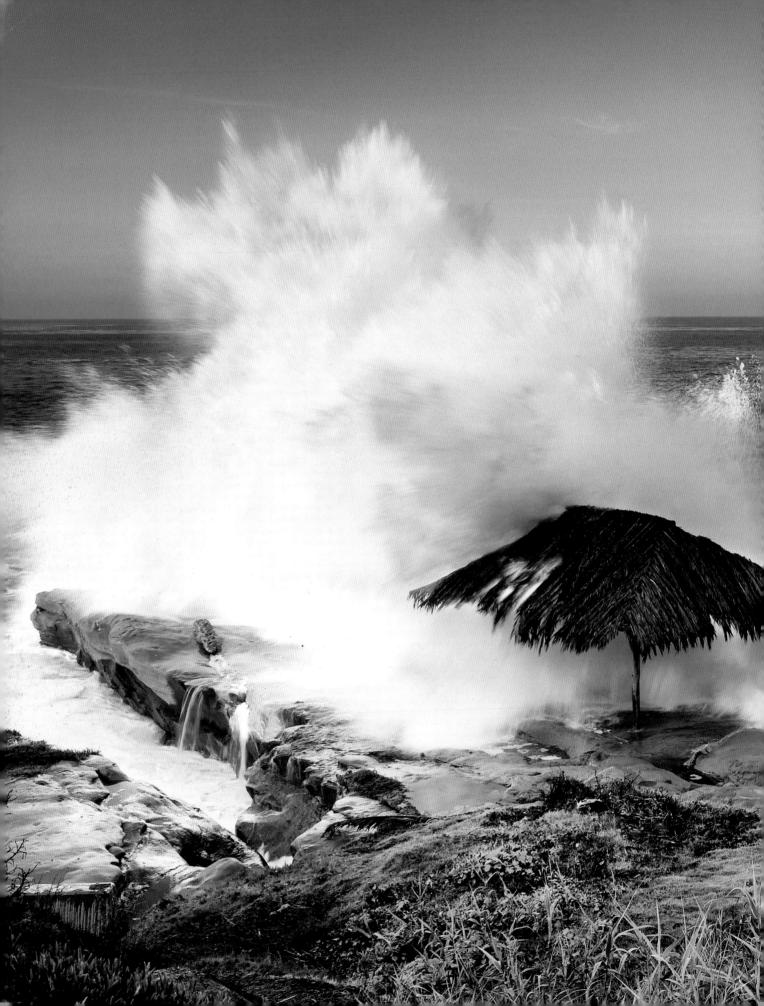

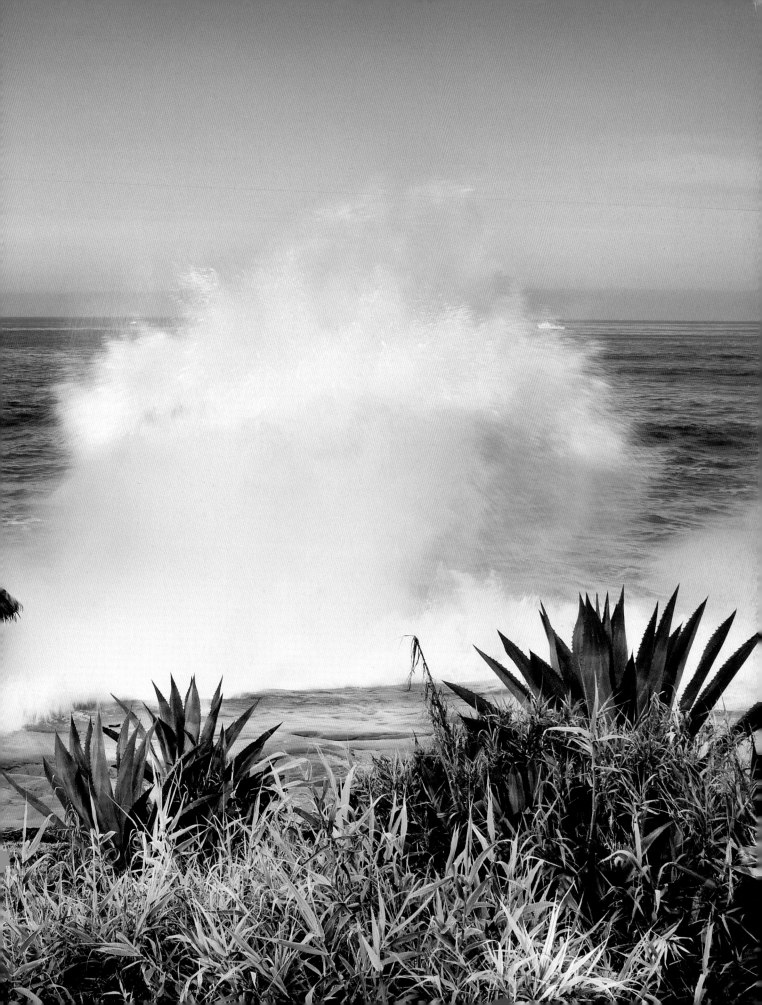

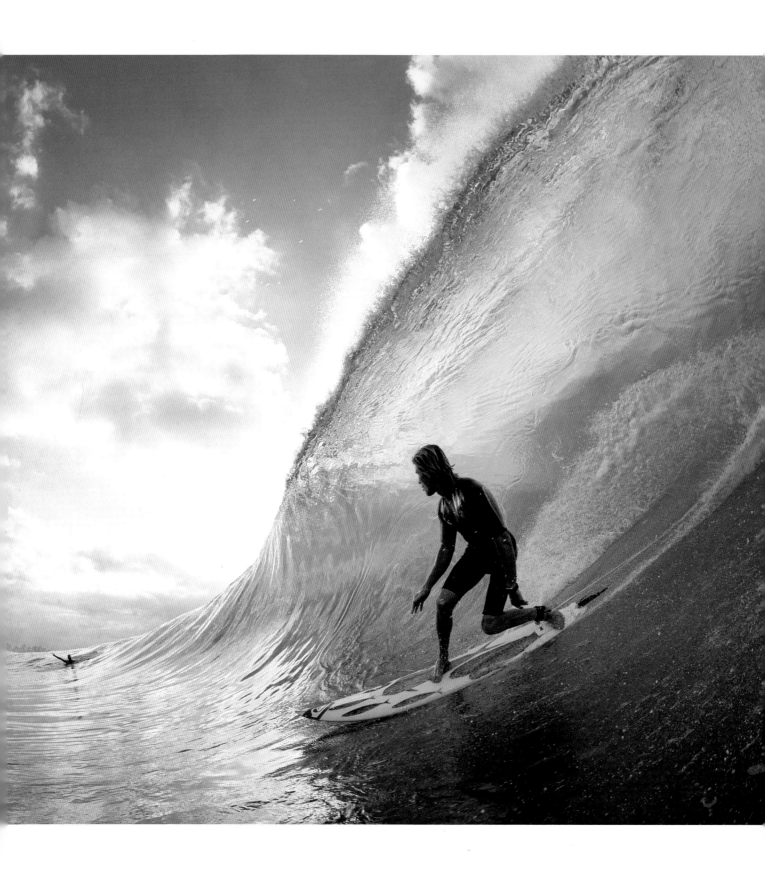

SURF

A DAY AT THE BEACH isn't always about sand and sun; for many photographers, it's about water. Dramatic wave formations (with or without the daring surfers who ride them) embody the raw power of nature. You'll need patience, practice, and a little bit of luck to capture the majesty—and sometimes, the menace—of the roiling ocean.

GETTING STARTED

Chasing the light is an integral part of photography, but to capture the quintessential surf shot, you need to chase the waves as well. Experience and experimentation increase the odds of finding the perfect combination of ideal light and great wave action. Study how the waves break at different locations, track the tides, listen to surf reports, and be ready to pick up your camera and head to the water's edge when the time is right.

If you dream of photographing waves or surfers while you're in the water, quell that urge until you've mastered shooting from the beach or pier. Once you understand how sets of waves behave in your chosen location and are comfortable composing and exposing surf shots, proceed carefully into the water. Big waves may be great for surfers, but they can create dangerous situations for photographers.

Surfing has its own particular culture, which is often closed to outsiders. You'll have an easier time if you start out photographing friends who ride the boards. If you're trying to break the ice with some new surfing acquaintances, try offering prints of your images.

TECH TIPS

EXPOSURE Set the camera to shutter-speed priority or manual exposure mode. To freeze a wave, the shutter speed should be at least 1/250 sec (preferably 1/800). Since you'll likely be shooting in bright light, use a low ISO and a stopped-down aperture (f/5.6 or higher). To avoid clipped highlights, underexpose by a stop, then pull out details in post-processing later. To soften water movement, expose for at least 1/30 sec or shorter. For more blur, slow the shutter to 1/8 sec or even longer.

METERING Evaluative or multi-metering generally work well for overall scenes. When shooting backlit waves, use center or spot metering.

FOCUS When photographing surfers from shore with a telephoto lens, set the camera to continuous autofocus to better track the subject. Try locking in the focus on a wide-angle lens for closeup, in-water angles.

FRAME RATE Action-packed conditions call for high-speed capture. Use the fastest burst mode, but check the maximum number of shots the buffer can handle when shooting RAW and see if RAW slows the rate.

WHAT TO SHOOT

Pick a focal point: say, a lone surfer or jagged rocks awash in glistening waves. As you compose around this element, look for dynamic leading lines, perhaps from a jetty or the coastline's curve. When a wave crashes, freeze the oceanic action with a fast shutter—or go with a slow one for a dreamily blurred portrait of water's softer side. If you're ambitious, you might even snag the ultimate surf shot: a closeup of a dude on a board encased in a tube of water.

When you're working from the beach, shoot perpendicular to the waves to capture the full impact of the onrushing water. A wide-angle lens and a low angle at the water's edge will emphasize the height of a wave. From there, move up to a cliff or bluff for a broader view, angling the composition to show the direction of the wave (and the surfer, if there is one). To compress the background and close in on the action, use a long lens. Head into the water only if you have a waterproof housing for your camera, understand the surf pattern, and are an excellent swimmer. Even then, be cautious.

PAGES 140–141 "I've become familiar with this location's mood, light, and composition potential," says Anthony Ghiglia of this California beach. Careful study of a spot makes you aware of its best moments—and when they're likely to happen, so you can be there, camera in hand.

PAGE 142 Pat Stacy grabbed this shot of pro surfer Mark Healey riding the Backdoor Pipeline on the northern shore of Hawaii. He used a fisheye lens to dramatize the wave's swell.

OPPOSITE Another tactic is to blur waves into a slow-motion cascade with a slow shutter speed. Paul Marcellini took one exposure at 1/8 sec and one at 1/2 sec, then blended them in software for a fluid effect.

GEAR UP

Underwater Housing If you plan to shoot with a DSLR, it's best to invest in an underwater housing, which comes in either aluminum (strong, but pricey) or high-strength plastic. You can also consider a less expensive housing for a small point-and-shoot camera. Special surf housings are a little less expensive, often smaller and lighter, and can even come with a handy pistol grip for one-handed shooting.

Tether Don't even think of taking your camera into the surf unless it's secured to your wrist with a strong nylon tether.

Tripod or Monopod You may be able to handhold a 70mm–200mm f/2.8 lens, but anything longer needs to be supported by a tripod or monopod. A tripod is sturdier (and has the added benefit of making waves look taller when set low to the ground), but a monopod is more mobile; the choice depends on how much you plan to change positions. Either way, wrap the legs in plastic to protect them from saltwater and clean it thoroughly before storing.

Filters A UV filter can protect against salt spray and sand, while a polarizing one will cut down on water glare and create vivid color in the sky (if you shoot early or late in the day).

Lenses A 70mm–200mm f/2.8 or longer lens is ideal for shooting from shore. Because they're fast, wide-angle lenses are ideal for in-water positions. But you'll need to be within 3 to 8 feet (0.9–2.4 m) of surfers to document their moves, which can be tricky—and risky—even for a pro.

Rain Hood These are not just for the rain: They're also handy protection for your camera during surfside shoots.

Blower Brush Bring one to rid your gear of sand during and after the shoot.

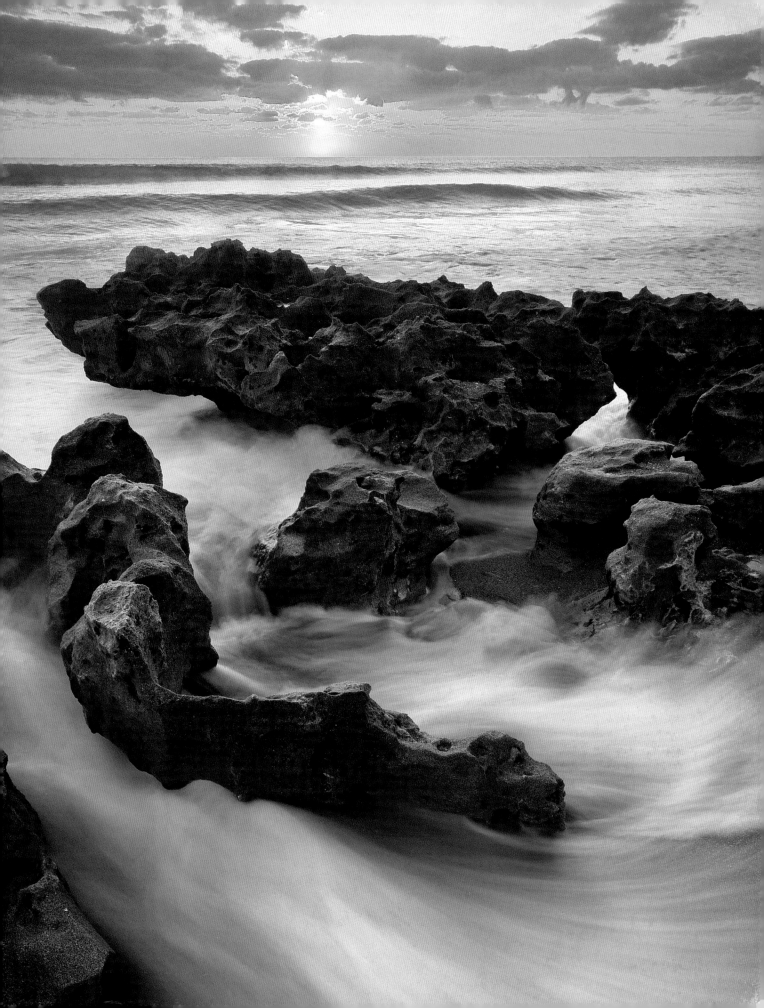

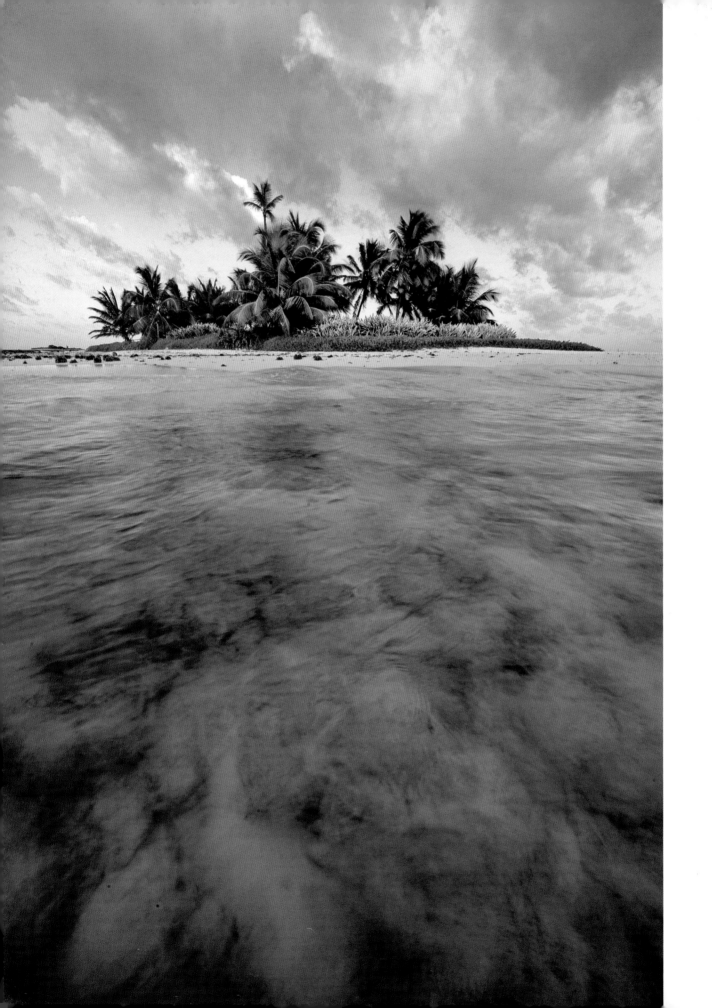

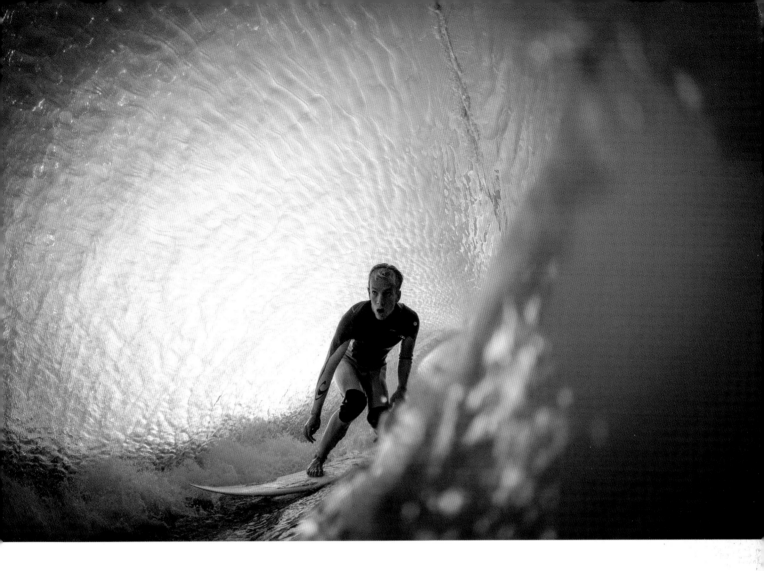

OPPOSITE Ian Plant accessed this deserted island off the coast of Belize by signing up for a chartered boat tour. To get the shot, Plant waded out into the water with a 14–24mm lens set at f/2.8 and covered with a polarizing filter to cut glare. "A wide-angle zoom comes in handy for coastal scenery," says Plant, "especially for combining incoming waves with colorful skies."

ABOVE Seth de Roulet woke up early so he could be in the right spot at the right time—namely, in a tube backlit by the sun as pro surfer Jake Kelley barreled down it. At this particular location, the light only hits the waterbreak at this angle in a ten-minute window after sunrise. To aid him in the current, de Roulet wears swim fins; he tries to keep at least 5 feet (1.5 m) away from his subject to prevent splashes from blurring his shot.

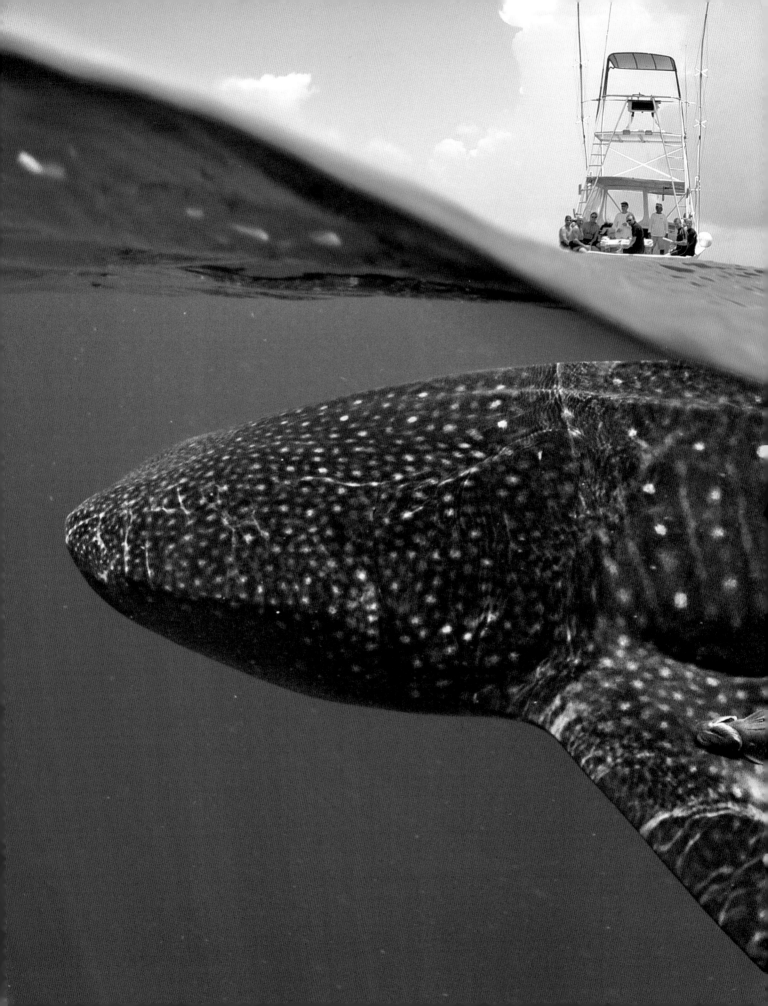

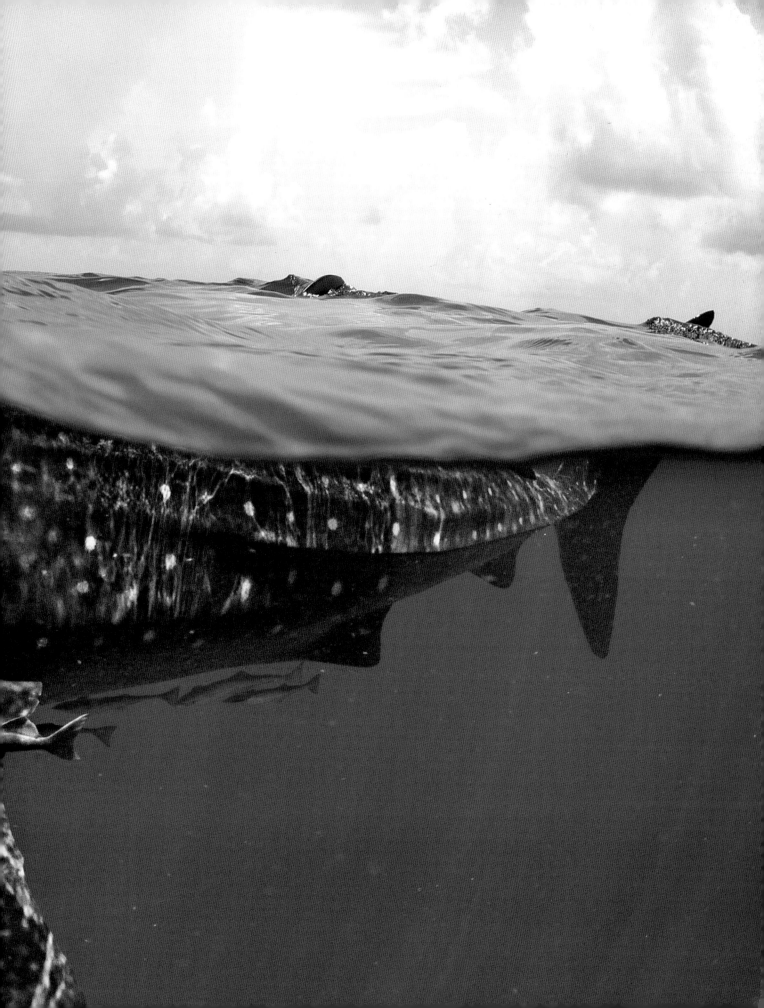

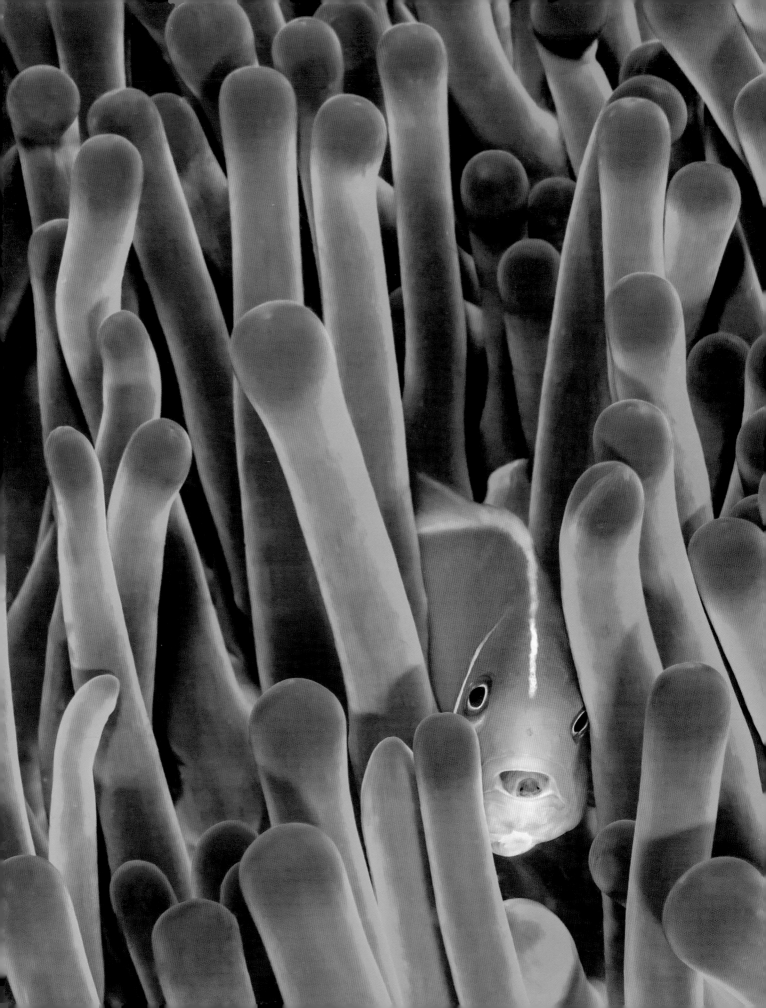

UNDERWATER

Hidden beneath the sea is a magical array of colorful landscapes, exotic sea creatures, and even the mysterious hulks of rusting shipwrecks—all waiting for you to discover with your camera. There are few places more beautiful to photograph, but you'll need special equipment and skills to bring back images that visually preserve this alien and captivating environment.

GETTING STARTED

Before you pick up a camera, you need to be comfortable in the water, whether you're scuba diving (make sure your scuba diving skills are top rate, including buoyancy control) or just having fun in a swimming pool. Starting off in a pool makes good sense for a number of reasons. It's shallow, so you can depend on natural light to illuminate the scene. Plus, a pool is a controlled environment where you can practice operating your camera. You're more likely to have willing models—such as your friends or children—and there are a number of inexpensive waterproof point-and-shoot cameras.

But if you want to shoot deeper than 10 to 13 feet (3–4 m), you need to step up your game in both equipment and skills in order to deal with the rapid falloff in visibility, loss of color, and increased pressure underwater. A DSLR or an ILC with a dedicated underwater housing is your best bet. In general, it helps to dive with an experienced guide who can lead you to reefs, wrecks, or other prime spots. If you're still learning and prefer to shoot in the shallows, snorkeling is a great way to capture wildlife without plunging to great depths.

TECH TIPS

EXPOSURE SETTINGS Your exposure is dependent on the scene's lighting conditions, of course. But as a rule of thumb for underwater photography, if you want to stop motion using ambient light, start with a minimum shutter speed of 1/125 sec, and try to keep the ISO as low as possible in order to prevent noise.

WHITE BALANCE Water absorbs light, so colors disappear the deeper you go, with red vanishing first at 15 to 20 feet (4.6–6 m), followed by orange, then yellow. That's why underwater photos taken with natural light look blue. So if you're using a flash, set your white balance to daylight, auto, or flash. If you're not using a flash, try an underwater setting (most often found on compact cameras), or choose cloudy to add warmth to the image. You can also photograph a white diver's slate underwater to set a custom white balance.

FOCUS AND METERING For autofocus and exposure metering, start out with a center-weighted setting and switch to spot focus or metering if needed. Autofocus is best in single autofocus mode with sufficient contrast. If the lens doesn't lock in focus, try setting it manually.

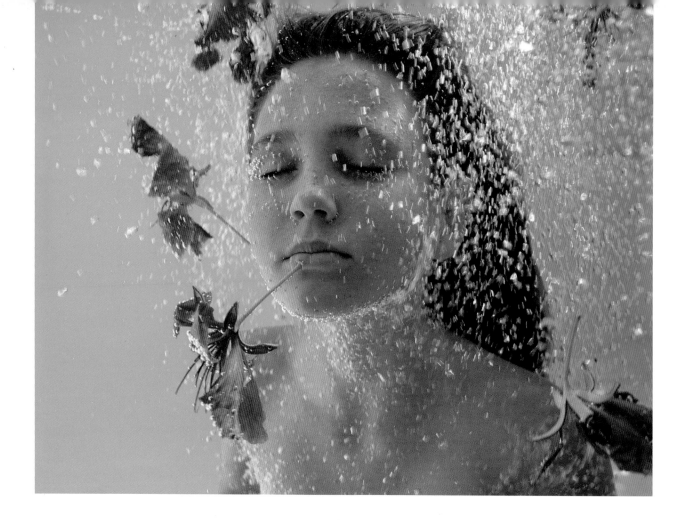

WHAT TO SHOOT

When scuba diving, underwater subjects are plentiful—reefs teeming with tiny creatures or large pelagics swimming past your viewfinder, perhaps. Whatever your subject, hold your camera as steady as possible and realize that you'll probably get only one shot of speedier creatures. Make it your best by presetting your camera and strobe settings, and "tracking" the animal ahead along its trajectory. If you're after shy reef-dwellers, stay as still as you can and wait for the denizens of the deep to get used to you—your reward may be surprisingly up-close shots of charming, colorful fish amid beautiful coral.

Swimming pools are perfect for starting off, but these controlled environments can also be used for more ambitious creative images. For example, for a fine-art feel, find a model who is comfortable in the water, then add a flowing dress and graceful poses. These shoots require planning, good communication, and underwater (or above water) lighting.

PAGES 148–149 For an over-under photo like Shawn Heinrichs's surreptitious one of a whale shark, set a small f-stop (such as f/16) to get maximum depth of field, keeping both parts of the image in focus, and expose for the shot's upper half.

PAGE 150 Peter Allinson captured this shy pink skunk clownfish with a 60mm macro lens (protected by a housing with a macro port), and two underwater flash units. A rebreather let him get close to the fish without spooking it.

ABOVE Working with a child, Elena Kalis staged this shot close to the pool's surface to harness natural light, and incorporated simple props and blew bubbles for dynamic effect.

OPPOSITE Mallory Morrison used natural light, a strobe, and a diffuser to create this ethereal underwater photograph. She shot with a wide lens with a f/7.1 aperture, keeping the shutter speed as low as possible to bump up ambient light and prevent motion blur.

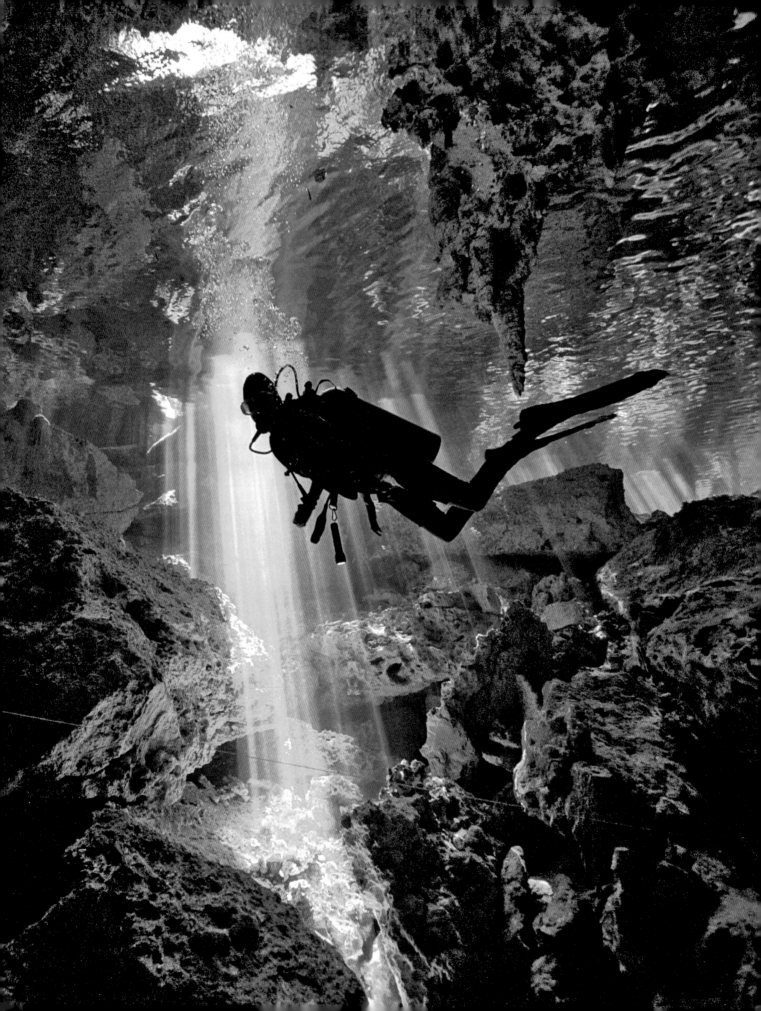

GEAR UP

Compact Waterproof Cameras
These easy-to-use, self-contained cameras don't require the added expense or bulk of a housing. Some go as deep as 33 feet (10 m).

Housings Underwater housings are available for some compact cameras and ILCs, but you'll find the widest range for DSLRs, constructed of high-strength plastic (polycarbonate) or aluminum. Aluminum is more rugged, but more costly. If you're looking for a compact camera housing, it likely will be plastic and available from the camera manufacturer with a depth-rating of 130 feet (40 m). Be sure it's tested at the depth you intend to shoot at. Otherwise, your camera could malfunction.

Underwater Strobes Other than those built for compact cameras, most housings aren't designed to use on-board flash. And built-in camera flashes generally don't have the power to penetrate through dense water unless you're 3 to 4 feet (0.9–1.2 m) away from your subject. Waterproof external strobes work best and—while two strobes define your subject's shape and add details—a single strobe can light up most scenes. You'll need one or two articulated arms for the strobe; check that the strobe-to-housing connections work together.

Waterproof External Monitor
Trying to look through a viewfinder while wearing a dive mask is difficult at best. While a camera's LCD is certainly a lot easier to manage, some photographers attach an external waterproof monitor for the best possible view.

Lens Port Protect your optics with a clear pressurized bubble that fits into the camera housing and accommodates different-sized lenses.

Lenses Water is about 800 times denser than air, a fact that can affect contrast, sharpness, and other image attributes, so get as close to your subject as possible. The best way to do that is to use a wide-angle or a macro lens. It also helps to use a prime lens, because you might not have access to the zoom ring through the housing.

Software If you end up with backscatter, you may want to try your hand at cloning out those tiny white spots. Shooting in RAW to begin with means you can extract every bit of missing color in post-processing.

MAINTAINING YOUR UNDERWATER HOUSING

Keep your housing in top condition and your camera safe and sound with these tips. Be sure to follow the manufacturer's recommendations for use and maintenance.

O-RINGS Follow the housing manufacturer's maintenance suggestions, including when and how to clean, lubricate, and change O-rings. The smallest grain of sand may be enough to break the O-ring seal and cause a leak. Bring a fresh set of O-rings with you on a dive excursion in case of emergencies.

LEAK TESTING Test your underwater housing before you use it, or after it's been sitting in the closet during the off-season. Submerse the housing, without the camera, in water—preferably to a depth of at least 33 feet (10 m)—to make sure it doesn't leak. Electronic leak detectors, which alert you to leaks while you're diving, are available for most housings.

AVOIDING DRIPS Double-check all the closures before you begin a dive. When you surface, dry the outside of the housing with a soft cloth before opening the case so you don't inadvertently drip water on your camera.

POST-USE When you're finished diving, soak the housing in fresh water for a few hours or overnight. Be sure to work the buttons and levers while it's soaking to rinse accumulated salt and debris. Don't leave the housing in the sun.

OPPOSITE Underwater cave diving is incredibly risky—it's only an option if you are experienced in scuba and shooting in areas considered safe with a buddy.

Low light is the biggest artistic challenge—Alastair Pollock framed this shot near above-water lighting, silhouetting his diving companion.

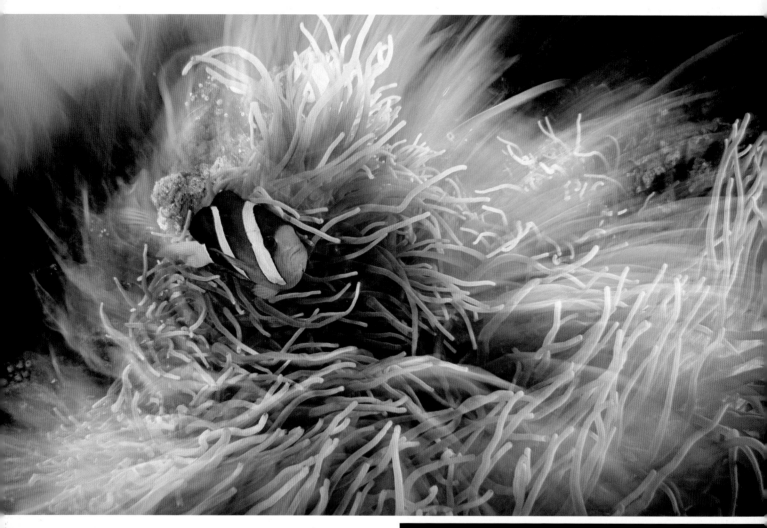

ABOVE Christian Loader shot this Clark's anenomefish in its host anemone in Indonesia. A wide-angle lens allowed him to move close to the subject (which ultimately helped reduce backscatter), while a slow shutter speed and zoom created a mysterious, blurred effect.

RIGHT Night-diving provides an opportunity to create dramatic marine life photos, like this stunning lionfish shot by Steven Kovacs in Honduras. To work in depths this dark, use your dive light to focus and strobes to illuminate the subject.

OPPOSITE If you want to shoot larger underwater fauna, go after slower, more gentle swimmers, such as sea turtles and whale sharks. In fact, underwater photo experts will tell you that it's not unusual to spend over an hour earning the trust of a turtle, but it pays off in the end, as they'll feel comfortable enough to drift by and give you ample opportunities for a great shot. Try shooting at an upward angle to separate the turtle from the seabed.

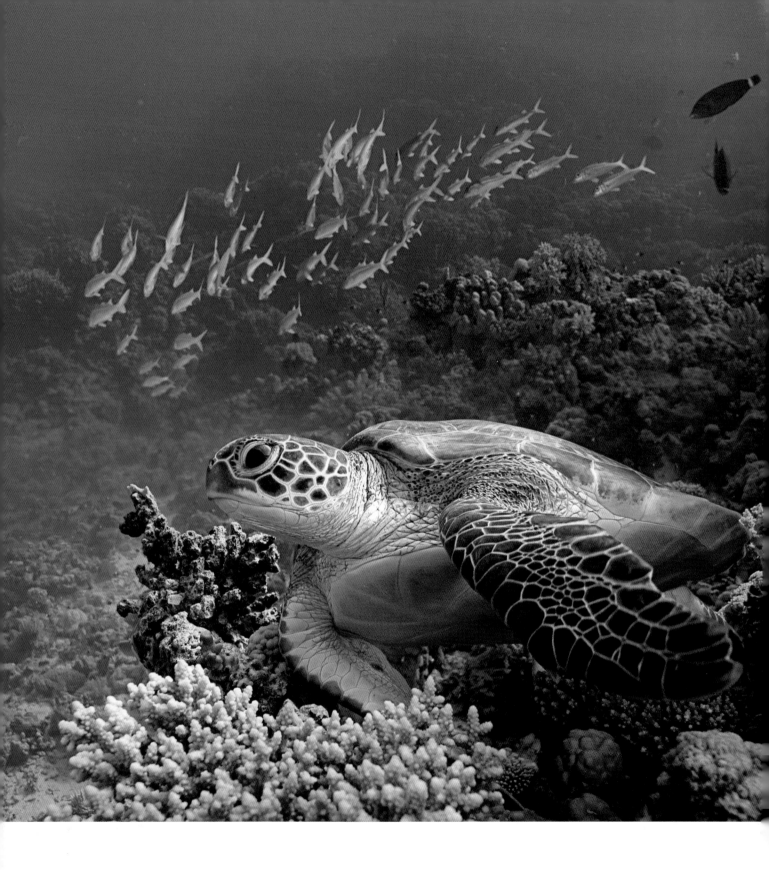

WEATHER

FOR MOST, CHECKING THE WEATHER is nothing more than a daily duty. But for a class of shooters who thrill at the sight of menacing twisters, zigzags of vivid lightning, and blizzards that blanket the world in whiteness, monitoring storms is the crucial prep work that puts them—and their cameras—in front of Mother Nature's most stunning displays.

GETTING STARTED

Documenting extreme weather is not for the faint of heart, and can pose real danger to you and your gear. It's best to start off with slightly more mild skies. Aiming a camera from under an awning or even through a window during a deluge or snowstorm is a good way to acquaint yourself with the camera settings needed to freeze or blur falling precipitation, while getting high up above surging floodwaters can offer sweeping views and keep you out of harm's way.

But if storm-chase you must, hit the meteorological books to learn about the weather systems you'd like to shoot, including which atmospheric conditions create them; where and when these conditions tend to be perfect; and how your subject tends to behave if it escalates. Doing this research up front will help you be there for striking cloud formations and awing monsoons, but more importantly, it will help you keep safe. Always have an evacuation plan and keep a radio on so you know of a storm's sudden changes.

As for gear, it helps to go light so you can move quickly. Keep your go-to photography equipment packed and ready for when lightning strikes.

TECH TIPS

EXPOSURE To blur rain for a torrential effect, switch to shutter-priority mode and set the shutter speed to 1/125 sec. To give definition to those drops, try a faster shutter speed of up to 1/1000 sec, but you may need to bump your ISO up to 400 or more to get a bright image. When shooting snow, decide if you want to freeze snowflakes in midair or depict a more evocative blur. For the former, set your shutter speed to somewhere between 1/250 and 1/500 sec; for the latter, start with a slower shutter speed of 1/2 sec.

WHITE BALANCE Your camera's light meter reads snow as a dingy gray, so use exposure compensation. Setting it +1 or +2 should keep snowy scenes looking crisp and white. It may help to bracket your shots so you nab one with true color. You can also take a test shot with a gray card covering your lens and, switching to full manual mode, use that exposure.

METERING Clouds are notoriously difficult to meter because they often display a wide range of brightness. Use a light meter to accurately gauge the light, setting it to spot-meter the brightest spots in your image.

WHAT TO SHOOT

To start, turn the next rainy day in your area into a prime photo-making opportunity. To record droplets as streaks, shoot against a dark background with the shutter set to about 1/30 sec, depending on lens focal length. (The longer the shutter speed, the longer the streak.) To home in on the drops, take some macro close-ups at a shutter speed of 1/500 sec. Drops clinging to surfaces add glistening highlights to any subject. And don't forget damp surfaces and puddles after a rain shower—the wetness makes colors sing and brings out interesting reflections.

Learn to welcome snow days, too, as they keep others indoors and make the world your own personal blank canvas. Bring a wide-angle lens for shots with a few visible snowflakes or a long lens to capture more of them, casting a lacy veil over your scene.

For more adventuresome types of weather (such as electrical storms, floods, hurricanes, or tornadoes), take wide-angle shots from a distance to encapsulate the scale of the event. Chasing such weather systems from a car makes good sense, as it allows you to follow the action—and provides a getaway vehicle in case the action starts to follow you.

PAGES 158–159 Chile's Cordón Caulle occasionally erupts in a spectacular phenomenon called volcanic lightning, in which vivid bolts occur inside a cloud of smoke and ash during an eruption. To take this photograph, Francisco Negroni used a tripod and a long exposure, allowing him to catch the lightning's intensity.

PAGE 160 Intrepid storm-chaser Jim Reed prepares for an event by looking at maps and data. "That part is a lot of science," he says, "but once I get there, it becomes a lot more artful." He shot this landspout tornado (which is less dangerous than a full-on tornado) from a mere 500 feet (12.7 m)—a technique he does not recommend.

GEAR UP

Lenses The ideal lens is a wide-to-telephoto lens such as 18–200mm, which allows you to adjust the focal length for a variety of shots. If you're after closeup shots of, say, snowflakes or raindrops, go in tight with a macro lens.

Rechargeable Batteries Shooting in burst mode during dramatic displays of lightning or quickly moving dust storms can drain your battery fast. Make sure you have extras on hand.

Tripod Keep your camera steady with a tripod—especially important when you're shooting long exposures. If your gear is out in the elements, try wrapping the tripod's legs in plastic or outfitting them with tripod snowshoes to keep them safe and dry.

Moisture-Proof Cases When transporting your gear, you'll want to keep it dry on the go, too. Hard cases are pricey, but if you're documenting a deluge, they are well worth the expense.

Bean Bag If you're shooting a storm out of a car window, a bean bag or similar stabilizer will help you balance the camera and lens as you lean out.

Rain Hood A must for covering watery weather, a rain hood fits snugly around your camera and lens, protecting it from rain, mist, and snow.

Media Cards Bring plenty, especially if you're shooting in RAW or RAW + JPEG.

ABOVE Shooting through a rain-streaked car window can result in a nearly abstract smear of the scene behind it. To do so, try your best to stabilize your camera within the car—possibly at a conveniently timed stoplight—and manually focus on the raindrops. Set your aperture to the widest possible setting to throw the background into a bokeh-like blur.

OPPOSITE TOP Jim Reed used a fast 1/250-sec shutter speed to freeze this frightening wall of water that hit Galveston, Texas, shortly before Hurricane Ike in 2008. To show the scale of the massive wave that swept over a 17-foot (5-m) seawall, Reed framed the shot to include a traffic light. He used evaluative metering in order to quickly set an exposure for the largely monochromatic onslaught.

OPPOSITE BOTTOM For this startlingly close, crisp, and crystalline image of a snowflake, Alexey Kljatov used a macro lens to capture a short, rapid-fire series of ten identical shots. He then applied a technique called "averaging" to merge the series into one photograph, which lowered noise and revealed microscopic details.

ABOVE "What makes this shot special is its exposure," says Vincent Soyez, who set it manually to capture detail. Meanwhile, his camera's flash exposure made sure the defocused snowflakes weren't fully blown out. A common pitfall, he adds, is the "green" or automode setting: Your autoexposure system will think the scene is well lit because of the bright snowflakes, and end up underexposing your shot.

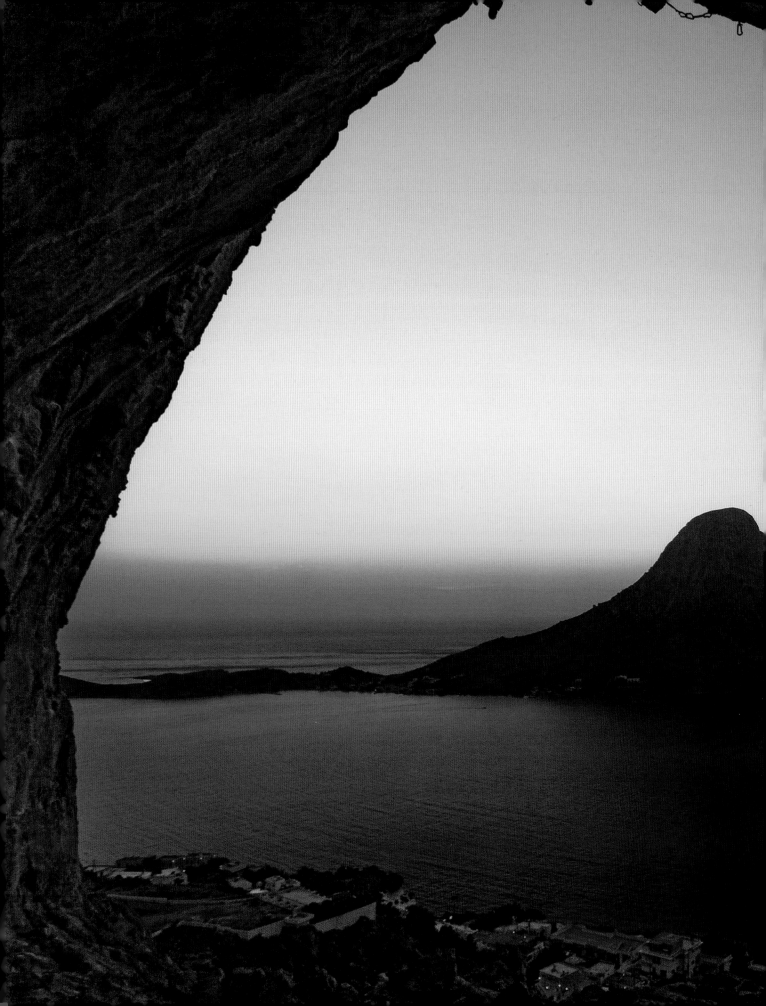

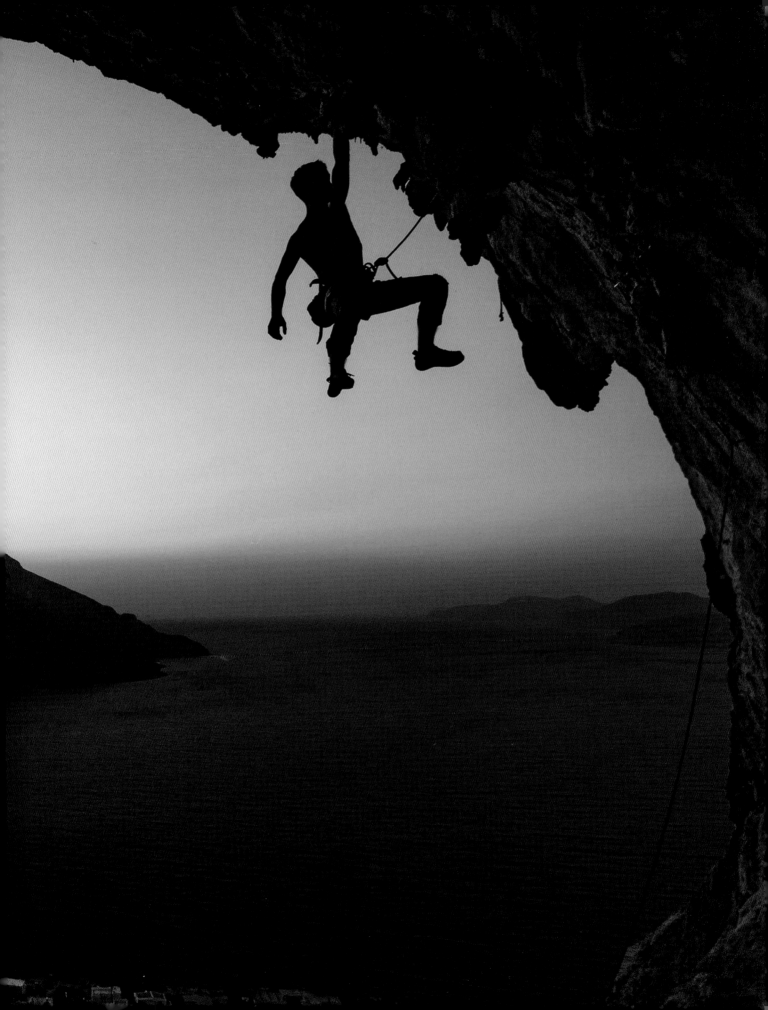

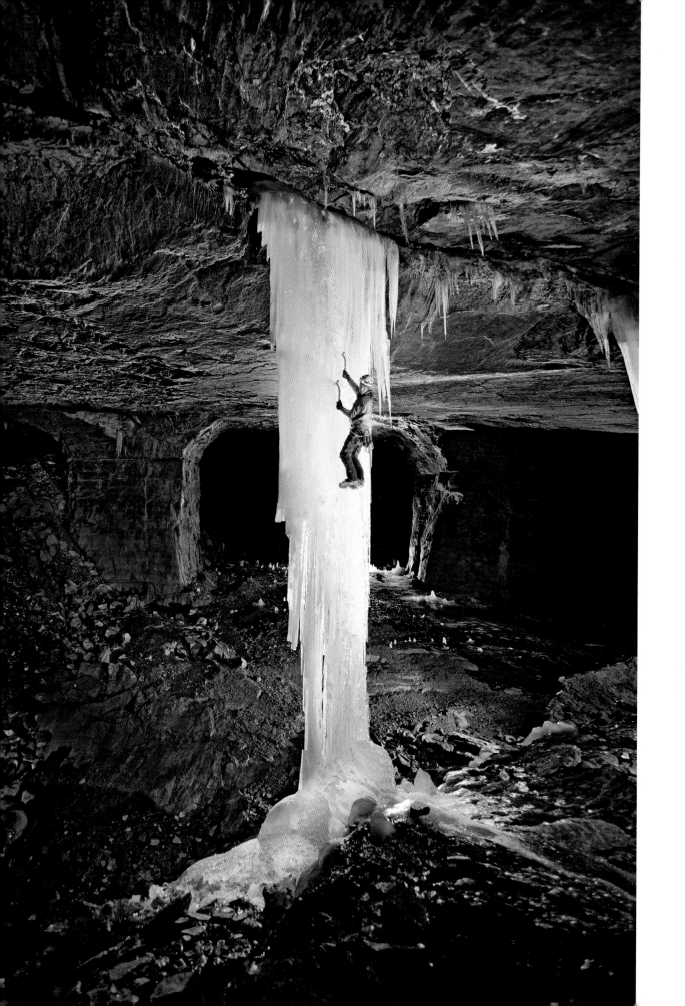

EXTREME EXPLORATION

SOME OF THE MOST COMPELLING IMAGES come from the most remote and extreme places—and the intrepid souls who venture there to capture them. If you have the desire and grit to explore desert dunes, Alpine crags, or the dark heart of a rain forest, plan carefully and take a camera worthy of the adventure. With perseverance and a little luck, you'll capture some awe-inspiring photos.

GETTING STARTED

The most important part of extreme exploration photography is safety. If you and your camera don't make it back in one piece, no one will know about your excellent adventure. So don't even consider extreme exploration unless you're in good health and physically prepared for the rigors of the trip.

The second most important part is preparation. For starters, research just how rigorous the trip is likely to be. Search the Internet for photos of your destination so you understand the physical and technical challenges you'll face. Consult guides—not just books and websites, but real people as well, like Tibetan Sherpas or trackers who know their way around African jungles. Create a shot list of photos you want, then figure where and how you'll bag those images.

When packing for the trip, make sure you have all you'll need to stay safe and reasonably comfortable in the challenging conditions ahead, whether they involve extreme cold, excessive rain, or sand. Once you're covered, consider your gear, and only bring items that can hack the conditions you're facing. And it never hurts to bring backup gear.

TECH TIPS

EXPOSURE There's no one correct exposure method for adventure photography. But you can never go wrong with manual exposure—as long as you understand it well enough to work fast. If you're dealing with rapidly changing light, try shutter priority for moving subjects; aperture priority for still ones.

WHITE BALANCE Shooting RAW with automatic white balance is the safest strategy. Current cameras are great at calculating white balance, and RAW affords you the luxury of fine-tuning the color afterward.

FOCUS Focusing is pretty straightforward for most adventure photography. Use single-shot autofocus and check your depth-of-field preview to make sure your subject is sharp. For closeup work or fine-tuning, use manual focus.

METERING Use evaluative metering and shoot in RAW mode for maximum dynamic range. If you're shooting a backlit subject or in difficult lighting, spot-meter off a medium-tone area of your subject. Check your histogram and highlight-warning display to make sure you aren't clipping shadow or highlighting detail.

WHAT TO SHOOT

If it's a once-in-a-lifetime trip, shoot everything. Use your shot list for direction, but leave time to discover new subjects, on your own or by asking the locals. Shoot the obvious like an active volcano, but keep your eyes open for the subtle and elusive, such as the puffins nesting in the cliffs you're climbing.

Seek details that help tell the story of the place and your adventure there. Capture sweeping shots of the landscape, tight shots of striking formations like icebergs, and closeups of details such as lichen. While you're at it, shoot your guides, vehicles, and even your trail food. Watch for surprising juxtapositions, like curious wildlife examining expedition equipment.

Perhaps the best way to capture your adventure may be to train your lens on your expedition companions, especially when they're involved in extreme (and

extremely photogenic) activities like rappelling, spelunking, or whitewater kayaking. Including people in your photos also adds scale to your images, highlighting the impressive immensity of features like glaciers and sand dunes.

PAGES 166–167 Shooting from a dark cave allowed for this dramatic silhouette of a climber against a dim sky. Using the cave mouth as the action's frame, the photographer used a large depth of field to keep both the climber and the distant hill in focus.

PAGE 168 Equipped with a battery pack and four heavy-duty flash units, Christopher

Beauchamp shot himself enjoying a frosty climb. The ice column formed over many months, so he stalked its progress until it was safe to scale.

OPPOSITE To freeze a stomach-turning fall down a rapid, set your camera on a tripod and try a 1/1600-sec shutter speed. The result will be terrifyingly sharp splashes and sprays.

GEAR UP

Zoom Lens Zoom lenses are perfect for adventure photography. Changing lenses exposes your camera to the elements and could mean missed photos, so go with one big superzoom like a 28-300mm f/3.5-5.6, or choose a pair of fast, standard zooms like a 24mm–70mm f/2.8 and 70mm–200mm f/2.8.

Camera Backpack Use a pack with a dedicated camera section, a compartment for protective clothing and other necessary gear, and a hydration compartment or water-bottle pouch. When you're in an extreme environment, water is a necessity, not an option.

Media Cards Estimate the number of photos you'll take to calculate how many batteries and memory cards you'll need. If you plan to travel with a laptop, bring an external hard drive. Store it separately so that your photos will be safe if your camera and computer are stolen or buried in a landslide.

Satellite Phone If you're off the grid, your cellphone won't get service. Experienced adventure photographers commonly carry satellite phones, which can get reception virtually anywhere.

Solar Panel If you will be off the power grid for any length of time, bring along a solar panel for charging batteries, phones, and tablets. They are available in soft roll-up versions.

Rain and Snow Gear For wet conditions, a waterproof (but breathable) rain jacket and rain pants are indispensable. For extreme cold, layering is the key, starting with moisture-wicking long underwear on out to wind- and water-resistant outerwear.

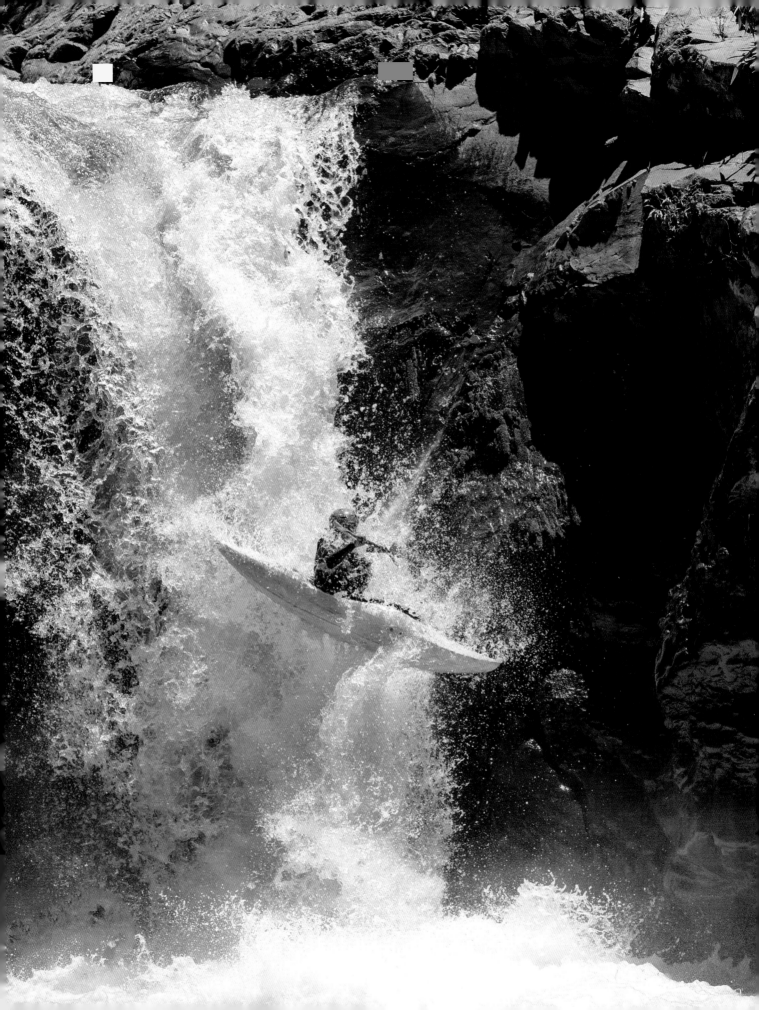

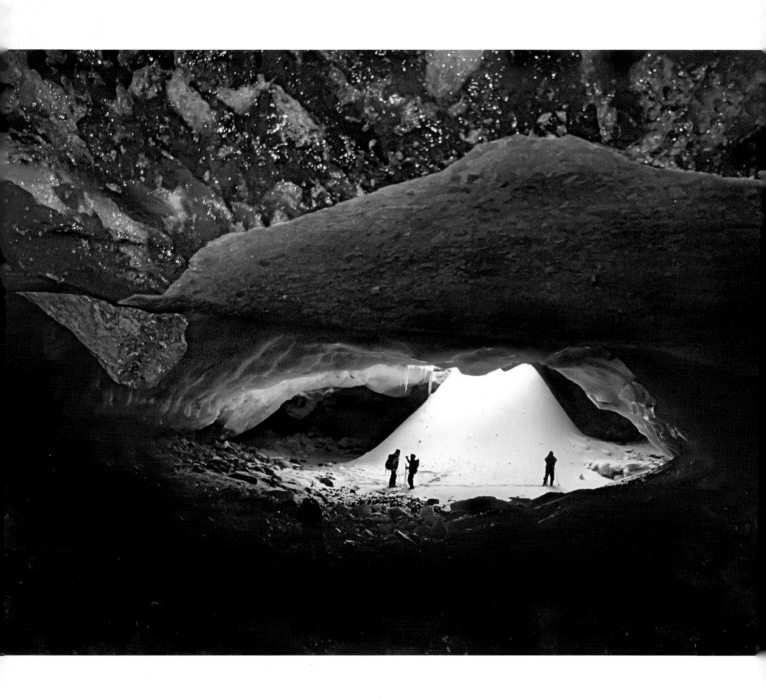

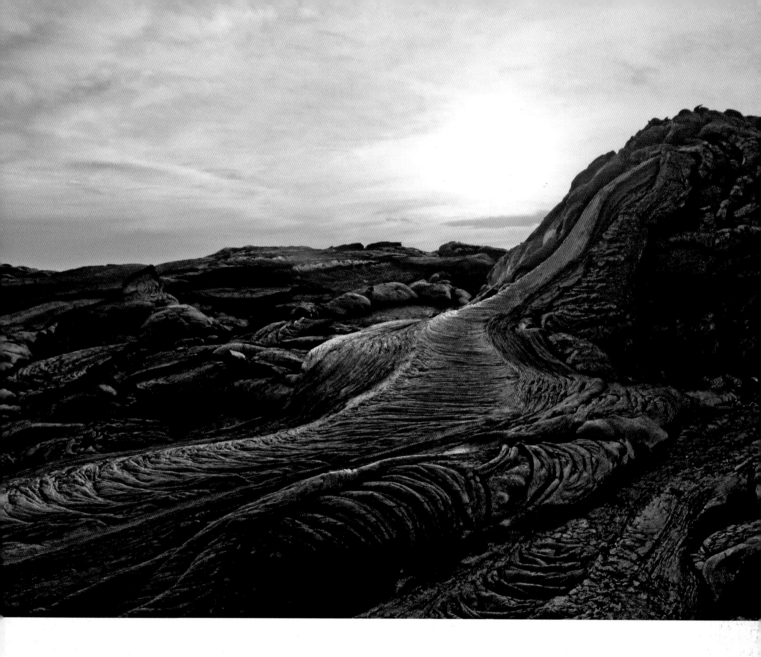

OPPOSITE To highlight the unreal mineral sparkle of this glacial cavern in the Canadian Rockies, Michael Anderson beamed a flash unit onto the ceiling above the camera, while light streaming in the cave's snowy mouth allowed him to keep his fellow adventurers in silhouette. Anderson shot the image on a 35mm slide and, for him, it encapsulates "the beauty, remoteness, and danger I felt on that incredible adventure."

ABOVE Dynamic leading lines of lava snake toward the viewer in Hollyn Johnson's image of sunset at Kalapana, Hawaii, where lava constantly oozes. When shooting lava fields, bring along a telephoto lens so you can stay away from the heat and still capture simmering details.

ABANDONED SPACES

IT'S TOUGH TO RESIST the melancholy allure of neglected structures. Derelict buildings entice the daring to explore the mysteries hidden within; crumbling ruins hold centuries of history within their forsaken walls; and ghost towns invite speculation on the fate of former inhabitants. Take along your camera—and a bit of extra caution—when you venture into these spooky spots.

GETTING STARTED

Sometimes referred to as urban exploration (or urbex), the investigation of desolate sites is an exciting, albeit sometimes dangerous, endeavor. Entry may be limited, either physically or by law, requiring an inventive or stealthy approach. If risk-taking isn't part of your DNA, consider photographing sites that are more easily accessible or open to the public.

Finding photo-worthy locations isn't difficult with a bit of Internet research or by scouting places in your area. Like any good location scout, make notes about the site, including barriers such as fences, overgrown bushes, and "no trespassing" signs. Then try to figure out a way around those obstacles. If a site is for sale, write down the phone number so you can contact the seller about gaining access. If a historical building is about to be torn down, speak with the local historical association and volunteer to document the building.

If you plan to shoot outdoors, visit the site at different times of day to determine when the light will be best. Moody shoots may be enhanced by the colors and shadows of sunrise and sunset, while midday light lends itself to stark compositions that lay details bare.

SAFETY TIPS

NO TRESPASSING The absence of a "no trespassing" sign doesn't put a welcome mat at your feet. If someone owns the space that you want to explore, there may be a security guard, cameras, or dogs at the location. Rather than risk getting ejected or arrested, try to contact the property owner and obtain permission. Even a friendly chat with a security guard might help you gain access.

PROTECTION Hazardous conditions may range from broken glass and ready-to-collapse structures to air borne contaminants like asbestos and hantavirus. Do some research so you have a better idea of the possible perils. Dress suitably, with rugged clothes, boots, and gloves. Flashlights or headlamps will help guide you through dark spaces.

BUDDY SYSTEM An abandoned space may be a haven for illegal activities, so don't travel alone, and bring a cell phone. Leave word with someone you trust about where you're headed and when you expect to return. Your well-being comes first when visiting abandoned sites, so keep your eyes peeled for warning signs.

WHAT TO SHOOT

Interior shots of abandoned buildings are the holy grail of urban exploration—and often, the most difficult to shoot. Be ready for low light conditions that will require high ISO and long exposures.

Wide-angle shots encompassing an entire room set the scene for detailed closeups of ominous doorways, broken windows, and the poignancy of personal items left behind. When shooting during the day, incorporate light filtering through cracks in the structure for a softer, moodier image—especially when shafts of light catch suspended dust particles. If you're shooting at night and trying to be discreet, use flash sparingly, if at all.

Exterior shots are important, too. If the place is guarded or boarded up tight, they're all you'll be able to shoot; if you manage to get inside, exteriors are an integral part of the full photographic story. A wide-angle shot of a building (complete with any barriers, such as a fence) adds context, especially if you step back so you can photograph the ruin in its entirety. Sometimes you'll want to cut out context, though an old barn with a collapsed roof set against an empty field conveys desolation—even if that barn sits beside a busy road.

PAGE 174 For this eerie shot of a chair-filled swimming pool in a now-defunct resort in New York's Catskills, Christopher Beauchamp wanted to show what happens to luxury when it falls into decay. He used a very tall tripod to get a better vantage point and shot with an ultra wide-angle 16–35mm lens in available light, cranking the ISO to 400 to deal with the low light conditions.

GEAR UP

Compact Camera A DSLR or ILC allow the flexibility of changing lenses, but any camera that excels at low-light, high-ISO capture should do the trick when shooting indoors. If you have to hike to the site or climb over obstacles, a smaller camera is best.

Filter Face Mask Even ordinary dust can pose respiratory problems; dust with contaminants, even more so. It's a good precaution to wear a filter mask when shooting in abandoned interiors.

Accessory Flash When discretion is important to your exploration, turn off the on-camera flash so it doesn't go off accidentally. An off-camera flash may prove more useful, especially since its output can be dialed down to a minimum.

Lenses Wide-angle primes or wide-to-midrange zooms are ideal for photographing interior rooms and hallways. Unless you have to shoot from a far distance, exteriors are best captured with a wide-angle lens as well, in order to frame an entire building. Beware of the distortion and convergence of straight lines that can crop up when shooting architecture.

Tripod or Monopod Mount the camera to keep it still during long exposures to avoid blur. Monopods are more compact and easier to carry when exploring, but tripods provide sturdier support.

Radio-Remote Trigger A radio remote-trigger or app helps prevent camera shake when shooting from a tripod. Alternatively, you can use the camera's self-timer to avoid the slight movement that occurs when the shutter button is pressed manually.

Hard Hat A construction worker's hard hat will protect against falling debris.

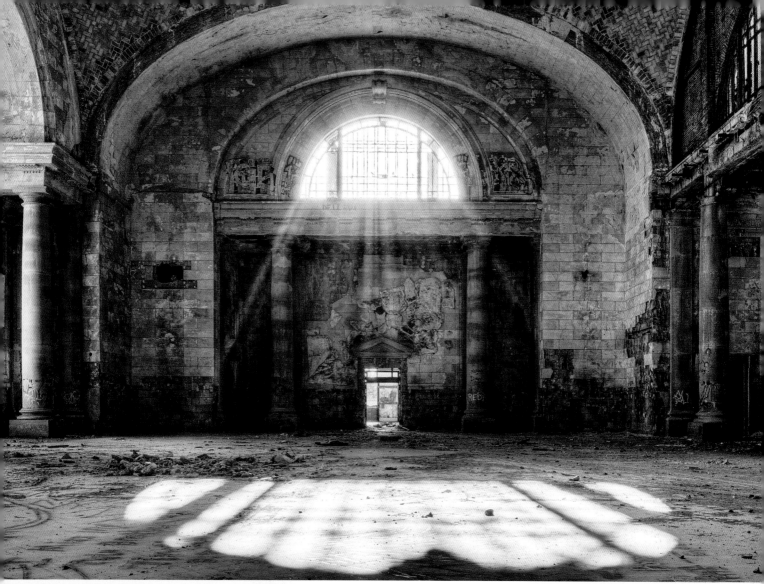

ABOVE Shooting "God's rays" through windows, as John Crouch does here, has the double benefit of creating an otherworldly effect and providing natural light in an otherwise dark space.

LEFT Large-scale, wide-angle shots do much to establish the magnitude of a huge ruin, but don't forget to linger on the details. The peeling paint, tarnished fixtures, and distressed surfaces in this photo by Lorraine DarConte provide a tactile element.

ABOVE Some of the most captivating imagery of ruins can be taken right from the road—without the risk of trespassing or stepping on a rusty nail. It's also great to get an exterior shot of a site, as it helps provide context and tell a larger story.

ABOVE Ian Plant visited the abandoned diamond-mining town of Kolmanskop, Namibia, where he documented a place reclaimed by the desert. Plant composed this image so the multiple door frames draw in the viewer, while the bright walls provide unexpected pops of color against the sand.

LEFT Sometimes reintroducing the human figure into run-down sites provides interesting contrast. Miss Aniela, for instance, shoots self-portraits in forgotten buildings as a way of reinstating people into the story. A fashion photographer by trade, she styles shots to have a spectral quality.

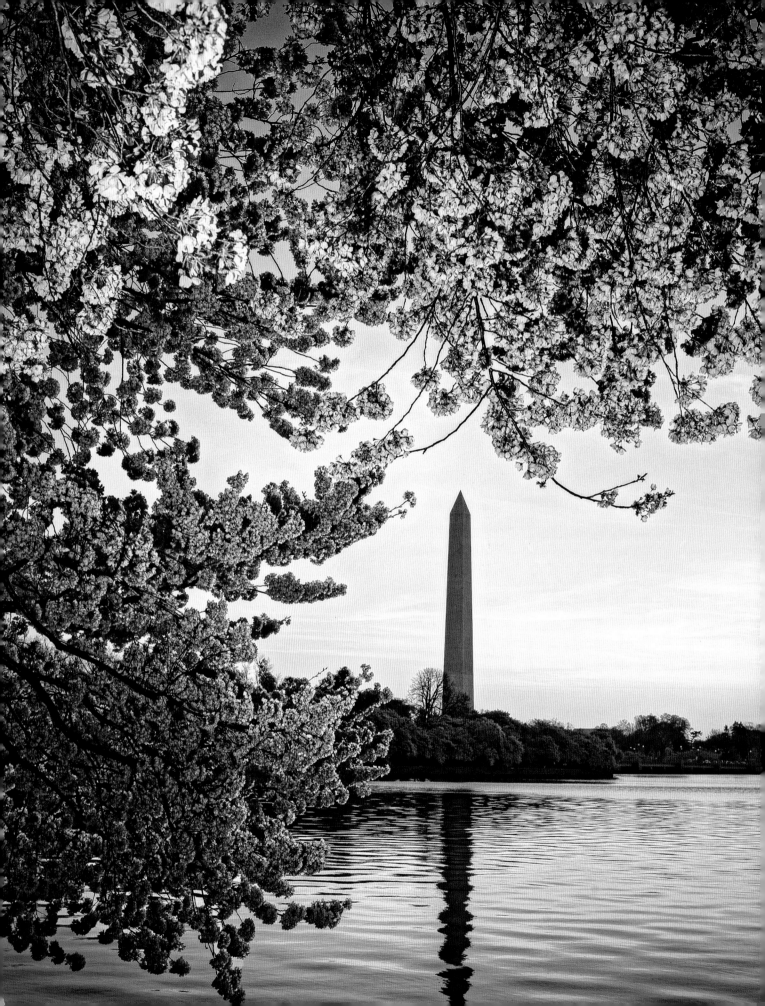

MONUMENTS

STRIKING AND OFTEN ACCESSIBLE, monuments and other landmarks hold a powerful attraction for photographers. Since they've already been depicted so many times, the challenge of creating distinctive images of landmarks can be steep. Rise to the occasion with shots that don't just say "I was here," but that also offer insight into the monument's meaning and impact.

GETTING STARTED

From statues and sculptures to bridges and dams, monuments and landmarks tend to be large—and those outsize dimensions present photographers with lots of intriguing options. Scout new perspectives by going far away and seeing how the monument or landmark fits into the landscape as you move closer. A tower or bridge can be shot from miles away and still figure as the subject of your image. Look for meaningful juxtapositions of foreground elements with your monument in the background, or head to higher ground to shoot looking down on your subject. If you can't scout out the site in person, go online to study shots taken from different vantage points.

Check in advance for any restrictions on photography, and also look into happenings at the location, since monuments often double as venues for parades and political events. When you're deciding on your shoot date, make sure you factor in weather and sun data.

Finally, read up on the significance of the monument you'll be documenting. That insight won't just enrich your visit, it will also enhance your photographs by directing your lens toward meaningful details.

TECH TIPS

EXPOSURE If you can use a tripod, capture long exposures to blur people and vehicles or even eliminate them from the scene. Start at 1/30 sec and incrementally slow the shutter speed from there. Try shooting at night, or using a neutral-density filter on your lens if you can't slow your exposure time sufficiently by shooting with a small aperture.

BRACKETING Take a series of bracketed exposures for creating an HDR composite, a series of long night exposures to build a composite image with star trails, or a series of images taken at different times that can be combined to show a day in the life of the monument.

PERSPECTIVE CONTROL If you have a tilt-shift lens, you can align your camera parallel to the monument and then shift the lens up to eliminate keystoning, which makes tall structures look narrower at the top than they really are. Or take a shot with a standard lens and use perspective-correction software tools to straighten things out later. If you want to emphasize the distortion, the closer you are to the monument, the more keystoning you'll capture.

WHAT TO SHOOT

When you're ready to start photographing, think about how your subject looks from the vantage points you've chosen at different times of day. For instance, a monument on the horizon might look much more dramatic when it's part of an illuminated evening cityscape or a dewy sunrise scene in the country. As you move closer to your subject, capture the ways people interact with it, then get up close and explore its surface details.

When you're very close, don't forget to look up. The scale and design of many monuments lend themselves to graphically strong shots taken from a low angle. Also keep an eye on what's happening in the sky beyond the monument. Birds, planes, and other denizens of the sky can bring life and a compositional counterpoint to a monolithic object.

Reflections and wet surfaces are another way to add drama to your shots. Some monuments are near reflecting pools and bodies of water, and capturing just a reflection in those (or on a nearby glass or metallic surface) offers an unexpected take on a familiar form. Shooting after a rainfall lets you take advantage of the shimmer of wet streets and surfaces around the monument.

PAGE 180 How do you change the tone of a stately, austere landmark? Frame it differently. Waiting until sunset to avoid crowds, Randy Santos composed this image of the Washington Monument so it was fringed with cherry blossoms and warmed by the day's last golden rays.

OPPOSITE Traveling light, Stephen Murray handheld his camera for this early morning, misty shot at the Great Wall of China. "I wanted to get strong leading lines in the foreground," Murray says. "My wide-angle lens helped me achieve this without cutting out too much sky."

GEAR UP

Tripod Even if you can't use a tripod in the immediate vicinity of a monument, it can come in handy at a distance for capturing long exposures, sharp cityscapes, panoramas, and image series for later compositing. It's also useful when working with a tilt-shift lens to manage lens distortion or create a miniature effect.

Panoramic Tripod Head For shooting panoramas, use a panoramic tripod head to create a seamless panorama without

parallax issues. Once attached to your tripod head, it keeps the point of view of your camera stable as you shift the image frame for a series of shots.

Software Image editors like Adobe Photoshop provide tools for removing people and objects from a scene. Look for cloning tools and content-aware object-removal tools. Meanwhile, a dedicated panorama-stitching program or image-merging tools in editors like Photoshop will allow you to stitch a series of side-by-side or top-to-bottom frames into a seamless horizontal or vertical panorama.

Scouting and Sun Position Apps These allow you to forecast the light angles at specific locations and view sight

lines from different elevations on a map. Some even let you simulate the fields of view you'll get with different lenses.

Variable Neutral-Density Filter
The slower your shutter speed, the more that people in a scene will "disappear"—a long exposure will make them blur out. A neutral-density filter will let you slow down the exposure below that of what you normally could. You can stack these filters, but some companies market variable neutral-density ones that let you dial up to eight stops of density.

Radio-Remote Trigger A remote camera trigger can help you capture time-lapse series and long exposures without jarring the camera.

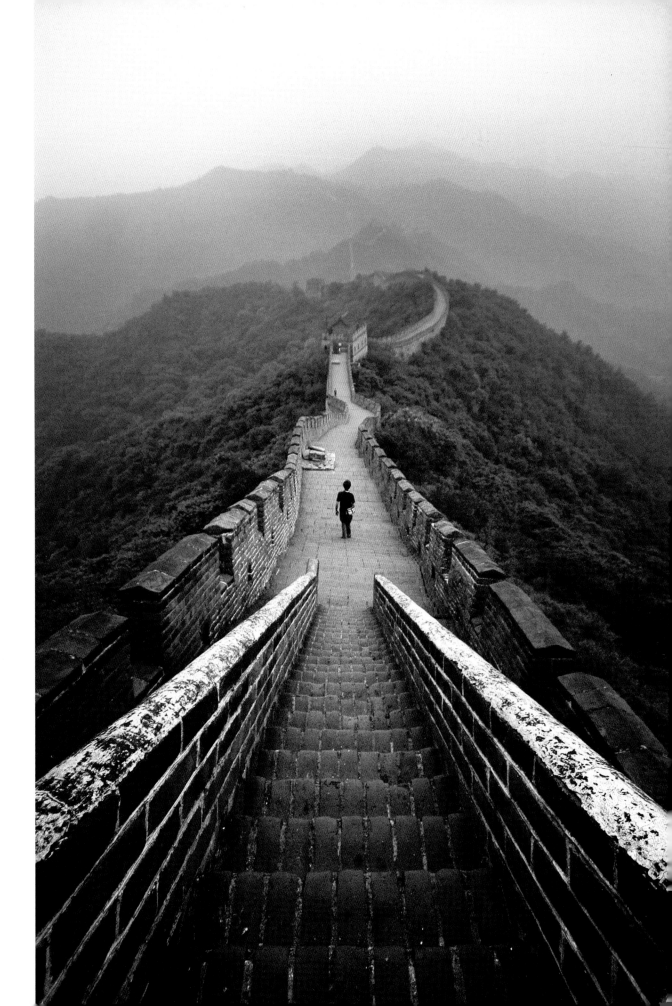

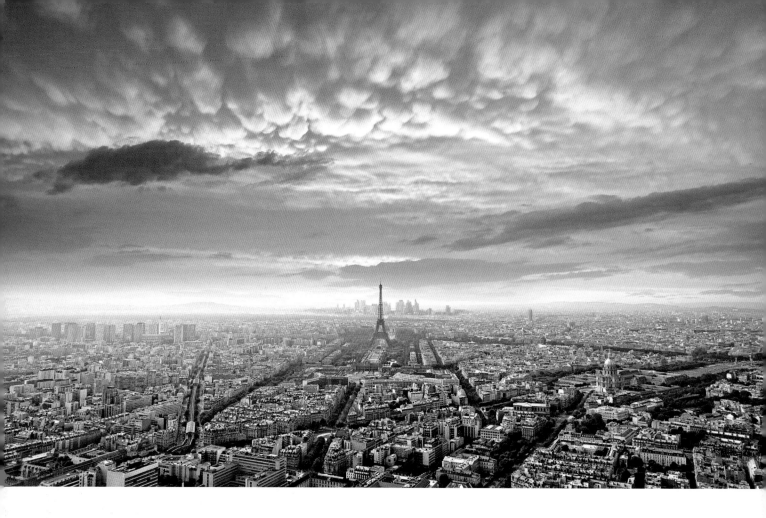

ABOVE Peter McKinnon wanted to show the tallest structure in Paris amid the city's skyline, capturing the strong leading lines of the city grid and giving equal real estate to a tumultuous sky. He converted the photo to black and white to give it a stripped-away effect.

OPPOSITE It helps to go in for details, as Veleda Thorsson did when shooting in a cemetery in Cologne, Germany. The gentle weathering on this mausoleum statue (captured with 50mm f/1.4 lens at ISO 200 with a 1/1000-sec shutter speed and an aperture of f/1.4) contributes to her subject's overall theme of grief and decay.

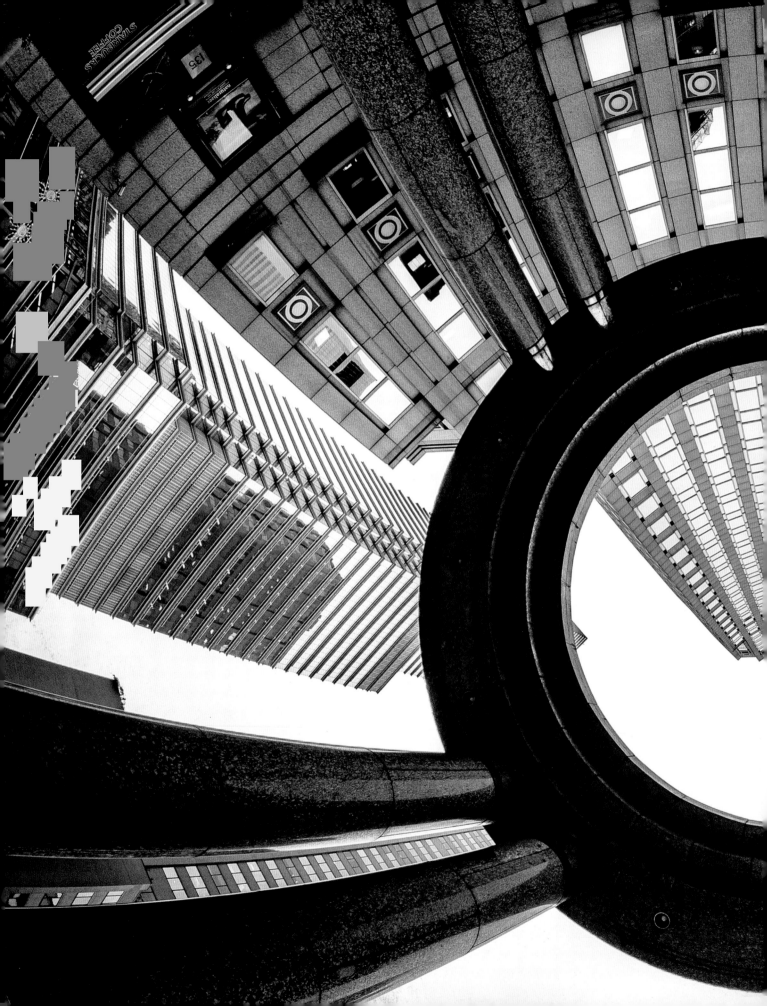

ARCHITECTURE

LIKE PORTRAITURE, architectural photography can do more than depict the facade of a country home, shopping center, or medieval church. It can reveal the aspirations of the people who designed those buildings—and provide insight into the lives of those who visit, work, and live in them. Preparation and creativity are key to architectural shots that delve beyond the facade.

GETTING STARTED

The first step in photographing a building is scouting before you take out your camera. Observe the kind of human activity that takes place in and around the site, and decide if you want to include it in your architectural portrait. Walk around the space to look at it from different angles and find vantage points for high and low perspectives. Natural light will probably be most striking early or late in the day, but consider artificial lighting, too. A building with lots of windows or outdoor lighting fixtures can look very different when those lights come on in the evening.

Search for images of the site online if you can't scout it in advance in person. Also check the weather and sun data, and find out if there are events or seasonal decorations planned that might affect the lighting or activity around the building when you plan to shoot.

If you're not sure about whether you need permission to photograph the building, check with the owners or local authorities in advance. That can be especially important in foreign countries, where laws and common courtesy may work quite differently than what you're used to at home.

TECH TIPS

EXPOSURE Since you'll probably be shooting on a tripod, you can use as slow a shutter speed as you want. Try apertures on the high side of the middle range of your lens, usually from f/8 to f/16. That will give you ample depth of field, and most lenses are at their sharpest in the middle of their range. If you're sure your lens maintains sharpness at small apertures, stop down for even more depth of field. Keep your ISO setting at 100 or 200 for noise-free images. Use exposures of 1/30 sec or slower to blur people and vehicles—or eliminate them completely.

BRACKETING Capturing several exposures gives you the option of creating composites and HDR images that show ample color and detail in both the building and the surrounding landscape.

FOCUS Since you're photographing a (very) stationary subject, your best strategy is to focus manually. If you're shooting a structure head-on, depth of field is of little issue, but if you're shooting at an off-angle, check depth-of-field preview and adjust your focus and aperture accordingly.

WHAT TO SHOOT

Think about what's most distinct about the building you're photographing. Is it structural inventiveness, bold materials, or delicate flourishes? Does it have an intriguing history, a striking setting, or an unusual feature? Work all the angles to emphasize what makes it special, starting with shots of the whole structure in its setting, and then zoom in on details. Make sure to keep prominent parts, such as the entrance, in sharp focus. And keep an eye out for interesting reflections in buildings with lots of windows or in nearby pools or other bodies of water.

Instead of shooting dead-on, compose for diagonal lines that draw the viewer's eye into your composition. To make your image dynamic, apply the rule of thirds or find a golden section—a pleasing ratio in which the overall length of a structure is proportionate to its sides. Some buildings lend themselves to abstraction, especially when you explore stairs, facade patterns, and elements that create strong contrasts and dynamic lines.

PAGES 186–187 A circular, open-roofed structure always struck Roman Kruglov as a fantastic framing device for the midtown Manhattan building behind it. He used a fisheye lens to capture the building's concave curve and converted it to black and white to keep the focus on its geometry.

PAGE 188 Philipp Klinger was going for a straightforward photo of this Mobius-like staircase, which he shot at eye level from 75 feet (23 m) with a 50mm lens. For a different interpretation, he says, play around: Switch lenses, get up close, or tilt your camera up at close range.

OPPOSITE Try shooting on a slight diagonal—here, it highlights the architectural motif of squares and rectangles, including a long and narrow rectangular pool.

GEAR UP

Lenses A wide-angle lens will help you capture large buildings even when you're close up. And by adjusting the angle of the lens to the camera's sensor plane, you can use a tilt-shift lens to keep parallel lines straight and prevent keystoning.

In-Camera or Bubble Level A level will help you keep horizons straight and vertical lines parallel with the edges of the image frame. If your camera doesn't have a built-in level display, look for a bubble level that you can mount on your hotshoe or a tripod head equipped with a built-in level.

Tripod To work with tilt-shift lenses, take long exposures and multiple frames for composites, and get the sharpest, most detailed shots possible, you'll definitely need a tripod.

Sun-Position Apps Use a smartphone app to look up sunrise and sunset times, and to find out what the angle of light will be at in a specific location and time.

Filter A circular polarizer can eliminate unwanted glare and reflections on windows and other reflective surfaces, as well as make blue skies and verdant landscapes look more vibrant.

Software Image-editing programs include tools for straightening out curvature caused by lens distortion, as well as for straightening parallel lines and minimizing keystoning.

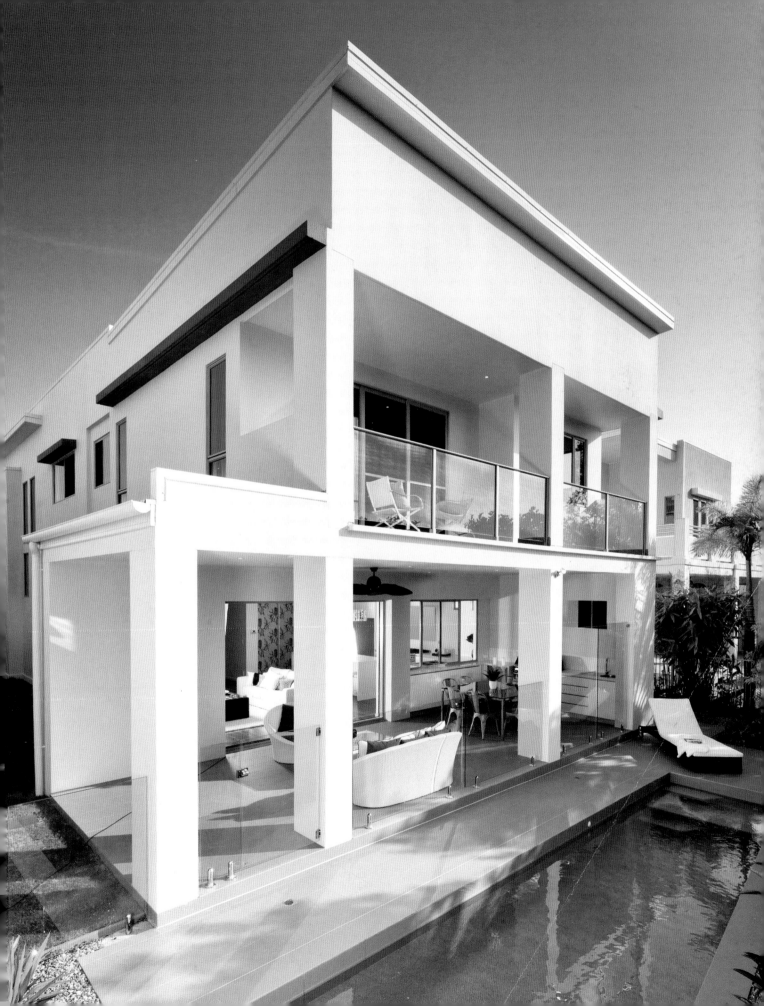

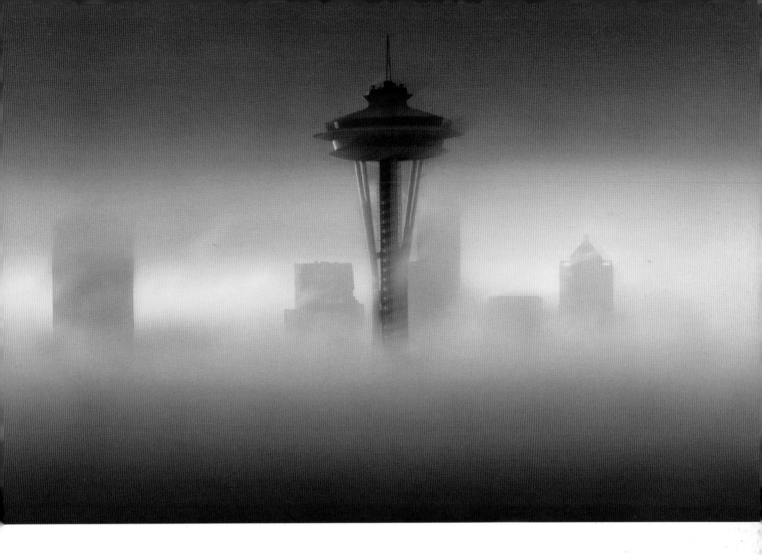

OPPOSITE Joseph Constantino photographed Tampa's Leepa-Rattner Museum of Art in color, then converted it to black and white and solarized it to create white lines between the shadows and highlighted areas.

ABOVE Clane Gessel believes in learning by experience. "Ninety percent of the time it's all about just getting yourself out there," he says. Through January, he set his alarm to catch the sunrise over the Space Needle in Seattle, Washington, from his bedroom window. One morning, the sun rose between two layers of fog, allowing Gessel to photograph the tower in between. Preparation met with opportunity.

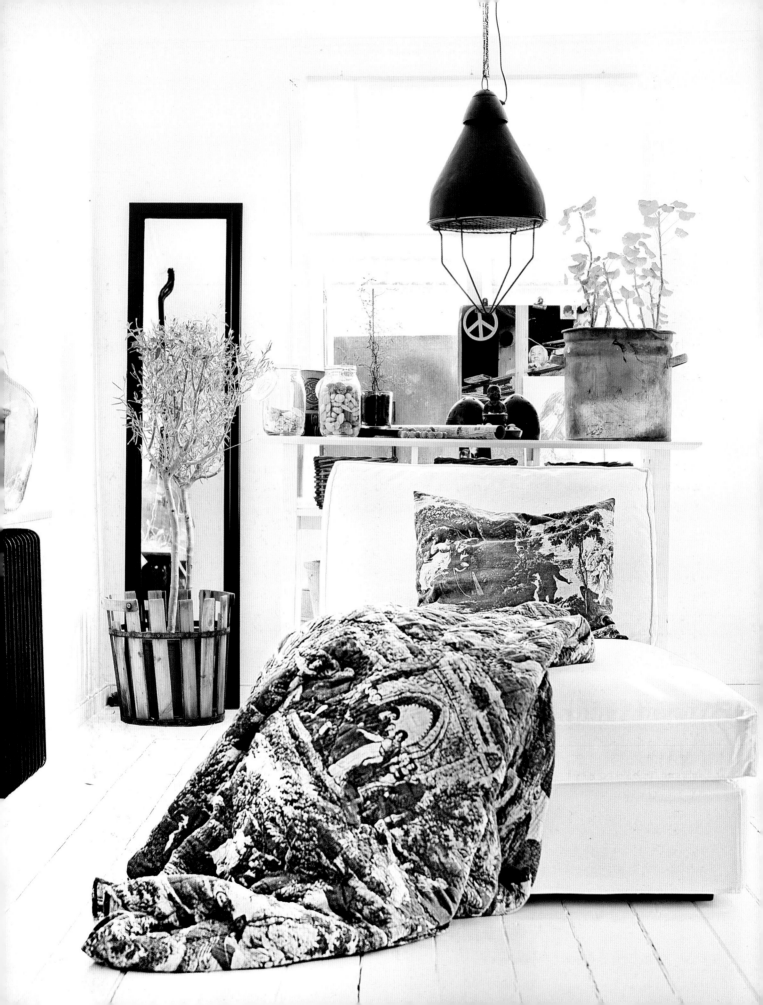

INTERIOR DESIGN

A SKILLFULLY CRAFTED INTERIOR PHOTOGRAPH isn't just a picture of a room; it's an invitation. The best interior photographers use light, color, and composition to welcome viewers into the spaces they portray—from sleek urban apartments and cozy country homes to dramatic restaurant dining rooms and futuristic workplaces.

GETTING STARTED

Whether you're out to document the decor details of a stylista's L. A. apartment or the arty architecture of a London gallery, the first order of business is scouting the space. A few days before your scheduled shoot, visit at the same time of day and study the light, including the types of bulbs in the fixtures and the size and orientation of windows. Measure and record light levels in different areas so that you can decide which modifiers you might need. If you're not able to scout the interior in person, ask for a floor plan or just a quick sketch with room dimensions and windows indicated.

If you have the run of the place, move furniture, tidy up, and remove items that create problematic reflections or don't work with the general color scheme. To help convey how the space is used, set the table in a kitchen, spark up the fireplace, shoot a restaurant with diners at the tables, or leave a few magazines and a cup of coffee out in a living room. When placing objects, aim for the "not-perfect" perfection that enhances compositions: Think slightly off-kilter symmetry.

TECH TIPS

EXPOSURE Use slow shutter speeds so you can keep your images clean with ISO settings below 400 and your depth of field adequate with small apertures. The aperture will depend on the space as well as your camera and lens, but f/8 is a good lower limit. For starburst effects, turn on some artificial lights and stop down to a small aperture like f/22.

METERING Interiors often have contrasting light levels, with bright windows and lights, dim corners, and areas of shade created by furniture and larger, indoor architectural details. Spot-meter with your camera or, better yet, use a handheld incident meter to measure the light in the brightest and darkest areas, then modify the light levels so the whole scene falls within your camera's dynamic range.

WHITE BALANCE To represent colors accurately, use a gray card or color checker to set a custom white balance. If there is mixed lighting, it may create inconsistent or inaccurate color casts. Try gelling lights to match the hues in another area, or replacing bulbs of various kinds with a single type.

WHAT TO SHOOT

When photographing an interior, imagine you're giving a tour. Think of the visitor following a path through the space and look for—and shoot—elements that will guide her eye along that path, such as leading lines and patterns that draw attention into the room. Composing with visual entry and exit points makes the image more dynamic. Use an object in the foreground to bring the viewer into the space, and in the background include an open door to another room or a window showcasing the exterior environment. Natural light from windows also makes a space seem bigger—though you can achieve similar effects with artificial light and reflectors.

Instead of shooting dead-on to a wall, angle your camera from a corner to create diagonal lines and a sense of depth. Always include part of the floor to ground the scene, and perhaps a bit of the ceiling as well. In spaces that have especially high ceilings, try shooting upward from a low angle, and then climb stairs or a ladder and aim down. After capturing the space as a whole, shoot detail images of arresting architectural or décor elements. The details say a lot about a space and its inhabitants, too.

PAGE 194 Lina Ostling shot this home feature with natural light and ample depth of field to give the image expansiveness. A limited palette made the space feel peaceful and harmonious, while a mirror made it seem even more airy. Plants and casual placement of the comforter give the space signs of life.

OPPOSITE Fill your frame with pattern, texture, and unique art pieces, as Jeremy Floto and Cassandra Warner of Floto+Warner Studio did when shooting designer Jonathan Adler's home. With this many vertical lines, keep the sensor as parallel to the wall as possible to avoid converging lines.

GEAR UP

Light Modifiers Use reflectors to bounce light into dark corners and diffusers to soften bright window light. An opaque flag can block unwanted reflections, so look for an all-in-one panel that collapses for portability and has interchangeable surfaces for different effects.

Gels Putting a color temperature orange (CTO) gel on a flash or fluorescent light will help you match it with incandescent lights. To match with daylight, use a color temperature blue (CTB) gel for incandescents, and use a green gel for fluorescents.

Lenses A wide-angle lens will help you capture most spaces faithfully. But also pack a tilt-shift lens. Besides allowing for perspective correction and extending depth of field, a TS lens lets you use a neat trick: By shifting the lens laterally, you can photograph into a mirror or other reflective surface without you or the camera appearing in the photo.

Strobes To get the exposure and feel you're after, try firing a flash or strobe into dim areas, or bouncing them off a white wall or ceiling. If you're positioning a remote flash out of sight of the camera, you'll need a radio trigger to fire it.

Colorchecker or Gray Card Capturing accurate colors can be vital. A portable colorchecker or gray card will ensure that you set your white balance correctly and you have a color reference shot when editing.

Software If you use wide-angle lenses to capture small spaces, you may end up with curvature around the edges of your shots. Straighten curves with tools for correcting lens distortion in software like Photoshop, DxO Optics Pro, and GIMP. If you've taken multiple exposures to create a high-dynamic-range composite as a way of handling tricky indoor lighting situations, try a stand-alone program or the HDR tools in Photoshop.

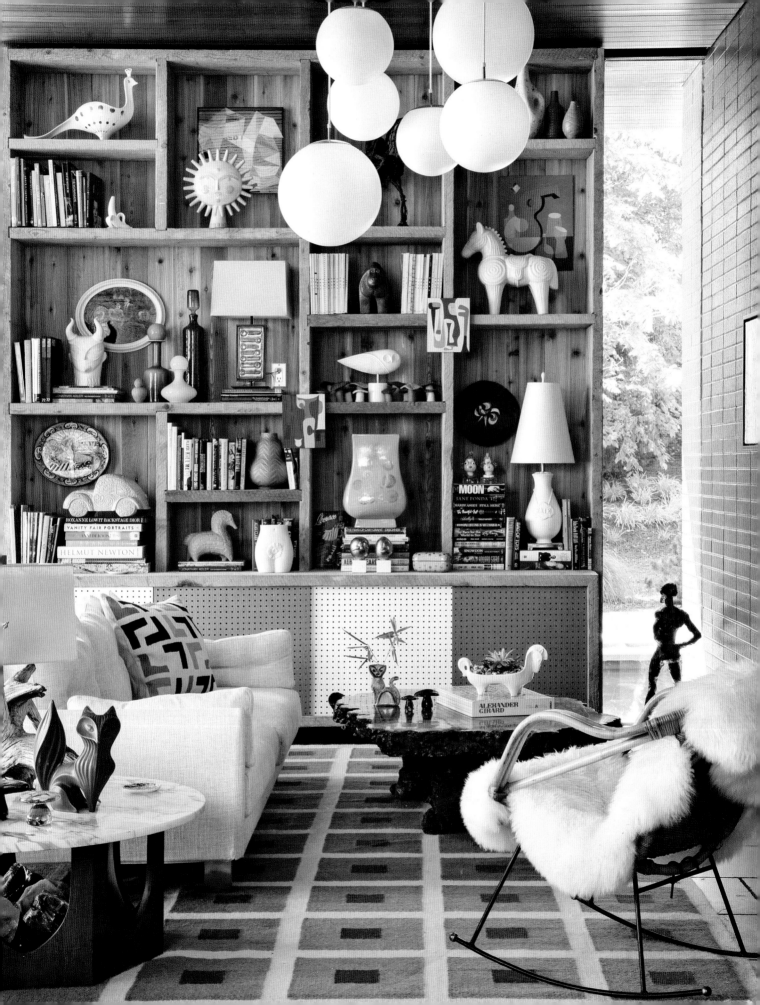

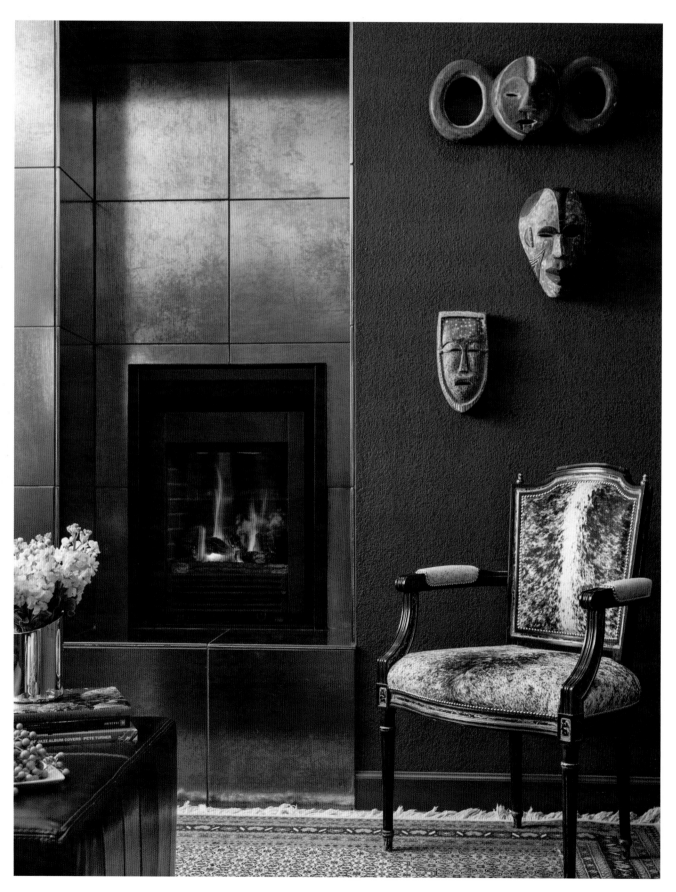

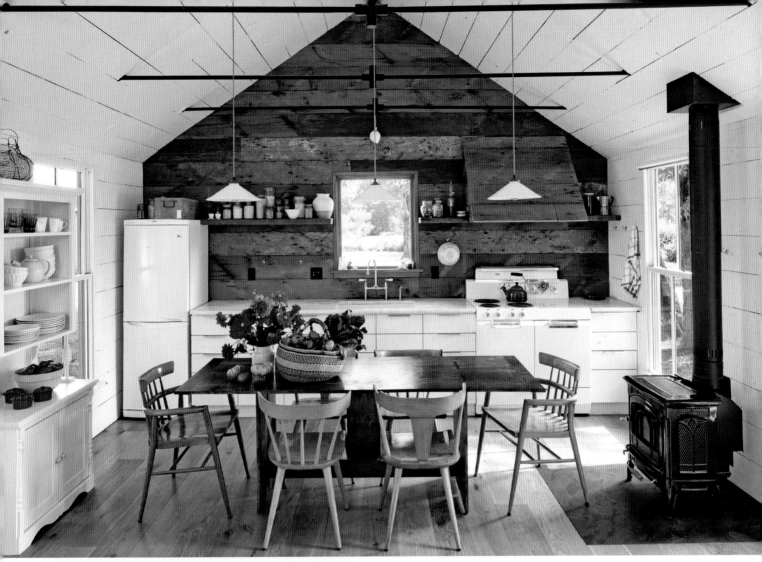

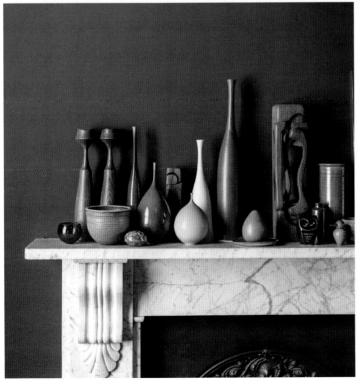

OPPOSITE Shooting from this angle allowed Christopher Stark to limit the view of the room and focus on a few key elements, such as the grouping of masks above an ornate chair and the warmth added by the fireplace.

LEFT A shot of an entire room doesn't necessarily tell the entire story. Try going in tight on a tablescape or vignette to display a well-chosen collection and nice architectural details, as Helen Cathcart did here.

ABOVE Lincoln Barbour used a wide-angle lens and cut off the top of the peaked ceiling to show the entire kitchen and create a feeling of spaciousness. The photo is lit naturally by sunlight streaming through a side door.

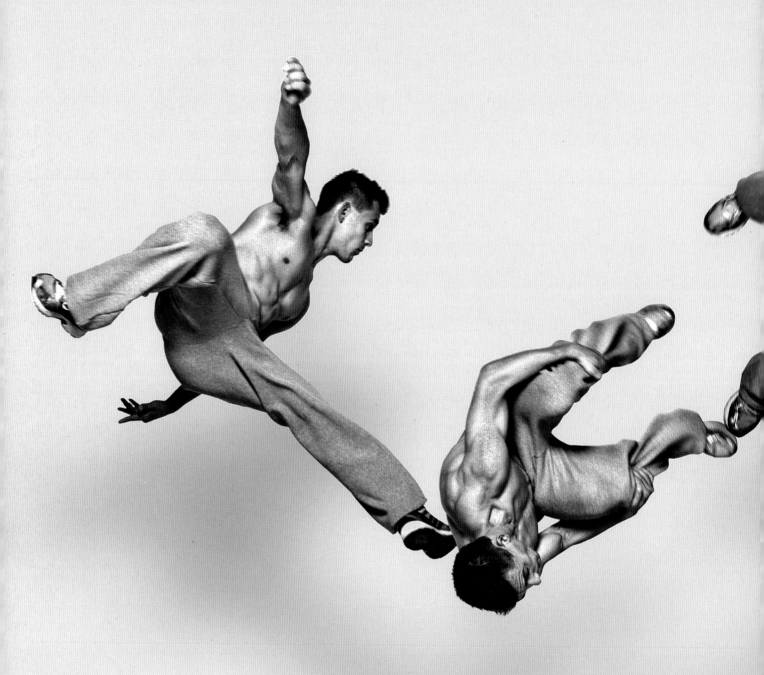

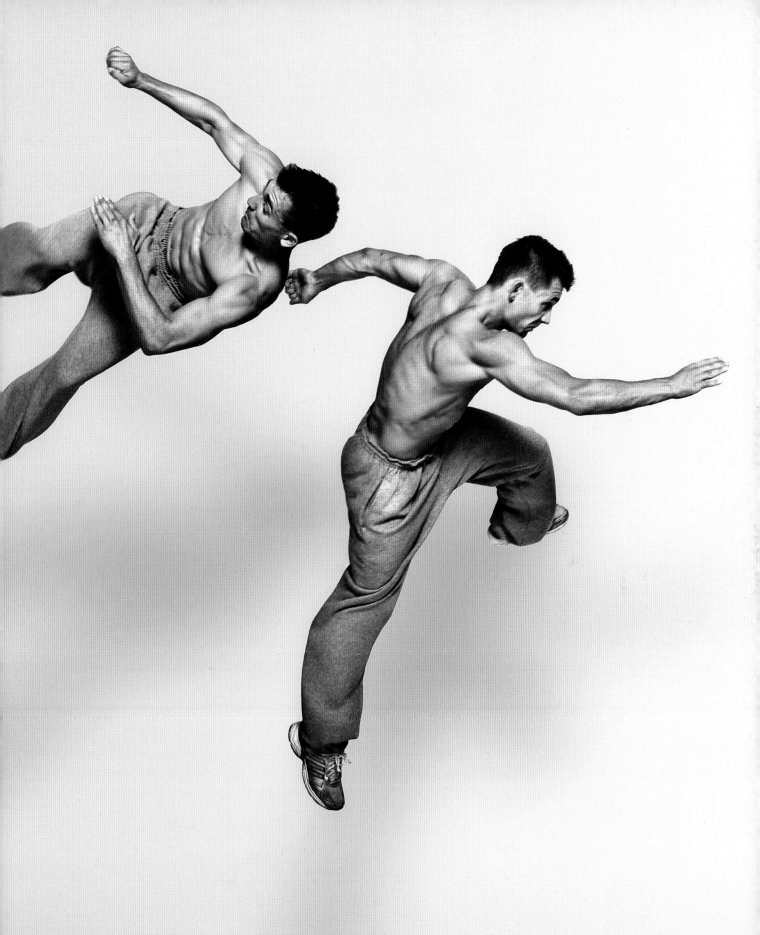

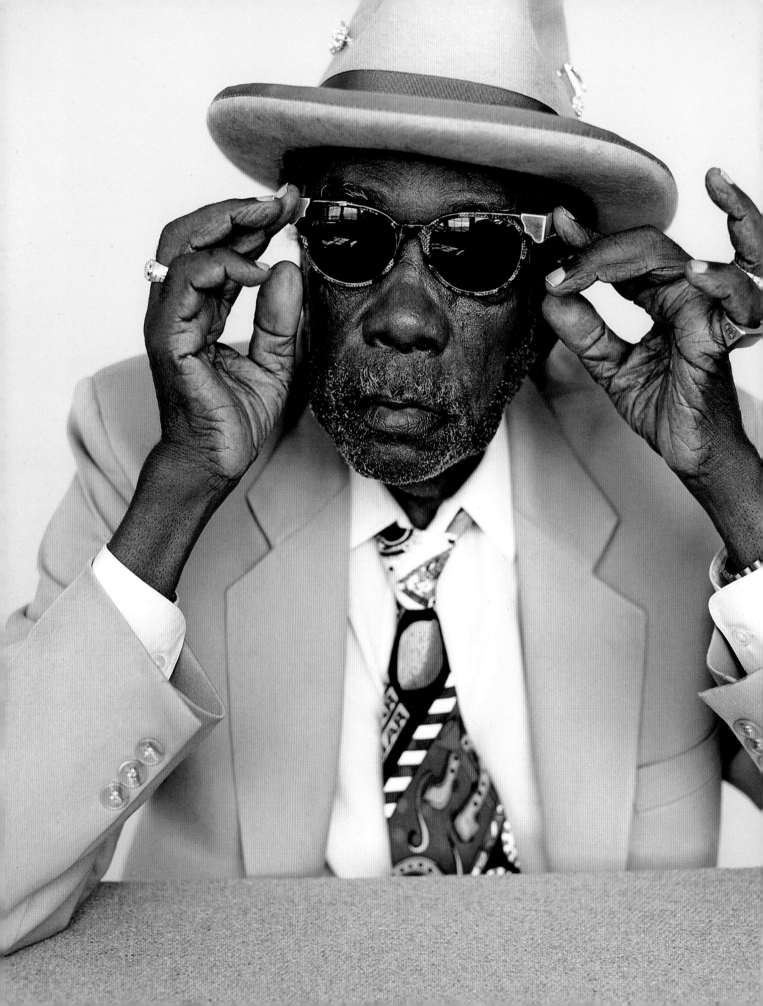

STUDIO PORTRAITS

LIGHTS, CAMERAS, BEAUTIFUL PEOPLE—the world of studio portraiture, with all its gear and complicated setups, can certainly intimidate. But adding artificial lighting to your repertoire photography skills will help you step up your game when portraying people—resulting in beautifully lit, impressively crafted portraits again and again.

GETTING STARTED

Your ideal photo studio may evoke visions of a large, light-filled room with natural wood floors, white walls, and racks of lighting gear. In reality, some photographers are more likely to rent a studio (most studio rentals either include lighting gear or allow you to rent equipment for an extra fee) or work out of their home in a spare guest room or a finished basement or garage. And, there's nothing wrong with taking your skills—and your gear—to a subject's home or on location for formal portrait shots.

If you're just starting out, abide by the keep-it-simple philosophy: a DSLR, a couple of lenses, and a basic lighting kit of one or two light sources and a few modifiers, and you're good to go. Study and practice various lighting setups until they become second nature, familiarizing yourself with ratios that flatter and styles that express a certain vibe, and then add your own special touch to develop a signature look. Practicing with yourself as a model will get you up to speed on your own time, and having a good grasp of poses will come in handy, too: Save photos of tried-and-true postures on your camera so you can share them with your subjects when inspiration runs low.

TECH TIPS

LIGHTING RATIO When working with multiple lights, measure the difference in f-stops between the light output to determine exposure and create different types of illumination. For example, a one-stop difference between the main and fill light is expressed as a 2:1 ratio. For more dramatic results, increase the ratio until you get the look you want and underexpose slightly.

AVEDON LIGHTING A style popularized by fashion photographer Richard Avedon, this scenario is clean and simple, with even lighting across the subject. As a bonus, you can easily achieve this look using a white backdrop and natural light.

BUTTERFLY LIGHTING This dramatic tactic features a light source placed directly in front of and slightly above a subject, angled at an angle of 25–75 degrees to create a butterfly-shaped shadow below the nose.

LOOP LIGHTING Highly flattering for most face shapes, loop lighting is achieved by having the subject face the camera directly and placing the light slightly higher than the subject's eye level, just to the side of and at a 35-degree angle to the camera.

WHAT TO SHOOT

The world of portraiture increasingly encompasses a broader range of genres: individuals, families, high-school seniors, maternity, babies, children, corporate environmental portraiture, headshots, and even pets. Poses, props, and lighting may vary but the end goal is the same: To make your subjects look at their best. Consider working with outside hair stylists and makeup artists, and maybe have a few accessories on hand as well.

Props and poses may vary depending on the nature of the portrait, but you can prepare for the shoot by speaking with the client and envisioning the types of desired images. A clean, white backdrop works well for headshots, while the setting for a high-school senior may involve props that speak to his or her personality.

Shoot children with pint-sized props, like a toy box or a mini-chair. Newborns, resting on a pillow or in a parent's hands, form display-worthy images and a chance to photograph the child throughout her life.

PAGES 200-201 Sometimes you plan to shoot one thing, and end up with a completely different concept. RC Rivera's original idea was to photograph this parkour artist jumping over a car, but when he saw the athlete jump, he decided to shoot a portrait combining many jumps in one.

PAGE 202 For Robert Schlatter, shooting a portrait is like conducting an interview in a single image—without posing. He sat Johnny Lee Hooker down just inside open shade so he was facing the light, creating soft illumination. Schlatter then tried to engage Hooker so that he forgot he was being shot.

OPPOSITE Simple props go a long way in creating a high-fashion feel, as the dramatic tulle headwrap used in this photo by Andres Chaves shows.

GEAR UP

Lenses A fast (f/1.4 or f/1.8) 85mm lens is, by many, considered to be the optimum portrait lens. Depending on the size of your studio space or location, you can consider an f/2.8 70-200mm lens as well. It's generally wide enough, particularly on a full-frame DSLR, to encompass group portraits. Prime lenses within these focal lengths are appropriate, although beware of wide-angle (e.g., 24mm) primes since they can distort.

Lights A moonlight will get you started. More expensive studio strobes have separate flash heads and power packs. They offer faster recycling times than moonlights and the option to set a very short flash duration.

Ringflash For beauty, fashion, and macro photography, look into a ringflash—a round strobe that is placed around the lens to deliver flattering light with soft shadows and round catchlights in the subject's eyes.

Light Modifiers Even more important than the lights you choose are the modifiers that shape that light. Basic umbrellas are portable, generally inexpensive, and can be used to reflect and, when the reflective panel is removed, to diffuse light by shooting through the umbrella. Perhaps the most useful of all light modifiers, softboxes are available in a wide variety of shapes and sizes. They create some of the most desirable light for portraiture.

Barn Doors This set of doors blocks and directs the light source and is most useful when you want to create dramatic spills of light.

Beauty Dish Essentially a concave reflector, this device goes around the light to create a concentrated spread of illumination over the face.

Remote Triggers Unless you use continuous lighting, you'll need a remote trigger to sync and fire the lights.

Lightstands Lighting kits come with a lightstand, but if you purchase lights separately or need more flexibility than the bundled stand provides, you'll need to pick up a lightstand for each light. Add some sandbags for lightstand stability and be sure to have an assortment of clamps, gaffer's tape, and other accessories to make it all work.

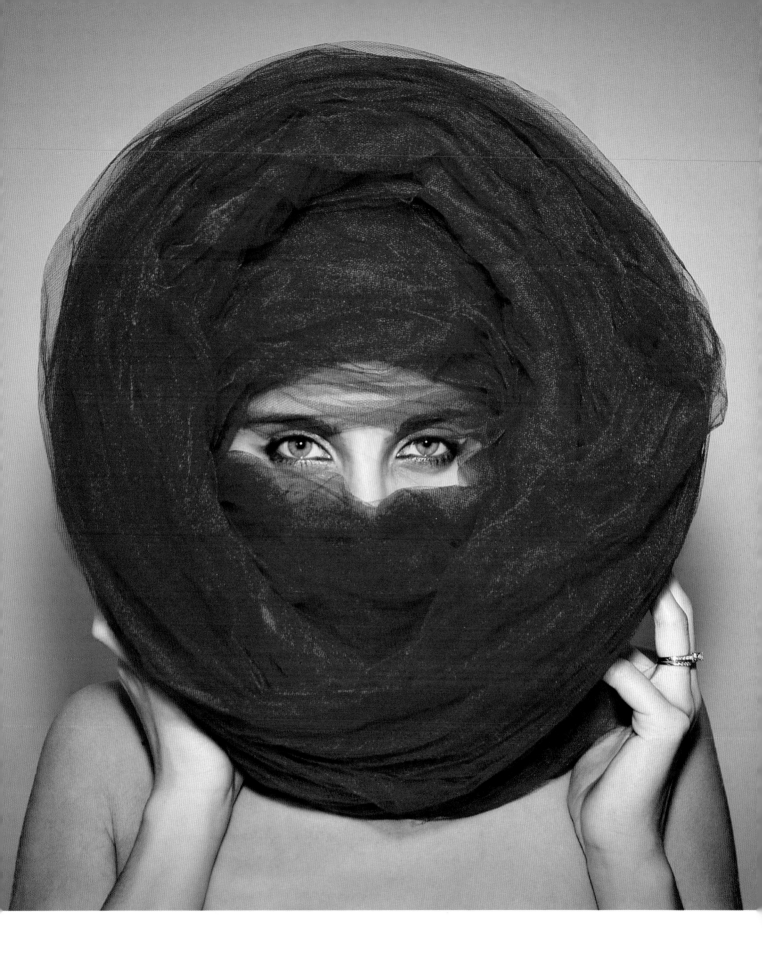

ABOVE High-key portraits wash over subjects with soft, white light and create a clean, minimalist look, as in Mick Fuhrimann's image here. To stage your own, position two lights with diffusers, one to the front on either side of your model, and overexpose slightly.

OPPOSITE Use harsh light and shadow to craft a dark, moody vibe, like in this shot by Vlad Lunin. Low-key portraits require a single light source focused intently on the subject (and possibly a reflector to distribute the light), a black background, and a slight underexposure.

PRODUCT

DESPITE APPEARANCES, product shots aren't just about things: They're about conceptualizing an object in a way that highlights its features and draws attention. So study the object that will be your photographic model and think about styling it in an eye-grabbing fashion, isolating it for dramatic effect, or putting it in an unusual scene that catches the eye or tells a story.

GETTING STARTED

From pros beefing up their portfolios to amateurs aiming to illustrate blogs or sell goods online, product shots are important to many photographers. They also can be a lot of fun to shoot, especially if you like the notion of heading into the mountains to photograph athletic gear in action, or tinkering in the studio to craft a beauty shot of an electronic gadget.

The core challenges of product photography involve the lighting and staging of the object you're shooting. The best place to manage those two elements is a studio, even if it's a make shift one set up in your garage or on a table outdoors. One of the simplest product-photography setups is of two inexpensive photofloods with umbrellas and a white seamless paper backdrop.

Pay attention to product photos you like and try to figure out how they were lit and staged. (Hint: Lots of clamps, poster putty, fishing wire, and improvised propping stands will help you keep products in place.) Once you've hatched ideas for your own product shots, assemble the gear you'll need to realize your vision, including lights, backdrops, and props.

TECH TIPS

EXPOSURE Motion is rarely an issue in product photography, so exposure is all about depth of field. That means shooting in aperture-priority or manual mode, stopping down to get everything in focus, or using a large aperture to emphasize a specific feature within a narrow focus zone. Use a tripod and the lowest possible ISO for optimum sharpness and image quality.

WHITE BALANCE Color accuracy is critical for product photography, so use a custom white balance. Ironically, the best target for a custom reading is a gray card. White cards can vary in color, and the light surface can overwhelm your camera if you are doing it with strobe.

FOCUS AND METERING Focus manually using your camera's live-view display and focus magnifier. For optimum depth of field, a focus point one-third of the way into the setup is the best starting point. Employ your camera's depth-of-field button or switch to check it in live view. Make a test photo to double-check focus, depth of field, and exposure. Use your camera's histogram and highlight warning display and shoot in RAW mode to avoid clipping highlight or shadow detail.

WHAT TO SHOOT

To craft a photo that shows a product in a flattering, disorienting, or exciting way, use the tools available: location, angle, composition, focal length, depth of field, and lighting. Classic catalog shots are closeups with out-of-focus backgrounds, but breaking the rules creates memorable images. Add interest by keeping the background in focus, placing your product on a reflective surface, or zooming in with a macro lens. To imply a story, shoot your product in a location that reinforces common associations (say, a wrench on a body shop's grease-stained floor) or subverts them—for instance, a jade necklace in the same setting.

In the studio, start out with a simple two-light, white-background setup. Then add drama with contrast-heightening lighting, larger shadows, and a lower camera angle. Start with your lights at a 30-to-45-degree angle from your product and adjust the distance and angle to change the light and shadow.

Consider positioning the product in unexpected ways—dangling it for a classic suspended-in-midair shot, or hanging it upside down, sideways, or in an unusual location.

PAGE 208 Mitchell Feinberg wanted to showcase the form and texture of an iconic luxury handbag without showing the bag itself. The answer was to create its impression in cornstarch.

OPPOSITE TOP John Kuczala shot this crystal-clear image of lab glassware by backlighting against a white backdrop and shooting in the dark, giving the glasses shape and transparency. "Pour a glass of wine or liquor and really look at it," he advises. "Hold it up in different types of light and against different backdrops until you notice something special."

OPPOSITE BOTTOM LEFT Altering apparel that possess great symbolic weight fascinates photo duo Jeremy Floto and Cassandra Warner. They destroyed these watches with a sledgehammer, then shot them mise en place. A moonlight with softbox and grid accentuated the broken texture.

OPPOSITE BOTTOM RIGHT Try to veer away from overly styled shots. Here, Mitch Feinberg threw guitar picks down on a light table over and over again until he saw something he liked.

GEAR UP

Lenses A standard 24-70mm f/2.8 zoom lens (17-50mm for crop-sensor cameras) is perfect for most product photography. Prime lenses can also be useful—especially a macro for detail shots of tiny products.

Filters A circular polarizing filter is critical for minimizing glare and reflections on products with lots of shiny surfaces.

Lighting Continuous lights work are easy to use, so you can focus on other variables.

Light Modifiers You may want to modify light with umbrellas, reflectors, or softboxes.

Tripod A good tripod and remote shutter release help keep your camera stable, regardless of shutter speed. That allows you to use lower ISO settings for better image quality, and smaller apertures for increased depth of field.

Acrylic A panel of clear acrylic will let you light a product dramatically from below (make sure the sheet you use is thick enough to support the weight of the products). A translucent panel (or just layering a clear panel with white paper or fabric) will give a softer and more diffused effect.

Armatures An armature in studio parlance is simple a piece of wire sturdy enough to support the object you're photographing in midair. You can simply clone armatures out in post-production. Photo putty will also keep products anchored at odd angles.

Backgrounds A roll of white seamless is a classic choice of background. Conversely, you can steam fabrics and hang them off stands for more texture.

Software For serious product photography, you'll want the best possible image-processing software—something that supports RAW files, layers, masking, color correction, and retouching.

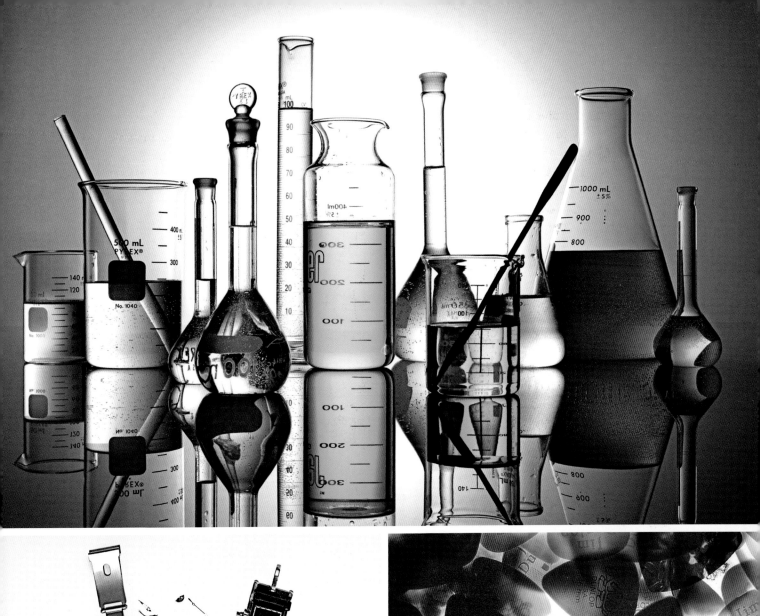

CARS & MOTORCYCLES

IF YOU'RE A FAN of classic chrome, supercars, or racing, you may want to take some serious pictures of some serious wheels. Shooting photographs of vehicles can be fun, challenging, and rewarding. Provided you've got the technique down and the right equipment, you can create dramatic still beauty shots and even capture high-octane action on the road or track.

GETTING STARTED

Most photographers don't have a studio large enough to accommodate cars or motorcycles. It's also difficult to get access to vehicles—especially exotic sports cars. So the best place to start may be shooting your own or a friend's car in a public place. Roadside pullouts with interesting backgrounds are perfect. Cityscapes, bodies of water, mountains, and interesting architecture all make dramatic backdrops.

The best way to shoot a moving car or bike is from a chase vehicle. Your ride doesn't need to be fast, since keeping the shutter open for several seconds creates an illusion of speed even if you're puttering along. Shooting from a pickup bed is great, since you have an unobstructed view and plenty of room for you and your equipment. If you want to mount a camera to your chase vehicle, you'll need gear like an articulated support arm, a suction cup, and clamps.

To expand your vehicular options, check out car clubs, motorcycle shows, and race tracks. Access makes a huge difference at races, so try to get a photo pass or sneak into the spots professional photographers vie for: the corners right behind the safety barriers.

TECH TIPS

EXPOSURE Use manual shooting modes for maximum control. If you want to keep things simple, try aperture-priority mode for still subjects and shutter-priority mode to catch vehicles in motion.

WHITE BALANCE Auto white balance is usually the best bet—especially if you're shooting in RAW mode, since you can tweak things later. If you're dealing with man-made or mixed light, custom white balance is worth the extra effort.

METERING Evaluative metering works great in modern cameras and generally delivers excellent exposures. Use your camera's histogram and highlight-warning display so you don't under- or overexpose.

FOCUS When focusing on still vehicles, check your depth of field to make sure everything you want sharp is in focus, and any distracting background elements are blurred out. At the track, the most foolproof focusing method is to prefocus where you plan to take your picture. However, with practice and good technique, a DSLR with good continuous autofocus offers more flexibility and delivers more in-focus photos.

WHAT TO SHOOT

The four core car photos that every hotrod-lover lusts after are the hero shot, the environmental portrait, the action shot, and the detail closeup. For a hero shot, use a wide-angle lens and shoot from a low angle to give the car or motorcycle a bigger-than-life look. For a compelling environmental photo, shoot a four-wheel-drive truck with a steep dirt road in the background. If it's a luxury car, you might photograph it in a mansion's circular driveway.

For action shots, use a telephoto lens, set your camera's mode dial to shutter priority or manual, select a shutter speed of 1/1000 sec or faster, and set the drive mode to high-speed burst. To convey a feeling of motion, try panning—following your subject with the camera as you take a picture. Start with a shutter speed of 1/250 sec.

Mounting a camera to a chase vehicle and holding the shutter open for several seconds is another way to convey a sense of speed, complete with streaky blurred lights.

Finally, don't forget the detail shots. Use a macro lens and fill the entire frame with your chosen part, be it a wheel, hood ornament, or headlight.

PAGE 212 Inspired by flashy car photos in magazines, Erich Chen shot this—his first—studio-style portrait of a Lamborghini Gallardo. He used several flash units, flags, and wireless remote triggers until he found an arrangement that accentuated every curve and contour.

OPPOSITE Get up close to document repeating patterns of shiny mechanics, as Kaspars Grinvalds did of these classic bikes all parked in a row. When shooting chrome, try to position the bike in shade or on an overcast day so it doesn't reflect a hot spot of the sun.

GEAR UP

Lenses You should have a couple of fast-aperture zoom lenses—preferably an f/2.8 standard zoom, such as a 24-70mm, and a 70-200mm f/2.8 telephoto zoom. A telephoto prime lens like a 300mm f/2.8 is great for photographing motor sports. They're pricey, so you might consider renting one.

Tripod A tripod is mandatory if you're shooting at night, at an indoor car show, or any other time you need to use slow shutter speeds.

Filters A circular polarizing filter minimizes glare and reflections while increasing color saturation and contrast in car finishes. Polarizing filters also make cloudy skies much more dramatic—perfect for outdoor hero shots and environmental car photos.

Mounts You'll need heavy-duty clamps, support arms, and suction cups to mount a camera on a vehicle. A low-tech option is to wrap the camera strap around your arm and lean out the window—but watch out for obstacles!

Teleconverter If you already have a fast, i.e. f/2.8, telephoto or tele-zoom, a teleconverter is a less expensive way to get an extended focal length. Consider a 1.4x or 2x converter, and be sure to buy the one made by the lens manufacturer specifically for your lens; otherwise you will risk unsharp shots. Teleconverters are not appropriate for kit zoom lenses. Also keep in mind that a converter will dim the image through your lens.

Earplugs Seriously. If you're photographing motorsports close to the track, you will risk hearing damage if you don't use earplugs. Pro motorsports photographers do.

OPPOSITE Positioned on the outside of a hairpin bend, Shan Moore was able to stand briefly in front of the frenzied, oncoming racers and capture the battered terrain as well as the spectators in the background. He kept his distance by using a telephoto lens and was able to focus sharply on the bikers with a portrait orientation.

ABOVE Sometimes, speed is all an illusion. For this shot at the Red Bull Ring in Austria, Philip Platzer attached a camera rig to the car and slowly pushed it as he triggered the shutter remotely to avoid vibration. A slow shutter speed of 2 sec blurred the background to mimic panning. After grabbing the shot, Platzer removed the camera rig in image-editing software.

SPORTS

|||

ACTION AND EXCITEMENT are integral components of sports—and, if done right, of sports photography as well. Whether you're a passionate fan or you just appreciate the photographic possibilities of bodies in motion, shooting sports is both challenging and rewarding. So get out there and nab a shot of the winning touchdown or a skateboarder's killer moves.

|||

GETTING STARTED

Sports photography is as varied as the wonderful world of sports itself. When picking your subject, consider both your allegiances (documenting the home team) and your aesthetics (you may not know much about polo, but everything from the horses in the field to the hats of the spectators in the stands make for visual gold).

Although most professional sporting events limit the equipment you can bring into the game, chances to shoot amateur sporting events abound. Check out schedules for school teams and adult scrimmages, or maybe just head over to the local tennis courts or high dive at the college pool. Some sporting events may require nothing more than showing up with your camera, although the players are likely to be more receptive—and let you return on a regular basis—if you chat with them before whipping out your camera.

Do a little homework about the sport and the participants. Knowing the rules of the game and the personalities and quirks of the athletes will help you capture outstanding images by having your lens trained on the right player at the right time.

TECH TIPS

EXPOSURE AND DEPTH OF FIELD A shutter speed of at least 1/1000 sec should be fast enough to freeze most action shots in available light. To separate athletes from the background, open the lens to its fastest aperture, such as f/2.8, and, when required, boost the ISO to reach the needed manual exposure balance. Aperture settings of around f/8 should provide enough depth of field to include players and in-focus backgrounds—including animated spectators.

FOCUS Set the camera to continuous autofocus and high-speed burst to capture movement. Not every shot will be a keeper; but with burst mode, you increase the odds. While RAW capture is usually recommended, it may seriously slow down burst mode, as well as limit the buffer to a handful of shots, so switch to JPEG-only capture. If you're tracking motion with your camera, prefocus, then use high-speed burst mode and a shutter between 1/250 to 1/1000 sec.

WHITE BALANCE Major sporting events likely have a lot of mixed lighting, so manually set the white balance according to the conditions in the stadium or arena.

WHAT TO SHOOT

When shooting a sporting event, go after the peak action or decisive moment: a football player catching a pass, a tennis ace returning a serve, or a bull throwing a cowboy from its back. Remember, sports are about emotion as much as action. Capture an athlete's reactions to a goal or a bad call, or document group shots of the winning (or losing) team at game's end. Audience reactions are important as well, so point your lens into the stands.

Panning—using your camera to track motion—is a wonderful technique for bicycle races and other events where the subject is moving in a continuous forward line. When done right, panning keeps the subject sharp while blurring out the background. Plant your feet and turn from the waist to shoot as the cyclist or runner passes by.

Wide-angle shots of the venue help present the full story, but if you're after unusual perspectives, experiment with camera placement. Mount a small action camera on a cyclist's helmet to get a first-person view of a race, or attach a camera to the top of a goalpost and remotely trigger the shutter for a bird's-eye view of the winning kick.

PAGES 218-219 Using multiple exposures, Max Rossi captured the lightning-fast snips and swipes made by each of these Olympic fencing semifinalists.

PAGE 220 Bring viewers impossibly close to the action with a cleverly mounted action cam. For this shot of a pro player dunking, Layne Murdoch secured his camera to the hoop's backboard and fired remotely.

OPPOSITE Alan Aaron used a 100–400mm zoom telephoto lens to capture this bold, humorous shot of tennis champ Maria Sharapova through a frame made by her opponent's legs.

GEAR UP

Lenses Fast lenses—f/2.8 or faster—are the best option, regardless of the event. A wide-open lens lets in more light, which is important when shooting at night or indoors, and delivers the shallow depth of field that helps separate a subject from the background. A wide-angle telephoto zoom, say from 18-300mm, will help you get in close.

Tele-extender Consider a tele-extender to gain focal length when subjects move from one end of the field or court.

Monopod A monopod is a great help when working with long lenses, but when you may need to run down the field at any moment for a shot.

Flash Gear Lighting that will allow high-speed shooting is expensive, but you can rent what you need: strobes; a high-speed, fast-recycling power pack;

modifiers; stands; and a set of remote triggers. Practice with the flash gear beforehand so you're ready for the action on location.

Action Camera If you plan to shoot some POV footage or stills, bring along an action cam and mounts appropriate for the sport (such as a helmet or a bicycle handlebar).

Radio-Remote Trigger You will need a wireless trigger to fire a remotely mounted camera or strobes—say, above the

backboard in a basketball court. There are a number of models from different companies, but the gold standard is considered the PocketWizard. Make sure that whatever brand and model you buy is compatible with your camera and flashes.

High-Power Battery Grip Most DSLRs can accept a dedicated vertical grip that can provide additional battery power. These will extend your shooting, and may also increase burst rate.

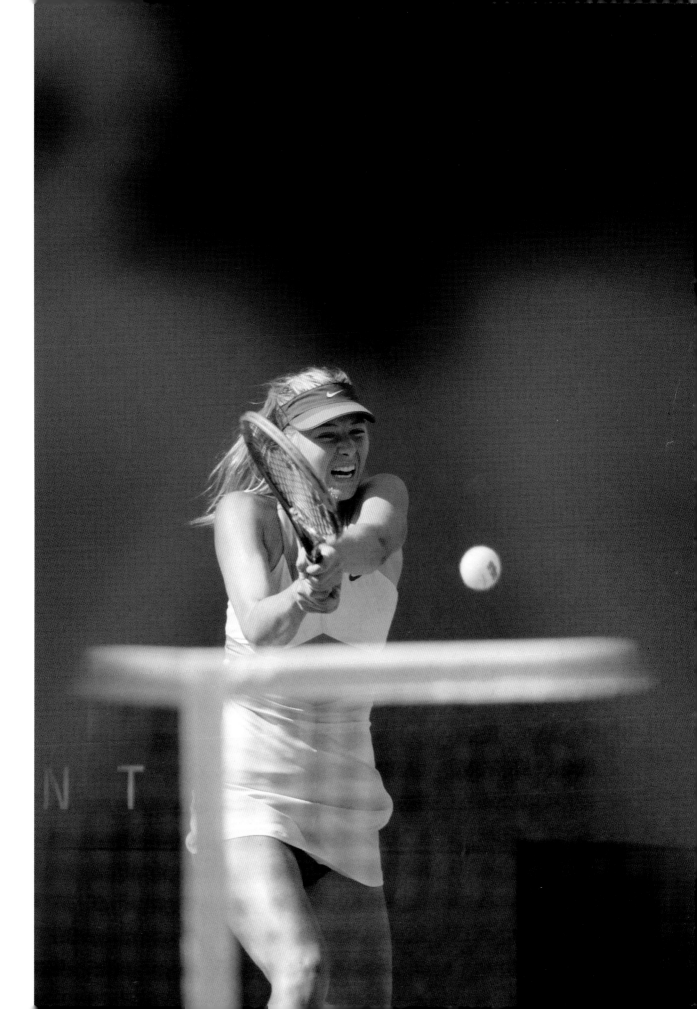

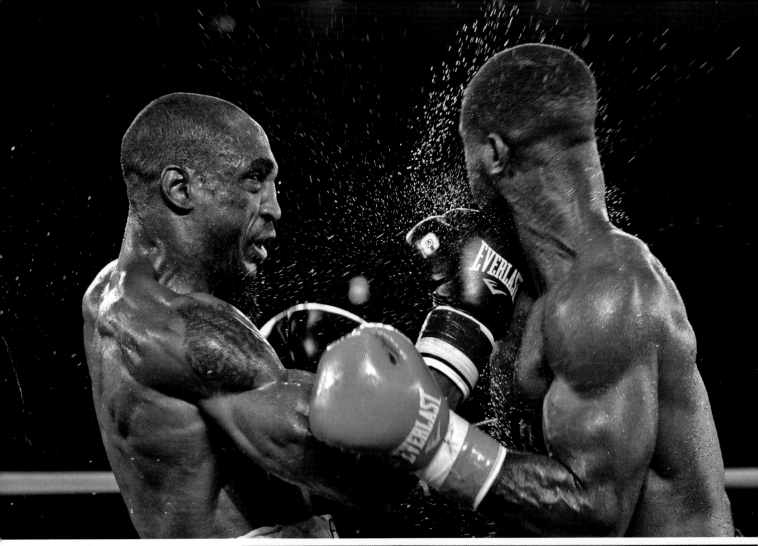

OPPOSITE TOP "A very large part of sports photography is timing and anticipation," says Tri Nguyen, who counteracted poor lighting at this boxing match with ISO 1600, 1/500-sec shutter speed, and f2.8 f-stop. He later converted the image to black and white to highlight the sprays of sweat and intensify the grittiness of the match.

OPPOSITE BOTTOM "Panning is a uniquely effective way to convey movement in a photo," says Olympic shooter Streeter Lecka. Here, he sharply captured Sweden's Susanna Kallur in the hurdles, while rendering all else a smear of motion blur. His shutter speed? A relatively sluggish 1/32 sec.

ABOVE Lilyana Vynogradova bumped up her shutter speed to capture Elena Rega in mid-revolution on the uneven bars. Olympic photographers encourage potential shooters to carry a teleconverter to get close shots from the designated nose bleed areas in the stands.

OPPOSITE TOP "Capturing a full scene is one of the more important aspects of action photography, because it gives a story to the image and creates a sense of place," says Connor Walberg, who chose to shoot this skier with a wide-angle lens to show the sheer size of the drop and capture the blue sky. A bonus of shooting in the snow: It acts as a giant reflector on a bright day.

OPPOSITE BOTTOM Who says you need to be on the sidelines to grab a compelling photograph? Gary Zakrzewski shot this image off his TV set, using a long exposure time of 1/4 sec at f/13 and ISO 200. He blurred the players by zooming in during exposure and moving his camera in random motions.

ABOVE A shot at the goal headed toward the protective glass in front of David Klutho, forcing him to fire off several pictures in rapid succession before the puck hit. Pros typically shoot hockey at ISO 2,000 with a shutter speed of 1/1000 sec at f/4. Hockey arenas are notorious for tricky lighting due to the many shades of white in the signage, uniforms, and ice. Set your white balance off the ice to keep it from looking gray.

UNCONVENTIONAL CONVENTIONS

POPULAR ICONS from the world of comics, movies, and TV come to vivid life at themed conventions, where costumed actors and fans don otherworldly attire, dramatic makeup, and elaborate masks. Pack up your camera and head over to one of these celebrations of the otherworldly and outlandish. You're certain to capture offbeat portraits—and have a ton of fun while you're at it.

GETTING STARTED

You'll find plenty of willing and interesting subjects among the masses at the various conventions. While most are based on a genre (such as Comic-Con) or a movie or TV show (like Star Trek), you don't need to be a comic book aficionado or a Trekkie to participate. Just be prepared to deal with crowds—including other photographers vying for the attention of costumed heroes and villains.

Many conventions have photography restrictions, so study up in advance. Be considerate and travel light in the exhibition hall; you don't want to invoke the wrath of Khan (or other convention-goers) by clogging crowded aisles. Instead, place yourself in the lobby or outside the entrance—you'll be right in the flow of attendees and primed for photo ops. (Another plus: You won't have to buy pricey tickets.) If you can, have a friend stake out a spot near a solid-colored wall that can serve as a backdrop, then approach intended subjects in a friendly manner. With this exhibitionist group, offering to share the photos goes a long way. Give out cards with your contact info, or use the recording feature on your camera or phone to keep track of their details.

TECH TIPS

WHITE BALANCE It can be tricky to get accurate white balance with convention centers' mixed indoor lighting. Shoot RAW or RAW + JPEG, and use a flash or set the white balance manually with a white paper or board—or even better, a gray card. Keep in mind, too, that garish costumes with a predominating color can also throw off automatic white balance, and beware of shooting against backgrounds that are not neutral colors.

EXPOSURE Take a meter reading off Darth Vader's black robes and your exposure will be a couple of stops over, and render the evil one as middle gray. Similarly, a meter reading of a Star Wars stormtrooper's white armor will push the exposure a couple of stops under, resulting in gray warriors. While autoexposure is a good option at conventions, be prepared to hit the exposure-compensation button to make appropriate adjustments. A light meter can help setting a quick manual exposure.

FOCUS Autofocus will work well, as you will be dealing with subjects ready to strike and hold a pose. Use a central focus point and single-shot autofocus to lock onto your subject's eye.

ABOVE This villainous duo stands in sharp focus on a sunny day in an image by Norman Chan. An aperture setting of f/1.4 gives the photograph a small depth of field, separating the subjects from the background.

RIGHT To enhance this Joker's surreal and mocking character, Andrew Boyle shot wider than usual, warping the perspective slightly but taking care not to foreshorten it. He also applied a blue cast to the image and used layers in image-editing software to tease out shadow and detail.

WHAT TO SHOOT

Your main goal when you head to a themed convention is to capture portraits of the most striking attendees, either individually or in small groups. Sometimes friends or families come outfitted as a team, which is great for group photos. Otherwise, home in on the individual with a full body shot and, if the makeup is particularly interesting, a headshot encompassing the face, neck, and shoulders. For a more dynamic photo, encourage a little prop-wielding and play-acting to showcase the character's traits. Don't worry, most people dressed up at conventions aren't shy!

While having your own little impromptu studio set up against a wall is great, sometimes you'll need to wade into a group of photographers gathered around an especially intriguing subject. Frame tightly to crop out the competition, then try shooting wider to show the other photographers in action. You can hold the camera above your head and shoot into the fray, too.

If it gets too crowded inside, take up a position outside the venue. That also lets you take a photojournalistic approach, nabbing scene-setting images of the venue and arriving participants.

PAGE 228 Using a gray wall as a background, Chris Gampat shot this stark, head-on portrait of a caped crusader at the New York Comic-Con. He got up close and personal with a wide focal length of 35mm, a shutter speed of 1/125 sec an aperture of f/5.6, and ISO 100. He set up a portable strobe and parabolic umbrella to soften the light and triggered the shutter remotely.

GEAR UP

Lenses Choose a lens that zooms from about 28mm–85mm so you can capture wide shots as well as portraits. In crowded aisles, zoom your lens to wide angle, since you'll be close to your subjects. If you plan to attend a presentation and want to photograph the people on stage, bring a long telephoto lens.

Accessory Flash Use an off-camera flash to pop some light onto the subject. The camera's built-in flash will make your shots garish, especially with all that bad interior lighting. If there's not enough available light, hold an off-camera flash at an angle to your subject. Alternatively, use a white wall or ceiling to bounce the flash. You can also mount an LED (continuous light source) to the camera's hotshoe. An LED light is useful for shooting video, too.

Reflector Bring a small collapsible reflector to direct light from windows or outdoors onto your subject, eliminating shadows.

Backdrop A backdrop and stand provide a smooth, solid background against which to photograph. Beware, though: Setting up a backdrop may be prohibited. To minimize the risk of getting evicted from the site, try to find an out-of-the-way corner for shooting.

Light Meter These meters measure the light falling on, not reflecting from, your subject, so you will be able to quickly determine a manual exposure setting for your black- or white-clad subjects, or those against very light or very dark backgrounds.

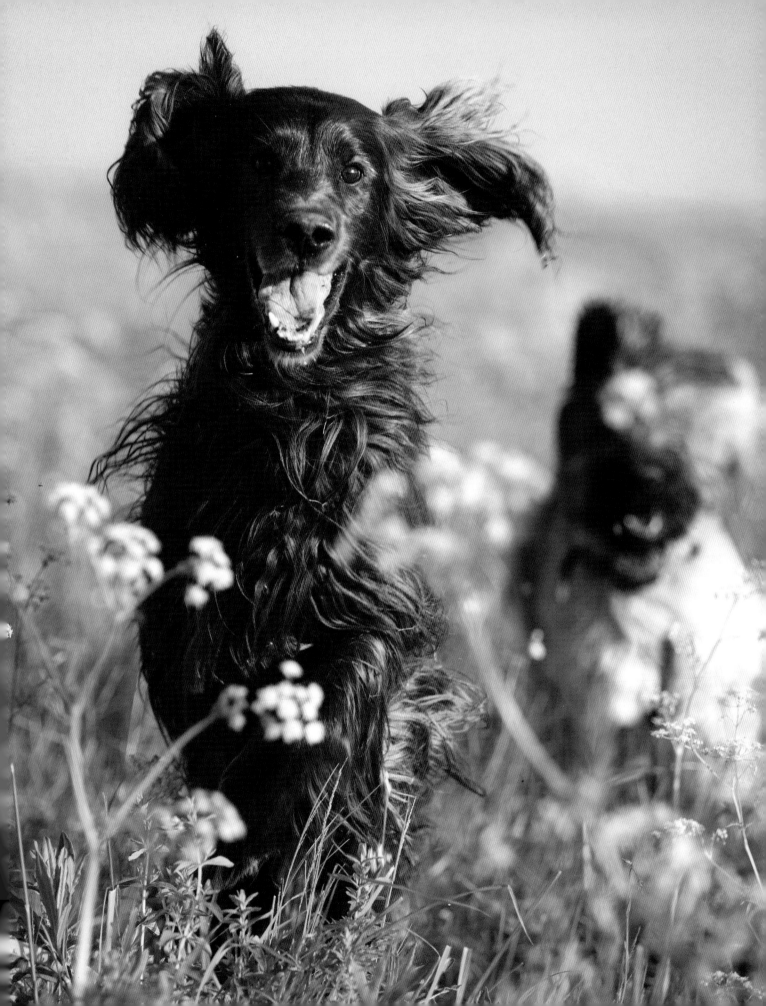

PETS

PHOTOGRAPHY OF ANIMAL COMPANIONS falls into two broad categories. There are snapshots—pictures on your phone of Fluffy or Rex that you share with friends. Then there are carefully composed and well-lit portraits of your furry, feathered, or scaly companions. If you want to do justice to your subject, both as a photographer and as a pet lover, those portraits are worth the effort.

GETTING STARTED

Planning is as important to pet portraiture as it is to the human variety, but some of the considerations are different. For starters, there's perspective to think about. Most portraits are shot at or near the subject's eye level to capture personality, but your pet's eye level and yours may differ considerably. If you have to get down low to go eye-to-eye with your pet, keep cushions or footstools at the ready for yourself, as well as a beanbag or bendable tripod for your camera. And because pets' behavior is more mercurial than humans', you need to work fast. Set up your camera so it's ready before the shoot—focus, drive settings, and exposure—and charge that battery.

Cats and dogs are as different in their reactions to cameras as, well, cats and dogs. For blasé creatures like cats, wave a favorite toy, make an attention-getting noise, or wiggle a treat nearby. For hyper-attentive species such as dogs, a modest feeding beforehand may chill them out. Experiment with various tones of voice. See how behaviors change at different times of day. Try gradually habituating a pet to a studio setup in your home, rather than expecting him to pose like a pro from the get-go.

TECH TIPS

EXPOSURE For most situations, autoexposure is best; you can use aperture-priority auto for the right depth of field in formal shoots, or shutter-priority auto for rambunctious subjects on the move. In either case, be sure to set a high enough ISO.

WHITE BALANCE If you're relying on a room's lamplight for illumination, auto white balance should work well as long as all the bulbs have the same color temperature. Higher Kelvin numbers (5,500) are bluer and closer to daylight, while lower Kelvin numbers (2,500) are yellower and closer in warmth to traditional tungsten lightbulbs.

FOCUS Single-shot autofocus, using a central focusing point, will work with a reasonably placid subject. For action shots in the backyard, switch to continuous autofocus, and, if needed, multipoint autofocus.

LIVE VIEW This is a big plus, especially if the LCD screen can be tilted up for low-angle shots.

FLASH Some animals are virtually oblivious to flash; others may freak out at the first pop. Know your animal companion's tendencies.

WHAT TO SHOOT

Speed and patience both come in handy when shooting pets. Reactions may be fleeting, so learn to be quick on the shutter button.

For more formal portraiture, consider lighting and background. A continuous light source or an accessory flash can be bounced from an opposite wall for flattering, softbox-like illumination. You can keep the background simple: Just move any clutter out of the frame and maybe spread out a neutral-colored throw on a pet's favorite chair.

Or head outdoors for an environmental portrait that captures your dog in a favorite activity, like rolling in something pungent on the beach. Use a slightly lower shutter speed than you might ordinarily to make for a little blur in the photo, and try for a pan of your pooch racing for a ball across the yard. Finally, consider including your child, or even yourself (use a self-timer or a remote trigger), in a pet portrait. Those aren't just portraits of a pet, but of a relationship.

Not all pets are of the canine or feline variety, of course—don't forget your friends in aquariums and stables. Macro shots of smaller reptilian or avian animal companions will faithfully present their fascinating textures, while for larger creatures, such as horses or goats, try using a zoom lens to achieve both detail and full-body shots.

PAGE 232 Drago Nika captured this frolicking Red Irish Setter in full sprint under bright natural light and with a fast shutter speed to avoid blurriness. Getting down to the pooch's level makes it easier for the viewer to connect to the creature.

OPPOSITE Toys, snacks, or noisemakers can be used to guide your pet's attention—some even wrap a lens in bacon. Since the focal point shifts all the time due to young pets' unpredictable movements, it's also a good idea to use autofocus.

GEAR UP

Lenses A 100mm f/2.8 (or faster) double normal portrait telephoto offers several advantages over the typical kit zoom: longer reach and, more important, a bright maximum aperture for faster and surer autofocus and faster shutter speeds when needed. Also, it provides flawless perspective for animal (and human) facial portraits. The closer-focusing the lens, the better. Constant aperture wide-to-short tele lenses such as the 24mm–70mm f/2.8 zoom provide brighter images than less-expensive kit zooms—making them a good choice for the lens you keep on the camera for ready shooting.

Accessory Flash If your pet will tolerate flash, one (or two) of these can provide excellent lighting options. Most current units can be controlled wirelessly from the camera. Top-of-the-line models have as much power as some portable studio flash units, so you can aim them into umbrellas or position them in softboxes. A simpler alternative: Mount a TTL unit on a light stand (or bendable tripod) and aim it into a corner of two walls and the ceiling; the effect is similar to that of an umbrella light.

Bendable Tripod You can attach this device to most anything (including, if need be, your knee or thigh), and setup and breakdown can be near instantaneous.

LED Light Panel These provide continuous lighting (usable with video, too), run cool, use little power, and put out consistent color temperature (some even have variable color temperature).

Smartphone A growing number of DSLRs and ILCs can be operated remotely via iOS or Android phones. This can make for easy adjustment and firing of low- or otherwise weird-angled cameras.

Beanbag You're going to be near or on the ground much of the time if you want to make good animal portraits. The beanbag sets up fast, and keeps the camera steady.

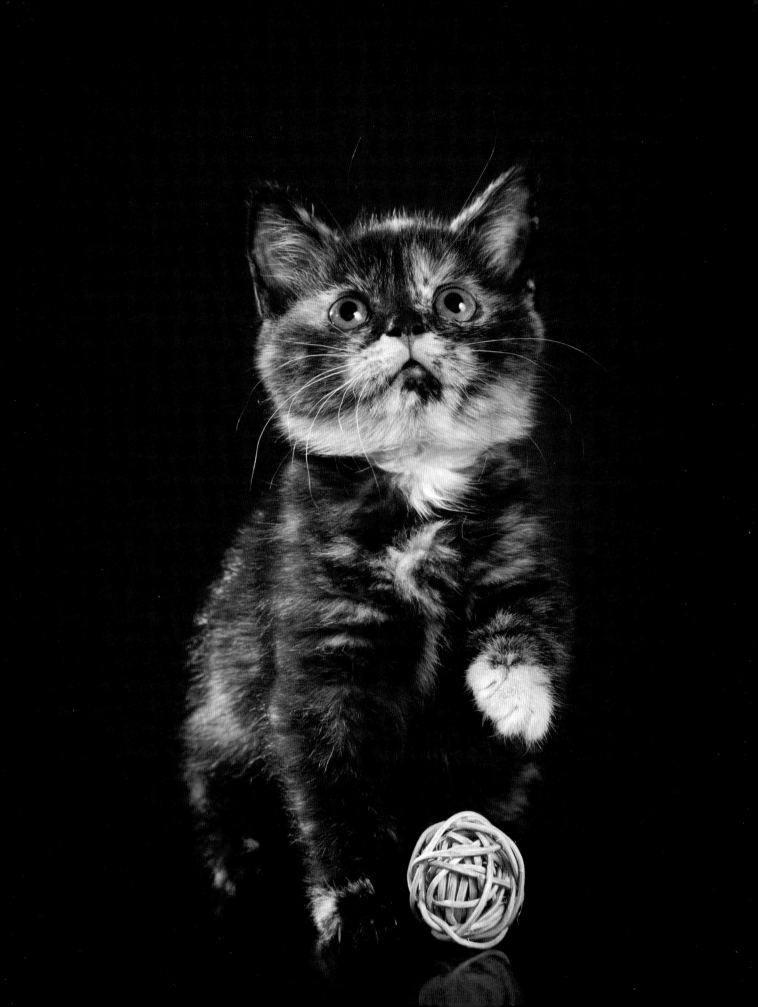

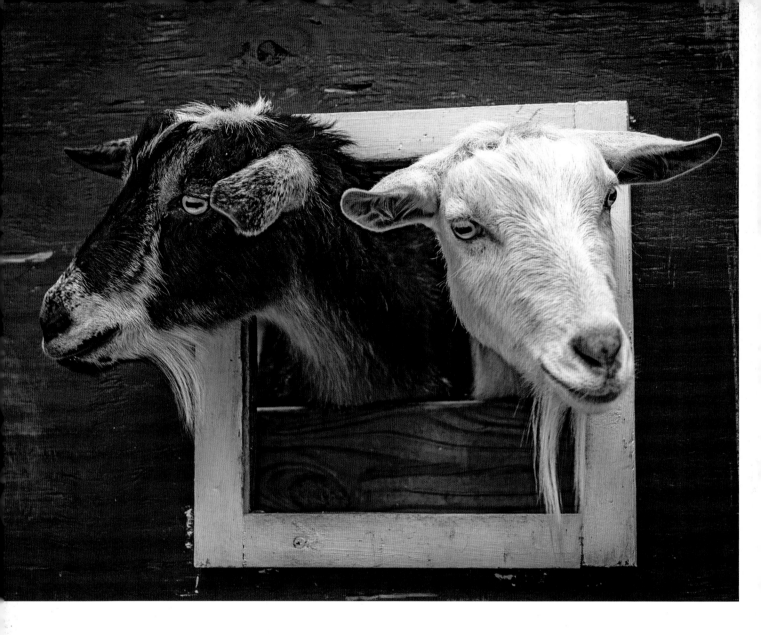

ABOVE Two heads are better than one—that's what Bill Killillay discovered when this pair of friendly goats ran into their enclosure at a petting zoo, peered out of a mutual window, and began begging. The white and red barn gave Killillay a richly colored, simple background. He shot with a focal length of 70mm, a shutter speed of 1/160 sec, an f-stop of f/5.6, and at ISO 250.

OPPOSITE TOP T. C. Morgan shot this days-old baby chick in his studio, using two strobes and two 27-inch (68.5-cm) softboxes to bathe his subject in broad, gentle light.

OPPOSITE BOTTOM Don't miss the moments that show the love between your pets and your family—especially when toddlers and puppies are involved, as in Antonio Diaz's shot here.

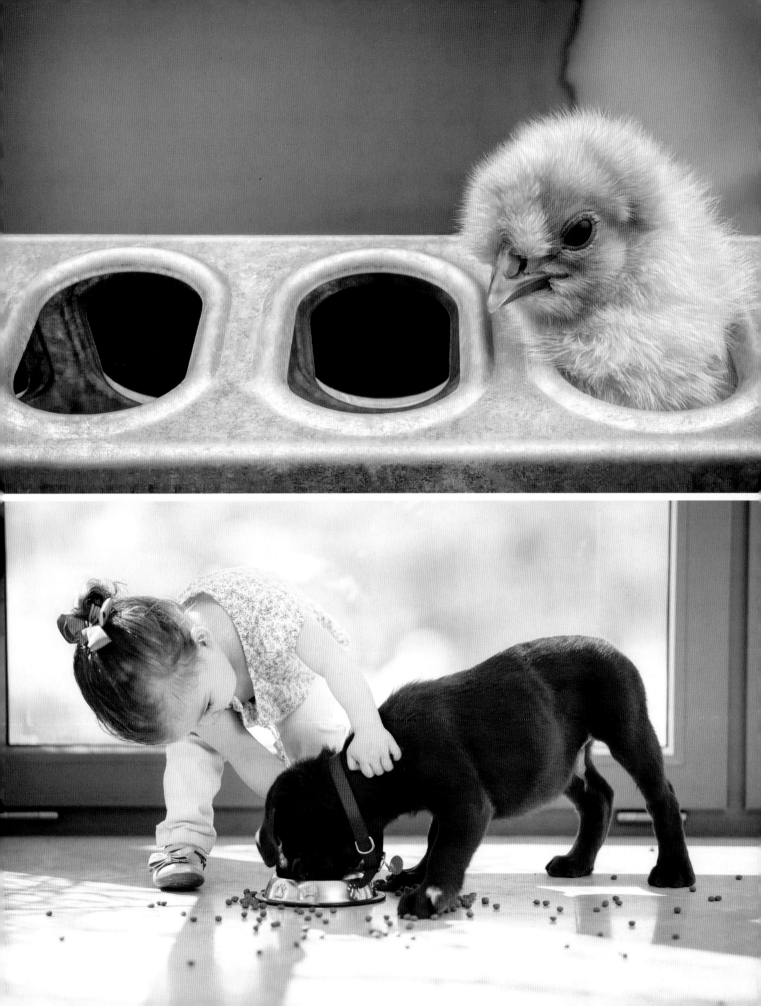

FRIENDS & FAMILY

OUR LOVED ONES are often our most photographed subjects. In these days of cell-phone cameras, we constantly document their everyday moments. But to craft a true portrait of the people you care about most, combine your knowledge of photography with your insight into the friend or family member on the other side of your lens.

GETTING STARTED

Whether posed or candid, taken in a controlled studio environment or out on a seaside hike, true portraits capture the heart and soul of your subject. Think about the telling detail you hope to capture: a gap-toothed grin, affectionate body language, or a characteristic action. To have a hope of capturing that kind of detail, creating an atmosphere in which your subjects are relaxed enough to reveal intimate parts of who they are is critical to your job—even more so than choosing what exposure mode to use.

Shoot your subject in a setting that puts them at ease. For some, that might be their kitchen; for others, a golf course. If you're shooting more than one person, the setting should be one that allows your subjects to interact in a natural way. If you're after a casual portrait, don't worry too much about the background, beyond making sure there's no clutter mucking up the shot. But if you're after a more formal portrait, pay attention to wardrobe and background selections. Group portraits work best when everyone wears similar tones, and individuals look their loveliest when their apparel and backdrop contrast nicely with their natural coloration.

TECH TIPS

FOCUS Let your camera's face-detection tool automatically focus on and expose for the face. Otherwise, place your focus point on the subject's eyes. Use continuous autofocus for subjects on the move.

IMAGE STABILIZATION Since you'll be handholding the camera for most shots, turn on your lens' image-stabilization switch to help avoid blurred images.

EXPOSURE In most family or friend situations, autoexposure is the way to go. For more careful setups where you want to control depth of field, aperture-priority is best; this will allow you to use shallow depth of field (for defocused background clutter) or deep depth (for environmental portraits showing their living space). For fast-moving family fun, shutter-priority is the better option. In either case, make sure the ISO is high enough to allow a blur-preventing shutter speed—worry about noise in post-processing.

DRIVE MODE For the calm scenes, single-shot drive is sufficient (and is less intrusive). For the family volleyball game, burst mode will make a peak action shot more likely.

WHAT TO SHOOT

Individual photos become character studies when you catch your subject being himself, whether that's dissolving in giggles or gazing thoughtfully out a window. Group shots can offer insight into relationships if people are interacting with each other. Make sure you take some shots that zoom in on details, like expressive hands or laughing eyes. Most important, stay alert so you and your camera can catch sudden flashes of true personality: You're after a surprising detail or a fleeting moment that says it all, and those tend to come and go quickly.

Comfort in front of the camera is the biggest determinant of the success of a photo shoot involving family and friends. You don't want people sitting stiffly and gazing nervously into your lens; you want them being themselves. In general, keeping the tone light and chatty will help put people at ease, and the more you shoot, the more comfortable they're likely to feel in front of the camera. Go light on the photography gear so you can stay spontaneous and nimble in the moment and, when dealing with groups, encourage connections by getting subjects to talk, touch, and laugh. Build trust by showing your models especially nice shots on your camera's LCD.

PAGE 238 Arrange your subjects into a traditional pose and give them permission to do whatever they want—shout, make a funny face, or kiss, as in this hilarious portrait by Lora Swinson.

ABOVE Try positioning your subject by a window for soft, flattering illumination, as Erin Kunkel did here. Experiment with the subject's distance from the window and the angle of his or her face in the light, and try a wide aperture for a blown-out background.

OPPOSITE You wouldn't know it from looking at Eric Schumacher's portrait, but exposing for people with different skin tones in the same image can be tricky. Expose for the midrange to avoid losing detail and highlight so that both subjects look their best.

GEAR UP

Lens A wide-angle-to-telephoto zoom lens is the most versatile lens for portraits, providing a variety of focal lengths for any shooting situation. When set at a wide angle, for example, it can encompass a group of people and their environment. Midway through the focal range (85mm–105mm) is the gold standard for single-subject portraits. Fast lenses, with small apertures, serve two key purposes: They soften backgrounds while keeping the main subject in focus, and they allow you to shoot in low light.

Accessory Flash To flatter your subjects and prevent red-eye, turn off the camera's flash. If you want fill flash, use an accessory flash mounted on the camera, held off to the side, or bounced off the walls or ceiling.

Reflector Pack a small, collapsible reflector to redirect available light and open up subjects on a backlit subject.

Diffuser A translucent reflector or a length of sheer fabric can soften harsh light.

Props When photographing kids, a little distraction can go a long way. Bring along a toy or other amusement to focus attention and coax out delighted expressions.

Software Lightly retouch blemishes, red-eye, and other unwanted elements so your subjects look their best. Don't overdo it, though: Portraits should be realistic. Shoot in color, but consider changing your images to black and white in post-processing.

OPPOSITE Victor Simacek likes to keep his portraits simple so the emphasis is truly on the subject. Here, he used a white backdrop and a beyond-basic pose to accentuate his model's expressive hair and piercings.

ABOVE If you look closely, a person's hands can reveal as much about them as his or her face. Ilya Andriyanov had her subject relax her hands in front of a playful, floral-patterned blouse, highlighting the subject's experience and personality. A good rule of thumb is to keep your model's hands relaxed to prevent tension and stress, to opt for a short shutter speed, and to shoot in shutter-priority mode for sharpness.

ABOVE When shooting older individuals, go for soft, diffused lighting—it flatters by minimizing wrinkles and other signs of age. Converting the image to black and white also helps conceal minor imperfections, as in this image of a mother and her sons by Eric Schumacher. An added plus: People of previous generations tend to like the classic look of black-and-white images.

OPPOSITE Cameras can make kids and teenagers feel self-conscious, so the more playful you can make the experience, the better. Suggest props and activities that sound fun—like playing with a bunch of flowers, as Terri Burke's daughter does in this photo. Put your camera in burst mode and follow the action, avoiding tripods, lights, and extra gear that intimidate and get in the way.

STREET PHOTOGRAPHY

IN THE STREET, we cross paths with people we'd never meet at home, we bring our closest relationships out from behind closed doors, we buy and sell and bargain, and we form and transform the spaces we share. What happens when strangers mingle, and what does our public life say about us? Street photographers look for the moments that propose an answer.

GETTING STARTED

As with hopscotch, stickball, and other pastimes that take place in the street, you don't need much to get out and have a good time doing street photography. The classic camera for the genre is a rangefinder with a prime lens in the 28mm to 50mm range, but the main requirement is simplicity and unobtrusiveness: It's the art of observing the everyday life around you, so your gear should never be the center of attention.

Street photography is mostly about people, and every photographer has to develop an approach to them. Some try to be inconspicuous and take candid shots, while others openly interact with their subjects. Either way is fine, but don't be sneaky and remember that the goal is to enlighten—not to exploit.

To start, just walk out your door and practice. If you're nervous about photographing strangers, start at events where people expect to be photographed, like parades (see pages 268–271), or going to a crowded tourist spot. If you're shooting in a foreign country, find out whether there are off-limits subjects and learn the polite way to ask someone if you can take their picture.

TECH TIPS

EXPOSURE Keep your shutter speed at 1/250 sec or higher to get sharp images of people walking. For crisp foreground and background elements, go with an aperture of f/8 or smaller. Given those limitations, your ISO setting will be the exposure parameter that you can be most flexible with as the light level falls in the evening. In dim light, boost your ISO. If your shots come out noisy, convert them to black and white for a classic grainy look.

FOCUS Tracking (aka "continuous" or "servo") autofocus modes can help with moving subjects, and face tracking can keep people heading toward you in focus. If you have a manual focus lens with a depth of field scale, you can shoot quickly, remain inconspicuous, and keep your eyes on the scene by zone focusing. Without using your viewfinder, aim your lens at your subject and eyeball the distance. Then set your aperture and focus ring so that the depth of field scale indicates that everything you want to be in focus falls within the distance range indicated. Using an aperture between f/8 and f/16 should give you ample depth of field.

WHAT TO SHOOT

Composition is one of the most important aspects of street photography. Choosing what to include in your image frame is a way of drawing out the patterns and narratives in street scenes that seem random at first. Look for elements that contrast with, mirror, or engage each other. Pay attention to what's happening in the background and the near foreground. See what the scene looks like from a low angle, or get up high and look down. Seek out the juxtapositions and interactions that we usually pass by without noticing. While many street images have an off-the-cuff, candid air about them, another popular approach is to pause interesting individuals for portraits against a wall or otherwise scenic backdrop.

Practice panning to capture sharp shots of passing subjects against a motion-blurred background and to give an indication of the city's bustle. To pan, pick out a subject approaching you and swivel your body to move in tandem with the person as he or she passes, releasing your shutter as you turn.

PAGE 246 Great street photos show people interacting with their environments in interesting ways. Here, Sivan Askayo nearly filled her frame with street art, but left room in the lower left corner for a couple pointing at the artwork. In a lucky coincidence, the couple is dressed in clothing that ties into the palette of the artwork itself.

OPPOSITE TOP Jamie Laurie wasn't out to take pictures the day he photographed this street-dancer performer in London's Trafalgar Square—he just happened to have his point-and-shoot on him. He dialed down exposure by 1/3 to 1/2 stop, which resulted in deeper definition in shadows.

OPPOSITE BOTTOM Jack Morey photographed this laughing child and mother in jovial pursuit in a rough area of Shanghai. "They gave a breath of fresh air to an otherwise dull street," Morey says. Look for similar moments of surprise and juxtaposition to tell an unexpected story about a place.

GEAR UP

Lens A wide-to-normal lens has a focal length equivalent to 50mm on a 35mm or full-frame camera. The view it offers is closest to that of the human eye. That or a slightly wider view is favored by street photographers for the naturalness of the images it captures, as well as the shooting distance it requires, which is usually close enough to mingle with people but not too close.

Filters A UV filter will protect your lens from moisture and debris, while a circular polarizer will eliminate unwanted glare and reflections and make images look more vivid.

Software Black-and-white remains a classic look for street photography to this day. While standard image editors like Adobe Photoshop let you make good monochrome conversions (always shoot in RAW color first), some plug-in apps provide a wide variety of presets and profiles for specific B&W effects—including film looks—along with sliders to vary those effects at your whim.

Rechargeable Batteries Because sometimes the most interesting shot happens at day's end.

WiFi-Capable Memory Card Seek out memory cards that can back up your images while you're out, by automatically uploading your photos to online destinations or other devices via WiFi.

Lens and Viewfinder Hoods Avoid lens flare in bright light by using a lenshood. If you'll be using your LCD as a viewfinder on sunny days, a viewfinder hood can make the onscreen image easier to see.

Camera Strap If the strap that came with your camera doesn't make it comfortable and secure to carry for long periods, or if it gets in the way when you shoot, look at other options from third-party strap makers.

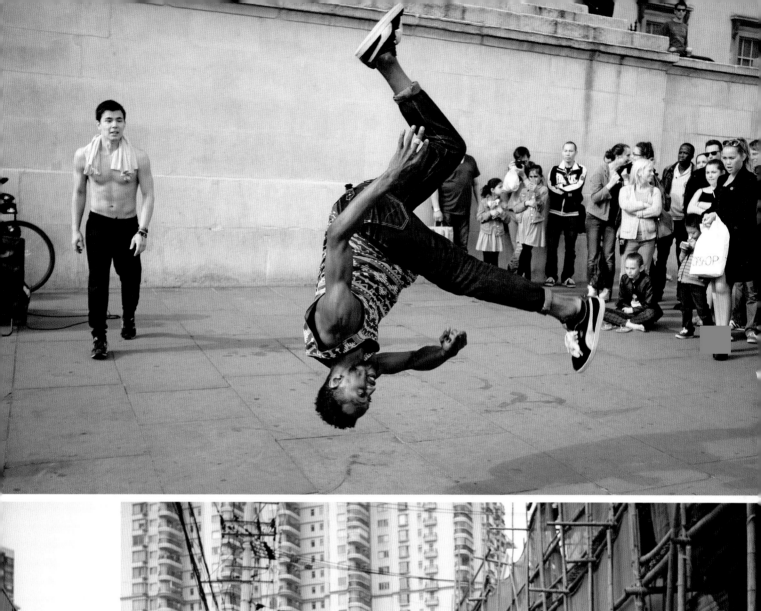

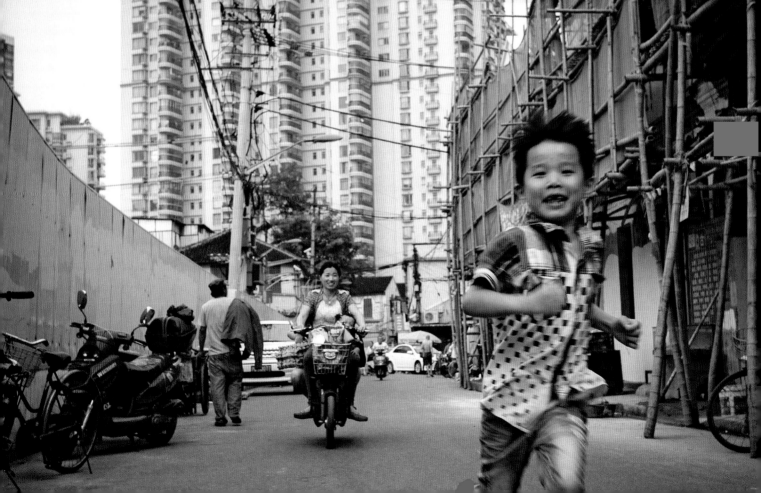

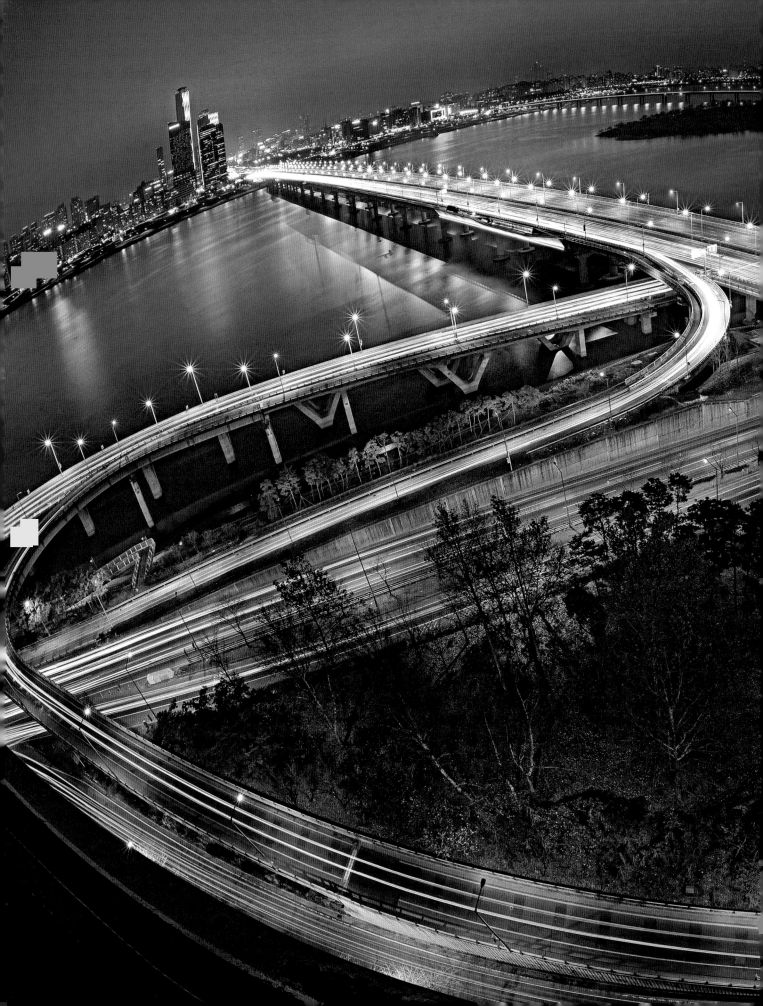

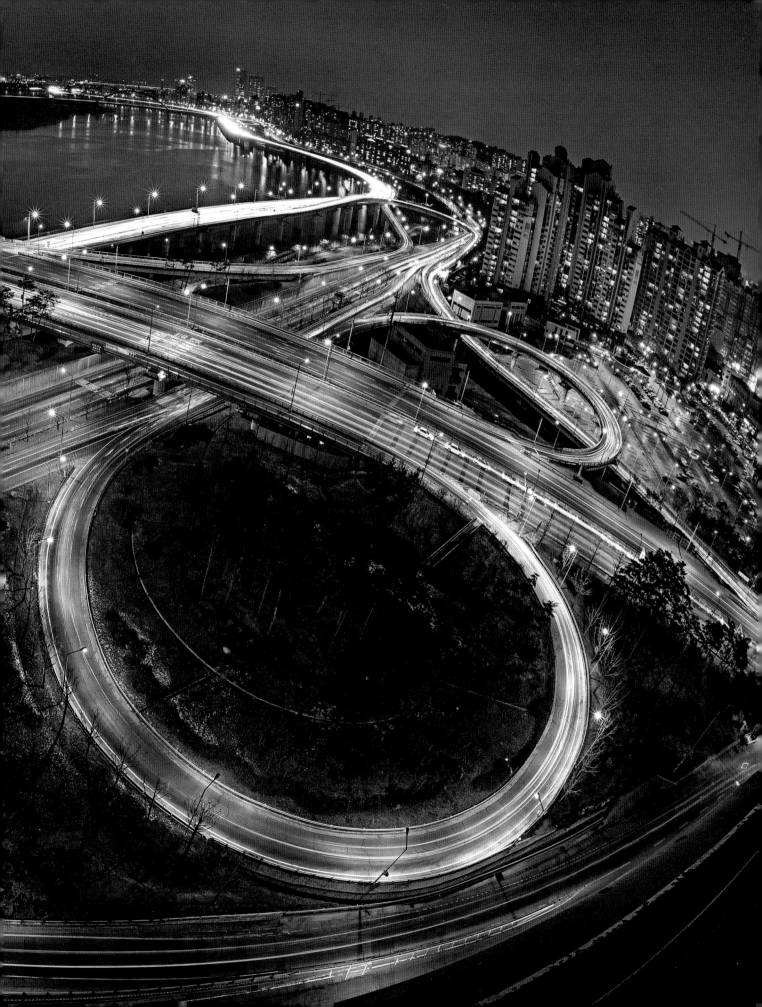

THE CITY AT NIGHT

CITIES COME ALIVE after dark, presenting photo ops that range from the vibrant glow of neon-scripted signs to the dingy menace of an alley lit by a single streetlight. Darkened skies create moody backdrops, and brightly lit store windows silhouette people passing by. To capture alluring night scenes, you'll need a sharp eye and a camera with good low-light capabilities.

GETTING STARTED

Low-light and night photography often requires long exposures and high ISO settings. So before you venture out into the night, work with your camera to get a feel for how it behaves under those conditions. Take some test shots varying exposure times, ISO levels, and in-camera noise reduction. Shooting in both JPEG and RAW modes gives you comparison shots to help you judge how far to push your camera settings and whether noise reduction is best done in camera or on your computer after the shoot is done.

Make location scouting a priority. Jot down notes about scenes and angles that are visually enticing at night. Photographing on the street or public property generally entails few restrictions, although setting up a tripod in crowded areas may be prohibited.

Finally, decide when you want to shoot. Midnight black can make for a dramatic backdrop, but sometimes the best way to showcase a skyline is against the rich hues that emerge during dawn and twilight. Painters and photographers refer to that time frame as the blue hour, since it yields subtle colors that give depth to a picture.

TECH TIPS

EXPOSURE Aperture-priority or manual exposure modes are ideal. Set the aperture between f/8–32 for the best depth of field. If you want individual lights to look like stars instead of out-of-focus blobs, go with an aperture of around f/16. If you'll be shooting larger cityscapes, choose a broader metering mode. Handheld shots require a higher ISO to reach a faster shutter speed, but to incorporate motion into the shots (people walking, cars passing), use a tripod and set the shutter to 1/6 sec or slower, depending on the lighting.

WHITE BALANCE Your camera's automatic white balance is easily fooled, so you probably need to get involved. Try to determine the temperature of the main light source (such as tungsten or fluorescent) and go with the preset or manual white balance that matches the scene. Shoot in RAW or JPEG + RAW to tweak the white balance in post-processing, if necessary.

FOCUS Manual focus is generally the way to go in low light. If the camera is mounted on a tripod, use live view and any manual-focus features your camera has, such as focus peaking or a zoomed-in view.

WHAT TO SHOOT

Nighttime in the city offers myriad photographic opportunities, and the most breathtaking images may be sweeping overviews of the cityscape. High perspectives are the best way to capture those, although looking across a body of water—a river, for instance—also affords an expansive view of the city and its twinkling lights.

Shooting from street level packs a different kind of visual punch. If you're photographing a larger space like a park, shoot wide but compose around a point of interest that will draw the viewer's eye into the scene. Play with tighter shots focused on details like a neon sign or a mannequin in a lit-up window. In fact, windows can create some of the most interesting nighttime effects. Depending on the lighting, they might offer kaleidoscopic reflections or intriguing glimpses of illuminated interiors.

Movement—both human and vehicular—can greatly enhance urban night shots. Experiment with illuminating people as well as leaving them in silhouette, and use slow shutter speeds to turn passersby into ghostly apparitions. To transform traffic into elongated streaks of light, use a long exposure and a tripod.

PAGES 250–251 Shot by Almer Frades with a 16mm fisheye lens, this ultrawide, panoramic view of Seoul is the final 30-sec exposure of a time-lapse sequence of 550-plus images.

PAGE 252 Dan Bracaglia captured a bustling night in Times Square, blurring the motion of traffic and passersby with an exposure time of 2 sec. He was able to bump the total luminosity and increase contrast in post-processing.

OPPOSITE TOP Robin Hill composed this image of sunset over the Miami skyline so that a balcony railing divides the outside and inside. Hill used tungsten lights to warm up the interior and boost the exposure, heightening the contrast between the vivid, cool blues of the exterior scene and the warm, wan look of the room inside.

OPPOSITE BOTTOM For this moody shot of reflections on a midtown Manhattan building's windows, Dan Bracaglia climbed to a rooftop and balanced his camera—equipped with an 18mm–200mm lens—on top of a railing. His lens was set at 70mm and his camera to 1/10 sec at f/5.6 and ISO 1600.

GEAR UP

Radio-Remote Shutter To hold the camera as still as possible, use a remote trigger to activate the shutter during extended exposures or slower shutter speeds. In a pinch, use the camera's self-timer; however, this function limits the length of exposure.

Lenses A wide-angle zoom is the most useful for night scenes since it's likely you'll be shooting from a variety of angles and distances. Wide-angle primes, from about 24mm to 35mm (the latter for full-frame DSLRs), work well for close-distance street scenes. The good news is that slow lenses, in the range of f/3.5 to f/5.6, should work fine, since it's likely you'll be stopping down the lens somewhere between f/8 and f/32 most of the time. Attaching a fast lens to your camera is always a plus, especially if it's image-stabilized to steady handheld shots.

Tripod or Monopod A sturdy but lightweight tripod is a must for long-exposure shots. If you're walking around town, try a carbon-fiber tripod to keep the weight down. A better alternative to a tripod—particularly in crowded urban settings—may be a monopod. Not as steady, for sure, but quicker to set up, and many fold up to very small size.

They can also come in handy for raising your camera above crowd level, e.g., in Times Square.

Software Urban scenes at night are usually mixed lighting—on steroids. RAW capture as always is the best option, and a RAW conversion program that has become a near-universal standard is Adobe Lightroom, which will allow all sorts of tweaks in conversion. But keep in mind that the converter that came on a disk with your camera—or is available for download—will likely be quite adept at this task, too.

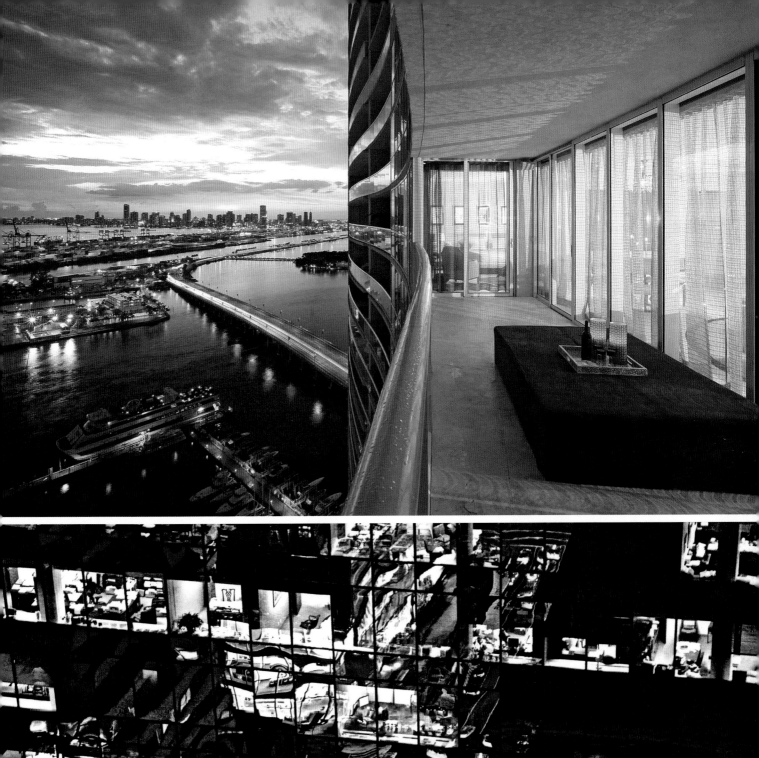

CONCERTS

||

SOME RELISH the pounding rhythms of heavy metal or the twang of country; others thrill to the soulful sound of a violin concerto. Whatever the music, the best way to experience it is to hear it performed live—and capture the highlights in photos. Concert images may be silent to the ear, but they speak volumes about musicians and fans.

||

GETTING STARTED

Music is everywhere, from large concert halls and outdoor festivals to impromptu performances on subway platforms and outside shopping malls. You can generally photograph street musicians and buskers any time and with any type of camera, so that's probably the easiest way to catch musicians in action. Ask first, and be sure to toss a little something into the hat or guitar case.

Photographing in small clubs and intimate venues is probably the next-easiest option. Tap your musician friends to see where they're playing and offer to photograph their gigs. Check out local clubs and barter your images with the band in exchange for prime access.

For other musical performances—including your child's recital—unless you get permission to photograph beforehand, picture-taking may be restricted to discreet shots from your seat with a compact camera. Concert venues and outdoor festivals often limit photographic gear to small, non-interchangeable-lens cameras. To gain more leeway, see if you can shoot during a rehearsal.

TECH TIPS

EXPOSURE Stage lighting can be surprisingly bright. Maintain a minimum of a 1/125-sec shutter speed (faster for longer lenses) with an aperture of about f/3.5 or faster (f/2.8). Bump the ISO as high as needed and use exposure compensation to adjust for lighting changes. Or set ISO to automatic and manually lock in shutter speed and f/stop settings, letting the camera adjust light sensitivity as you shoot.

FLASH Turn off the camera's on-board flash and shoot with available light. If you're in a small venue and or close to your subjects, use an off-camera flash at very low power such as 1/8 or 1/16th. Be sure the shutter is set below the camera's fastest sync speed and bounce the flash off the ceiling or wall, when possible.

WHITE BALANCE Use a preset such as tungsten if the light is consistent; if it's not, go automatic.

FOCUS Continuous autofocus should keep up with the musicians' moves as you shoot in Burst mode.

METERING Set metering to be center-weighted; spot-meter on the subject's face if the lighting is uneven.

WHAT TO SHOOT

If you're a longtime fan, you can probably anticipate the lead singer's signature leap or the drummer's kickass solo. If the band's new to you, study its music and moves in online videos so you're ready to roll when the guitarist rocks out.

Proximity to the performers dictates which shots to go after. When you're close enough, wide-angle views of the entire group are a must. If you've got a telephoto zoom, you can take full-band photos from more distant positions; when you're nearer the stage, a telephoto is great for closeups of a single performer. Try to catch the pianist's concentration as she reaches a crescendo, or a bluegrass performer's hands flying up the neck of a banjo. To better your chances, pack plenty of memory and take lots of shots—or shoot in burst (continuous) mode.

You can shoot one-handed overhead if you want to cut out the girls pogoing in front of you, but sometimes the audience is the best part of the scene. So don't be bummed if you're stuck in the nosebleed seats or the back of a festival mob. Go wide to encompass the crowd, leaving the stage and band as a component of the composition. Focus on your fellow music lovers reacting to the music and each other.

PAGE 256 A fast 55mm, f/2.8 lens and a 1/500-sec exposure helped Sami Siilin freeze this head-banging guitarist in action—including the beads of sweat as they flew from his brow.

OPPOSITE Even when you can't use flash, live productions often have their own stunning visual effects, which make for great photo opportunities. Here, Veleda Thorsson took advantage of the mood created by theatrical fog and a starburst of lighting to capture this bass guitarist in a climactic moment.

GEAR UP

Compact Cameras and Smartphones If you can't bring a DSLR or ILC into the venue, bring a camera that's small enough to pass through security without problems. Ideally, it should feature an ISO of at least 3,200, a fast (f/2.8 or higher) lens, and an image-stabilized zoom. A high megapixel count lets you crop an image to get a closer photo of the band with less degradation than with a low-resolution image.

Lenses Lenses with f/2.8 or faster apertures are highly recommended. A wide-angle zoom or prime, with a field of view starting at 24mm or 28mm, works well when aimed into the crowd or positioned close to the stage. An image-stabilized telephoto zoom (70–200mm) is useful for tight shots and photographing from a distance. Lenses much longer than 200mm will be unwieldy, particularly in a crowd.

Specialty Lenses For wild and cool special effects, consider a full-frame fisheye lens for your DSLR or ILC. (Too expensive for you tastes? Consider renting one.) They are especially effective if you can get close to the stage, but they can also provide an altered perspective from the back of the hall, too. A selective focus LensBaby, with its ability to radically reduce depth of field for the so-called miniature effect, is another way to put a personal stamp on your concert photography.

Software Typically, photos of music performances—including classical performances in traditional concert halls—are a ghastly mess of mixed lighting and a contrast range that can blow your images to smithereens. For starters, use RAW capture to get as much info the image file. Even rollicking rock concerts don't involve that much action—you don't need burst mode, just good timing in single-shot—so RAW capture is perfectly viable, and you can make a high-dynamic-range image from a single raw file in many of today's image editors.

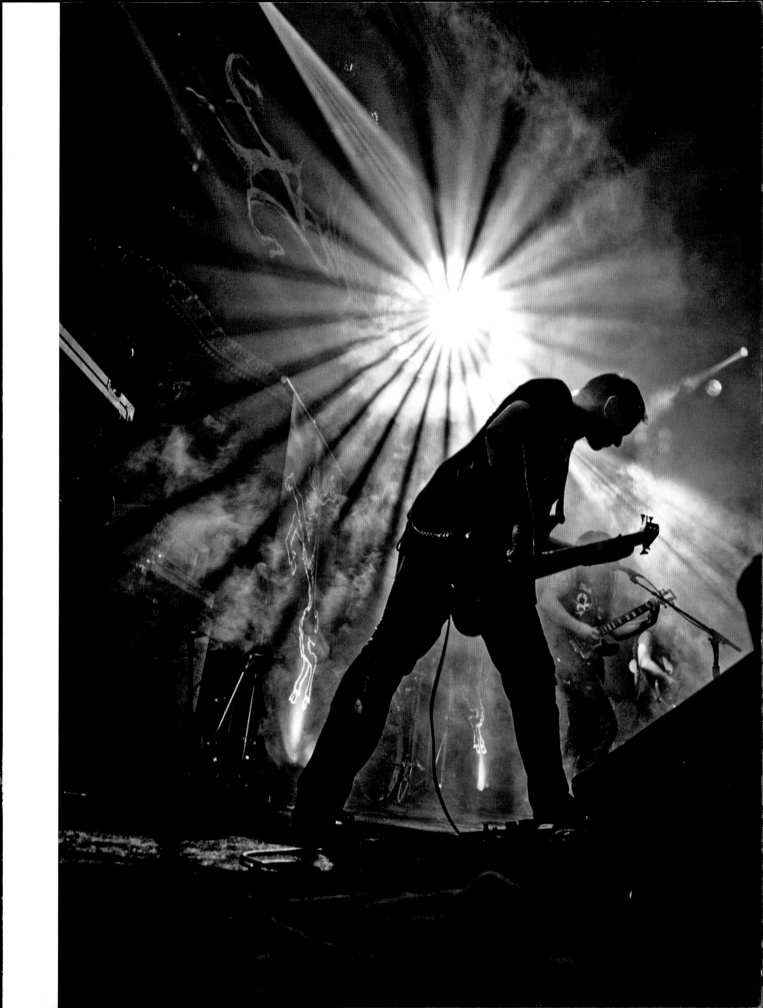

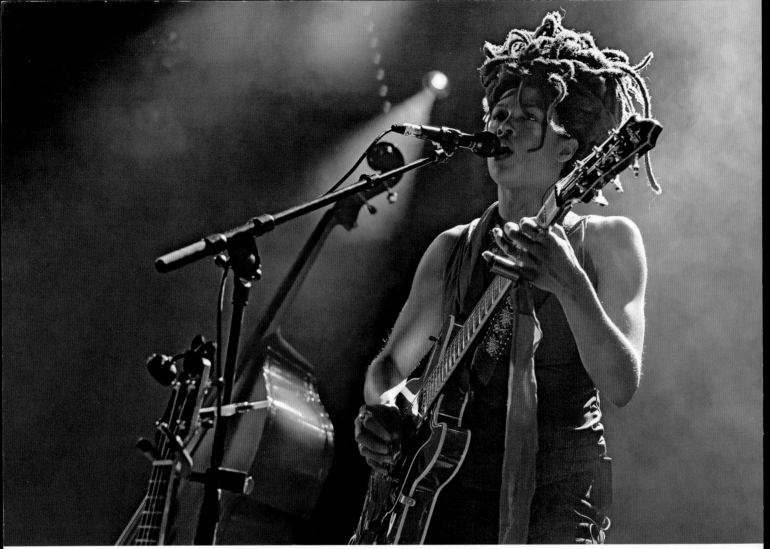

OPPOSITE TOP Yann Cabello was lucky enough to have a press pass, which put him close enough to the stage to use a 24mm–70mm lens. He snapped a shot and chose evaluative metering to take a light measurement of the entire scene. Then he waited for the right moment and shot the guitarist soulfully crooning with the bass in the background.

OPPOSITE BOTTOM Frédérique Ménard-Aubin captured two DJs silhouetted against a massive projection of sultry purple and orange. When shooting silhouettes, look for clearly delineated shapes that will read against the background.

ABOVE Don't forget the crowd when you're shooting concerts, especially outdoor festivals. In Stephan Jacobs' image here, a fisheye lens exaggerates and warps the audience, capturing all the mayhem. He recommends shooting in manual to cope with constantly changing light and relies heavily on his camera's light meter. Shot with a high ISO of 1,600, the image required a little noise reduction in post.

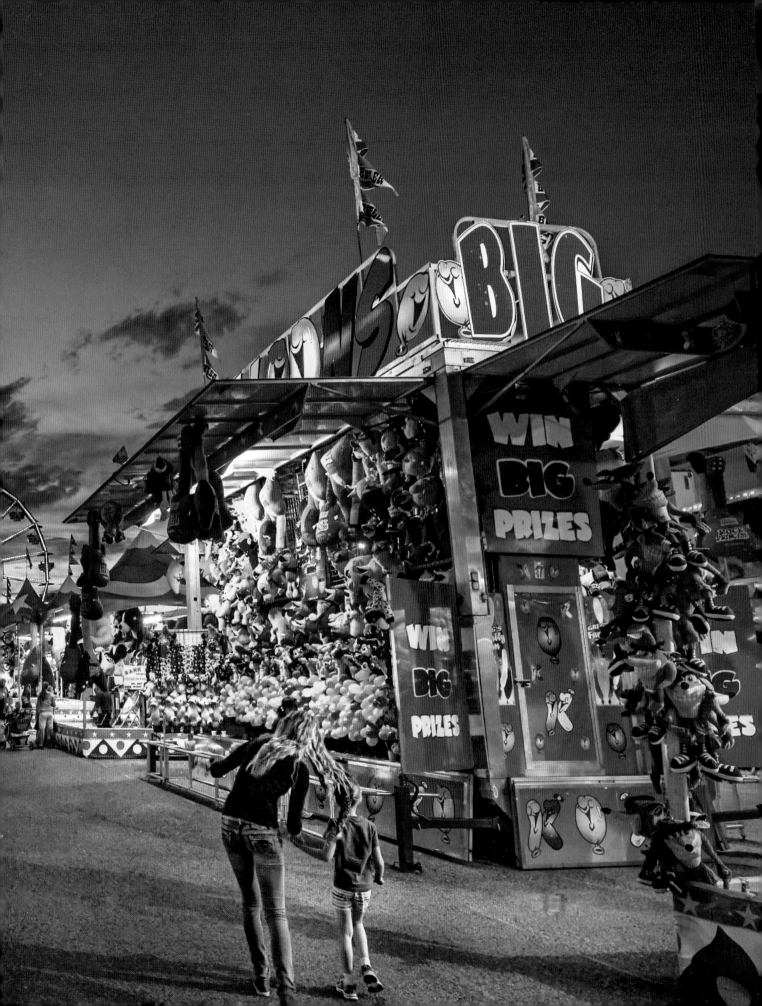

FAIRS & AMUSEMENT PARKS

SUMMER FUN is nowhere more evident than at fairs, festivals, and amusement parks. The carnival-like atmosphere offers a dizzying array of colorful, offbeat subjects just waiting to be photographed, including rides, signs, and games. And don't forget people, from excited kids to cynical barkers. If you can manage the crowds, you may leave the fairway with some great shots as your prize.

GETTING STARTED

Most fairs and festivals start in late morning and last into the night, which means you may be faced with varied and sometimes harsh lighting. Check the forecast; a partially cloudy day helps cut the sunlight—even if you have to wait for a cloud to pass before you trigger the shutter. The most promising time to shoot is the blue hour, when the sun dips below the horizon and the sky takes on a deep blue hue that perfectly offsets the fair's dynamic colors.

Before you shoot rides like roller coasters, study them so you know where the most dramatic—and photogenic—moments occur. Then scout for the best vantage point to capture the action at its peak, whether it's a loop-de-loop or the splash of a flume (keep your camera gear out of the spray).

Creative scouting will also improve your odds for memorable shots when you're at an event like a county fair. Explore the grounds to see what's on offer so you can document visually interesting subjects like high-diving pigs, elaborately costumed dancers, and the telltale queasy expression on the face of the pie-eating contest winner.

TECH TIPS

EXPOSURE Stop down the aperture to f/8 or lower in order to get good depth of field. Open it up to f/2.8 or more to keep the focus on the point of interest and blur the background. To freeze a ride's movement, set the shutter speed to at least 1/250 sec.

FOCUS Autofocus works fine during the day and when photographing bright lights at night. To home in on people on rides, particularly after dark and with a slower shutter speed, pan the camera to keep the subjects in focus while blurring the background.

SPECIAL EFFECTS Use HDR or your camera's highest-saturation JPEG setting to emphasize the scene's dazzling colors. To add an element of motion to the shot, adjust the lens from wide to telephoto during a long exposure.

WHITE BALANCE This can be crazy at fairgrounds at night. Generally, the lighting on most rides will be tungsten or neon, but it can also be halogen or fluorescent. Take test shots and adjust white balance with either the Kelvin color temperature, or the color-balance control joystick control in your DSLR.

WHAT TO SHOOT

Rides are compelling subjects for their movement, bright colors, and slightly hysterical passengers, so experiment with shots that focus on those three attributes. Shoot at high shutter speeds to freeze the moment, then slow down your shutter to give a sense of the ride's motion. Switch the angles that you're shooting from, capturing riders from below or stepping away to frame the entire ride. You'll get the most interesting effects with long exposure shots if you train your camera on rides with multicolored lights and varied movements—in other words, go for the Zipper instead of the Ferris wheel.

Rides aren't the only game in town—indeed, games can be great subjects. Point the camera at a water-balloon competition, or come in tight on that row of brightly colored prizes. Keep in mind that where there are people, there are plenty of portrait opportunities. A carnival barker with a weather-worn face juxtaposed against the booth's bright lights,

a small child with a huge cone of cotton candy, or even a shot that captures the motion blur of crowds milling around the fairgrounds are all interesting representations of fairs and amusement parks.

PAGES 262-263 James Neeley shot this vivid, wide image during the blue hour, when there was still sunlight in the sky but the rides' lights had flickered on, creating balance between natural and artificial light. His only post-processing edits were to adjust shadows and highlights.

PAGE 264 Dave Pidgeon shot this nostalgic swing carousel from the ground, capturing the carefree, kicking legs of the riders. He set the rainbow-colored canopy against the dreamy, softly clouded blue sky. He later added grain and shifted the blue to

a more aquamarine color with image-editing software.

OPPOSITE TOP The Dragon Khan roller coaster in Barcelona, Spain, is known far and wide for its thrilling inversions. Chris Bertrand captured one here by picking a high shutter speed to freeze the action. Try 1/500 sec or above.

OPPOSITE BOTTOM To blur a ride into streaks of dizzying light (as Terry Aldhizer did here), use a tripod and a slow shutter speed—1/4 to 30 sec. Consider zooming during the long exposure for extra motion.

GEAR UP

Photographer's Vest Traditional camera bags and backpacks get in the way when you're elbow-to-elbow with crowds of people. It may be easier to wear a photo vest to carry lenses and other accessories.

Lenses A single all-purpose, wide-angle zoom will help streamline the amount of gear you're lugging around. However, a wide prime lens of about 24mm (35mm-equivalent) or wider is better for shooting under physically tight conditions. A 70mm–200mm zoom complements the wide-angle prime and allows you to capture scenes that may be difficult to get close to. Image-stabilized lenses are important when shooting at night with slower shutter speeds if your camera doesn't have sensor-shift image stabilization.

Tripod or Monopod Night shots and long exposures call for the use of a tripod, but check to see if it's prohibited. Also consider the extra bulk and potential difficulty of setting up a mounted camera in a busy setting. Although not as sturdy, a monopod is a good alternative to help steady your camera.

Software Processing is de rigueur for night shots—or even day shots taken in crappy lighting conditions. Curves, in programs like Adobe Photoshop, will let you knock down the exposure in night skies for more dramatic renditions. The sliders in Adobe Lightroom offer a multitude of intuitive adjustments to contrast, white balance, exposure, and more.

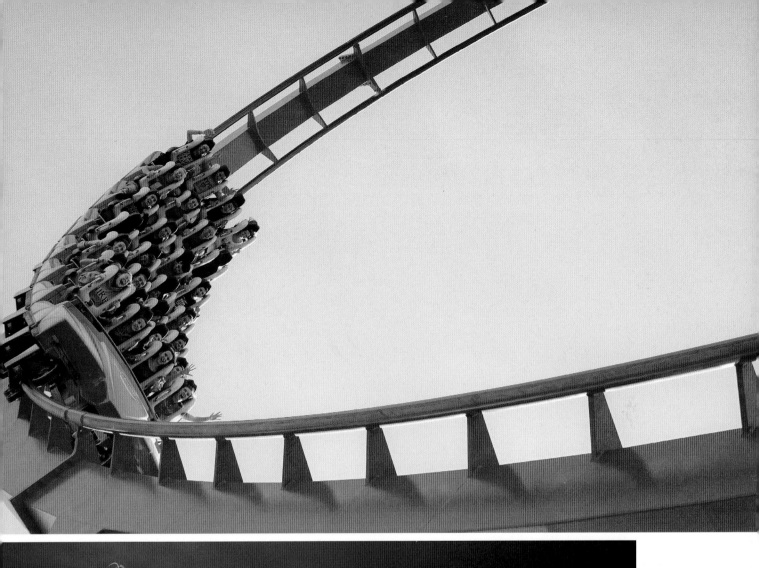
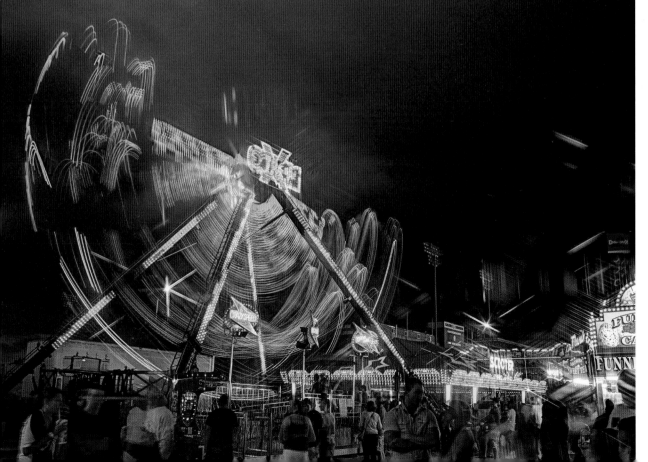

PARADES

DRAG QUEENS, SOLDIERS, AND SOUSAPHONE PLAYERS—you can find just about any character marching in a parade somewhere. For photographers, these events offer a continuous stream of eye-catching subjects. A huge variety of parades occur every year, from classics like Macy's Thanksgiving Day Parade to pious processionals to DIY neighborhood marches that anyone can join.

GETTING STARTED

Find out all the practical details you can about the parade you want to photograph: the starting time and location, the route, whether there are related events scheduled before or after the parade, and where the participants will prepare. Ask whether you can march in the parade, too. If not, inquire about special areas on the sidelines for photographers. If there is a VIP area on the route, plan to position yourself nearby even if you can't get in. In some parades, performers stop and face the VIP area to provide entertainment.

Walk the parade route in advance to scout out the best vantage points. Look for a high place to shoot from so that you can capture the whole parade pouring through the street. Check the weather predictions for the event's date—you may need to shoot from sheltered areas or bring protective gear. After all, it does sometimes rain on parades.

Last, plan your outfit so that you can blend in and make people feel at ease with your photographing them. If it's a festive parade, try a costume, but if it's a military parade or a serious event, wearing something that conveys respect is a good choice.

TECH TIPS

FOCUS Parades go quickly, so a tracking (a.k.a. "continuous" or "servo") autofocus mode is often the best choice for capturing sharp shots of participants as they move toward you. Face-detection autofocus can work well when their faces aren't covered by costumes and heavy makeup. If you're having a hard time focusing on subjects as they pass, try locking your focus on a particular spot on the parade route, setting your aperture to f/8, and then releasing your shutter as interesting subjects reach the spot you've focused on. You can make slight adjustments for composition while they pass without altering your focus.

EXPOSURE Program (P) exposure is widely disdained, but a well-kept secret is that it's great for parades—you aren't necessarily worried about depth of field, and they generally proceed at fairly leisurely pace, so shutter speed isn't a huge consideration. You can shift P exposure in a half-second with the spin of a dial to a smaller f-stop for more depth, or a faster shutter speed for a more frenetic parade participant. Just make sure your ISO setting is high enough to give you enough leeway on both.

WHAT TO SHOOT

The transformation that occurs as parade participants get into costume or uniform, put on makeup, or hoist a giant paper dragon onto their shoulders can make for some great photographs. Find out where the preparations are taking place and show up early to capture them.

If it's the kind of parade that doesn't require you to stand on the sidelines, get into it at the head of the procession and photograph people and vehicles as they come directly toward you. Try panning to keep your subject sharp against a motion-blurred background, or using a slow shutter speed with a flash and zooming in on an oncoming subject while releasing the shutter.

While you're in the parade route, don't forget to photograph the people cheering on the sidelines. Get down low so that you can shoot the event from a child's point of view. Don't be shy about approaching people and interacting with them. People in parades usually enjoy being photographed and will strike a pose or perform for the camera.

Sometimes the party—and the best photo ops—really starts after all floats have crossed the finish line. Parades can serve as preliminaries to festivals, or they might introduce a day or night of impromptu celebration. Stick around and see where people go—if there's no official post-parade event they're heading to, stop in at restaurants or bars where people might gather informally to watch the fun continue.

PAGE 268 Venice is photogenic enough, but especially during Carnival, where Christian Kober happened across this green-feathered creature perched in front of gondolas. He advises, "Be assertive. It helps to befriend the people in costume!"

GEAR UP

Lens It's sometimes hard to predict how close you'll be able to get to the action, so bring a telephoto zoom lens that gives you some flexibility and lets you zoom in close from a distance.

Filters Parades are often held under harsh midday sun and sometimes involve confetti, spraying water, and other airborne elements that can mar your lens. Protect it with a UV filter, and bring a polarizer to cut glare and make colors pop.

Camera Strap The one that came with your camera isn't always the best option. Look to third-party strap makers for something that makes your camera comfortable to move fast with and carry all day, and that doesn't get in your way when you shoot.

Lens and Viewfinder Hoods Shield your lens from bright sunlight with a lenshood, and if you'll be using an LCD viewfinder, consider attaching a viewfinder hood to improve your view.

Memory Cards and Extra Batteries Don't run out of the essentials just when things start to get interesting.

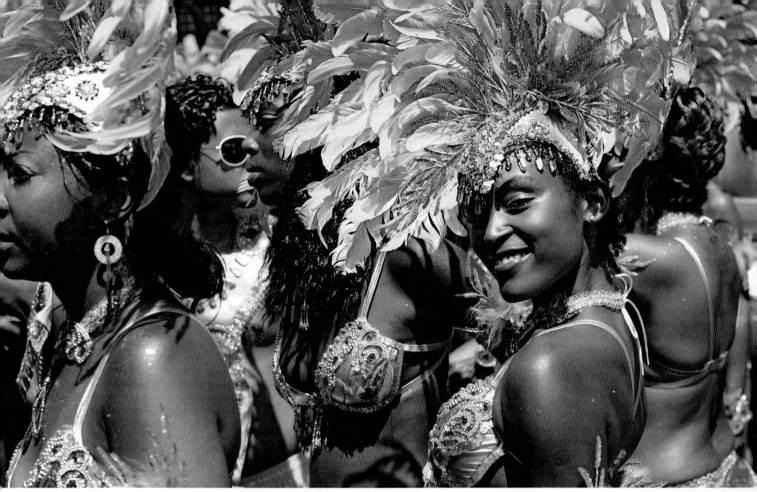

ABOVE Kristian Cabanis shot these carnival performers in Port of Spain, Trinidad. He was drawn to their charming smiles and brilliant yellow costumes, which he felt conjured the radiance of the bright, tropical sun. Cabanis recommends shooting in Trinidad because it's easy for a photographer to get very close to the dancers. In this case, one of the performers looked straight into the camera and smiled, engaging the viewer.

RIGHT When it comes to parades, vantage point is everything. Yadid Levy recommends arriving hours before an event to claim a good spot, as he did for this wide-angle, all-inclusive shot of Rio de Janeiro's Carnival.

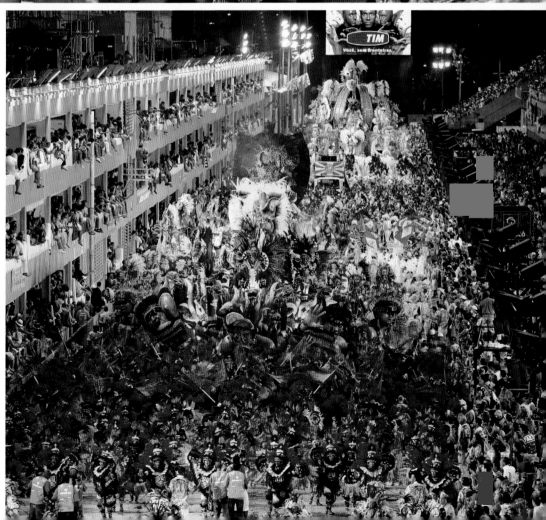

FASHION

OPEN A HIGH-END FASHION MAGAZINE and you'll find glamorous models in exquisite clothing on every page. But fashion photography goes beyond glossy ads and multipage editorial spreads. There are runway shows previewing the latest looks, personal fine art projects, and street-style images that capture a more down-to-earth view of the sartorial world.

GETTING STARTED

Fashion photography encompasses a number of genres, each requiring a different approach. Shoots for advertisements and magazine spreads tend to be all-out, in-studio collaborations between the photographer, model, makeup artist, and stylist. On the other hand, runway and street-style photography are solo pursuits—it's just you, your camera, and the models or stylish citizens who parade by.

Documenting high fashion requires access to designer apparel, unique modeling and art talent, and, if you're lucky, front-row seats at fashion shows. If you don't have an in with a designer, try recruiting aspiring stylists, models, and makeup artists in exchange for pictures that showcase their work. Enlisting friends as models is tricky, so reach out to agencies that might have talent in need of headshots.

The difficulty with shooting runway events is getting in the door without press credentials. Beginners can start building a portfolio at small, local shows. For street-style shots, hang out where fashionistas congregate: high-end retail zones, clubs, art galleries, and runway venues.

TECH TIPS

EXPOSURE For runways, shoot in manual. Each venue is different, but a rule of thumb is to set the shutter speed to a minimum of 1/250 sec. When shooting with a telephoto lens, go with 1/500 sec or faster. Shoot in aperture priority or open the aperture to between f/2.8 and f/4; adjust the ISO accordingly.

WHITE BALANCE If the show is professionally lit, white balance is generally between 3000K and 3200K. Try to attend the show's run-through to test the white balance or ask a production person for lighting information.

SHOOTING MODE Shoot stylish passersby or models at a fashion show in burst mode with continuous autofocus. Set the focus point on the models' eyes.

METERING Center-weighted metering is best, since the runway is generally well lit while the audience is a couple of stops darker. If the metering is too broad, the model may be overexposed; too narrow, and only his or her face may be well exposed. Underexpose a little to darken the surrounding area to black for a more dramatic shot. Monitor the meter for hot spots along the runway; adjust exposure accordingly.

WHAT TO SHOOT

Fashion photography is all about the clothing and the model—and both need to look great. Bone up on classic poses by flagging ideas you like in magazines, then coax your subject into garment-flattering stances, like turning slightly toward the camera and placing most of his or her weight on one leg. Sometimes, angular and even somewhat awkward poses can add interest and edginess, as well as elongate the model's body. Shooting from slightly below creates a lean silhouette that shows clothes and models at their best. As for the model's gaze, try a few different tactics: A head-on stare into the camera puts the subject in direct eye contact with the viewer for a bold, engaging effect, while looking away can create a sense of intrigue and mystery.

Get creative with concepts for your shoot, using props and locations that reinforce the aesthetic of the clothes you're shooting—or offer stark contrast, as in this photo opposite of girlie fashion on a gritty street. Most important, connect with your models, giving them permission to try out bold gestures and a range of facial expressions. Set your camera in burst mode so you don't miss a single, beautiful moment.

PAGE 272 The best runway photos capture both the garment and the model at his or her best—poised in a spot of perfect light, as in Andrea Hanks's shot of supermodel Karlie Kloss. Hanks used a 70mm telephoto lens to close the gap between the audience and the catwalk.

ABOVE When it comes to fashion, many photographers fear building a portfolio of images that become dated with the clothing. To avoid this, photographer Joao Carlos went for sharp, crisp menswear in classic black and white in this street fashion shot captured during Fashion Week in Portugal.

OPPOSITE Street fashion doesn't always have to be about designer apparel. Sivan Askayo lurked outside a Tokyo department store to shoot Harajuku girls: Japanese counter-culture style icons who favor frilly, over-the-top, ensembles and hyper-feminine accessories.

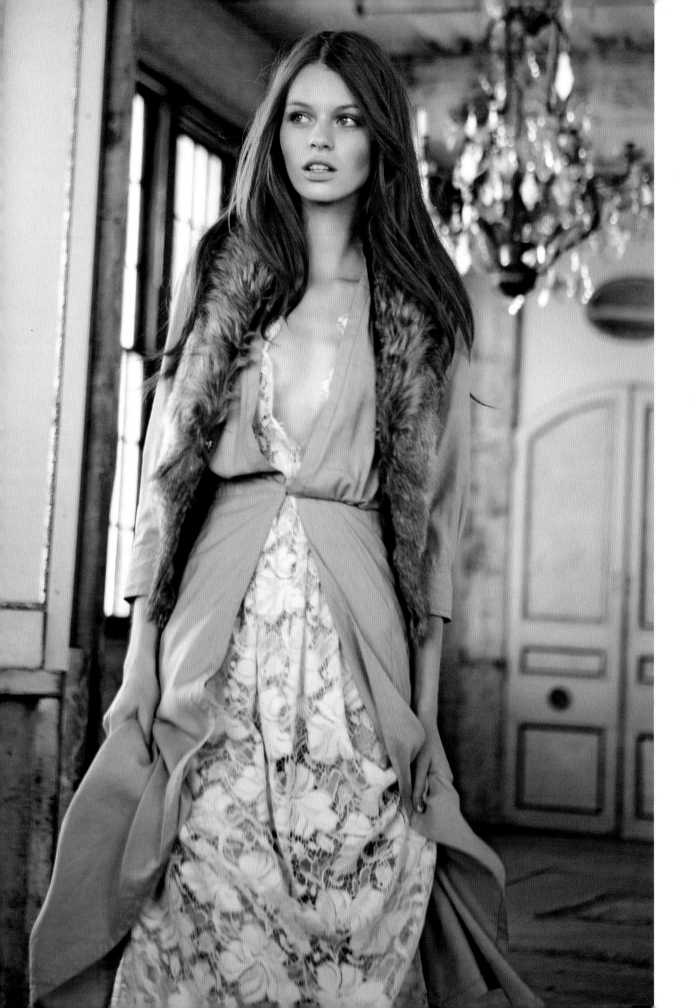

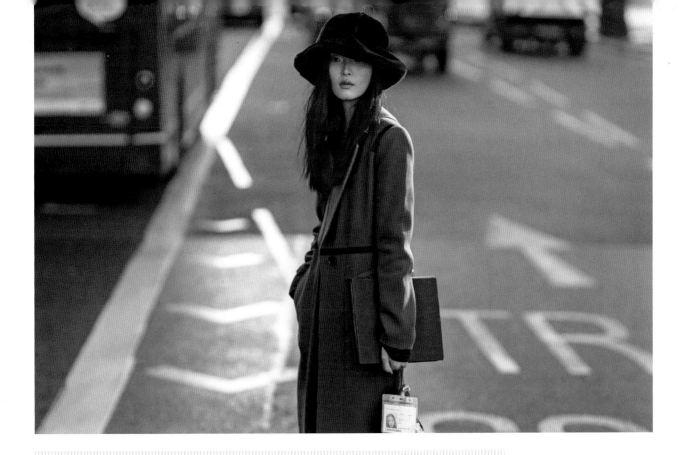

GEAR UP

In general, the gear you need for fashion shoots is the same you'd need for studio portraiture (see page 204), with these additions for runway shows:

Strobes If you plan to shoot movement (such as a model jumping or dancing), bring studio strobes and a power pack that's capable of high-speed output to freeze motion.

Lenses When shooting a fashion show, bring a fast, 70–200mm f/2.8 telephoto zoom lens (with a teleconverter for long runways). Wider-angle lenses, such as a 24–70mm f/2.8, work well for street and backstage shots.

Monopod When shooting the catwalk, use a monopod to support your long telephoto lens and hold it steady.

Flash and Small Light Modifier Backstage, street, and front-row shots usually require a flash. Use a small light modifier or a bounce card to avoid harsh direct flash.

Media Cards You'll be shooting a lot, so make sure you have adequate storage.

Tethering Setup Tether the camera to a laptop so you can see if you got the shot.

ABOVE Bold, primary colors, strong leading lines, and a graphic but simple silhouette make for a traffic-stopping shot that feels classic. Its creator, Simbarashe Cha, doesn't believe in a "go-to" group of settings on his camera. He does most of his photography in chance encounters. Here, he spotted Korean fashion model Sung Gee Kim in London.

OPPOSITE For creative studio-style shots, set up shop in a space with understated texture and intrigue that can add to the garment's fantasy, such as the chandelier and regal setting in Della Bass's image here. Bass predominately used natural light, plus a gold reflector to bounce in some fill.

THE HUMAN FORM

A CENTURIES-OLD ART, the nude has long inspired artists working in a variety of media. For the photographer, it makes for an intriguing and versatile genre—whether you're presenting a classical study of form, a sensual abstract, or a more provocative, eroticized image. Whatever your preference, viewing the body through your lens will spur your creativity in a whole new way.

GETTING STARTED

Sensitivity and trust are key components of any nude photo shoot, whether you're photographing an experienced model, a client, a friend, or your partner. Before your subject arrives, create a warm, comfortable environment with a private changing area and a fresh robe. As the photographer, it's up to you to set the tone for the experience, so approach the session with a relaxed and friendly but professional demeanor to help put the model at ease. Keep your lighting setup simple and tweak it minimally during the shoot—maintaining focus on your subject will likely build rapport and confidence.

Before working with a model, try your hand at making some nude self-portraits in order to get comfortable with lighting scenarios, propping, and poses you'd like to explore in the shoot. Flip through portraiture books and magazines for inspiration, and keep those images on hand to share with your model. Alternatively, enroll in a nude photography workshop at a local studio or one sponsored by a reputable photographer or magazine—these resources will provide models and secure any necessary permits or permissions for shooting nudes outdoors or in unique locations.

SHOOT TIPS

COMMUNICATION Before the shoot begins, sit down with the model for a relaxed conversation to instill trust and calm nerves. Discuss how the session will proceed, agree on the types of poses, and talk over what props are available for the set. If planning to shoot a series of boudoir images, go over the lingerie and other apparel items you intend to use. Be sure to address any concerns your model might have and come to a consensus on how the images will be used.

MODEL RELEASES Always get a signed model release as proof of a model's legal age and as a document outlining how the image may be used. Although you generally only need a release for commercial use (not editorial or fine art), when it comes to nudes, play it safe and get a release. You can find standard model releases online and adapt them as needed; there are also model release apps for mobile devices.

ASSISTANCE To establish a more supportive environment, either have an assistant in the studio (with the model's permission) or suggest that your subject bring a friend or relative along for the shoot.

WHAT TO SHOOT

If the model is a little nervous, start with more neutral territory such as a closeup of a hand on the shoulder or the nape of the neck. A swath of sheer fabric, draped or wrapped, may help put him or her at ease—plus, it creates an ethereal look. Experiment with different poses: standing, sitting, kneeling, and reclining. Within each pose, place the feet and legs first, then arrange the arms, hands, and the rest of the body. People—particularly dancers and athletes—are usually aware of their best attributes, so let your subject suggest poses as well.

The human form is an endless source of mini-landscapes that can be framed to make abstract shapes or artful curves. Create contours with deliberately directed shadow and light, concealing and emphasizing specific regions of the body—either for visual interest or to highlight certain aspects. Try dramatic silhouettes, too: They eliminate skin flaws and are easily created using backlighting.

Boudoir photography is very popular and, depending on the attire and pose, can be sexier or subtler than full nudes. Pick a theme and play with storytelling for next-level erotic images.

PAGE 278 Andrey Ushakov's stark, modernist portrayal of a male torso uses harsh, low-key lighting to create dramatic contours. Try using barn doors or a snoot to control the spill of light in a similar fashion. Not seeing the man's face gives a sense of mystery and makes the body seem like a landscape.

OPPOSITE This tasteful boudoir photo by Tammy Swales keeps the focus on the woman's face by using a narrow depth of field, blurring out the barely clad body in the background.

GEAR UP

Lenses A moderate telephoto lens with a focal length of 85 or 105mm is ideal. A 70mm–200mm zoom works well, too. All three allow you to keep a respectable distance from the subject, which is especially important if the subject feels uncomfortable during the shoot.

Lighting Since the subject is static, continuous lighting (including LEDs) or strobes mounted on stands are both appropriate for nude photography. A two- or three-light setup is preferable, but a single, directional light source can be angled for a more dramatic effect. Window or outdoor natural light can be used alone or in combination with artificial light.

Diffusers and Reflectors Bring one for each light source. Softboxes create a more diffused light and eliminate hot spots, while a collapsible reflector positioned by hand or on a light stand helps direct natural light and prevents shadows on the face.

Barn Doors or Baffles These modifiers give directional light, creating shadows and highlights on the body.

Remote Trigger When shooting with a strobe, use a remote trigger to fire the flash.

Backdrop A black or dark backdrop provides a neutral, clean, non-distracting background to keep the emphasis on your subject.

Black-and-White Conversion Software Black-and-white or sepia-toned images are subtler and more classic-looking than nudes in color. Always shoot in color and convert in post-processing prior to retouching the entire image. While almost any standard image editor will allow B&W conversion, specialized plug-ins like Nik Silver Efex Pro an Alien Skin Exposure let you apply specific film looks.

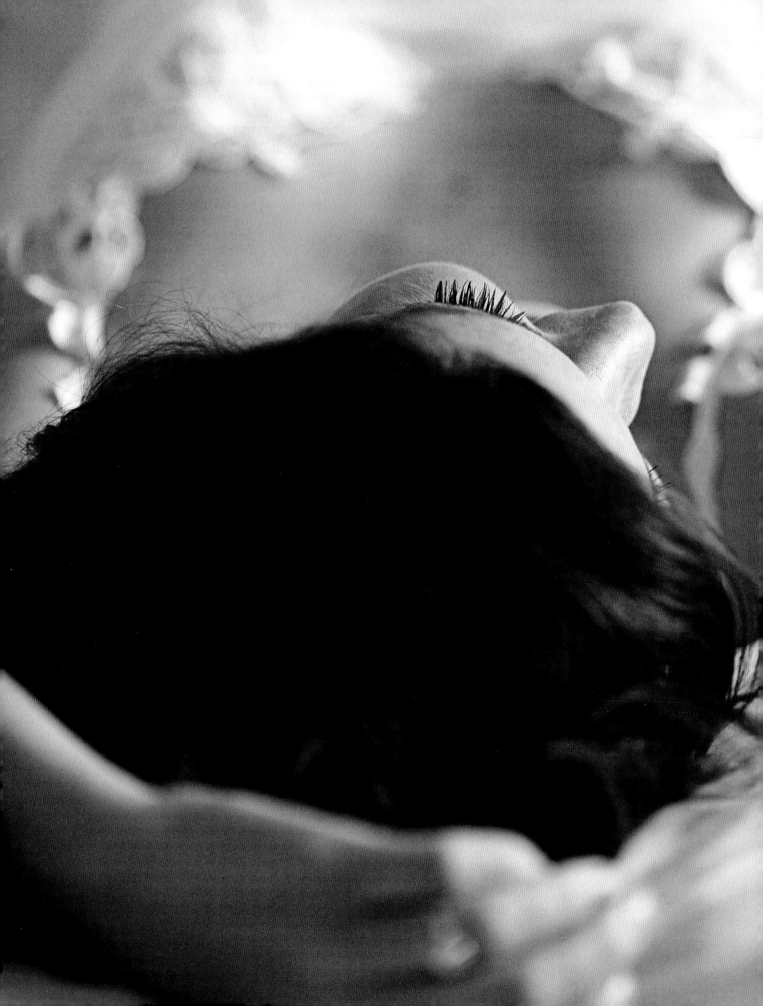

MUSEUMS & AQUARIUMS

THERE ARE SOME THINGS in life—like Michelangelo's *David*, or penguins at feeding time—that you really just have to see in person. Luckily, we have museums and aquariums, where works of art, historical artifacts, and living creatures of the sea are open for visitation. The images you capture when you tour these places can serve as a guide to your own personal observations.

GETTING STARTED

There usually isn't much prep work to do before photographing a museum, an aquarium, or another public building that houses works of art or nature—largely because these institutions often prohibit flash photography and tripods, and most have artificial lighting that you won't be able to improve upon. Check out the institution's rules about photography in advance, and look online for images of the interior to get a sense of what the lighting and the spaces are like. Keep an eye out for glass surfaces so that you know what to expect in terms of glare and reflections. Also look for areas with natural lighting, including skylights. Check the weather and the time of sunset to get an idea of what the lighting conditions will be in the areas that are lit by natural light.

Also research special events and tours so that you can visit the site when there are more or fewer people around, depending on your preference. And don't neglect the institution itself—the structures that house our most precious objects and fascinating species can be equally interesting. Learn about the building and the works or creatures it houses so that you can take more insightful photos.

TECH TIPS

EXPOSURE Unless you've been hired by the institution, you likely won't be able to use off-camera devices. So you'll need to rely on in-camera settings and take handheld shots. Set your shutter speed at 1/60 sec for static subjects if you have a steady hand, or 1/125 sec if you're prone to camera shake. Use wide apertures to make the most of available light, keeping your ISO setting as low as possible for clean images. To photograph fish in an aquarium, you'll need to bump your shutter speed up to 1/125 sec or higher, depending on their speed.

METERING An average, evaluative metering mode works well when you're filling the frame with a work of art, while a spot meter can help you properly expose fish in an aquarium or artwork details.

WHITE BALANCE Use your camera's custom white-balance setting to capture colors accurately. Carry a small white or gray card so that you can take a reference shot to set custom white balance and fine-tune the color when you edit RAW image files, or use an on-camera white-balance tool.

WHAT TO SHOOT

Photographing two-dimensional works of art lets you capture the details that interest you most. Start with a shot of the whole artwork, taken dead-on to avoid perspective distortions, and then zoom in to capture details and textures. (Pro tip: Take a shot of the wall text near the art so you can easily create a caption later.) For sculptures and other three-dimensional pieces, walk around them to explore different angles, and zoom in to compose detail shots. You may capture some interesting abstract shots that way, as well as gain insight into the artist's intentions. Try going in tight on a piece of art with a shallow depth of field, leaving just enough indication of the museum's activity blurred in the background.

In aquariums, put your camera right up against the glass (as long as that's allowed) to get closeups of the creatures inside the tanks and cut out reflections and glare. Then back off and look for schools of fish that form interesting compositions as they move through the image frame. Try panning with your camera to capture fast-moving marine animals as they swim by.

Don't forget to include people in some of your shots. In museums, photograph visitors responding to the artworks. In aquariums, try taking silhouettes by exposing for the well-lit tanks behind them.

PAGE 282 One day, while shooting wildlife dioramas at the American Museum of Natural History in New York City, Traer Scott discovered that the visitors' ghostly yet lively reflections formed an intriguing juxtaposition with the dead, preserved subjects. She created this completely candid, single-exposure image in-camera with minimal post-processing.

GEAR UP

Lenses A fast zoom lens with a wide maximum aperture will help you make the most of low indoor lighting. Carrying a bag with multiple lenses in a museum can be cumbersome and sometimes prohibited, so opt for one versatile lens that lets you zoom in on subjects that you can't get physically close to. A macro lens pressed up against aquarium glass will also help capture closeups of sea creatures, or you can use it in a museum with small objects and details of two-dimensional art.

Filters A polarizer can cut reflections and glare on glass panes and tanks, and a split neutral-density filter can help you get an even exposure in areas with skylights.

Lenshood Using a lenshood can help you cut glare and reflections, especially if you put it right up against the glass of a display case. Look for a lenshood without scalloped edges so it blocks all side light.

The best option is a rubber lenshood, which can be pressed tight against a glass wall.

Hand Wipes Before shooting into display cases, you may want to give the glass a wipe-down to eliminate fingerprints and smudges from your shot.

Monopod Most museums and aquariums prohibit tripods outright, although you may be able to get a permit for one beforehand. A monopod, though, is a more portable alternative—although, again, check whether you can use one. Think light (carbon fiber) and compact (folding to about 1 foot/30 cm).

Accessory Flash Most art museums prohibit flash due to concerns about its effect on delicate artworks. An aquarium, though, may allow flash (check beforehand). When held off-camera against a fish tank's glass, with your hooded lens pressed against the glass, it can work pretty well.

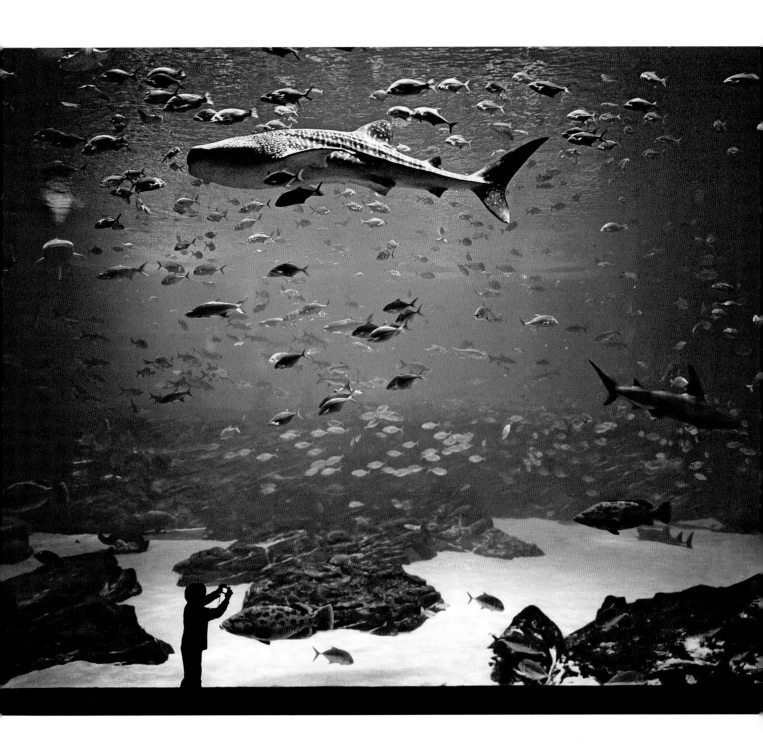

ABOVE For Kyle Ford, shooting in aquariums is fun but fraught with challenges. He advises preventing reflections by turning off the camera's flash, using a high-speed lens, and combining images with software, which he did here with ten different shots from the same perspective taken at varying times. He included silhouetted humans for a sense of scale.

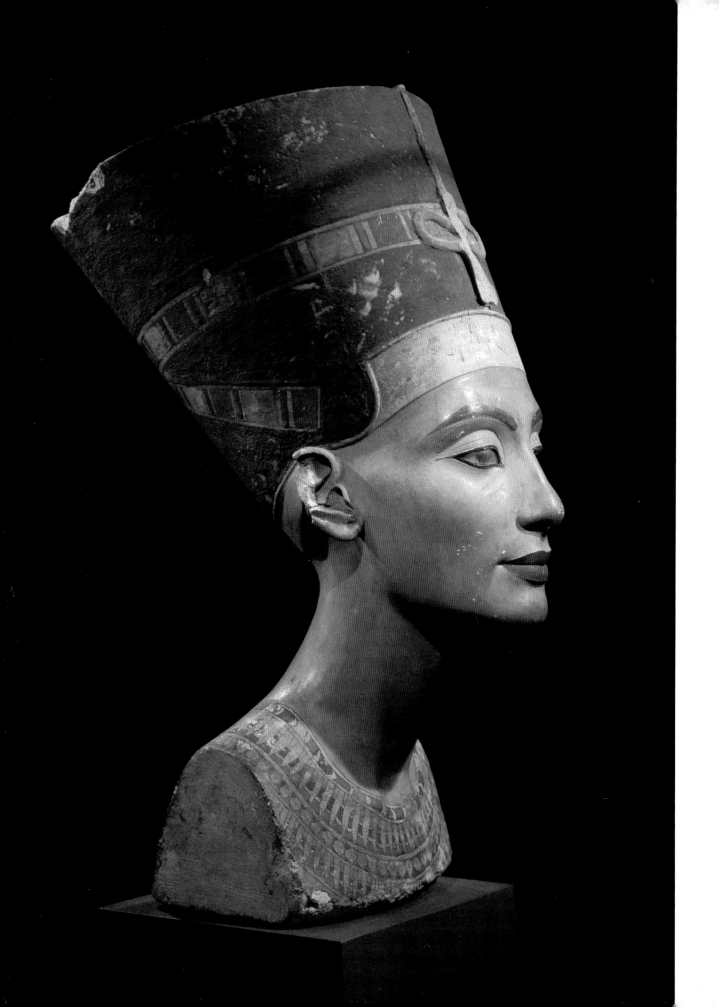

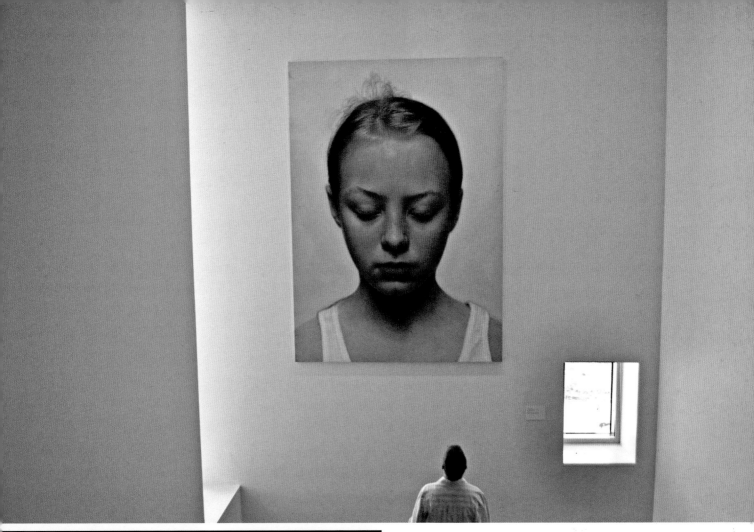

OPPOSITE When shooting a piece under glass (as Vladimir Wrangel did of the famous bust of Nefertiti), try to press your lens up to the case to avoid reflections. A polarizing filter can also help reduce glare.

ABOVE Richard Nagler has made an art out of others looking at art, documenting museum-goers in communion with the pieces on display. In this image, for example, a man gazes up at a downward-looking woman.

LEFT As part of an ongoing effort to draw attention to conservation, Sharon Beals photographed this nest at the California Academy of Sciences. To carry depth of field through the image, she shot at three different focus points and merged the images in software.

ABSTRACTION

READY TO BUST LOOSE from the norm and try a different approach to image-making? Abstract photography transforms everyday objects and scenes into potent visuals that stretch viewers' imaginations. Technical skills count, but opening your mind to new ways of seeing is the key component to creating non-representational images using form, color, texture, and patterns.

GETTING STARTED

In many ways, abstract photography goes against everything photographers usually strive to achieve. Rather than creating a crisp, clean representation of an object or a scene, abstraction breaks down a subject into its core elements. Those components may be forms, colors, textures, patterns, or the interplay of shadow and light. Before you pick up a camera, look long and hard at your subject to decide on the visual ingredients you want to capture.

Fortunately, you don't have to stray far to find interesting subject matter—just look around a bit. Abstractions abound both in nature and manufactured objects, or they can be created for a specific photo. In your quest to find your subject's most compelling aspects, consider that visualizing an abstract image often requires approaching it from a different point of view. For instance, some patterns, shapes, and textures may reveal themselves only from a distance, or when you're using a wide-angle lens. Others form interesting configurations when extraneous portions are cropped out by using a telephoto or macro lens. Open your mind's eye to discover the myriad possibilities right in front of you.

TECH TIPS

FOCUS AND DEPTH OF FIELD For images that focus on visual elements such as form or pattern, use a small aperture (such as f/8 or f/16) to keep shots sharply focused. Selective focus with wide-open apertures (f/2.8) or overall blur creates a totally different look. Autofocus in most instances will provide nothing but frustration—as with still lifes, abstractions are about careful placement of the zone of focus.

LIGHT SENSITIVITY Standard guidelines apply for light sensitivity. For images in which you want to emphasize crisp detail, use a lower ISO, preferably 200 or below. But the noise (graininess) created by high ISOs, especially 3,200 and above, may enhance the abstraction, especially in monochrome images.

WHITE BALANCE Color accuracy is not a priority for abstracts—in fact, deliberately throwing the color cast away from the expected may all the more striking.

ANGLE OF VIEW A simple way to explore abstraction is to shoot a subject from an unexpected angle. For things usually seen from the side, shoot them straight down. Turn objects over, or, if they are flexible, inside-out.

WHAT TO SHOOT

A camera and a creative eye can do interesting things with just about any environment. Patterns and textures are abundant in nature's leaves, flowers, rocks, and sand formations. And mundane household objects like a rug or the bubbles formed by dishwashing detergent can present intriguing visuals.

Cityscapes offer a wide range of potential subjects. Windows of tall buildings and other repetitive architectural elements generate patterns that are perfect for wider-angle or mid-telephoto lenses. Examine buildings from a variety of perspectives. Try pointing your lens up and use the resulting keystoning (distortion) as part of the abstraction.

Motion and blur can transform an everyday scene into a mysterious image. For landscapes, flowers, or night scenes with neon lights, set a slow shutter speed (1-4 seconds) and zoom the lens or rotate the camera for a unusual image of patterns and colors.

Patterns reveal themselves from a distance, or try giving the familiar a new slant by homing in on a subject from a macro or a micro perspective to reveal the big picture or tease out hidden details.

Keep an eye out for surprising filters, too—shooting through frosted glass or lace can have an intriguing effect on whatever is on the other side

PAGES 288–289 Heidi Westum put colored paper underneath a Plexiglas rack and clamped on two small LEDs. She then placed a clear bowl containing small drops of colorless oil on the Plexiglas, then zoomed in with a 105mm micro lens.

PAGE 290 At a scrap metal market in Bandung, Indonesia, Herbert Freedom spotted intriguing patterns formed by pipes stacked and stored inside one another. He converted the image to black-and-white to highlight the recurring shapes.

OPPOSITE Faisal al Malki created this image of the Milwaukee Art Museum's facade by hand-holding his camera and zooming in halfway through a half-second exposure. The technique captures the building's details and a sense of motion.

GEAR UP

Lighting Natural or available light is often ideal, particularly when shooting outdoors. For macro shots, a ring flash or off-camera flash angled to prevent shadows works best. Experiment with backlighting for transparent subjects and add a colored gel to change or enhance colors.

Lenses Zoom lenses, such as a 24mm–70mm or a typical 18mm–55mm kit lens, cover most of the focal lengths you'll need. A 35mm prime comes in handy for architectural shots, while a 70mm–200mm telephoto helps compress backgrounds to zoom in on the main subject. Add a macro lens such as a 60mm or 105mm, and you're good to go. Third-party specialty lenses can help you achieve looks with selective focus. And tiny macro/micro lenses can turn your smartphone or tablet into a creative tool for close-ups.

Tripod When possible, use a tripod to keep the camera steady and images crisp.

Boom Arm A boom arm for your tripod will enable you to position your camera at all sorts of odd angles—for example, directly above an object for a different take on viewpoint.

Software Photograph various patterns and textures, then overlay them in image-editing software to create a unique look. Some images, particularly architectural ones or those that concentrate on shadows and light, often benefit from being converted to black and white with software. Bump up the contrast to emphasize form, texture, and detail.

Colored Gels When placed over a flash unit, studio strobe, or continuous light source, color gels can also help alter reality and throw ordinary objects into abstraction.

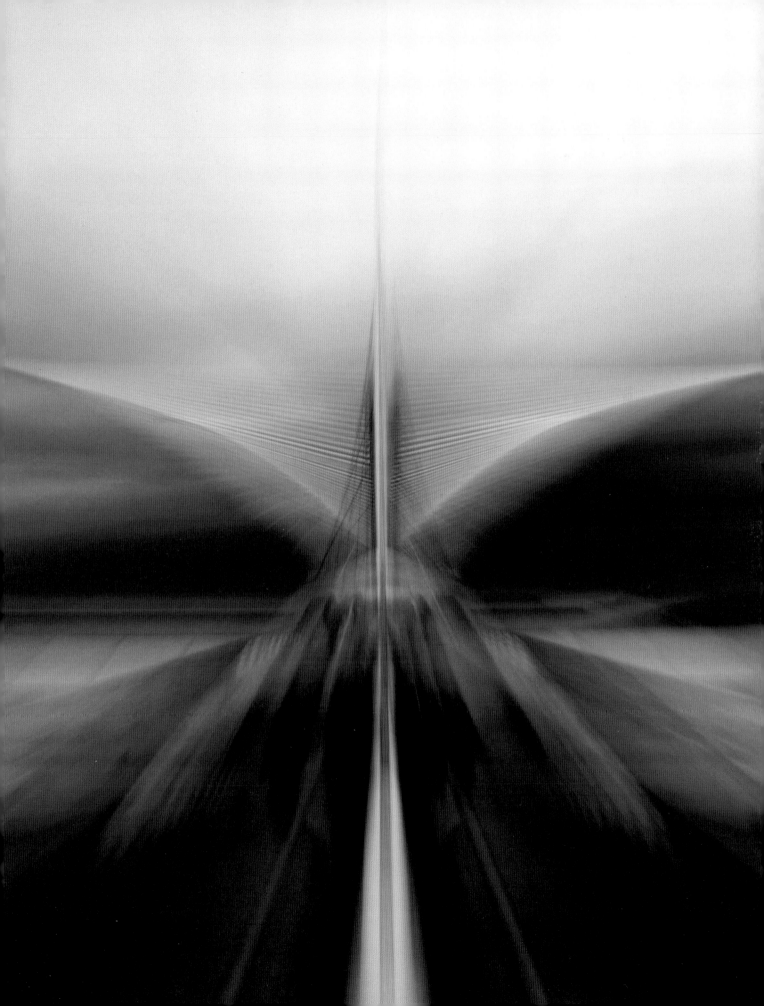

OPPOSITE TOP Believe it or not, the subject of Nicole Quevillon's image is a tube of tiny magnetic balls (which she carefully kept at a safe distance from her camera). A lamp placed at the tube's other end created a "light at the end of the tunnel" look, while a narrow focal length lent the shot a warm blurring effect.

OPPOSITE BOTTOM Courtney Cochran was drawn in by the swooping lines and crosshatched texture of these welded rebar pieces. She got up close to capture the tactile patterning and converted to black and white in image-editing software, locking in a grainy look.

ABOVE Rob Turney did not use a lens to create this ethereal image of light bending. Using a technique called retrophotography, he mounted an LED flashlight onto a stand and taped cardboard over the flashlight head, then poked a pinhole through the cardboard. He positioned a wineglass (any clear plastic or glass object will do) in front of a lenseless DSLR body and aimed the light at it. Colored gels held between the glass and the camera produce the vivid, intriguing hues.

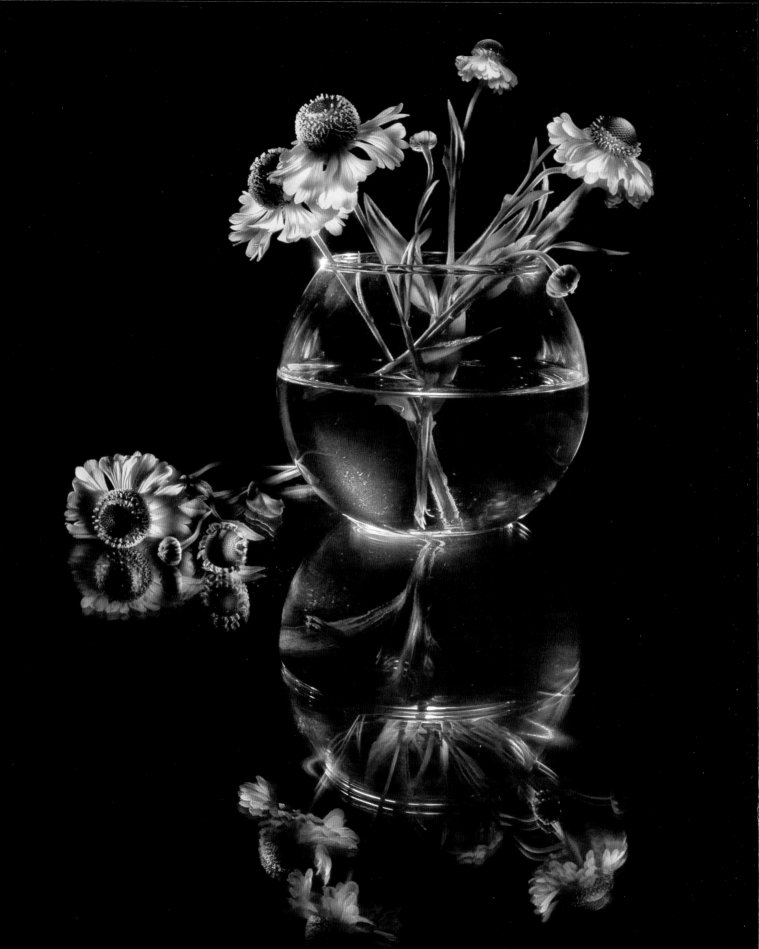

LIGHT PAINTING

EVEN IF YOU'VE never been to a rave, as an adventurous photographer you may appreciate the possibilities presented by glow sticks and LED lights. Try using them and more conventional photographic light sources to paint arty abstracts, or place them in scenes—and the hands of your fellow light-painters—to add dramatic visual interest with vivid streaks of light.

GETTING STARTED

Assemble a light-painting palette of glow sticks, flashlights, and other illumination sources,and then find a dark space to work your magic with long exposures. When shooting indoors, find a room that can be darkened without light leaks and with enough room to move around in. Outdoor locations without streetlights, traffic, and other lights are preferred unless you want to include them in the shot. Plan a twilight shoot if you want to feature the residual glow of the almost-gone sun in your images.

Consider whether you want to do the light painting on your own, or invite family and friends to join in. The advantage of doing the painting yourself is that you control all the variables and don't have to direct others. But working with others lets you concentrate on taking pictures—and supplies built-in assistants for triggering the shutter, popping a flash, or becoming part of the scene. Since you and others may be working in front of the camera, dress in dark clothing and keep moving to remain invisible. Before activating any glow sticks (which fade), ask participants to wave around flashlights or lit-up smartphones so you can prepare exposure settings.

TECH TIPS

EXPOSURE This is the tricky part, but after enough practice, choosing an exposure becomes intuitive. Shoot in manual mode and decide on a base setting with a low ISO between 100 to 400, and go with f/8 to f/11 to get better depth of field. Maintain the settings you choose for all or most of your shoot and play around with the shutter speed. Start with 20 to 30 seconds for objects that are close to the camera; switch to bulb mode and increase the length of exposure to one minute or more for larger or more distant subjects.

FOCUS Light the subject (using room light or a flashlight), focus manually, and tape the focus ring. If you're using a model, place a piece of glow-in-the-dark tape on the floor or ground as a stand-in focus spot.

PAINTING TECHNIQUE Depending on the strength of the light source, you may need to move close to the subject to better illuminate it evenly. If you want to photograph people (including yourself), have them stand still and give them an extra swoop of light. Unless you want a hard outline, keep the light source moving in small strokes to avoid overexposure and hot spots.

WHAT TO SHOOT

Just like regular painting, light painting has subgenres: abstract, landscape, and still life. If you want to try your hand at abstract drawings, create various shapes and lines in the air or against a solid background. If you have good eye-hand coordination, paint the outline of an animal or a flower. For a real challenge, write a word or a sentence with your light.

Landscapes, particularly in isolated locations, are wonderful canvases for light painting. Painting a small rock formation under a sky filled with stars is more manageable than a larger landscape, but both can be achieved given enough time, energy, and appropriately sized light sources.

Light can also bring an arty spark to a still life, whether it's an arranged tableau on a table indoors or a scene like an abandoned truck in the woods. A still life consisting of objects may work best with light softly dispersed across the setup, while lighting only part of a larger outdoor subject—or outlining it with strong light—can create a striking image.

PAGE 296 Working in the dark, Alexey Kljatov moved an LED flashlight in random patterns in front of a vase. In image-editing software, he selected a darker photo as the base, then layered others with different lighting on top.

OPPOSITE TOP Darren Pearson used a pen light to paint this highly detailed dinosaur skeleton on a path, then lit up the arch of tree branches above with gel-covered spotlights.

OPPOSITE BOTTOM Harold Ross created this idyllic, softly illuminated landscape with an LED panel, changing its direction and the amount of time it shined on certain areas. He then merged multiple exposures in software using layers and masks.

GEAR UP

Tripod While you can achieve interesting streaks of light by moving the camera instead of lights, a tripod is necessary for long exposures. Since you'll be working in the dark, you might want to mark the legs with glow-in-the-dark tape so you won't knock into your tripod.

Lights Flashlights are excellent light-painting tools. As you progress in your light painting, step up from the typical (but weak) household flashlight to more powerful models with adjustable beams and output strength. But really, any movable light source will do. You can buy glow sticks and LED lights online or at novelty stores, or use lights you already have on hand: a desk lamp, an off-camera flash, a spotlight, even a lantern.

Colored Gels To add color, purchase a flashlight with interchangeable clip-on, hard plastic gels or make your own. Pick up some photographic gel sample packs, cut them to size, and tape them to the front of the flashlight. For more focused light, build a small snoot or tube with aluminum foil and wrap it around the flashlight.

Portable Power Source If you plan to use large, more powerful light sources (such as studio LED panels), a portable power pack is essential. There are a number of rechargeable units that feature conventional AC power outlets. And some studio strobes have optional portable battery pacts.

Software More adept light painters use an image editor with layers and masks (typically Adobe Photoshop) to adjust the balance of a painted object with the background exposure. The blending of multiple exposures in post-processing is a common technique, too.

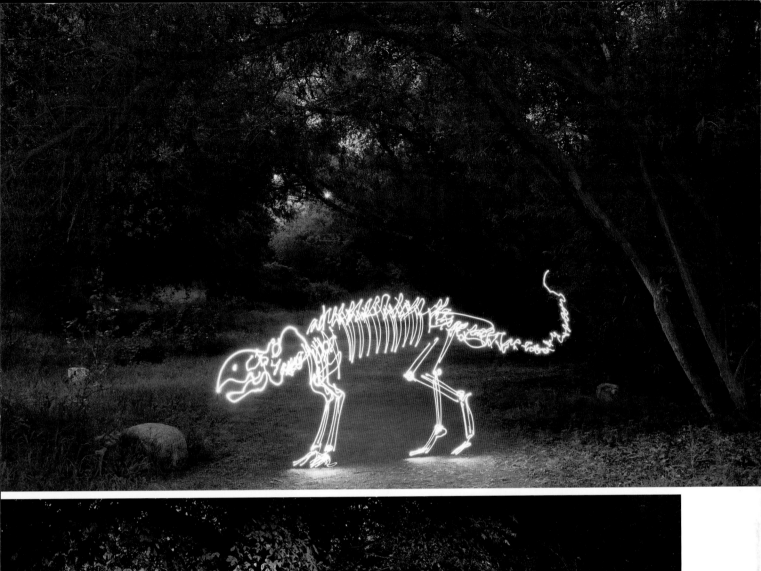

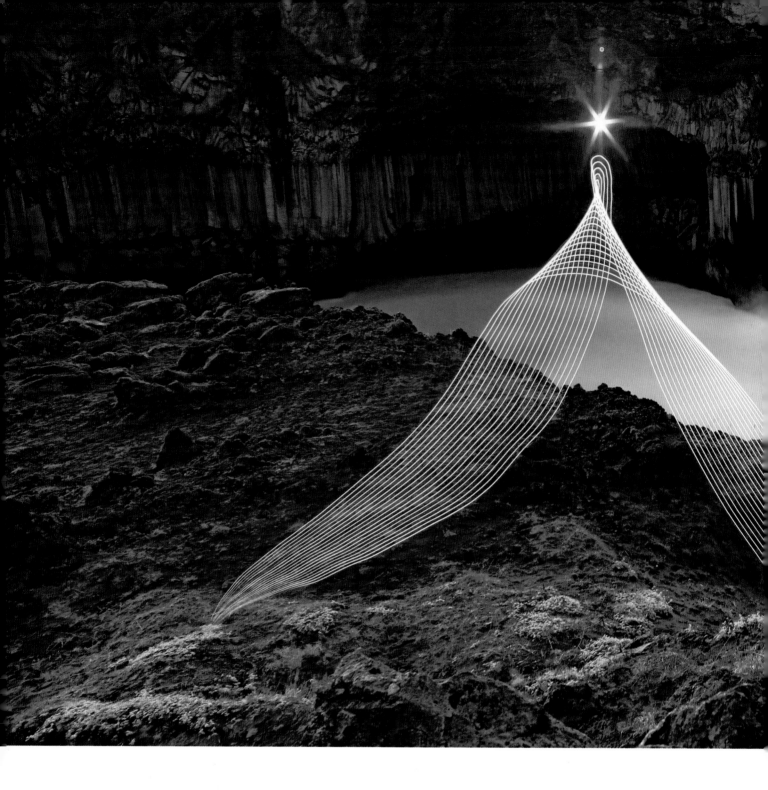

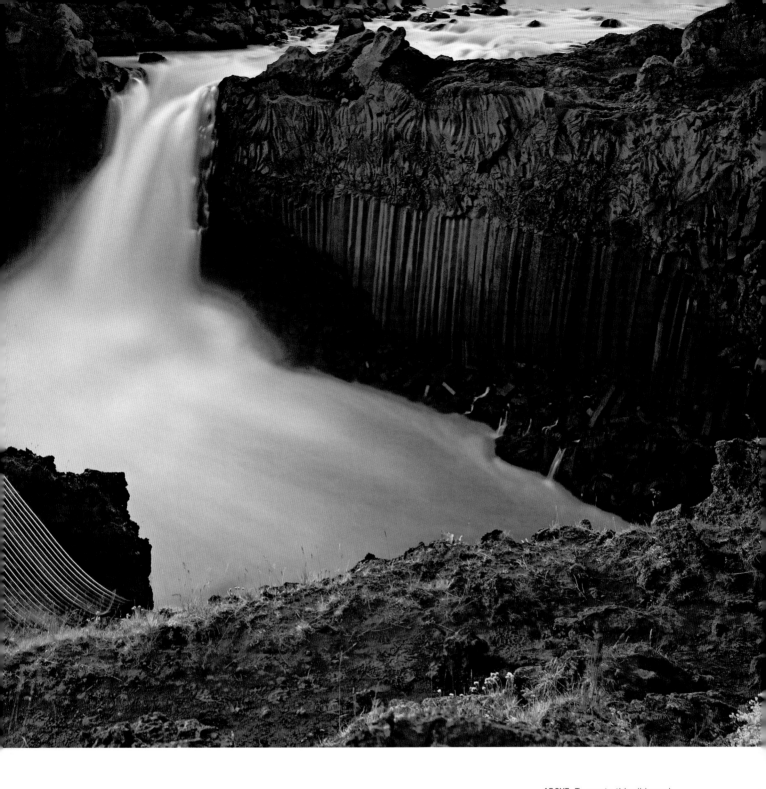

ABOVE To create this ribboned, gently twisted abstraction with a starburst at its peak, Cenci Goepel and Jens Warnecke attached an LED strip and a flashlight to a tent pole, then drew the tentlike shape in the air during a 45-second exposure.

REFLECTIONS

REFLECTIONS ARE EVERYWHERE—you see them when you pass by windows, stroll through puddles, or catch a glimpse of yourself in the silver of a spoon. Photographers usually go to great lengths to prevent reflections in their pictures, but sometimes a natural or deliberately produced mirrored scene can introduce a welcome element to an image, whether realistic or abstract.

GETTING STARTED

There's not much prep work to do when it comes to shooting reflections—it's more about learning to recognize their photo potential in the wild. Any shiny surface can echo back the scene in front of it: the buffed chrome of a hubcap, your friend's sunglasses, a grandiose marble floor. Slick, flat surfaces produce the cleanest reflections. Before snapping your shutter, inspect the object to make sure it's clear of smudges, scratches, and fingerprints. This is doubly important if you hope to capture detail within the reflected image.

Shiny objects and camera flashes rarely mix well, so most of the time your best bet is natural light. If you do have to use flash, try using the biggest light source possible to throw even light on the scene and keep the light itself out of the reflection so you don't get a big hot spot in your image. (You can also experiment with lighting your subject from behind.) If you're after crystal-clear reflections in water, seek them early in low, direct sunlight and minimal wind.

Once you start seeing reflections, you won't be able to stop. Graduate to mirrored surfaces that are textured or surprising in shape for next-level image-making.

TECH TIPS

EXPOSURE The right exposure will, of course, vary with the scene, but it's best to shoot in manual or aperture priority mode, stopping down the aperture to f/8 to f/11 or more to maintain the broadest depth of field. This allows you to keep both the source and reflection in sharp focus. Use a split or graduated neutral-density filter to balance differences in exposure between sky and land when necessary. For rippling or moving water, use a fast shutter speed to capture the texture. To smooth the water's surface, set the camera to 1/30 second or slower for a gentle blur. Reflections can be unpredictable, even if you're using a polarizing filter, so you have to give yourself a little more leeway when it comes to small, blown-out highlights or slightly lost shadow details.

FOCUS There may be times when you want to focus on the reflection of the main subject. Autofocus may be fooled by reflections, but manual focus provides better accuracy and lets you selectively choose the area to emphasize in the composition. Use depth-of-field preview with live view whenever possible to make sure you have the depth—or lack of depth—you want.

WHAT TO SHOOT

Watery reflections of natural scenes are a solid starting point, and bright lights flickering off urban puddles make for exciting alternatives. Pay attention to the light, of course, and the wind. A still body of water creates a glassy mirror image, while water rippled by a light breeze results in a more textured, ruffled look. (You can drop a rock to create your own ripples.) For an abstract image, find rapidly moving water and capture a mirrored swirl in its current.

Tall buildings reflected in windows produce interesting cityscapes, as the one at right shows. On a smaller scale, a shop window's display combined with a reflection of the opposing street scene can present captivating—and sometimes humorous—tableaux. Don't shy away from incorporating people into your shots. If a person is in the scene, it's usually best to center the focus point on his or her eyes. You can frame a portrait using a basic mirror, or go outdoors to capture a reflection in their sunglasses for an environmental theme.

When composing, break the rules. Place the horizon dead center to create slightly jarring symmetrical images. Move the horizon up or down or tilt the camera for surreal effects. Reflections give you the opportunity to embrace the unusual.

PAGE 302 Fleeting reflections—such as this street mirrored in a floating bubble—are especially tricky. It helps to have a dark background behind the bubble so that the scene's colors pop.

OPPOSITE Daniel Schwabe suddenly noticed this warped grid reflected in the windows of an office building while driving in Houston, Texas. He parked and shot the scene with a point-and-shoot, using a 52.8mm focal length, an ISO of 100, an aperture of f/4.5, and a shutter speed of 1/200 second to reproduce the strangely fluid geometry.

GEAR UP

Lenses Fast, wide-angle lenses with a full-frame equivalent focal length of 16mm–35mm are ideal for landscapes and window reflections, allowing you to position the camera close to the subject. Wide-to-midzoom lenses work well, too, for more distant scenarios, including tall buildings or, perhaps, easily spooked wildlife reflected in a pond or at the edge of the ocean. Tilt-shift lenses also let you completely remove yourself from a reflection. If you keep a camera parallel to a mirror, but off to the side, and then shift the lens sideways toward the mirror, the picture will appear as if taken head-on. Objects in front of the mirror, though, will look rearranged from a head-on perspective.

Filters Perhaps even more important than a graduated or split neutral-density filter is a circular polarizing filter. The polarizer gives you more control over reflections and helps cut down on unwanted parts of the reflection.

Tripod and Level A tripod is optional for most types of reflections, but using a sturdy support for landscape images is important to keep the camera steady and, with the help of a built-in or accessory level, keep horizons straight. Legs should have a height of at least 1 foot to 2 feet (30 cm–60 cm) since you'll want to shoot low when close to the water's edge to get a broad view of the reflection and the scene.

Radio-Remote Trigger A remote shutter release or app further minimizes movement when you snap the photo. The tripod and shutter release combination is helpful for long exposures.

Software Pull out more detail from highlights and shadows—a common issue when shooting reflections. If needed, apply sharpening to specific areas. Exposure may also need tweaking, particularly of high-contrast scenes shot without a neutral-density filter.

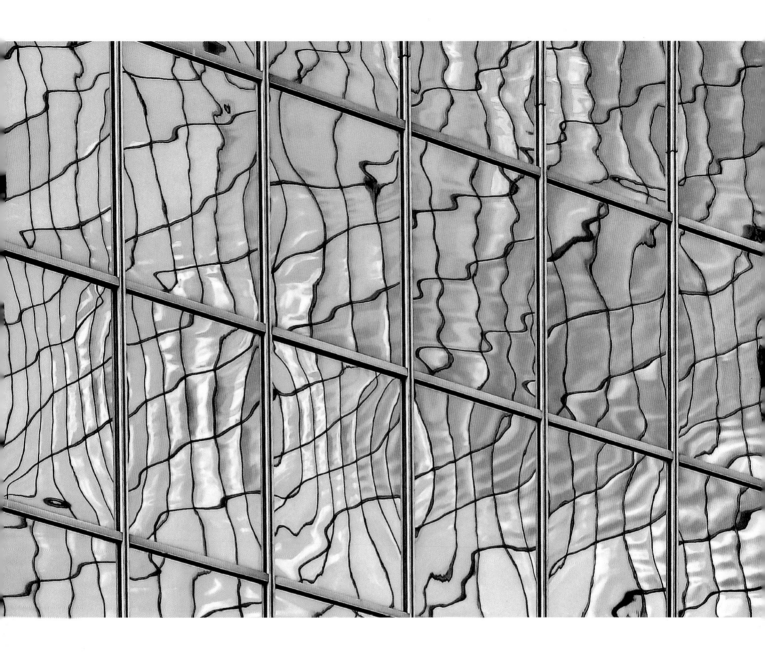

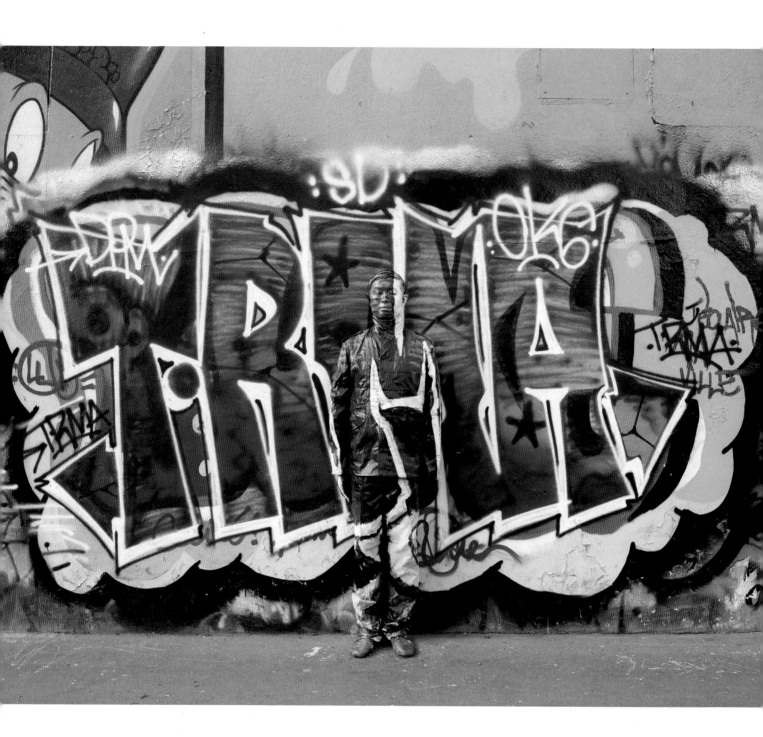

SELF-PORTRAITS

LONG BEFORE SELFIES began popping up all over social media, photographers have been making images of themselves—first as a method of learning about exposure in portraiture's early days, and now as a way of creating expressive, conceptual photos that tell a story. Anyone can shoot a self-portrait; the trick is to elevate it beyond the everyday snapshots we see online.

GETTING STARTED

Working in self-portraiture is a great learning tool, forcing you to step out from behind the camera and in front of the lens. Since you're the subject, the director, and the photographer, the possibilities are limitless—as is the technical growth you'll gain.

The first step is deciding what type of self-portrait you'd like to make. Maybe you're after a straight-on headshot (for your website), which may be the most technically challenging of the genre. Some headshots, such as those for passports, have required specifications, so work out the composition and background beforehand. Or perhaps you want to explore your emotions—some photographers use a series of self-portraits to create a fantasy world. Explore other people's self-portraits for inspiration and sketch out a series of shots to visualize your idea and to refer to as a guideline for your shoot.

Before stepping in front of a camera, stand in front of a mirror to get to know your face as a subject: Test out expressions and angle your head to find what flatters. Play with the mirror's position, too, so you know how to set up your camera when it's time for your closeup.

TECH TIPS

FOCUS To mark your position in front of the camera, have a friend stand in for you, or place an object at about the same height as your face or eyes to obtain focus. Manual focus is ideal. If you use autofocus, disable it after getting the focus point so it doesn't change when you trigger the shutter.

POSING Place a mirror behind the camera to see what you look like when posing. Alternatively, if the camera has a vari-angle LCD, turn on live view and flip the LCD to face you.

EXPOSURE Another place where manual may be best. Since you're your own model, you can take a test exposure using evaluative metering, check it, and adjust it accordingly. If you have an incident light meter, use it to measure the light falling on the scene where you will be posing.

ZOOM SETTING If you're using a zoom lens for your self-portrait, keep in mind that most modern autofocus zooms are in fact varifocal lenses—that is, the lens varies the focusing point as it is zoomed. So try not to nudge your setting after you've set a manual focus.

WHAT TO SHOOT

When it comes to basic headshots for professional use, simple is sufficient: You want a quiet background, a lot of nice natural light, and apparel that pops but isn't too busy. Standing near a window during the golden hour is best. Or head outside and find a good spot in the shade—never in harsh direct sunlight—before setting up your tripod.

A slight change in expression, background, or light source will take your self-portraits from serious to seriously intriguing, as in the image at bottom right. For more playful results, try switching up lenses or incorporating props and costuming.

A thematic or storytelling self-portrait is often more complex. Think about the message you want to communicate and what role you play within that message. For more difficult shoots and those that involve more fantasy than reality, consider compositing. Photograph various sites that best meet your vision and then, using-image editing software, place yourself and other elements in the scene. Look for interesting backdrops, skies, and objects for possible inclusion in composited self-portraits.

PAGE 306 At first glance, it may seem like a photo of an ordinary graffiti wall, but a closer look reveals a person camouflaged (literally painted) into the landscape. The person is photographer Liu Bolin himself, who has earned the nickname "The Invisible Man."

OPPOSITE TOP Teenager Zev Hoover scouts for backgrounds for his inventive, composited self-portraits by imagining the view from a tiny person's perspective. After shooting the space with a selective-focus lens and soft lighting, he shoots a self-portrait in a studio setup and brings both images into Photoshop, then cuts and inserts himself into the background. To make it believable, he draws shadows around his portrait and adjusts the lighting and color.

OPPOSITE BOTTOM Graphic interplay of light, shadow, and architectural elements can elevate a basic headshot, as in Chantal van den Broek's moody, window-lit self-portrait.

GEAR UP

Camera Self-portraits can be captured with virtually any camera. Some of the smaller point-and-shoot models have special features like face recognition to help with focus. Larger, more complex productions often require the flexibility of ILCs.

Lighting When natural lighting doesn't work, continuous lighting is a good alternative to strobes.

Lenses The best focal length depends entirely on the scene. A fast, 85mm lens works well for self-portraits including headshots. For more environmental images, where the surroundings are a critical part of the photograph, look for wider lenses—35mm–50mm (on full-frame cameras). Wider-angle lenses are a given in small spaces and provide more wiggle room for focus, while longer lenses require more accurate focus.

Tripod You'll need a tripod or a level surface for self-portraits. Tripods are ideal, especially when photographing outside on rugged terrain. Place sandbags around the feet or hang your camera bag at the bottom of the column for stability. Use a level (either on the tripod or the camera's virtual level) to ensure the camera isn't off-kilter.

Laptop and Tethering Gear For the ultimate setup, a laptop, tethering cables, and software provide immediate feedback on your shot. With the large view of a laptop screen, you can easily see the full composition and zoom in to check focus. Some tethering software allows you to adjust camera settings remotely.

Radio-Remote Trigger Most cameras have self-timers and often have a signal beep that counts down to when the shutter will snap. However, you need to reset the timer after each shot. A better option is a remote trigger: It lets you maintain your position and capture multiple poses without having to return to the camera (other than to check focus and exposure).

V-Reflector A simple reflector made of two large panels of white foamcore or other stiff material, hinged together, makes an excellent variable fill reflector.

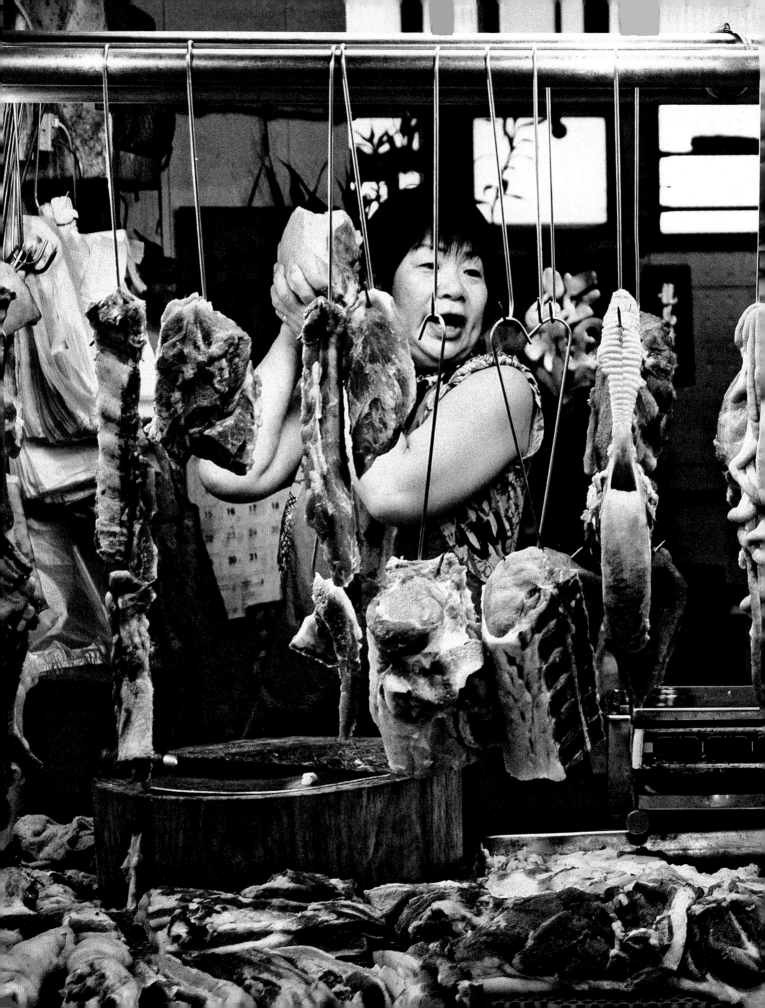

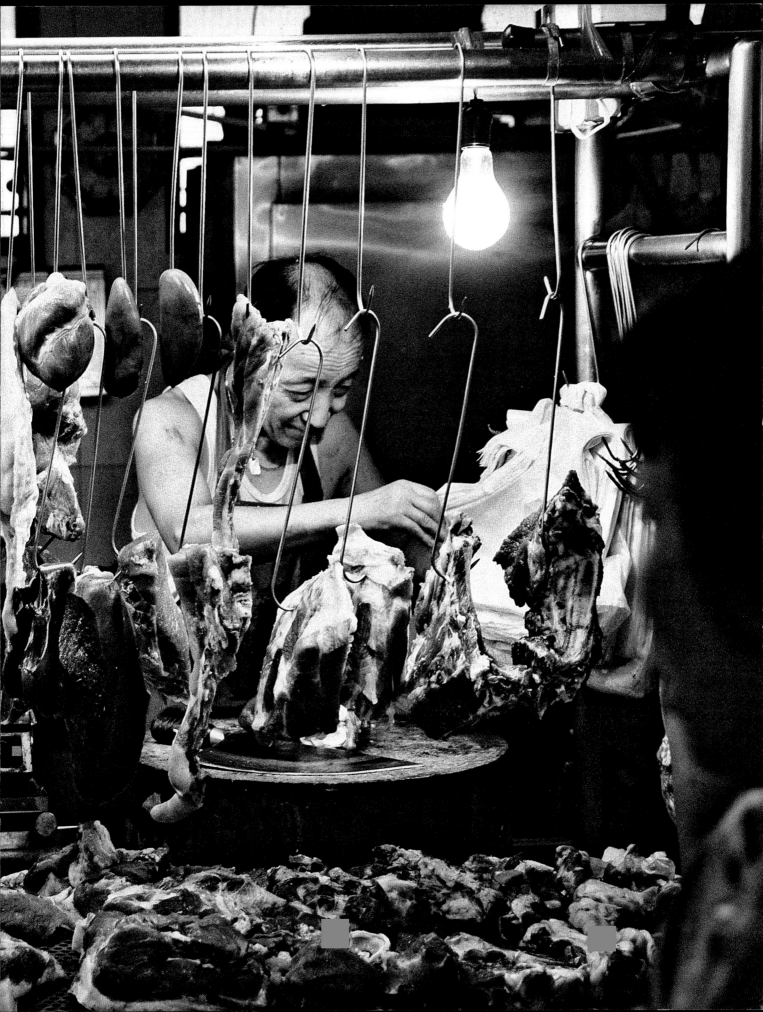

PHOTOJOURNALISM

||

NO OTHER GENRE matches the power of photojournalism to influence the course of world history, shed light on events close to home, and help the public keep an eye on the powers that be. Whether you're covering local news or delving into long-term feature projects, pursuing photojournalism gives you both a front-row seat—and a serious responsibility.

||

GETTING STARTED

Gaining access to newsworthy events and people is essential to your adventures as a photojournalist. Press credentials can help you get past police barriers and reassure subjects and officials that you're shooting for a legitimate reason, and local authorities can issue press identification that will likewise get you in places that most other people wouldn't dare to go. Until you're the real deal, however, practice citizen journalism: Take to the streets and document the events that matter to you. Chances are there's always something afoot in your community—a labor strike, student protest, forest fire, or other conditions that you feel strongly about documenting and sharing.

If you're planning to shoot a specific location, look for online discussion groups of journalists working there and ask about logistical or cultural concerns. Always be safe: No matter how passionate you are about a subject, stay out of designated danger zones.

One of photojournalism's defining aspects is ethics. When you're documenting, realize that your photo op may be another's immensely bad day. Approach the subject with dignity and professionalism.

TECH TIPS

SHOOTING METHODS Use a manual, priority, or programmed automatic mode. Avoid automatic scene modes that might add inappropriate special effects or otherwise distort your images.

METADATA Make sure that the date and time are set correctly on your camera, especially when you change locations. If you have a GPS function or attachment on your camera, activate it to embed location data in your image files. Using a mobile geotagging app on your phone can also help you record location data and embed it in the metadata of your image files later.

FOCUS AND DEPTH OF FIELD Use an aperture of f/8 or smaller to avoid shallow depth of field, so that you can show more detail in the scene. Compose the shot to direct the viewer's eye to your subject instead of isolating it against a blurred background.

EXPOSURE AND METERING An average or evaluative metering mode will help you keep most of the scene well exposed. Spot-metering for a high-contrast look isn't usually the best choice, because some elements of the scene might be obscured.

WHAT TO SHOOT

Photojournalists take images that tell the story of events unfolding before their lens. Consider these questions when you're shooting: What is happening? Who are the important actors in the event? Where and when is it happening? Why is it happening and what effect will it have? Compose your images to answer as many of these questions as possible within a single frame. If you're working on a lengthy assignment, create a series of images that explores the answers in depth.

Composition is perhaps the most important aspect of photojournalistic shooting, since your choices of what to include in—and exclude from—the frame create the narrative. Juxtapositions of foreground and background elements can show relationships between people and their environments. Moments that capture the defining actions or emotions of an event are also important. Look for expressions and gestures that communicate feelings, relationships, and roles.

Keep in mind the distinction between relating a story and making one up. You should never manipulate the scene by asking people to change what they're doing or interacting with them more than is needed for you to be present. You're there to record what is happening, not to affect it. An exception is taking portraits of newsworthy subjects. You might tell people where to stand or look in this case, but you shouldn't ask them to alter their appearance or perform any activity for the camera.

PAGES 310–311 Brad Cook grabbed this everyday glimpse of a meat market in China. Faced with low-light conditions, he set his ISO and stuck with aperture-priority mode so he could shoot quickly without adjusting his settings. "I saw the guy on the right, who had a great face full of character, but the wife would not be upstaged," he says.

PAGE 312 Being at the right place at the right time can, for some, mean putting yourself at risk. It paid off for Giovanni Auditore, who captured these police officers as they formed a barrier at a student protest in Italy. An officer was caught looking toward the camera, confronting the viewer. Auditore converted the image to black-and-white for a gritty feel.

GEAR UP

Two Camera Bodies Carry two camera bodies that are both compatible with your lenses in case one breaks down or gets damaged. Make sure the cameras you select let you focus quickly and shoot a long series of images.

Wide & Telephoto Lenses Having a couple of lenses that cover a wide range of focal lengths will give you the flexibility to adapt to any situation, regardless of how close to your subject you're able to get and what size space you're in.

Speedlight and LED Panel To handle any lighting situation that arises, carry a flash unit as well as a small LED panel light, such as a video lamp.

Action Camera and Audio Recorder Many photojournalists carry a small HD action camera to supplement their still images with motion footage. This type of camera can be mounted on an SLR hot shoe for simultaneous still and video capture or used separately. An audio recorder can help with both gathering information and capturing sound for multimedia slideshows.

Notebook, Pens, and Note-Taking App It's important to record the names, ages, and other pertinent details about photographic subjects for captions. A note-taking app that can take both audio and written notes is useful, but bring a small paper notebook and pen in case you run out of power.

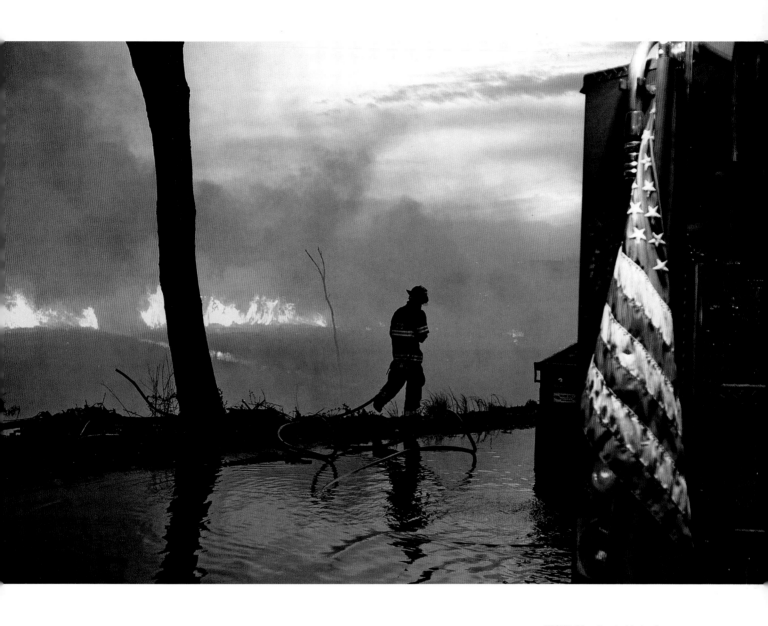

ABOVE Standing behind a fire truck allowed Michael Bocchieri to keep a barrier of water between himself and the flames, and include the American flag draped over the vehicle's side as a strong vertical element. He made the flag brighter in post-processing to connect it to the intensity of the blaze in the background, furthering its symbolism in the shot.

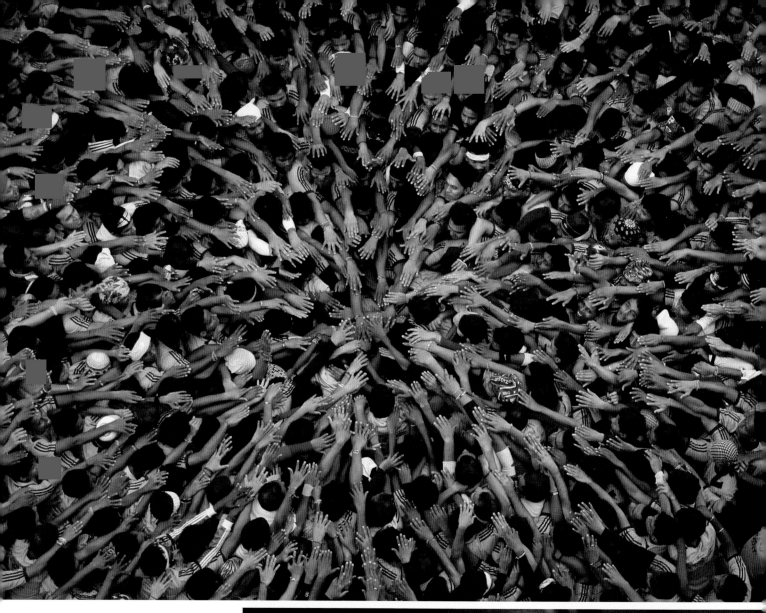

ABOVE Moving above the crowd makes it easier to shoot without being obstructed by others. If you can, find a small wall or a nearby building with a window to get a clear, wide shot of the gathering, as Danish Siddiqui did to capture the formation of a human pyramid during the Hindu festival of Janmashtami.

RIGHT Daniel Becerril photographed this miner on break inside an unregulated coal mine in Sabinas, Mexico. Becerril chose the man's eye as the focal point of an otherwise pitch-black face, highlighting his adverse working conditions.

ABOVE Taking advantage of the calm weather and favorable ice conditions in Norway, Ralph Lee Hopkins captured a polar bear and cub navigating semifrozen sea ice. He shot from a ship using a teleconverter lens to maintain a safe distance.

RESOURCES

GLOSSARY

AMBIENT LIGHT The available light in a scene (natural or artificial) that is not explicitly supplied by the photographer.

APERTURE The adjustable opening inside the lens, the aperture determines how much light passes through to strike the image sensor. The size of the aperture is measured in f-stops, and higher numbers signify a smaller opening.

APERTURE-PRIORITY MODE A camera mode in which the photographer chooses an aperture setting, and the camera automatically selects a complementary shutter speed for proper exposure.

ARTICULATED LCD A flip-out image screen that can rotate and swivel, allowing flexibility in the angle of view.

AUDIO FLASH TRIGGER This device allows you to sync your camera with a microphone so that the shutter is triggered by sound rather than the shutter.

AUTOEXPOSURE A mode in which a camera automatically calculates and adjusts exposure settings in order to match an image with the subject.

AUTOFOCUS A mode in which the camera automatically focuses on the subject in the LCD or viewfinder center.

BACKGROUND The elements in an image farthest from the viewer.

BOUNCE Light that is redirected toward a subject by a reflector or other reflective surface. Usually soft light, it helps spread light and fill shadows.

BRACKETING The technique of taking a number of pictures of the same subject at different levels of exposure, usually at half- or one-stop differences.

CENTER-WEIGHTED METERING A system that concentrates the light reading mostly in the central portion of the frame and feathers out to the edges.

COLOR FRINGING Also known as chromatic aberration, this image disruption occurs most frequently at high-contrast edges and often appears as bands of color, especially purple.

COMPOSITE A picture made of multiple, separate images that have been pieced together with software.

CONTINUOUS (HOT) LIGHTS Traditional tungsten or halogen lights that stay on continuously during shooting.

CONTINUOUS MODE Also known as burst mode, this is the digital camera's ability to take several shots in a second with one press of the shutter button. The speed and number of frames differ among cameras, and are often adjustable.

CONTRAST The range and distribution of tones between the darkest and brightest points in a photograph.

DEFOCUS Defocusing a subject seen through the camera's lens makes it appear softened and less defined.

DEPTH OF FIELD The distance between the nearest and farthest objects that appear in sharp focus in a photograph.

DIFFUSER Any material that softens and scatters light that passes through it.

EXIF DATA Information (such as the date and settings used) that your camera stores for each image it captures.

EXPOSURE The total amount of light allowed to fall on the photographic medium (determined by aperture, shutter speed, and ISO) during the process of taking a photograph. Also refers to a single shutter cycle (that is, a frame).

EXPOSURE COMPENSATION A feature that lets you increase or decrease your camera's exposure settings in small increments to achieve proper exposure.

FILL LIGHT A technique usually used to soften the contrast in a scene by shining a light that's softer than the main light into a scene's shadows to erase them.

FILTER A camera accessory that can be attached to the end of a lens to alter or enhance its effect.

FLASH The brief illumination of a subject during the moment of exposure.

FLUORESCENT LIGHT A type of continuous light that produces a cool light, the effects of which can be warmed with the corresponding white balance setting.

FOCAL LENGTH With a lens focused at infinity, this is the distance from the point in the lens where the path of light rays crosses to the film or sensor. Longer focal lengths magnify images, while shorter focal lengths reduce magnification and show a wide angle of view.

FOCUS When an element in an image is defined and its outlines are clearly rendered, it is said to be "in focus."

FOCUS RING A ring on the lens barrel that a photographer rotates to adjust focus manually.

FOCUS TRACKING A camera feature that can calculate the speed of a moving subject in order to properly focus and position the camera's lens to capture it.

FOREGROUND The elements of an image that lie closest to the picture plane, appearing nearest the viewer.

F-STOP A number that indicates the size of a camera's aperture. The larger the number, the smaller the lens opening, which works in conjunction with shutter speeds to accomplish correct exposure.

FULL-FRAME A camera sensor format that has the largest sensor (36mm by 24mm) commonly found in DSLRs.

HARD LIGHT Light that has a narrow focus and falls off quickly into shadow on striking a subject.

HIGH-DYNAMIC-RANGE (HDR) IMAGING A technique in which several versions of the same picture taken at different exposures are overlaid to create the widest range of tones possible.

HIGH-KEY A very brightly lit photo that contains large areas of white and bright tones, and few midtones or shadows.

HISTOGRAM An electronic graph on a digital camera showing an image's distribution of tones, from dark (on the

left) to light (on the right). Helps tell whether an image contains the correct range of tones for a proper exposure.

HYPERFOCAL DISTANCE The closest distance at which a lens can focus while keeping objects at infinity in sharp focus.

IMAGE SENSOR The medium in the camera that captures an optical image and converts it into an electric signal.

IMAGE STABILIZATION A camera or lens function that reduces blurring created by movement during an exposure.

ISO The sensitivity of a digital camera's sensor to light. A higher number indicates the sensor is more light-sensitive.

JPEG The most common type of image file, useful because it can be saved at a range of compression levels; high levels of compression will cause more data loss and image degradation, especially when the image is resaved multiple times. Suitable for emailing and web use because of their small size, JPEGs are not recommended for image editing.

LCD (LIQUID CRYSTAL DISPLAY) A thin, flat display screen on a digital camera that provides a live feed of what the camera is seeing, allows you to play back images, and offers access to menus.

LED (LIGHT-EMITTING DIODE) A type of light often used in video and studio lighting. Long-lasting and cool, it can serve as an alternative to fluorescent light.

LENS FLARE Unwanted distortion in an image, including odd rings, bands, and reflections, caused by light scattered inside the camera.

LIVE VIEW A function that sends the image through the lens to the LCD rather than the optical viewfinder. Using this function affords a larger view of the frame, easier depth-of-field preview, magnification for manual focusing, and other benefits.

LOW-KEY Describes an image in which the tones are mostly dark and have few highlights.

MACRO Closeup photography of very small subjects. The image on the sensor is close to the size of the subject or larger.

MOTION BLUR The streaking in an image that results when either the subject or the camera moves during exposure.

NOISE Undesirable graininess and flecks of color in a portion of an image that should consist of a single smooth color. Generally increases with higher ISOs.

OPTICAL VIEWFINDER A glass eyepiece used to frame and focus before taking a picture. Most compact cameras lack an optical viewfinder and rely on LCDs only.

OVEREXPOSURE When too much light strikes the sensor, the image is overexposed, meaning its colors and tones appear very bright or white, and highlighted areas are washed out.

PANNING The horizontal movement of a camera along with a moving subject. The technique is used to suggest fast motion, and brings out the subject from other blurred elements in the frame.

PANORAMA An image that depicts an extremely wide angle of view, typically wider than the human eye can see and than most lenses can capture. Often created through compositing.

PIXEL The smallest single component of a digital image. Also refers to the light-gathering cells on a camera's sensor.

POST-PROCESSING The work done with software on an image after a camera has captured it. It ranges from converting the image into a different type of digital file to editing and altering the picture.

PRIME LENS Any lens that has a fixed focal length, as opposed to a zoom lens, which has a variable focal length.

RAW FILE To output the losslessly compressed RAW files created in your camera, you must modify them with a converter, such as the one provided with your camera. RAW files let you alter settings after the fact and provide the most possible original data in an image.

RULE OF THIRDS A compositional guideline stating that visual tension and interest are best achieved by placing crucial elements of a photograph one-third of the way from any of the frame's edges.

SATURATION The intensity of color in an image. A saturated image's colors may appear more intense than the colors did in the actual scene, an effect that can be achieved with software.

SELF-TIMER A camera mode that gives a predetermined delay between the pressing of the shutter release and the shutter's firing. Can be used on a tripod-mounted camera to eliminate the effects of camera shake when you press the shutter.

SEPIA A warm brown tone, originally achieved by dipping a black-and-white photograph into a sepia bath, now imitated by software.

SHUTTER A mechanical curtain that opens and closes to control the amount of time during which light can reach the camera's image sensor.

SHUTTER-PRIORITY MODE A camera mode in which the photographer chooses the shutter speed, while the camera automatically adjusts aperture to achieve a proper exposure.

SHUTTER SPEED The amount of time during which the shutter stays open to light, measured in fractions of seconds. (1/8,000 sec is a very fast shutter speed, and 1/2 sec is very slow.)

SOFT LIGHT Whether diffused or coming from multiple or broad sources, this light falls on a subject without casting deep shadows or creating much contrast.

SPOT-WEIGHTED METERING A camera function that measures the light in only a small area, generally in the center of the frame. Use this feature when you want to precisely meter a particular point or element, and don't want other areas of the scene to affect the exposure.

STROBE Another term for *flash*. Can refer to large studio lights or portable accessory flash units.

TIFF A type of digital image file that is great for editing because it retains image quality and doesn't compress files.

TUNGSTEN LIGHT An incandescent continuous lamp that gives warm light.

UNDEREXPOSURE When too little light strikes the sensor, the overall tone of an image is dark, shadows are dense, and colors are muted.

VIEWFINDER The opening the photographer looks through to compose and focus the picture.

WHITE BALANCE The camera setting that defines what the color white looks like in specific lighting conditions and corrects all other colors accordingly.

ZOOM LENS Any lens that is constructed to allow a continuously variable focal length, as opposed to a prime lens, which has a fixed focal length.

INDEX

CREDITS

||

Main text by Theano Nikitas, with the following contributors: Aimee Baldridge (pp. 44–47, pp. 106–109, pp. 180–183, pp. 188–191, pp. 194–197, pp. 246–249, pp. 268–269, pp. 282–285, pp. 312–315); Daniel Richards (pp. 36–39, pp. 54–57, pp. 66–69, pp. 72–75, pp. 92–95, pp. 232–235); John Shafer (pp. 168–171, pp. 208–209, pp. 212–213). Captions by Jaime Alfaro.

All illustrations by Francisco Perez.

Front cover, clockwise from top left: Lisa Pessin, James Neeley, Heidi Westum, Roman Kruglov, Pat Stacy, Yann Cabello
Back cover, clockwise from top left: Giovanni Auditore, Shutterstock, Cliff Laplant, Terri Burke, Marco Crupi, Randy Santos p. 1: Michael L. Cable pp. 2–3: David Maitland pp. 4–5, clockwise from top left: Peter Allison, Victor Simacek, Clane Gessel, Design Pics Inc/National Geographic Creative, Kristian Cabanis/Robert Harding, Annabelle Breakey, courtesy of Williams-Sonoma, Shahul Hameed, Daniel Schwabe, Floto+Warner/OTTO, Andrew Boyle, Chico Lima, Frank Heuer pp. 6–7: Suryo Ongkowidjaja. p. 8: Shutterstock p. 11: Jun Ahn pp. 13–15: Shutterstock p. 16, top: Brian Smale p. 16, bottom: Helen Cathcart pp. 17–19: Shutterstock p. 21, top right and bottom left: Shutterstock p. 21, bottom right: Anita Bowen p. 23, top: Hilary Cam p. 23, bottom left: Delbarr Moradi p. 23, bottom right: Antonio Torres p. 25: Shutterstock p. 27: Pol Ubeda pp. 28–29: Freddie Bennett p. 30: John Cornicello p. 33, top: Michael Brands p. 33, bottom: David Johnson pp. 34–35: Kenneth M. Podgorski (Kenneth Mitchell Photography) p. 36: Chico Lima p. 39: Menno Aden p. 40: Kalee Vidanapathirana p. 41: Navid Baraty pp. 42–43: Sivan Askayo p. 44: Vivek Prakash/Reuters/Corbis p. 47: Helen Cathcart p. 48: Lincoln Barbour p. 49, top: Agnieszka Rayss p. 49, bottom: Sivan Askayo p. 50: Kenneth Ginn/National Geographic Creative p. 51: Brian Pineda pp. 52–53: Frank Heuer p. 54: Chris Axe/Getty Images p. 57: Ian Plant pp. 58–59: Matt Walker p. 60: Design Pics Inc/National Geographic Creative p. 63: Willie Huang p. 64, top: Darren White p. 64, bottom: Mark Kilner p. 65: Eric Schafer p. 66: Frans Lanting/National Geographic Creative p. 69, top: Tony Martin Photography p. 69, bottom: Kathleen Wilkie pp. 70–71: Klaus Echle p. 72: Lisa Pessin/Shutterstock p. 75: White Voodoo Photography/Adam Liddy p. 76: Richard Bernabe p. 77, top: Richard Bernabe p. 77, bottom: Robert Sullivan p. 78, top: Ron Lutz p. 78, bottom: Shahul Hameed p. 79: Ian Plant pp. 80–81: Marco Crupi p. 82: Cliff LaPlant p. 85: Jared Ropelato p. 86: Paul Marcellini p. 87: Richard Bernabe

p. 88: Ian Plant p. 89: Kah-Wai Lin pp. 90–91: Jaro Krivošriv/500px Prime pp. 92– 95, top: Shutterstock p. 95, bottom: Mehmet Karaca pp. 96–97: Norman Press p. 98: Harold Davis p. 101: Magdalena Wasiczek p. 102: Willie Huang p. 103, top: Shon Baldini p. 103, bottom: Shutterstock pp. 104–105: Dave Getzschman/Chrisman Studios p. 106: Dina Douglass/Andrena Photography p. 108: Sean Flanigan p. 109, top: Hilary Cam p. 109, bottom: Todd Laffler p. 110: Delbarr Moradi p. 111: Dave Getzschman/Chrisman Studios p. 112, top: Tyler Wirken p. 112, bottom: Kitty Clark Fritz/Twin Lens p. 113: Ron Antonelli for Brian Dorsey Studios pp. 114–115: Shutterstock p. 116: Brian Kuhlmann p. 119, top: Jordan Matter/Dancers Among Us p. 119, bottom: © 2014 Christian Witkin pp. 120–121: © Amy Weiss/Red Edge images p. 122: Laura Today p. 125: Alice Gao p. 126: Sue Tallon p. 127: Vladimir Shipulin pp. 128–129: Alex Farnum p. 130: Helen Cathcart p. 133: Annabelle Breakey, courtesy of Williams-Sonoma p. 134: Ray Kachatorian, courtesy of Williams-Sonoma p. 135: Eric Wolfinger p. 136: Markus Reugels p. 139: Tom Smith pp. 140–141: Anthony Ghiglia p. 142: Pat Stacy p. 145: Paul Marcellini p. 146: Ian Plant p. 147: Seth de Roulet pp. 148–149: Shawn Heinrichs p. 150: Peter Allinson p. 152: Elena Kalis p. 153: Mallory Morrison p. 154: Alastair Pollock Photography/Getty Images p. 156, top: Christian Loader/Scubazoo Images p. 156, bottom: Steven Kovacs p. 157: Shutterstock pp. 158–159: Francisco Negroni p. 160: Jim Reed p. 163: Shutterstock p. 164, top: Jim Reed p. 164, bottom: Alexey Kljatov p. 165: Vincent Soyez pp. 166–167: Shutterstock p. 168: Christopher Beauchamp/Wonderful Machine p. 171: Shutterstock p. 172: Michael Anderson p. 173: Hollyn Johnson p. 174: Christopher Beauchamp/Wonderful Machine p. 177, top: John Crouch p. 177, bottom: Lorraine DarConte p. 178: Shutterstock p. 179, top: Ian Plant p. 179, bottom: Miss Aniela p. 180: Randy Santos p. 183: Ste Murray p. 184: Peter McKinnon p. 185: Veleda Thorsson pp. 186–187: Roman Kruglov p. 188: Philipp Klinger p. 191: Shutterstock p. 192: Joseph Constantino p. 193: Clane Gessel p. 194: Lina Östling p. 197: Floto+Warner/OTTO, residence of Jonathan Adler and Simon Doonan p. 198: Christopher Stark/Designed by Applegate Tran Interiors p. 199, top: Lincoln Barbour p. 199: Reprinted with permission of the publisher © Ryland Peters & Small Ltd/CICO Books/Helen Cathcart (All rights reserved) pp. 200–201: RC Rivera p. 202: Robert Schlatter p. 205: Andres Chaves p. 206: Mick Fuhrimann p. 207: Vlad Lunin p. 208: Mitch Feinberg p. 211: top, John Kuczala/

POPULAR PHOTOGRAPHY

P.O. Box 422260
Palm Coast, FL 32142-2260
www.popphoto.com

ABOUT *POPULAR PHOTOGRAPHY*

With more than 2 million readers, *Popular Photography* is the world's largest and most noted photography and image-making publication. The magazine brings more than 75 years of authority to the craft, and in its advice-packed issues, website, and digital editions, its team of experts focus on hands-on how-to hints and inspiration for everyone from beginners to top-notch professionals.

POPULAR PHOTOGRAPHY

Editor-in-Chief **Miriam Leuchter**
Art Director **Jason Beckstead**
Senior Editor **Peter Kolonia**
Features Editor **Debbie Grossman**
Online Editor **Stan Horaczek**
Senior Technology Editor **Philip Ryan**
Associate Technology Editor
 Dan Bracaglia
Technology Manager **Julia Silber**
Assistant Online Editor **Jeanette D. Moses**
Assistant Photo Editor **Linzee Lichtman**
Designer **Wesley Fulghum**
Editorial Coordinator **Jae Segarra**

weldonowen

415 Jackson Street
San Francisco, CA 94111
www.weldonowen.com

President, CEO **Terry Newell**
VP, Sales **Amy Kaneko**
VP, Publisher **Roger Shaw**
Director of Finance **Philip Paulick**

Senior Editor **Lucie Parker**
Editorial Assistant **Jaime Alfaro**

Creative Director **Kelly Booth**
Art Director **Lorraine Rath**
Designer **Jennifer Durrant**
Senior Production Designer
 Rachel Lopez Metzger

Production Director **Chris Hemesath**
Associate Production Director
 Michelle Duggan

Weldon Owen and *Popular Photography* are both divisions of **BONNIER**

A WELDON OWEN PRODUCTION
© 2014 Weldon Owen Inc.

Library of Congress Control Number:
2014948571

ISBN 13: 978-1-61628-806-8
ISBN 10: 1-61628-806-X

10 9 8 7 6 5 4 3 2 1
2014 2015 2016 2017 2018

Printed in China by R. R. Donnelly.

ACKNOWLEDGMENTS

POPULAR PHOTOGRAPHY
Popular Photography would like to thank Lucie Parker, Jennifer Durrant, Lorraine Rath, Kelly Booth, Maria Behan, Brianna Smith Spiegel, Sarah Edelstein, and Jaime Alfaro for their efforts on this title.

WELDON OWEN
Weldon Owen would like to thank Marisa Kwek for initial design development, and Jacqueline Aaron, Maria Behan, and Kevin Broccoli for their editorial assistance. We would also like to thank Sarah Edelstein and Brianna Spiegel for permissions management; Lou Bustamante for production assistance; and Dan Richards for his expert technical review of the material.